THE PRINTS OF
ADOLF DEHN

THE PRINTS OF
ADOLF DEHN

A CATALOGUE RAISONNÉ

COMPILED BY JOYCELYN PANG LUMSDAINE AND THOMAS O'SULLIVAN

WITH ESSAYS BY RICHARD W. COX AND CLINTON ADAMS

MINNESOTA
HISTORICAL SOCIETY
PRESS
ST. PAUL
1987

This project is supported by a grant from the National Endowment for the Arts. The publication of this catalogue of the prints of Adolf Dehn is in conjunction with an exhibition of the same name in 1987–88 by the Minnesota Historical Society.

Minnesota Historical Society Press
St. Paul 55101
© 1987 by Minnesota Historical Society
All rights reserved
Manufactured in United States of America

10 9 8 7 6 5 4 3 2 1

International Standard Book Number:
0-87351-203-0

LIBRARY OF CONGRESS
CATALOGING-IN-PUBLICATION DATA

Lumsdaine, Joycelyn Pang.
 The prints of Adolf Dehn.

 Bibliography: p.
 1. Dehn, Adolf, 1895–1968 – Catalogs. 2. Prints,
American – Catalogs. 3. Prints, Modern – 20th
century – United States – Catalogs. I. O'Sullivan,
Thomas, 1951- . II. Dehn, Adolf, 1895–1968. III.
Title.
NE539.D44A4 1987 769.92′4 87-7776

CONTENTS

PREFACE

The basis for this catalogue raisonné may be found in Adolf Dehn's own concern for his prints. While Dehn maintained no ledger or systematic record of his output, he kept at least one impression from each edition. Marginal notes on some impressions attest to his concern for posterity: "Rare!" "Only copy," "Do not sell!" he penciled on various prints. His master set, compiled over more than four decades, was preserved intact by Virginia Engleman Dehn, his widow, after Adolf Dehn's death in 1968.

The monumental task of compiling a catalogue raisonné of more than six hundred prints was undertaken by Joycelyn Pang Lumsdaine for her master's thesis at the University of California at Los Angeles. Working under the tutelage of E. Maurice Bloch of UCLA's Gruenwald Center for the Graphic Arts, Lumsdaine completed the thesis entitled "The Prints of Adolf Dehn and a Catalogue Raisonne" in 1974. In subsequent years Virginia Dehn continued her stewardship of the Adolf Dehn prints, while seeking a permanent repository for the master set and a publisher for the catalogue raisonné. In 1985 by donating the master set to the Minnesota Historical Society, she fulfilled both goals.

As thorough as Dehn may have been in com-piling a set of his prints, there are some gaps in the Minnesota Historical Society master set. Documentation of prints not at the Society has been made possible through the cooperation of individuals listed below. A very few prints could not be located or identified for inclusion in this book. Although a catalogue raisonné for such a prolific worker as Dehn may be considered comprehensive only until a previously undocumented print appears, this book represents the most complete and accurate information available. Its omissions and errors are the sole responsibility of the authors.

The catalogue raisonné as it is here published draws on Lumsdaine's thesis, verified and amended as necessary by the Society's staff. The addition of Dehn's own words to individual print captions has also been made by the Society's staff. Original essays by Richard Cox and Clinton Adams provide a biographical context and technical assessment of Dehn's printmaking career. The authors have been instrumental, beyond the call of specific duties, in shaping the final form of this book. In addition, Norman and June Kraeft of June 1 Gallery and Susan Teller of Associated American Artists have been foremost among the museum and gallery personnel who have sup-

ported the project. Barry Walker, Brooklyn Museum, Daniel Knerr, Memorial Art Gallery, University of Rochester, Nancy Sjoka, Philadelphia Museum of Art, Gertrude Dennis, Weyhe Gallery, Karen Lovaas, University Art Museum, University of Minnesota, Eve Wilen, Artists Equity, John Ittman and Richard Campbell, Minneapolis Institute of Arts, and David Kiehl, Metropolitan Museum of Art, have all provided valuable assistance.

Sally Rubinstein, June Sonju, Alan Ominsky, Deborah Swanson, Mary Burrell, and John McGuigan of the MHS Press all devoted much time and painstaking effort to preparation of this book. MHS staff members Jennifer Goossens, Pamela Owens, and Special Libraries personnel Tracey Baker, Nancy Erickson, Dona Sieden, and Bonnie Wilson also contributed to the project. Eric Mortenson of Minneapolis photographed nearly 670 Dehn prints in black and white; color photography was done by MHS staff photographer Phillip Hutchens.

Generous grants from the National Endowment for the Arts and from Laura Jane Musser of Little Falls, Minnesota, helped to fund the preparation and production of the book. The Archives of American Art made available for research and quotation its invaluable collection of Dehn's correspondence. The final debt of gratitude is due to Virginia Dehn — not just for her generosity to the Minnesota Historical Society but also for her dedicated efforts to preserve, promote, and share the prints of Adolf Dehn.

Thomas O'Sullivan
Project Coordinator
Curator of Art
Minnesota Historical Society

ADOLF DEHN: THE LIFE

RICHARD W. COX

As he entered the crowded quarters of the Associated American Artists Gallery one evening in late 1942 and let his eyes travel over twenty years' worth of his lithographs hanging on the walls, Adolf Dehn must have been slightly nonplused at the recent rush of honors. By any standard he had become a success. Leaders in the printmaking community were hailing him as one of the few Americans who had made a major contribution to modern lithography, he had recently been awarded a Guggenheim Fellowship, and he had just finished teaching his third summer session at the prestigious Colorado Springs Fine Arts Center School where he had worked alongside Boardman Robinson and Lawrence Barrett. His work was now in the collections of the Metropolitan Museum of Art, the Whitney Museum of American Art, and the Museum of Modern Art. Standard Oil and Time-Life had paid him handsomely to make paintings and drawings for their firms. And there was a comfortable balance in his bank account.

Dehn's checkered career had been marked by false starts, personal adversity, romantic adventure, technical experiment, neglect, and, finally, critical acclaim. Even after the triumphs of the 1940s, however, Dehn still did not arouse much interest among art historians, perhaps because his art defied any effort to assign it a pattern. While his prints have Early Modernist, Regionalist, and Social Realist aspects, they do not fit neatly into any of these textbook categories. That he was until the late 1930s exclusively a draftsman and a lithographer also may explain the pallid impression he left on scholars, who until very recently have been interested only in those printmakers whose major reputations rest on their paintings. By and large, Dehn has been regarded as one of the numerous near-major figures who dotted the American art scene between the two world wars, yet his career continued for twenty years after World War II.[1] It is time to give a connected history of this prolific artist's life, which is a fascinating study of courage and endurance and of the art that touched many of the key issues in twentieth-century culture.

Born in Waterville, Minnesota, on November 22, 1895, Dehn was the son of second-generation, German-American parents. Both his mother and his father were strong iconoclasts. Emilie Haas Dehn could have easily stepped out of a Willa Cather novel. A rugged

and kind-hearted woman who participated in feminist politics and the socialist-inclined German Lutheran Evangelical Church, she held the family together in the worst of times. Her husband Arthur was an anarchist and an atheist, a hard-bitten hunter and trapper, "more handsome than any man should be, free-as-the-wind, original in what he had to say and absolutely remote and tight-fisted."[2] Adolf assimilated this frontier freethinking without disaster.[3] The Bible, which he was encouraged to interpret freely, Walt Whitman's *Leaves of Grass*, and Thomas Paine's *The Age of Reason* provided structure for his early passions.

He began sketching farm animals at the age of three, and at nine he dazzled the townfolk attending the Waterville Festival with a big drawing of a train. Caricatures of local dignitaries followed and cemented his standing as the unrivaled "First Artist" of Waterville. Adolf won a scholarship to the University of Minnesota but against his parents' wishes decided to go to the Minneapolis School of Art (later the Minneapolis College of Art and Design) in the fall of 1914. Probably to try to appease his father, who could not understand why his son would want to throw his life away as an artist, Adolf announced that he was going to study to be a cartoonist-illustrator in the long and well-paying tradition of Winslow Homer, Thomas Nast, and Rollin Kirby.[4]

In the Twin Cities Dehn constantly went on sketching ventures outside his classrooms—he drew the circus, the Wild West shows, and Jess Willard, who had recently knocked out Jack Johnson to become the heavyweight boxing champion. With country-boy bluntness he lampooned college fraternity rituals on covers for the University of Minnesota humor magazine, *The Minnehaha*. As for his actual classes, "making still lifes and copying plaster casts wasn't much fun," Harry Salpeter wrote. "He was either bored or bewildered. He wanted to be a good artist, or none at all, and he feared that his inability to copy meant the skids."[5] Later on Dehn credited only one teacher, Gustav Goetsch, with making any real impact on him, probably because the professor encouraged his "tendency toward caricature, exaggeration, and wildness," while impressing upon him the need for good drawing and modeling.[6]

The other classmates supplied most of the incentive for Dehn when he was in Minneapolis. Wanda Gág, Harry Gottlieb, John Flannagan,

Elizabeth Olds, Arnold Blanch, Lucile Lundquist (later Lucile Blanch)—all passed through the Minneapolis School of Art's classes during these years. There were few, if any, galleries or exhibitions of contemporary art in the Twin Cities in 1915. As Harry Gottlieb remembers, "We went downtown to work, drink, and hear political speeches, not to look at art."[7] Possibly because his political consciousness was further developed than that of the others, Dehn became the ringleader. His immense charm, "shock of black hair, movie star smile and loose-jointed frontier stride"[8] may also explain his powers of persuasion, especially with the female students. He talked them into subscribing to *The Masses*, a freewheeling socialist journal of literature and art he had started reading when he was seventeen. He posted notices of upcoming lectures by Eugene V. Debs, Margaret Sanger, Emma Goldman, and other radical advocates who passed through

Dehn and Wanda Gág in about 1915 near Waterville

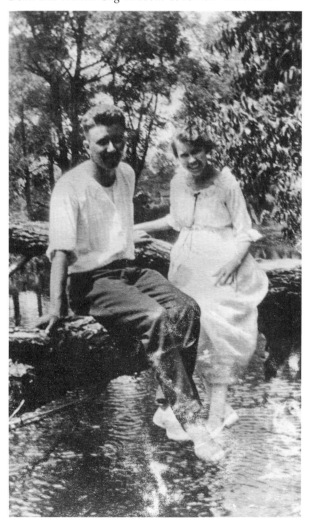

the Twin Cities in these years.[9] His special project was the talented and innocent Wanda Gág from New Ulm, who sprinkled her diary with mentions of the "exciting Mr Dehn."[10] His attitude was that there was no time like the present to make a serious attack upon the problems of life and art.[11]

Dehn, Gág, Flannagan, Blanch, and the other Minneapolis students had the good fortune of being young in the heyday of the Progressive Era, the 1900–20 period that was the seedbed of new political and artistic ideas. There was an exhilarating sense of a new age at hand; artists, by joining writers and political reformers, could transform the world into a decent, modern, liberated paradise. When they finished their studies in Minneapolis, Dehn, Gág, and company decided to take their wide-eyed ambitions to the American nerve center, New York City. Dehn and Gág, having won scholarships to the Art Students League in August 1917, were soon joined by Gottlieb, Flannagan, and Blanch. Dehn quickly set about ingratiating himself with the Greenwich Village luminaries – Max Eastman, Floyd Dell, and especially Boardman Robinson – who were trying to hold together *The Masses*, which was feeling the hot breath of government censors.[12] Dehn signed up for classes with Kenneth Hayes Miller, listened to guest talks by Joseph Pennell, George Luks, and John Sloan at the League, and spent much of his spare time walking the streets of Lower Manhattan, sketching life in the ethnic neighborhoods as Sloan and Luks had done a decade before.[13]

Unfortunately, Dehn could not settle into a normal student routine. When the United States declared war against the Central Powers in April 1917, President Wilson immediately outlined a conscription plan, which boded ill for Dehn and other professed socialists who faced a choice of soldiering or going to jail. Dehn was drafted in February 1918. After many hand-wringing discussions (especially with Wanda Gág) Dehn declared himself a conscientious objector.[14] He arrived at the Spartanburg, South Carolina, boot camp in July, fearing the worst. He was showered with epithets ("slacker, goddamned coward"), underwent psychiatric examinations, and heard threats of a twenty-five-year penitentiary sentence. But he muddled through. To reassure his worried family, Dehn sent home letters that were almost jaunty in tone. He preferred to look on his confinement as another character-building ex-

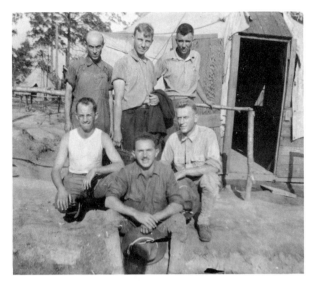

A group of conscientious objectors posed at the Spartanburg, South Carolina, camp "just as Mozer left us to return to the G.H. [guardhouse] for the third time," Dehn noted on the back of the snapshot; standing, left to right, Isadore, Mozer, Dehn, sitting, Humphreys, Friedman, Griesbach.

perience, something akin to the dangerous evening sketching strolls he had taken through the Tenderloin district of New York several months before.[15] Ever alert to human folly, he seemed actually to thrive on the company of

> intellectual atheists and sixteenth century Puritans who think checkers nearly as sinful as adultery. All sure of the one fact that they will not kill. Sonorous hymns are sung by a group of zealots. . . . The Ethical Culturist and Socialist are delving into the forbidding intricacies of sex. . . . My stomach gurgles from too many prunes. Taps have been blown.[16]

What he did not foresee was the effect his stand would have on the Dehn family when war fever mounted in America in late 1917. His sister Viola recalled that some of her earliest memories in Waterville were of brass bands, parading soldiers, and patriotic speeches.[17] Edward Lawless, editor of the *Waterville Sentinel* and an active member of the America First Association, went headlong for the war and bitterly criticized Dehn's pacifist stand and his mother for publicly supporting her son.[18]

Lawless's hysteria was not universal in Minnesota. Across the state there was an undercurrent of opposition to America's entry into the war, although rare was the pacifist like Emilie Dehn brave enough to state her disapproval openly. She paid a penalty for speaking out as

most of the town citizens ostracized the Dehn family, and the local postmistress opened their mail. Some of the Dehn relatives denounced Adolf's action.

The cruel treatment of his mother infuriated Dehn. He wrote bitter letters home declaring Waterville off-limits for himself in the immediate future. He vowed that he would show all these parochial fools that he could overcome his war troubles and go on to become a famous and possibly rich artist.[19] When the Armistice came, Dehn volunteered for duty in an Asheville, North Carolina, hospital for victims of tuberculosis and mustard gas. He received an honorable discharge in July 1919 and took the train straight to New York.

He found he could not resume his art training where he had left it before the war. Repression resulting from the growing Red Scare dogged left-wing journals, forcing Dehn and other cartoonists to keep a wary eye on the New York state committee that had been appointed to investigate seditious activities.[20] This assault may have been a blessing in disguise, as Dehn was already coming to the conclusion that he did not want to be a professional cartoonist; Blanch, Flannagan, Sloan, and other artist-friends coaxed him away from journalism and toward "serious" art. Even Boardman Robinson, the cartoonist Dehn most admired, had branched into mural painting and lithography by this time.[21]

Indeed, Robinson, with the aid of George Miller, the New York master printer, instructed Dehn in the rudiments of lithography in 1920. Robinson then conducted his protégé to the Weyhe Gallery on Lexington Avenue to meet Carl Zigrosser, the evangelistic promoter of American printmaking, who took some of Dehn's drawings and seven lithographs on consignment and offered him a place in a small graphic arts show in 1921. Dehn entered seven drawings and three lithographs; only two drawings sold, one of them to Arthur B. Davies, a painter, for $16.50, which was not a bad price in those days. Photographer and gallery-owner Alfred Stieglitz put one on hold but never came back to pick it up. Dehn's other works languished in the back room.

Many of these drawings were of the oil and coal refineries along the East River, one of which *The Liberator* featured on its July 1921 cover.[22] These bulging, oversized monuments to the new technology revealed an ambivalent attitude on the part of the artist; like John Marin, Joseph Stel-

la, and others, Dehn was both awestruck and uneasy about the Machine Age. Curiously he did not pursue the subject beyond this East River series, and while they represented his first attempts at art outside of cartooning, these renderings of oil storage tanks lacked the structure and conviction that other American interpretors of the technological age brought to their art in the early 1920s.[23] Although he sometimes boasted that his drawings should be hanging on museum walls beside those of the best-known American artists, Dehn felt insecure about his talent and direction.[24] Perhaps he was paying the penalty for his diffident studies in Minneapolis and for his interrupted schooling at the Art Students League. But he had no taste for more formal classes.

Dehn's constant companion was Wanda Gág, and their friendship blossomed into romance during the war. More than anyone else, Wanda gave Adolf steady moral and philosophical support through her long letters that helped to lift his spirits in those difficult months. After his return to New York they rambled on frequent sketching outings, went dancing, and took in plays, movies, political rallies, and art openings. Together, they worked their way onto the Weyhe Gallery artist roster. She cooked him meals when he was sick and sewed his shirts; he made her laugh and kept her "loose" (as much as anyone could lighten up this intensely driven young artist).[25] They talked of going to Europe together. Later, both Dehn and Gág characterized their relationship in the early 1920s more as puppy love than serious romance, but their letters leave no doubt about their occupying much of each other's time in those years.[26]

The main factor that prevented Dehn from focusing all of his attention on art was his financial bind. By 1920 his scholarship at the Art Students League had elapsed, and no money was coming in from Waterville. His failure to sell more than two drawings at the 1920 Weyhe group show must have opened his eyes for the first time to the possibility that art might be more a labor of love than a remunerative profession. In 1920 and 1921 he resorted to painting lampshades, running errands, and working as a night watchman. Dehn, whom one friend called "a broad shouldered specimen of Midwestern humanity," was well suited to scaring away would-be intruders, but he could not sell his drawings. As John Sloan later reminded those who wailed about the miseries of the 1930s, artists had staged

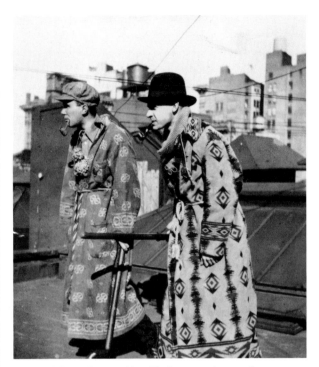

Dehn, left, and an unidentified companion on duty as night watchmen for the Holmes Electric Protection Company, New York

numerous dress rehearsals for the depression long before the Hoovervilles went up and bread lines formed in the stricken cities.[27]

In time Dehn grew discouraged about his prospects in the New York galleries, and his thoughts turned more and more to Europe. Since John Singleton Copley, how many stymied young American artists had not made plans to go abroad? That itch was perhaps more powerful than usual among the disenchanted Lost Generation of the immediate post-World War I years; with considerable fanfare these writers and artists proclaimed that only in Europe could they "find themselves" and receive proper respect. Adolf's letters to Waterville from mid-1920 onward carried notices that he was apt to be going abroad any day; at one point he told his mother that he was sick at heart to have "barely missed a chance to go to Constantinople on a ship. Learned about it too late. Wanda was very much against the idea."[28] Gág was, presumably, holding out for the joint trip to Paris that she and Adolf had been discussing. In the end she could not break free of family and work responsibilities and never got to Europe.[29]

Dehn's chance finally came in September 1921, and he booked passage on a freighter that docked at Cherbourg. After a brief swing through France, Germany, and Austria, he met a writer-friend, Norman Matson, and they swooped into Italy where they had a grand time seeing Renaissance art, especially the great paintings of Giotto at Padua. He and Matson "slept out of doors and found substantial meals in peasants hovels for a few sous" and drank their fair share of wine. After six weeks of these adventures Dehn had just enough money to get back to Vienna and was clearheaded enough to know that he had to find work.[30]

In the winter of 1921–22 he rented a flat near St. Stephen's Cathedral in the Austrian capital where Frederick Kuh, a prospering journalist and an old friend from the Spartanburg guardhouse, introduced him "to an international crowd of newspapermen, some Americans, but mostly Europeans."[31] Through his friendship with Scofield Thayer, the editor of *The Dial*, numerous Dehn drawings soon appeared in that magazine. Thayer hired Dehn to be superintendent of *The Dial's* Portfolio of Modern Art, which meant that it was his job to meet other artists and art dealers, to get original pictures from Berlin and Paris, and to ascertain printing costs and export and import duties for shipping the portfolio.[32] A monthly salary of forty-five dollars supported him in modest style, principally because the cost of living was unbelievably low in the wrecked economies of postwar Austria and Germany. In Berlin he became acquainted with Matthew Josephson, who had moved his little literary magazine, *Broom*, there because it could be published much more cheaply than in New York or Paris.

Dehn fit in well with other transient illuminati in Vienna and Berlin. E. E. Cummings was possibly his best friend during this time, and they operated within a freewheeling circle of friends who regularly met at Viennese coffee houses where they sipped espresso and cognac. With his sketchbook always in hand, Dehn would find a chair in the corner and absorb the varied moods of the kaffehauses. Over time, Dehn's satire reached into nearby parks where businessmen leered at young fräulein, old men walked their dogs, mothers watched over their infants, and priests and nuns struck pious poses for anyone who might be watching. *Nice Day* (or *Afternoon in the Stadtpark*) [27] and *Temptation of St. Anthony* [13] were sophisticated, wire-thin renderings of the park milieu. Dehn developed an open drawing style with mobile lines and a distribution of ornamental loops that merely hinted at the fleshy

Teutonic forms; he equated the grotesque with the arabesque, which softened the tone of his satire.

In Vienna, Dehn also met an eighteen-year-old dancer, Mura Ziperovitch. She and her family were among the tens of thousands of refugees fleeing the ongoing civil war in the Soviet Union. Escaping on an English ship based in Odessa, they had made their way in 1920 to Constantinople and then through Sophia and Budapest to Vienna.[33] One look at Mura at an artist's ball in 1922 was enough. Dehn fell madly in love, and he told everyone about it, including Wanda Gág, who was still trying to wrench herself free of obligations in New York.[34] Mura was a truly exotic creature, and everyone raved about her sensational beauty, which, combined with her dramatic Eastern origins and dancing talent, produced an almost universally stunning effect upon males.[35] She and Dehn became instant companions and, in time, lovers. They married in 1926.

Altogether, this first period in Austria was a

Mura Ziperovitch and Adolf at the opera in Vienna in February 1923

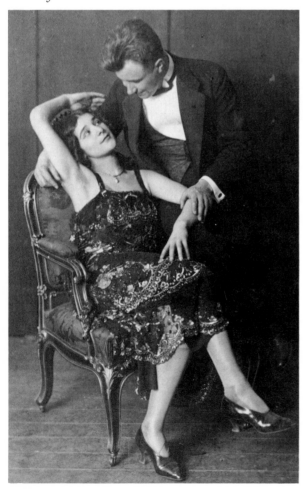

wonderous time in Dehn's life. He had plenty of magazine work and enough money and freedom to travel about Europe. Feeling vigorous and suffering none of the nervous spells that had afflicted him in New York, he went hiking in the Austrian Alps with Mura and friends; there he meditated on the inner harmony of nature and explained to Mura how he was going to translate all the lovely nuances of green on the mountain meadow slopes into the black-and-white lithographs he was preparing to make.[36] And, of course, he found an endless supply of satirical subjects among the Viennese bourgeoisie.

Eventually Dehn's funds ran low. The cost of living in Vienna rose steadily as Austria rebounded from its postwar economic distress. His work for *Vanity Fair*, *The Dial*, and *Broom* gradually slowed to a trickle when these magazines began to lose money. Dehn's belief that these specialized, high-culture magazines could indefinitely finance his free-and-easy life in Europe proved to be naive. He returned to America briefly in mid-1924 to try to sell his drawings but by September was back in Europe, this time in Berlin.

In the 1920s Berlin became an ultramodern metropolis, futuristic to the point of being eerie, especially at night on the neon-lit Kurfurstendamm. Foreign journalists described Berlin as coarse and sinister, lacking the Old World charm of London, Paris, and Vienna.[37] Dehn spent extended periods in Berlin between 1922 and 1926 and again late in 1929 when the city was living in the sunset of the Weimar Republic.

At every turn in downtown Berlin the passerby was bound to come upon a spectacle of some kind. Milling about were scruffy radicals of every political color, petty tradesmen and their status-crazed wives, German adolescents dressed like Montana cowboys, and girls on the make, who, in the words of one observer, "would quite simply bump into you, quite hard."[38] And Russian immigrants. Berlin in the twenties became the melting pot of eastern Europe, the gateway to the West for Slavic peoples, which may have cured some of the homesickness the Ziperovitch family was feeling.[39]

These features as well as the many shades of Berlin night life appeared in Dehn's drawings and prints. He sketched the celebrated Josephine Baker, the jazz singer-dancer originally from the St. Louis slums who had arrived in Berlin fresh from her sensational performances at the Folies Bergère; he attended Kurt Weill's *Threepenny Opera*

and drew the sensation of the cabarets, Anita Berber. As Mura Dehn remembers, there were few appetites that could not be satisfied in Berlin, and Dehn was right there on the spot, sketching the lesbians, the society parties, and the dissolute club patrons.[40]

For Dehn, as for other American satirists, the opera became a subject of special appeal. Since his Minneapolis days he had been a fan of the opera, and Berlin had three major companies. Without knowing it the Wagnerian singers and dancers, as well as their audiences, exposed themselves to the third degree of this young American satirist, who spent many evenings at the Deutsches Opernhaus. Outlandish spoofs such as *Lohengrin* [81], *Die Walküre* [201], and *Nine Women at the Opera* [89] scrutinized the opera scene, from the puffed-up prima donnas with their exaggerated mannerisms to the extravagantly choreographed dances that took place on the enormous stages. (Mura was frequently the model or at least the inspiration in the more voluptuous of these opera-dance satires.)

At times he could be harsh in these German-based works, hitting hard in *An Aristocrat* [235], *All for a Peice* [sic] *of Meat* [31], and *We Nordics* [231]. Dehn's temperature would occasionally rise to the boiling point when he came face-to-face with the German privileged elite, as when he wrote to Carl Zigrosser about the Bavarian spa at Karlsbad:

> No Carl, I am not exactly taking the cure in this god-damned place full of creeping, cringing robbers and lackeys. I really can't think of a more disgusting place than this — full of fat toads and jaundiced ladies trying to get back youth and beauty and health. Sometime I hope to present you with a lithograph . . . about this place.[41]

A most angry comment to be sure, and the indignation eventually resulted in Dehn's *Hypochondriacs at Karlsbad* [245]. The boorish behavior and loud swagger of Germans that foreign correspondents would find so alarming in the Nazi years of the 1930s had already been inventoried by Dehn. But more often he filed down the jagged edge of his satire and inflicted wounds rather than death blows on his victims. His Berlin was, on the whole, a study in nuance: for every savage view of the crass, depraved "Nordic" there were several images that conveyed more subtly the moral ambiguity of the Berlin night culture where a curious mixture of exuberance and crudity reigned each night. There were even nonsatirical drawings of the stolid, sedate respectability of Berlin thoroughfares and parks—the elegant promenades—seen in daylight hours.

Because he spoke fluent German and because George Grosz had taken a special interest in him, Dehn seemed to have the best chance of any American to break into the clique of German artists who gathered at the Romanische cafe near the center of Berlin. Grosz reportedly told him: "You will do things in America which haven't been done, which need to be done, which only you can do—as far at least as I know America."[42] (Dehn hoped this praise would help him land a place on the staff of *Simplissimus*, but the magazine turned down his submissions every time he sent them in. Smarting from the rejection, he talked of organizing an American version of the satirical magazine, but the plan came to naught.) Grosz was a treasure trove for Dehn and other American satirists, although Dehn had enough sense to know he could not match Grosz's vitriolic, tightly coiled satires. Instead, the majority of Dehn's satires were good-natured, off-beat commentaries on "preposterous things" he saw in the European capitals. True, the editors of *The Liberator* and *The New Masses* published his drawings as strong statements about the class-struggle-festering-into-revolution theme,[43] but less biased and more perceptive critics such as Guy Pène du Bois read them as frenzied comic burlesques.[44]

The difference in tone between Grosz's and Dehn's satires can be better understood by looking carefully at the erratic progress of Dehn's political education. Dehn's parents instilled in him a suspicion of conventional forms of authority, and affiliation with Greenwich Village radicals deepened his political consciousness. For a dizzying short period in 1918, 1919, and 1920, young firebrands like Dehn looked forward to some kind of political upheaval. From Berlin, Dehn wrote an animated letter to his sister, saying that he anticipated a socialist uprising in Germany.[45] Resorts such as Baden Baden and Karlsbad represented to Dehn the prime example of corrupt German privilege, and several times in both Austria and Germany he was within earshot of unruly street demonstrations. More than once Dehn gloated over the weaknesses of the central government as runaway inflation and bitterness over the Versailles Treaty gradually eroded most of the thin defenses the Weimar Republic attempted to set up around itself.[46]

Nonetheless, Dehn's left-wing leanings never hardened into stiff ideology. No mention of regret can be ferreted out of his letters when socialist revolutions did not materialize in America or Germany. His art might have bite and tang, but it rarely pulsated with political indignation any more than Weill's *Threepenny Opera* did. Dehn remained a cautious radical, not eager to let his life or art get too close to choppy political waters. Squabbles dividing the various socialists seemed as unfathomable to Dehn as the theories accompanying the nonobjective paintings of Wassily Kandinsky and Piet Mondrian.[47] Separated from New York by four time zones, Dehn stayed aloof from the internecine ideological warfare that eddied around the offices of *The New Masses*. He submitted fewer drawings each year to that journal toward the end of the 1920s. Art meant much more to him than politics; like most painters and printmakers he did not want anyone telling him what or how to draw.

In December 1926 Dehn took the train to Paris. He had spent short working holidays there before, most recently in early 1925. Now, in the cold, fading days of the year Dehn set about making lithographs at the Atelier Desjobert in preparation for a print show at the Weyhe Gallery sometime in 1928. The Atelier was one of the outstanding print workshops of Paris, and Dehn thrived under the skilled, flexible guidance of Edmond Desjobert, who had a general liking for American artists.[48] The next two years in Paris (actually until January 1929) was the dividing line in Dehn's artistic development. He became a full-fledged lithographer, and his art matured measurably. He was able to translate many sketches from Vienna and Berlin (and even a few from New York) into some of the most experimental landscape and satirical lithographs yet seen in American printmaking.

Paris was enjoying one of its golden eras during the 1920s. Foreign visitors praised its grand and intimate wonders; American artists and writers saw it as a mecca where they might satisfy their urgent searchings for freedom, diversion, beauty, adventure, and intelligence. For Dehn, Paris was all of this and more as he and Mura stepped off the train. In this most cultured of all cities, Mura quite reasonably expected to find the dance opportunities that had so far eluded her. (As it turned out she would be absent much of the next two years choreographing dance sequences for the Coburg opera company.)

Although he missed Mura very much when she was away and wrote passionate letters imploring her to return, Dehn did not confine himself to his studio flat and devote all his waking hours to making prints. Not this dashing, rakish character with a self-described fondness for all the pleasures of the flesh—cuisine, liquor, women, and French chocolates.[49] And certainly not when he found himself living in the middle of Montparnasse, the bohemian haven for expatriates that Ernest Hemingway and other Lost Generation writers had so recently immortalized. The choices of night activities in this modern Babylon were "almost overwhelming" as his artist-friend Andrée Ruellan recalls.[50] Dehn's taste in hangouts ran the gamut: cafes such as Le Select, La Rotonde, and Café du Dôme (Bar Américain), basement cabarets where American jazz reigned, dance halls like the Café du Dingo, and Rue Blondel and other brothels that ringed the entire Latin Quarter. Those who remember him at this time share unmixed impressions: he was softhearted, loyal, devoted, oozing in charm with a delectable sense of the absurd, generous, and easygoing in his manner, making him an ideal companion for men and women alike. His company included artists such as Joseph Stella, Reginald Marsh, Stuart Davis, Ernest Fiene, and Rockwell Kent, as well as the writers, Rex Stout and Max Eastman; he also saw a lot of old Minnesota and New York friends—Andrée Ruellan, John Flannagan, Harry Gottlieb, and Arnold and Lucile Blanch.[51] The Latin Quarter was still affordable for poor artists, and most of the time Dehn was deliriously happy: "Life in Paris is simply glorious," he wrote to his mother in 1928. "One never wants to go to bed it is so glorious— and daybreak is best of all."[52]

Amid the frenetic activities Dehn sketched and eventually turned numerous pencil notes into lithographs at Desjobert. His basic method was to thrash out a few primary ideas, carry them around in his head, often for months or even years, and then in a burst of inspiration work them rather quickly into lithographs. A remarkable number of the prints produced in Paris were of landscape themes, the moody quality of which came partly from the alternating cadences of light and dark notes Dehn experimented with and the choice of evening or nighttime he used to evoke the Alps, Brittany, and Paris itself. In works such as *Landscape near Moret* [77], *Landscape at La Varenne* [76] (both scenes of Brittany), *Bridge over*

the Seine [65], *Paris Street at Night* [107], and *Place Chatelet* [111], Dehn began fully to extract tone and texture from the lithographic stones and to strengthen the drama with suggestions of wash. The poetic resonance of these lithographs partly grew out of his appreciation of the landscapes of the Blaue Reiter group and the Chinese artists, but his style developed in a distinctly personal way by the end of the 1920s.

Lyrical is not an appropriate word to describe the dozens of satires Dehn made in Paris. In the cafe, cabaret, and brothel scenes he delighted in distorting faces and physical gestures to the point of farce, so that a preposterous Dionysian madness rather than social realism floods the paper. This method brings up the inevitable comparison of Dehn's art to that of the Bulgarian-American-French eroticist, Jules Pascin. They probably met in Berlin around 1924; certainly Dehn was aware of Pascin's drawings for *Simplissimus* that appeared in the early 1920s.[53] In Pascin, Dehn encountered a strange, irreverent character, who helped to steer him away from political art toward erotic satire, which would form an important core of his art in the Paris and New York years, 1926–33. Dehn's love letters in this period to Mura and to other women are filled with exuberant, unabashed sexual excitement. They profile a hearty romantic who regarded actual (and imagined) indulgences of the flesh as natural and necessary to give authenticity to his voluptuous art.[54] As Dehn phrased it more candidly later on:

> My attitude to life is rather sensuous — and sensual too — and only after I have filled myself with sensuous experiences can I go about working. Putting it simply: when I am fed up, I work. I am crazy about life and want to have as much out of it as I can. Take away my work and I lose interest in life, yet the work comes after my living life, or rather out of it.[55]

Dehn brought humor to his juicy, near-lascivious drawings of prima donnas, jazz dancers, coquettes, whores, and artists' models. The manner in which he wove the arabesque lines around the swelling hips and thighs of these bountiful women moved his erotica close to that of Pascin and some distance away from the mean-spirited sexual art of Grosz. Dehn never took a moral attitude about "loose women," and his prints were a witty mixture of mythology, sex, and slapstick.

Reading over his letters and thumbing through his prints leads one to wonder whether Dehn in this Paris period made a serious effort at self-discovery. If there is a strong air of frivolity wafting through many of Dehn's lithographs, we should not be too surprised. Dehn was barely thirty, younger than many of the other bohemians, a long way from the restraints of the strait-laced Midwest, and sure that self-discovery meant more than learning new techniques of drawing and painting. It is also well to remember that "carrying-on" was integral to the general adolescence of the Flapper Age with its full cup of frolicking, rootless expatriate artists who worshiped at the shrine of personal expression and Freudian liberation.[56] Through much of the rest of the 1920s Dehn also sustained the American expatriate belief in the European haven, in the intoxicating dream of a superior sensitive place where artists would be valued.[57]

This said, by the time Dehn settled in Paris, he was talking about himself only as a long-term visitor to Europe, not as a permanent exile. He craved the company of old Minnesota friends and eagerly looked forward to the news and gossip they brought from America. He wrote more than a hundred letters to his family and offered advice at those times when his sisters were wrestling with career and personal decisions.[58] Even in his wildest, most restless periods, Dehn remained a loyal and dependable family man.

In Europe he had taken on new and difficult responsibilities — not only for Mura but also for her mother, Fanny, and her much-troubled brother, Boris. The Ziperovitches had arrived in Vienna nearly penniless and were still in debt by the time Adolf and Mura married in 1926. Mama and Boris were in constant proximity to Adolf and Mura — when not actually living with them — and while Adolf enjoyed their company and took pride in looking after their interests, it sometimes interfered with his work. Dehn spent time and money traveling around Europe with the Ziperovitch clan hoping to find a paying company that might give Mura her breakthrough. The job in Coburg was looked on as just a temporary position, and it was doubly disappointing since it took Mura away from Paris for extended periods of time.[59]

Trying to live up to these family demands while simultaneously staying active in the Montparnasse cafe scene and producing lithographs stretched Dehn's resources. Physically and emo-

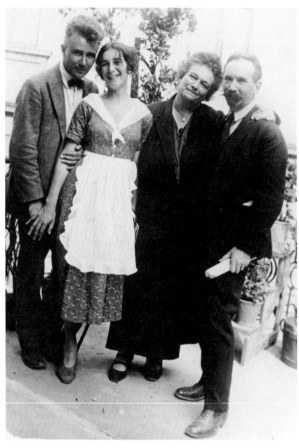

In 1927 Adolf and Mura posed with her parents, probably in Paris, for a picture to be sent to Boris Ziperovitch in London.

tionally he was worn to a ragged thread by late 1928 and developed a severe recurrent bronchial infection. A sympathetic French doctor accepted lithographs in payment for treating the penniless artist.[60] In one letter Dehn cried out for a normal routine: "My hours are turned upside down. I go to bed at four or five a.m. don't get up until one p.m. I'm fed up. I long to see the sunrise."[61] At one point he rented a studio apartment of his own, hoping to get some serious work done; Mura, along with Mama and Boris, was sent to a nearby hotel where Adolf would visit them nearly every evening.

It was not unusual for American writers and artists in Paris to unravel when trying to cope with guilt brought on by the ascendency of cafe hopping over their novel writing or picture making. Dehn managed to keep his juggling act of art, family, and social activities going through 1928 without cracking up. He swallowed his pride and borrowed money from his mother and sisters. Mura helped Adolf through this trying period. She may not have provided him with

what one could call normal domestic tranquility, but her indomitable spirit and avant-garde tastes constantly pushed him forward in his work. She urged him to experiment in his prints and drawings, as she was doing in her dancing. Earning a good living be damned, she would declare with passion! True artists like themselves should never have to compromise their vision for the sake of acceptance on someone else's terms.[62]

By mid-1928 Dehn was making a major effort to prepare for his one-artist exhibition at the Weyhe Gallery, which had been delayed until February 1929. Friends grew accustomed to seeing him rise early and work well into the evening. By September he had pushed the series of forty-five prints to the halfway point, and he kept the mails humming with packages of his lithographs and drawings to Carl Zigrosser in New York. Zigrosser, who is remembered for giving many young American artists their first gallery experience, had become a trusted friend and believer in Dehn's work over the years. He had organized an exhibit of Dehn's drawings in 1923 that brought the artist his first real attention in New York.[63] Their relationship hit a temporary snag in 1928 when Zigrosser, looking at a fresh batch of Dehn's Montparnasse subjects, critized Dehn's "superficial" direction and implied that his fondness for the Latin Quarter fleshpots was undermining his earlier promise:

> You are right in sensing a certain lack of sympathy with your recent work, an attitude that is shared by such old friends as Wanda Gág and John Flannagan. I was hoping to have a heart-to-heart talk with you in Paris, but the fates decreed otherwise. . . . I think that for the time being you are on the wrong track in the cafes and boulevards of Paris. Frankly, I don't see . . . how you can work in such an atmosphere. It is marvelous for a holiday, but for serious work—well, I don't know. To some of us it seems as if you have been on a holiday for a number of years. What do you really think is the dominant art passion of your life? . . . If it is to be a social critic and caricaturist, then you ought to touch *all* walks and modes of life and countries. In either case, the Paris of Montparnasse is not the exclusive background of research. I should like to see you engaged on a piece of real research—wrestling with a big problem and not resting on researches of the past.[64]

This censure was not what Dehn wanted to hear from Zigrosser, and he let out a wounded

yell to Arnold and Lucile Blanch who were visiting Paris at the time. He believed that Wanda Gág, nursing old wounds from their thwarted romance, might be unduly influencing Zigrosser's judgment.[65] But, wisely, he did not answer right away. He let his anger abate, kept on turning sketches into lithographs, and without giving the slightest ground eventually told Zigrosser that he was doing prints on a variety of subjects — landscapes and satires. He was sure they were his best works ever and would be recognized as such when his show opened.[66]

Dehn continued diligently through the early winter of 1928–29. When he finished there were in his portfolio more than ninety prints, many of which are still considered among his greatest works. Dehn sensed as early as the fall of 1927 that he was becoming a formidable artist and was excited by his lithographic innovations: "I made discoveries and I dared to do things technically that seemingly nobody had done before with washes, ink washes, crayon, scrubbing, scrumbling, erasings, scraping, razorblading."[67] He continued to defy the prescribed textbook procedure of gradually building up form with light to dark grays; line remained the touchstone of his prints, but short spurts of values now lent more expressiveness to his satire. All of his subjects were intensified, rubbed to a sharper edge. Dehn had a natural sense of the absurd, but it was in Paris that he first succeeded in finding a form and language for it — and for giving lyrical power to his landscapes. He knew he had made some extraordinary lithographs, and as the days of 1928 ran out, he readied himself for a triumphant return to New York.[68]

Dehn sailed into the New York harbor shortly before the opening of his February 1929 show at the Weyhe Gallery. His early impressions were mixed; the New York skyline, he wrote, seemed "unreal with its toy buildings, dead little buildings with endless windows. Dead and sad, it seems to me . . . New York is vivid, a great spectacle, but often I have a feeling of acute desolation and I want to run back to the charm and quiet of Paris."[69] Mura was still under contract to the Coburg opera company, and Dehn had to be content with her promise to join him soon. He knew people who could advance her career, and since he would soon be a successful artist he promised to buy her "many

elegant, glorious dresses and wonderful shining shoes."[70]

As usual, Dehn did not lack company in Mura's absence. He took a room in the four-story Brooklyn brownstone of Margaret de Silver, a wealthy friend and art collector. Dinner parties or trips into the city occurred almost nightly. If a man is known by the company he keeps, Dehn was one of the luminaries of the New York art world, for among those who accompanied him to the Manhattan haunts and Harlem jazz clubs were John Dos Passos, Yasuo Kuniyoshi, and his old drinking and prowling companion from the Paris days, Reginald Marsh. Dehn also patched up the relationship with Wanda Gág, now engaged and a celebrity after a string of successful shows at the Weyhe Gallery and especially after the recent publication of her pioneer children's book, *Millions of Cats*.[71]

Everything was geared toward the February exhibition — every one of his muscles twitched in excitement over the show. After a year of working hard and nourishing dreams of fame and success, he told himself that the Weyhe show would thrust him into the front ranks of American art because New York was at last ready to appreciate his art. He took heart from the observations of Guy Pène du Bois, who had recently returned to New York after a lengthy stay in Europe. Pène du Bois expressed amazement at the tremendous development that had taken place in the New York art scene between 1920 and 1929. Audiences had come to appreciate modern art, galleries had sprung up to sell contemporary paintings and prints to the expanded clientele, and now a growing camaraderie and spirit of adventure existed among artists.[72] With Zigrosser's assistance, Dehn selected thirty-four lithographs and fifteen drawings (nearly all of French, German, and Austrian subject matter) to exhibit. About half were satires, and the rest were park scenes and landscapes. Prices ranged from ten to fifteen dollars for the lithographs and up to seventy-five dollars for the bigger drawings.

About a third of the drawings and prints sold in the weeks and months following the opening; Zigrosser had earlier warned Dehn that black-and-white media works seldom moved as quickly in his gallery as watercolors and oils.[73] Still, Dehn did not become discouraged. He made enough money to pay off his debts to Desjobert, and he was heartened that important patrons like the Rockefeller family, the Minneapolis Institute of

Arts, and the Metropolitan Museum of Art purchased works. Furthermore he was encouraged that critics and the printer, Bolton Brown, seemed enthusiastic about his prints.[74]

He set his sights on a second Weyhe Gallery show. This time it would be an all-lithograph exhibit dealing with fresh ideas – New York subjects. In September 1929 he took seven months' worth of sketches and drawings to Germany where he worked on lithographic stones at Meister Schulz's Berlin workshop. Some of the prints were wide-angled interpretations of industrial-age New York: prints that probably germinated in the East River series of drawings of 1921 but which showed more depth and maturity. *Factory* [129], *Brooklyn Waterfront* [152], and *Hudson River at Night* [132] relate to references in Dehn's letters where he wrote of the "spectacle and the acute desolation of New York."[75] Complementing these densely textured lithographs were somber, moody nocturnes of Eighth Avenue and Lower Manhattan – prints with wonderful shades of black and gray that depicted the gathering darkness of the city.

Dehn also found plenty of satirical subjects in New York. He frequented the burlesque houses with Reginald Marsh and discovered in Central Park an American bourgeoisie that differed only marginally from its counterparts in Vienna and Paris. Perhaps his most energetic art of the 1929–31 period focused on jazz subjects: the bands, the singers, the strutters, the cakewalkers, the people who listened and danced to jazz in the clubs and on rooftops throughout the city. By 1929 the Harlem Renaissance was in full bloom, and Harlem became a chief pleasure ground for thrill-hungry whites who trekked up to the Savoy, Connie's Inn, and the Cotton Club. Jazz was the byword for exotica and modernity, the glue binding the two great twentieth-century cities, Paris and New York. In Europe Dehn became a fan of this special American musical idiom as he watched Josephine Baker in Berlin and Paris; artists as diverse as George Grosz and Piet Mondrian were habitués of the Rue Blomet and other Paris jazz clubs.

Dehn's jazz subjects – *Harlem Orchids* [216], *Blackbirds* [239], *Madonna* (or *Jazz Madonna*) [250], *Harlem Night* [244], and, the most notable lithograph of the group, *Gladys at the Clam House* [213], which featured Gladys Bentley singing blues songs like "Saint James Infirmary" – brought new verve to his draftsmanship. The

bending, swaying figures are energized by parallel black thrusts of various thicknesses – drips and specks of ink that capture the sardonic side of this subculture. As Pène du Bois remarked, these were some of Dehn's most uninhibited works where "the carnal sensation of the orgy on closer examination seemed more like a swirling mass of beef than like anything human."[76] Dehn also sharpened his eye and made victims of his friends among the audience, which, because he realized there was a gloomier, less exotic side of Harlem from what his crowd was experiencing, may have been a form of instinctive self-criticism.[77]

Fifty New Lithographs by Adolf Dehn opened on April 7, 1930, at the Weyhe Gallery. Within a week Dehn sounded an optimistic note in a letter to his mother. "Tell Pa I am making money hand over fist – two hundred fifty dollars before the show began and the Weyhe people have bought $375 worth of lithographs."[78] But five days later he passed on the bad news that while the critics liked the show, "the sales are slow now, not so good as the first day."[79] Although Dehn gave every outward appearance of entering a period of prosperity, he could not hide from the painful truth that his fourth Weyhe show had, like the others, brought many laudatory reviews but scant

Adolf in front of the Weyhe Gallery, New York, in 1930

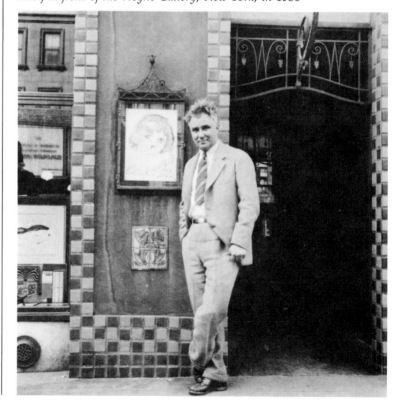

few purchases. His disappointment at finding his career stymied can be easily imagined. In Europe he had survived some difficult, even desperate, times; more often than he cared to remember he had tapped close friends and members of his family for small loans. Once in September 1928 he cried out to Olivia Dehn that he did not understand why the artist had always to make a "Goddamned terrible fight for existence."[80] But those who knew him best said he never expected to make much money from his art in Europe. He rationalized that Europe was to be looked on as a kind of laboratory-playground, a place to soak up multifarious experiences while he waited patiently for his talent to mature, like some fine Beaujolais aging slowly. His real professional, money-making career would begin later on in America. But now in mid-1930 he was approaching middle age with no sign that his American career was going anywhere soon.[81]

Part of the problem may have been the elliptical style of Dehn's satire that did not easily claim the sympathy of the general art audience. Mura Dehn remembered that viewers were often perplexed by Dehn's florid, visual rhetoric—the baroque, sometimes airborne, forms that looked as if they might belong in the Macy's Thanksgiving Day parade. The extravagant and bizarre figures, "walking like they were rolling," as Mura put it, and the enigmatic space they occupied pushed beyond the limits of the plausible, which ran against the grain of the realistic satirical style of John Sloan, George Bellows, Peggy Bacon, and other successful satirists of the 1920s.[82] Also, Dehn finally may have grasped what Zigrosser had been trying to tell him for years; an artist could not make a living strictly as a lithographer.

The main impediment to Dehn's aspirations, however, came from forces over which he had no control. His 1930 show took place just when the American economy headed downward, pitching toward the darkest, most miserable depths of the depression. With close to 25 percent of the work force idle, industrial production slowing to a trickle, and people reluctant to part with what little money they had left, the art market took a tumble. The vast majority of American artists, including those more established than Dehn, soon found it impossible to support themselves on art sales and began scrambling for other jobs, which were themselves fast disappearing.[83]

Even the belated arrival of Mura and her mother in New York in April 1930 could not keep Dehn's spirits from sinking lower and lower. He wrote Olivia in October:

> There is so goddamn little to tell that is good. The season's bad, everyone is depressed and I am too. Broke as hell. This week I will take stuff to a couple of magazines. I was invited to Philadelphia to Mura's opening and was so broke I couldn't go. Got drunk one night. Had a good time for two hours, then the Weltschmerz descended on me again.[84]

Attempts to get Mura's career off the ground in America ran into the same depression-caused barriers that blocked Dehn. She discovered that there were many more talented dancers than jobs for them in the dwindling number of companies. Her big effort, a self-financed production entitled "The Dance of Foolish Virgins," ended in a fiasco. Although Mura's brilliant experimental choreography drew praise in certain quarters, few people came to see the performances, and of those that did, Dehn wrote in frustration: "I am on pins and needles. They simply don't know what Mura drives at. It's all over their heads!"[85] Before it was over, the concert director had swindled funds from the production, leaving Mura in debt once again.

The gloom lifted a bit in the summer of 1932 when Dehn took Mura and Mama Ziperovitch to Waterville for the first time, stopping by to see Viola who was then living in Duluth. Mura charmed all the Dehns, although she scandalized local residents by hitchhiking alone from Duluth to Waterville and by swimming nude in German Lake adjacent to the town.[86]

Sometime in late 1932 or early 1933—it is not clear precisely when—Adolf and Mura decided to get a divorce. Letters do not open the details of their marital troubles to dissection, and all the survivors talk around the subject. Perhaps the couple had been separated too often over the ten years of their romance—too many times she was in Coburg while he was in Paris, or she was in Paris while he was in New York. Perhaps there were too many women in and out of Dehn's life, too many men making a great fuss over Mura's beauty. Maybe the financial struggles wore them down. Mura's divided family loyalties were certainly a factor; in Europe and then in New York, Mura and her mother had been inseparable. "It was my greatest pleasure to be the daily companion to my mother—that is the Russian way of family," she recalled. "Men, including Adolf, had to come second."[87] When the breakup finally

came it was amiable, as Olivia wrote to her sister Viola and mother Emilie, who was confused by it all:

> I have told you all I know about Adolf and Mura. All I know is that they are very, very good friends and get along well. They have a deep fondness for each other. I know from what Adolf says—they admire and respect each other greatly. Whether or not they sleep together? I don't know—one doesn't ask . . . I daresay—if they don't—they are still better friends and have a deeper fondness for each other than 9/10 of married people.[88]

Mura remained in New York and eventually remarried. She and Adolf maintained close, friendly ties for many years, and she continued to take an active interest in his art. She had been a vital force in Dehn's life, and their separation left a certain emptiness that only his second wife, Virginia Engleman, would fill fifteen years later.

Amid the personal and professional setbacks of the early depression years, Dehn continued to produce experimental lithographs. Neither anxieties nor frustrations could hold back his creative spirit when it was ready to break loose. Lithographs would pour out. From November 1931 to February 1932 he made thirty prints in Paris. Most were cityscapes and landscapes: some were classics like *Lower Manhattan* [217], *Under Brooklyn Bridge* [263], and *Grey Day* [215], some were based on the drawings he had made of the Harlem nightclub scene in 1929 and 1930. In 1933 he maintained this brisk pace with thirty more lithographs, many of them satires: *Art Lecture* [236], *Big Hearted Girls* [237], *The Immaculate Conception* [246], and *Up in Harlem* [264]. Some of these were printed at Desjobert, some in New York by George Miller. The bulk of the 1931–32 group was exhibited at the Weyhe Gallery in 1932. This time Dehn seemed resigned to the fact that Weyhe shows were not going to bring in much money. In a matter-of-fact tone, he wrote to Olivia: "I have received some very good criticisms and everyone likes my work, but one does not eat off that."[89]

Through the rest of the depression period, Dehn made few lithographs for gallery sale. Instead, he busied himself with public art projects and commercial work. He signed up for the easel picture division of the New York Public Works of Art Project (PWAP) in December 1933, promising to paint a big mural of Noah's Ark that could be used in the public schools. Although he received thirty-four dollars a week for several months, the mural never got much beyond the preliminary stage before the program folded in April 1934.[90] Dehn also participated in the Contemporary Artists Group's ambitious profit-sharing scheme entitled *American Scene No. 1*, whereby he and five other artists (George Biddle, Jacob Burck, Reginald Marsh, José Clemente Orozco, and George Grosz) made social-satirical prints to be distributed for a small subscription price around the country by a New York entrepreneur, Leo Fischer. Dehn had high hopes for the project as he told Biddle:

> This subscription scheme could grow into a gallery. [It is] meant for the masses, a big audience which has always said "we cannot afford art." Dammit! Every school teacher, Greenwich Village radical, every Communist, and *New Republic* culture-seeker can afford this series.[91]

Alas, few prints from the joint lithographic project sold, and there were no real profits, at least not for Dehn; but he was intrigued with the concept to the point that in late 1934 he decided to set up his own print-marketing business. He called it the Adolf Dehn Print Club and set out enthusiastically to promote the concept in New York and especially in Minnesota. Lithographs were offered through the mail for five dollars each; over the next several years *Central Park at Night* [282], *Creek in Minnesota* [283], *Menemsha Village* [285], *North Country* [292], and *Broadway Parade* [280] were among the offerings. Most of the prints were tightly drawn with nostalgic, American-scene images he believed would have more mass appeal than his cosmopolitan satires and semiabstract landscapes of the 1920s. But after three years of intermittent labor on this project, his expenses still exceeded the sum of his sales, leaving a distraught Dehn to wonder if there was any way to sell his lithographs.[92] At least he could take comfort that he had become a true depression-age artist; through various outreach schemes he had done his share to bring art to the people, one of the shibboleths of that time.

Just when things appeared the bleakest, Dehn's life began to turn around. Modest successes in commercial art saved him from who-knows-what fate in the middle years of the thir-

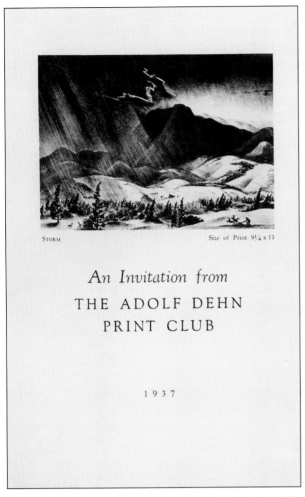

STORM Size of Print 9¼ x 13

An Invitation from

THE ADOLF DEHN
PRINT CLUB

1 9 3 7

In 1937 Adolf produced a brochure advertising the Adolf Dehn Print Club.

ties. He did drawings for the *New Yorker, Vogue, Ringmaster,* and the *New York Times Book Review,* as well as for various political journals. For one publishing project, called Living Americans Abroad, he was sent to Europe to oversee the printing of trial proofs of reproductions of contemporary American paintings. He arrived in Vienna in 1936 and was much startled by the changes in the city that had been so important to him fifteen years earlier. The "modernized cafes and twelve-fourteen story skyscrapers" stamped out any possibility of déjà vu, and he was appalled to find that Vienna was "almost as pricey as New York."[93] He also traveled into Yugoslavia where he did nonsatirical, picturesque drawings of villages along the Dalmatian Coast. In the gloomy political climate of Europe, he worried about the Spanish civil war that was going badly for the Republican side, and he found it foreboding that the Nazis had come to power in Germany and were threatening to annex Austria. He wrote sadly about the ruthless German treatment

of the Jews. War seemed close.[94] The *American Magazine of Art* featured him in an article on the Minnesota group of artists, and in 1936 the Whitney Museum bought one of his landscape drawings that had appeared in its biennial print and drawing show.[95]

In 1937 Dehn turned one crucial corner in his career: he began to paint watercolors. For a long time he had made noises about painting, boasting to his mother twenty years earlier that it was his master plan some day to draw cartoons for a living and settle by "some lake" and paint for that inner satisfaction an artist requires.[96] In Europe during the twenties he wistfully looked at George Grosz's *Ecce Homo* watercolors and wondered if color could not bring more vigor to his own satires.[97] Many times he told his close friends, Zigrosser and Blanch, that he was making plans to start painting.[98] When Mura arrived in New York from Paris in 1930 she brought with her the watercolor paints and brushes Dehn had requested that she buy.[99] For years Zigrosser had nudged Dehn toward watercolor, believing in Dehn's case that the blousy, semiabstract style he was developing in his brush-drawn landscapes was well suited to the wet, loose medium. Dehn knew all the good reasons why he should paint, but he had built up an enormous insecurity about color, as he explained much later to Dorothy Seckler of the Archives of American Art:

> I had been very unhappy all those years because I was just a black and white artist . . . I wasn't color blind; I knew that . . . I was so frustrated and so unbelievably unhappy. In 1936 I sat on a ship coming back [from Europe] and said to myself, this has to stop because I know I am just a lazy coward . . . and I made a definite decision: when I get back I shall paint a watercolor everyday.[100]

To his amazement, people reacted favorably to his very first batch of watercolors. Dehn recalled how he "very nervously" took two paintings to the 1937 *Artists' Congress Show* at Radio City Music Hall and "on the first evening [one of his watercolors] was the only picture that was sold."[101] Possibly audiences responded to the rural American subject matter of Dehn's watercolors as much as they did to his new use of color.

Dehn had always loved the country. City life, especially in New York, would unnerve Dehn at times, and in the 1930s he spent nearly every summer away from Manhattan, either at a beach

house on Martha's Vineyard or in Waterville. In the latter he did a few farm chores, "loafed a lot," and coaxed Viola into driving him around the back country roads as he searched out good landscape subjects. Cameron Booth, the well-known Minnesota artist, lived in a nearby summer home, and he and Dehn became steady companions on these drawing excursions.[102] Dehn's colorful views of farmland and northern Minnesota lakes revealed both a fascination and affection toward his home state — feelings that related to the growing Regionalist sentiments of many American artists of the late 1930s. Throughout the decade some lithographs, including *North Country* [292] and *Threshing Scene* [312], were done in conjunction with the watercolors; the prints celebrated the special quality of light and open space of rural Minnesota. Although Dehn continued to have his principal residence in New York, he felt the special tug of his childhood haunts, which relates him to the motives and attitudes of Thomas Hart Benton and John Steuart Curry during that era.

One side effect of his early efforts at watercolor painting was the opening up of new commercial art jobs and travel opportunities. *Fortune Magazine* paid him five hundred dollars to go to Chicago to make watercolors of Pullman railroad cars in 1939. A few years later Standard Oil sent him to Louisiana, Mexico, and Venezuela to make extensive watercolors of their operations there. He was carving out a sizable reputation in the 1940s as an artist who could produce unusual and appealing corporate images and complete them on time. It was not always "fun work," he admitted, but the pay was good, and he did not embarrass himself. Dehn insisted on a large measure of freedom on these assignments.[103]

Dehn's growing national reputation earned him several teaching offers. In 1938 Victor Christ-Janer brought him to Stephens College in Columbia, Missouri, and the next year Dehn used some of his Guggenheim Fellowship money[104] to spend six weeks in Colorado Springs where his old friend and early mentor, Boardman Robinson, had become director of the Colorado Springs Fine Arts Center. Dehn taught summer sessions there for the next three years. Just west of the college, which rests on the western edge of the vast American plains, are the sudden beginnings of the Rocky Mountains. The Rockies enthralled Dehn and made the Austrian Alps "look like hills," he once said.[105] With Lawrence Barrett as his printer, he did numerous lithographs of

Colorado. Old mining towns and occasionally even fanciful mountain satires supplemented the rugged landscapes that over the next twenty years became more and more abstract. Dehn thrived on the stimuli of Robinson (still a towering figure in his eyes) at the Colorado school. The money from these teaching sessions afforded Dehn the opportunity to travel to the West Coast and through much of Mexico in 1939 and 1940.

When America entered the war against Japan and Germany in December 1941, Dehn was forty-six, too old to be a soldier. A long-time anti-Fascist, he did not take a pacifist position during this war and, indeed, sought ways to be helpful to the Allied cause. He created a series of paintings for the United States Navy depicting the training, patrol, and warfare of the air arm of the navy.[106] Some of his watercolors for Standard Oil of New Jersey were also used to illustrate "the necessity of oil during wartime."[107] The war put a crimp in gallery activity in New York just when his art (including his lithographs) had begun to move, but Dehn did not complain. One unexpected and gratifying outcome of the war was Dehn's reconciliation with his father, Arthur Dehn. They exchanged warm letters and compared notes about the battles in Europe, making predictions to one another as to when the Third Reich would collapse. For decades Adolf had desperately wanted his father's approval, which Arthur withheld; but Dehn, the wayward son, the useless artist-bohemian, was finally vindicated in his father's eyes for his recent art successes and his public work for the war cause.[108]

It was also during the war that Dehn met Virginia Engleman, who was working in the sales department at the Associated American Artists Gallery. Dehn could not sweep Virginia off her feet as he had other women over the years. They dated in 1943, but the romance did not catch fire, although not for any lack of trying on Adolf's part; he bought her a year's supply of nylons, which were almost impossible to come by during the war. In 1944 she went to live near her father in Corpus Christi, thinking it would be interesting to have the company of young pilots from the Texas Naval Air Station. Returning to the East Coast after the war, she worked briefly in Connecticut and then returned to the Associated American Artists Gallery where she again ran into Dehn. They married in 1947 and moved into Dehn's large apartment in the East Fifteenth Street complex where other notable artists, in-

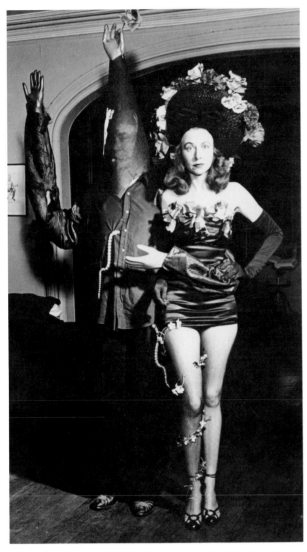

Virginia Dehn recalls that her costume for this Beauty and the Beast duo in the late 1940s was based on some of Adolf's showgirl prints, but his was strictly Dehn fantasy.

cluding Reginald Marsh, lived. In 1953 Adolf and Virginia purchased a century-old studio-home on West Twenty-first Street that had been designed by Harvey Wiley Corbet. Over the twenty years of their marriage, they were inseparable companions, two artists working side by side.[109]

Emerging like an inquisitive squirrel after a long winter, Dehn embarked on another active period of printmaking immediately after World War II. He made large lithographs (approximately thirteen by seventeen inches) on old themes — Central Park and the waterfronts of New York, the lakes of northern Minnesota, and the eastern ridge of the Rockies.[110] Most notable were the latter, based on five years' worth of sketches. In the majority of his prints, he narrowed the viewpoint to a section of the mountains; the rugged peaks

seemed composed of light more than rock. He expressed a reverence for the big western landscape without evoking the immense spaces most artists feel compelled to try to describe. Cliffs and buttes were immersed in the noonday glare, in evening mist, or in the moonlight, and delicate nuances of tone carried the observer toward the sublime in a way that recalled the American Luminist paintings and Chinese landscape art — two of Dehn's enthusiasms.

He brought his many years of technical wizardry to new heights in these romantic lithographs; the darkened clouds, sloping meadows, pine forests, and sudden glacial drops were all rendered in a complex, layered, shorthand language. Ironically, just when Dehn was bringing his art to its most experimental point, he found himself being brushed aside as a latter-day Regionalist artist by the champions of the new movement that was overwhelming everything else in New York after the war — Abstract Expressionism. Like Ben Shahn, Jack Levine, Edward Hopper, and a host of other prewar representational artists, Dehn was bewildered and frustrated by the sweep of the Abstract Expressionists and the fact that "the tide of modern art was running against him."[111] He told friends that he believed that for all their merits the paintings of Jackson Pollock, Mark Rothko, and others contained emotion that was too private and inaccesible to the viewer; he was not willing to sink his landscape forms so completely into boundless fields of abstract color and line.[112]

In these same years (1945–60) Dehn made proportionately fewer satires, and those he produced were often hard to read. Some probed tragic themes. *Naked Truth Pursued by Bare Facts* [355], *That Mad Night on Schulz's Farm* [431], *Prudence and Scarlet* [442], and *Beauty and the Beast* [444] still had the maniacal tone of his prewar urban satires, but a serious side emerged to accompany the broad humor. Familiar, identifiable locations and people gave way to images of fantasy and quasi mythology. Partly, the change reflected a deeper introspection expected of an artist going through the sobering passage of middle age — Dehn turned fifty in 1945. No longer was he the peripatetic, bohemian social commentator, careering from one jazz club and cabaret to another in New York, Paris, and Berlin. His marriage to Virginia, who was a young, disciplined artist, the purchase of his first real home in Manhattan, and

Adolf with the litho stone for the Whore of Babylon
(1946)

expanded business and art responsibilities gave Dehn a new outlook.

Actually the depression-dreary nights in New York and the anxious mood of Europe in the late 1930s had dulled the edge of his satire even before World War II. After 1947 he and Virginia traveled to Mexico, Haiti, Venezuela, Afghanistan, India, and other underdeveloped countries, which, he explained, "did not put me in a satirical mood." He had always shied away from ridicule of the poor and downtrodden classes, no matter how foolish members of the proletariat might act at times, believing that they were out of bounds for the legitimate, humane satirist. Dehn now spent more time reading biography, philosophy, religion, and mythology, more time reflecting on the uncertain prospects of beleaguered mankind in the tragic times of World War II and the Nuclear Age. These deliberations

contributed to the growing gravity of his satire that became even more ominous and "saturated with beasts and demons" in the 1960s. He said, "In my old age I discovered a streak of Bosch in me. I have fun niggling around with all those demons, pulling them out of nowhere all over the picture. The closer you look the more of them you'll see."[113] In *Jerome Patinir and Mr. Adolf Dehn on the River Styx* [604.ii] (1963), a hellish, green leaden light filters down on the pair of lost souls as they try to make their way through semidarkness toward their legendary final destination. In this print and in *Brave New World* [346] and *Time & Space Befuddled by the Immediate Now* [364], the artist tipped the balance from satirical humor to melancholy.

Dehn's watercolors, now shown at the Milch Gallery in New York, continued to attract commissions from corporations, which sent him in the 1950s on assignments to Latin America, North Africa, and the Middle East. Dehn managed a smooth mix of commerce and art; while on location doing watercolors for Standard Oil, for instance, he would make sketches to be worked up later into gallery lithographs. He also earned enough money from the commercial assignments to finance independent trips to Haiti, India, and Ireland. Most of these lithographs were printed in Paris in separate working sessions, but some were printed by George Miller in New York.

Several dozen prints came fron Dehn's periodic visits to Latin America between 1939 and 1958. With part of his Guggenheim Fellowship money Dehn left Colorado Springs in September 1939 and drove slowly through Mexico, ending up in the tropics near Vera Cruz.[114] A small city, Orizaba, at the base of the Sierra Madre Mountains particularly excited Dehn and inspired one of his most famous prints. In *Man from Orizaba* [331], we view an Indian peasant standing in front of a large cactus with the Citlaltéptl volcano in the distance. It is one of the few prints where Dehn evenly divided his attention between the human figure and the landscape.

Most of Dehn's trips to Mexico were long enough so that he had ample time to observe the country and the habits of the local people. He spent more than six weeks in the Yucatan Peninsula in 1955 and followed up by reading about the archaeology of that area.[115] While he was partly seduced by the mystique and exotica of Mexico, he was nonetheless able to steer clear of the usual cliché-ridden subjects: the quaint adobe

villages, the religious processions, the bull fights, the Indian maidens riding burros down mountain trails, and the peons sleeping under their serapes. His composite images of Mayan women, drawn from that trip, have a primal, almost ferocious force that is far from picturesque. As art historian Una Johnson explains *Mayan Queen* [559], *Three Mayan Women* [508 and 571], and others of this group, "their strong, blunt countenances have the elemental qualities of a majestic landscape."[116] Some were composed in color, some not, but in all of them Dehn gave increasing attention to the rich, liquid surfaces he had been working on in another medium, watercolor. Along with George "Pop" Hart, Emil Ganso, and a handful of others, Dehn had established himself as one of America's pioneers of the painterly print.

Dehn's further development of color printing and his fascination with transferring watercolor wash techniques to lithography can also be seen in his prints of Haiti. In 1949 Adolf and Virginia took a maison in a village high above Port-au-Prince. From their little house they could see the capital town and the Caribbean beyond, and they could watch the tall Haitian country women coming down from the mountain hamlets, carrying fruit and vegetables on their heads and often walking all night to be at the markets at dawn.[117] There is a gentle, ambulatory kind of movement, a graceful rhythm of feet on the mud trails, that is suggested in his prints, *Haitian Processional* [454], *Haitian Ballet* [480], *Haitian Tapestry* [474], and *Haitian Caryatids* [481].

In the Haitian markets hundreds of villagers—many of them women and children—would mill around and load up stalls with tropical produce. With verdant mountains on one side and sailboats dotting the harbor on the other, the sight of ebony-skinned women dressed in white native dresses was breathtaking and made Dehn feel a special bond to the elemental stirrings of nature in this least industrialized land of the western hemisphere. He portrayed the Haitian women as noble and heroic, and their routine activities took on the ring of magic ritual. Dehn's rapturous feelings may have been akin to those Gauguin wrote about in his Tahitian diary, *Noa Noa*.[118]

Dehn was able to enjoy the fruits of his considerable success during the late 1950s and early 1960s. When elected to the National Academy of Design in 1961 he quipped: "That's as high as I

can go. I told Virginia, now there's nothing left but to drop dead."[119] He was used to an active social life and insisted on having lots of people around his New York home. He and Virginia also spent many short stretches of time in Woodstock, which had been an active art colony since before World War II. Arnold Blanch, Doris Lee, Lucile Blanch, Andrée Ruellan, Karl Fortess, Bruce Mitchell, Dehn's sister Olivia Dehn Mitchell, and many other friends resided in Woodstock. He spent much less time in Waterville because both Emilie and Arthur Dehn had passed away. Over the 1957–67 decade Adolf and Virginia split their time between the New York area and various places around the world. Dehn hankered to visit and draw new lands; "I am a romantic, always curious about what is over the hill," he once told Karl Fortess.[120] Trips to nearly every continent satisfied his craving for adventure; Virginia always went along, and they established that special kind of intimacy that develops through a series of shared experiences on exotic and sometimes dangerous journeys.

In 1958 after five months of touring France, Italy, Lebanon, Turkey, and Greece, an unexpected opportunity came to travel through the Middle East to India to do a poster for Ariana Airlines. Adolf and Virginia left Athens and passed quickly through Iran and flew into Afghanistan. Two months in Kabul and Kandahar and the villages just south of the Soviet border were like none ever spent anywhere else, Virginia recalls. They experienced the fierce heat of the sun that took charge of the day in the rugged interior where few railroads or paved roads traversed the vast arid spaces. In Afghanistan, Dehn caught sight of at least one camel caravan that inspired the 1958 lithograph, *Men of Afghanistan* [528].[121]

Then it was on to India where from July to October 1958 Dehn and Virginia made sketches and watercolors (and eventually lithographs) of that complex culture. They struck the monsoon season in Benares, resulting in *First Rain* [547], *India Night* [554], and *Monsoon* [530]. Next they ventured into the more bracing air of the sub-Himalaya region of Kashmir.[122] Numerous prints pictured the Indian people standing shoulder to shoulder in mist-shrouded landscapes, participating in folk processions that recall the graceful moving line of Haitian villagers from earlier prints. Grand, sweeping landscapes such as *Lake Dal, Kashmir* [527] reflected the artist's continuing sensitivity to the lyrical side of nature, but

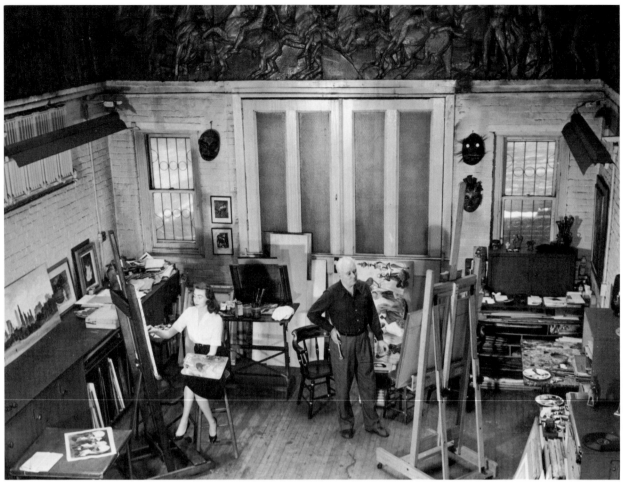

Adolf and Virginia in the studio of their house on West Twenty-first Street, New York, in the late 1950s

dominating the India prints were the women and the rituals of the countryside. *The White Bull* (or *Woman Riding Bull*) [574] and *Indian Women in Procession* [602] are notable examples.

Dehn's final trip to a remote place occurred in 1967 when he went to Ireland. Curiously a reverse situation prevailed. He and Virginia took note of the Gaelic folk eking out a sparse living along the barren, rocky western coast of Ireland, but when composing the lithographs he showed more interest in the coastal rock formations, the promentories sculpted by the furies of the Atlantic Ocean.

Dehn turned sixty-five in 1960. The long, cross-continent journeys like the one in 1958–59 undermined his health, although he refused to admit this and planned new ventures. Extended working sessions in Paris every other year throughout the 1960s were supplemented by trips to Egypt, Ethiopia, Morocco, Kenya, Italy, and Ireland.

The Paris work periods were critical since it was at the Desjobert lithography shop that he put the ideas from his many travels onto the stones. In June 1961 he flew to Paris with Virginia and immediately wrote to Viola:

> I'm weary of touring, ready to go to Desjobert to work hard and eagerly on lithographs. If I can put down half of what I feel capable of, there should appear in the next two or three months a fine body of work. The print market is good now and may pay off big for me—but the main thing is I have an urge to see whether I cannot go way beyond my earlier work.[123]

Realizing these technical ambitions was not easy:

> The work went well for the first weeks, but now I'm depressed. It all seems so unimportant . . . what I have done, and last week one important stone I had overworked would not print. Now I must recover, get my optimism back and start over.[124]

As in the past Dehn's moods could shift suddenly. By September he boasted to Viola that weeks of ten-hour days had produced at least the good beginnings of dozens of lithographs. A

month later he had finished more than thirty-five prints by sticking to a "routine of 9 to 9 at the lithographic rockpile."[125] When they were exhibited at his 1962 show at the Milch Gallery, sales amounting to more than seven thousand dollars enabled him to pay off his entire eight-month trip to Europe as well as most of his printing costs.[126]

In 1963, 1965, and 1967 the pattern of anticipation, frustration, exhilaration, and release was repeated in his Paris printing sessions. He worked himself at an increasingly furious pace, seemingly driven as if each day was vital and there were not many of them left. Although he clung doggedly to this grinding routine (and maybe partly because of it) he encountered mounting frustrations; he felt that the young Desjobert printers, no longer working under the watchful eye of Maestro Edmond, were not up to the task of translating his complex, experimental techniques into finished prints. He was wracked by the "terrible tensions of printing three-color lithographs"[127] and suffered many of those blank creative periods all artists loathe. He wrote to Olivia in August 1963: "No news. We work very hard so that I think only lithographs. Part of the time exalted, rest of the time I hate lithographs."[128] A month later he noted: "Life goes on. We suffer over lithographs. I feel everything is no good. Today I pulled proofs on a bison which for a change looks real good, so I'm happier than usual."[129]

Deteriorating health in the 1960s added to Dehn's unrest and much alarmed Virginia. Over the years he had been told by his doctor to eat and drink less and cut down on salt to control his elevated blood pressure, but generally he impressed everyone as being physically robust.[130] Now he pushed himself beyond reasonable levels, developing severe headaches and dangerous hypertension. His leg mysteriously went numb while he was walking one day on a street in Paris. The low point came on his 1967 Paris trip. There was scant else on his mind but work. "Paris should be wonderful," he said, "but I see little of it. Too weary and tired after a day of working."[131] Shortly thereafter he developed a case of shingles and continued to suffer from hypertension and insomnia. At one point in July he fainted while working at the Desjobert and had to be rushed to the hospital because of excruciating facial pain (located just under his eye) that lasted nearly three days. It was diagnosed as tic douloureux, a serious neurological disorder;

Adolf in a French cafe in 1963 as photographed by his old friend, Federico Castellón

Virginia wrote sadly to Olivia: "Poor man, what torment he has been through this year."[132] Massive doses of vitamin E temporarily helped Dehn—one side effect was that his hair grew thicker, but as he said, "not fuller where there is none, like on top of my head."[133]

Dehn told an interviewer in early 1967 that he doubted whether he had many prints or years left in him. The satirical lithograph, *Jerome Patinir and Mr. Adolf Dehn on the River Styx* [604], was meant to be a more grave and portentious print than anyone realized at the time. Virginia Dehn, of course, knew about his persistent thoughts of mortality and believed that the rush of entertaining that Dehn insisted they carry on at their New York home in 1966 and 1967 was meant to disguise his increasing depression.[134] He never stopped making prints or planning new trips abroad, and he was excited about a proposed book on his drawings by the University of Missouri Press. With Mahonri Sharp Young, an old Paris friend and director of the Columbus Gallery of Fine Arts, he laid the groundwork for a comprehensive Adolf Dehn retrospective of painting, prints, and drawings. He had been organizing prints in his files the day he suffered a massive heart attack. Dehn died May 19, 1968.[135]

Dehn never grew feeble as an artist, even in the last few sad years of his life. He died protesting that his best work was just ahead. In the later stage of his career he assessed his significance primarily in technical terms—the experiments he

had made that advanced the craft of stone prints.[136] But this judgment may have been unduly weighted by the popularity of his landscape prints where his complex technical feats were most evident and by the general mood of the 1960s when technique dominated discussion of American lithograpy. It is not the place here to try to measure in a critical way Dehn's different lithographs; it can be said, however, that he was first and foremost an expressionist printmaker, a passionate artist with two overriding interests, nature and satire. Twenty years of desperate struggle to survive as an artist could not diminsh his eagerness to make lithographs on these subjects. For all his lazy and self-centered indulgent behavior, Dehn was, at bottom, a resilient artist of tough fiber and good cheer. He also had his share of luck and was fortunate in the loyalty and love of his family and friends.

Certainly he was an irrepressible romantic.

Nearly every writer on Dehn has admired his deeply felt response to nature, which represents the lyrical side of his personality. When life in the big cities – in the clubs and the cafes – seemed tight and cramped, Dehn would head to the mountain areas of Europe or Colorado or to his ancestral Minnesota. Sometimes he simply retreated to the quieter places within Vienna, Paris, and even New York. In later years he often escaped into his imagination. But he always returned to the hectic city where the other half of his personality expressed itself in satires: lithographs where a wild and weird humor seized the prints. As art critic Ernest Brace once described the feeling of the viewer who comes upon a batch of Dehn's satires shortly after spending time with his landscape prints: "We feel as if we had been on a long vacation at the mountains or the seashore and were back in the city again taking our first ride on the subway."[137]

NOTES

Notes from author's interviews are in author's possession.

1. Dehn is not mentioned in the major textbooks. But Dehn is discussed in Milton Brown, *American Painting from the Armory Show to the Depression* (Princeton, N.J.: Princeton University Press, 1955), 187–88; Una E. Johnson, *American Prints and Printmakers: A Chronicle of over 400 Artists and Their Prints from 1900 to the Present* (Garden City, N.Y.: Doubleday, 1980), 51–54; James Watrous, *American Printmaking: A Century of American Printmaking, 1880–1980* (Madison: University of Wisconsin Press, 1984); Clinton Adams, *American Lithographers, 1900–1960: The Artists and Their Printers* (Albuquerque: University of New Mexico Press, 1983), 72–74.

2. Mura Dehn, interview with author, New York, May 27, 1975. For information on Dehn's ancestors, see Harry Salpeter, "Adolf Dehn: Happy Artist," *Esquire*, May 1941, p. 94–95, 162–64.

3. In the 1920s Dehn changed the spelling of his first name from Adolph to Adolf.

4. Recollection of Viola Dehn from later conversations she had with her brother; Viola Dehn Tiala, interview with author, St. Cloud, Minn., June 15, 1975.

5. Salpeter, "Adolf Dehn," 162.

6. Dehn to Emilie Dehn, January 12, 1916, Adolf Dehn Papers, Archives of American Art, Smithsonian Institution (microfilm copies, Minnesota Historical Society). All letters cited below are from this collection.

7. Harry Gottlieb, interview with author, New York, June 3, 1975. None of the teachers at the Minneapolis School of Art made mention of the Armory Show, which had traveled from New York to Chicago with considerable fanfare in 1914.

8. Lucile Blanch, interview with author, Woodstock, N.Y., May 30, 1975.

9. Writing to his family in January 1916, Dehn related one of his busier, but not extraordinary, days: In the morning Dehn attended a rationalist lecture at the Lyric Theater on the "survival of savages in Biblical history." At noon he rushed back to the school to a new exhibit, where he engaged Ada Wolfe, a "well-known artist and anarchist" in a spirited debate for more than an hour. Professors Goetsch and Koehler remarked about his "wild drawings" in a late afternoon class, and, to finish the day, he went with Wanda Gág to the Unitarian Church to hear Allen Brooms lecture on "free love." Dehn to Emilie Dehn, January 12, 1916.

10. See Wanda Gág's diary on these years, *Growing Pains: Diaries and Drawings for the Years, 1908–1917* (New York: Coward McCann, 1940; reprint, St. Paul: Minnesota Historical Society Press, Borealis Books, 1984), 369, 375–429, 436–37, 439, 441–45, 447, 449, 457–59.

11. There developed an exhilarating camaraderie among these young artists as they banded together in a big city, growing up and growing apart from the small town upbringing of their midwestern homes. "There was a special feeling among us," Lucile Blanch recalls. "We had a separate make-up from people who expected us to

work in a store or do this or that. When we got to Minneapolis, the old life seemed empty, dry, barren, and dull." Blanch interview.

12. Adolf Dehn, interview with Dorothy Seckler, at the Archives of American Art, New York, January 1968, audio tape, Archives of American Art. See also Dehn to Emilie Dehn, December 27, 1917, April 26, 1918.

13. Dehn to Emilie Dehn, September 29, October 16, 1917.

14. Dehn to Emilie Dehn, December 7, 11, 22, 1917, February 19, March 1, April 8, 1918.

15. Dehn, interview with Seckler; Dehn to Emilie Dehn, November 6, 1918. The Tenderloin was the red-light district.

16. Dehn to Emilie Dehn, August 11, 31, 1918. A more detailed treatment of Dehn's struggle during this period can be found in Richard W. Cox, "Adolf Dehn: The Minnesota Connection," *Minnesota History* 45 (Spring 1977): 170-73.

17. Viola Dehn Tiala interview.

18. *Waterville Sentinel*, January 11, February 1, 15, March 1, 13, 29, April 6, 1918 – all p. 4.

19. Dehn to Emilie Dehn, October 23, 1918, February 16, 1919.

20. Dehn to Emilie Dehn, March 1, April 2, 1919. The committee, named for chairman Clayton R. Lusk, was formed in March 1919 and soon became one of the most notorious such investigating groups in the country. Robert K. Murray has written about the Red Scare: "The general public, which heretofore had tolerated the Socialists, now [1919-20] unleashed a wave of hatred for these non-conformists. . . . The Socialists' opposition to the war was universally regarded as irrefutable proof that they were either spies or pro-German and wanted the enemy to win"; Murray, *Red Scare: A Study in National Hysteria, 1919-1920* (Minneapolis: University of Minnesota Press, 1955), 20.

21. Here and below, see Dehn, interview with Seckler.

22. The drawings of industry were partly inspired by the "nocturnal wanderings" Dehn made with Claude McKay, an editor at *The Liberator*, in 1921; see Claude McKay, *A Long Way from Home* (New York: L. Furman, Inc., 1937), 133.

23. A more thorough discussion of this topic is found in Karen Tsujimoto, *Images of America, Precisionist Painting and Modern Photography* (Seattle: University of Washington Press, 1983), 69-73.

24. Dehn to Emilie Dehn, April 12, 1920. In a letter to Olivia Dehn written in March 1928 he admitted to having an inferiority complex during the first years that he was a student in New York.

25. "Loose" is the term Harry Gottlieb used to describe Dehn's effect on Wanda Gág. Nearly every one of several dozen letters in the 1919-21 period mentions Wanda; among the key ones are November 13, 1919, April 8, May 2, October 26, 1920.

26. Gág, *Growing Pains*, xiv; Adolf Dehn, interview with John Chambers, Woodstock, N.Y., October 1965, in possession of Olivia Dehn Mitchell.

27. Helen Farr Sloan, interview with author, Wilmington, Del., June 8, 1970.

28. Dehn to Emilie Dehn, August 1920.

29. A further discussion of Gág during these years is found in Richard W. Cox, "Wanga Gág: The Bite of the Picture Book," *Minnesota History* 44 (Fall 1975): 238-54.

30. Carl Zigrosser, *The Artist in America: Twenty-four Close-ups of Contemporary Printmakers* (New York: Alfred A. Knopf, 1942), 17.

31. Dehn, interview with Seckler.

32. Dehn to Emilie Dehn, April 2, 1922.

33. Mura Dehn, interview with author, New York, November 30, 1985. Mura's father was an engineer who had worked for a British firm in Odessa before the Russian Revolution. He spent most of the 1920s in London.

34. Wanda Gág wrote back to Dehn of her humiliation: "What will become of me, who cares: whether I mean anything to you, whether I become an artist, an intelligent mother, or a famous cortesan"; Gág to Dehn, March 23, 1923.

35. One typical expression came from an admirer named "Tauc" (code name?) who described his obsession with Mura's face in an undated letter, probably written in the 1920s: "It is an amazing face, unaccountable, moody, joyous, restless, always alive. And, of course, I think your eyes, when they begin to swim (always toward the end of the evening) just magical"; "Tauc" to Mura Dehn, no date.

36. Mura Dehn interview, May 27, 1975.

37. Alex de Jonge, *The Weimar Chronicle: Prelude to Hitler* (New York: New American Library, 1979), 127. See also Otto Friedrich, *Before the Deluge: A Portrait of Berlin in the 1920's* (New York: Fromm, 1972), 246-47.

38. Alec Swann, quoted in de Jonge, *Weimar Chronicle*, 127. Swann was talking about girls, "not a tart, just an ordinary girl in a shop."

39. De Jonge, *Weimar Chronicle*, 127; Friedrich, *Before the Deluge*, 82-86, 92-97; Mura Dehn interview, November 30, 1985.

40. De Jonge, *Weimar Chronicle*, 162. Mura remembered going with Adolf to see performances by Josephine Baker and Anita Berber – Dehn with his sketchbook poised; Mura Dehn interview, November 30, 1985. See also Dehn to Emilie Dehn, August 13, 1929; de Jonge, *Weimar Chronicle*, 137.

41. Dehn to Carl Zigrosser, quoted in Zigrosser, *Artist in America*, 19.

42. Grosz, quoted in Zigrosser, *Artist in America*, 15.

43. Dehn to Olivia Dehn, March 12, 1926.

44. Robert Minor (editor of *The Liberator*) to Dehn, December 26, 1923; Guy Pène du Bois, "Adolf Dehn," *Creative Art* 9 (July 1931): 33-34.

45. Dehn to Olivia Dehn, August 23, 1923.

46. Dehn to Olivia Dehn, September 14, 1923; Dehn to Emilie Dehn, June 16, 1929.

47. Dehn's attitude toward Kandinsky – and abstract art in general – was partly expressed after he visited a show of the Bauhaus and Kandinsky in Weimar. He had serious reservations: "They go in a direction away from mine and I am skeptical about them, but still they made one speculate a lot and one needs that"; Dehn to Emilie Dehn, September 14, 1923. Mura Dehn said she never once recalled Dehn discussing Marxist dialectics with her, although he would talk about his general support of the socialist experiment in the Soviet Union; Mura Dehn interview, November 30, 1985.

48. Adams, *American Lithographers*, 72-74.

49. Adolf Dehn, interview with Karl Fortess, New York, July 16, 1967, audio tape, in the possession of Karl Fortess.

50. Andrée Ruellan, interview with author, Woodstock, N.Y., August 3, 1985.

51. Mura Dehn interview, November 30, 1985; Ruellan interview.

52. Dehn to Emilie Dehn, May 13, 1928; Ruellan interview.

53. Mura said that Dehn and Pascin probably became acquainted in Paris around 1926, although she could not

recall any specific meeting; Mura Dehn, interview with author, New York, June 2, 1975.

54. Mura Dehn and Andrée Ruellan speak of Dehn's uninhibited, very unneurotic lust for women, his attraction to the "American shape; women with long legs and big busts — women with much style"; Ruellan interview.

55. Dehn, quoted in Zigrosser, *Artist in America*, 17.

56. Dehn's interest in Freud and sexual liberation began as early as his school days (1915–17) in Minneapolis and was increased by his close association with Floyd Dell at *The Liberator*. Dell's classic manifesto on the subject came in his autobiographical work, *Moon-Calf* (New York: Macaulay, 1920). In Europe Dehn's attitude did not change; see Dehn to Emilie Dehn, January 16, 1916, October 30, December 7, 1917, February 6, 1918, May 2, 1930.

57. Two examples of this attitude: "I think Europe will accept me more readily than America. It is damn important for my reputation that I do things in Europe now," Dehn to Emilie Dehn, no date (1923); and "I am poor but not unhappy. Europeans accept me as an artist and that rarely happens with an American," Dehn to Emilie Dehn, March 12, 1926.

58. On one occasion in 1927 Dehn urged Olivia, who was just then starting school at the Art Institue of Chicago, to consider fashion design or some other "practical option" instead of painting. This gesture of good sense, ironically, recalled similar counsel he had rebuffed from his father a decade before; Dehn to Olivia Dehn, March 15, 1926. Dehn sent Christmas presents home, except in 1925 and 1928 when he was flat broke. He frequently in the 1920s spoke of his determination to return to America for the sake of his art career; Dehn to Emilie Dehn, March 8, 1924, February 5, 1927, May 13, 1928.

59. Dehn to Mura Dehn, no date (1928); Dehn to Emilie Dehn, January 28, 1924, no date (1924), September 18, 1928, February 18, 1927. Briefly in 1926 Dehn, Mura, and Fanny and Boris Ziperovitch went to London to see Mura's father and look for possible dance positions. Her parents has been initially involved with the Soviet government in 1918, which did not sit well with the Conservative-dominated British officials, and Mura believed that the Dehns' expulsion from London late in 1926 was connected with that, too. Dehn himself referred to the incident only obliquely: "I took a side trip to England in 1926. They kicked me out for some unknown reason"; Dehn, interview with Seckler. See also Cox, "Adolf Dehn," 174.

60. Ruellan interview. It would not be the last time that Dehn dealt in kind rather than money; during the depression in New York he frequently paid his doctor with drawings or lithographs.

61. Dehn to Emilie Dehn, March 20, 1928.

62. Mura Dehn interview, November 30, 1985. One letter from Dehn to Mura, for instance, demonstrates how much value he placed on her criticism of his work. He wrote to her in Coburg: "I made four lithographs. I have worked out something different technically and that which you have been demanding 'light ones.' They are very simple and quick and light much like my Chinese ink drawings. I am excited and must do several more. Also I made nine women at the theatre in a loge and that I think is a very rich lithograph. It may be one of the very best"; Dehn to Mura Dehn, no date (1928). Another letter asked Mura to make a "kritic" on some new lithographs. "I would like to send myself. I present you myself entirely as a slave — I come to you and go down at once begging you to take my hands till I cry and kiss your feet"; Dehn to Mura Dehn, no date (1928).

63. Zigrosser wrote: "The exhibit [of Dehn's drawings] was a great success. Everybody spoke favorably of the work. But very little was sold"; Zigrosser to Dehn, May 3, 1925.

64. Zigrosser to Dehn, January 13, 1928.

65. Blanch interview. See also Dehn to Emilie Dehn, January 15, 1929.

66. Blanch and Ruellan interviews.

67. Dehn, interview with Seckler.

68. Dehn to Emilie Dehn, October 13, 1928.

69. Dehn to Mura Dehn, January 1929. See also Dehn to Andrée Ruellan, March 19, 1929, which speaks of the excitement he felt about drawing New York City.

70. Dehn to Mura Dehn, March 12, 1929.

71. Dehn to Mura Dehn, no date (1929); Cox, "Wanda Gág," 249–50.

72. Guy Pène du Bois, *Artists Say the Silliest Things* (New York: Duell, Sloan and Pearce, 1940), 258.

73. Zigrosser to Dehn, June 4, 1926.

74. Dehn to Mura Dehn, May 21, 1929.

75. Dehn to Mura Dehn, January 1929.

76. Pène du Bois, "Adolf Dehn," 35.

77. Andrée Ruellan remembers, "We knew there was a sad, miserable side to Harlem and there was a touch of guilt in our slumming up there in the late evenings; but we were all sympathetic to the blacks, we knew the black artists and writers personally and frequently went with them to the Harlem clubs"; Ruellan interview. For more on this psychological aspect of the mixing of whites and blacks in Harlem, see Nathan Huggins, *Harlem Renaissance* (New York: Oxford University Press, 1971), 65–67.

78. Dehn to Emilie Dehn, April 13, 1930.

79. Dehn to Emilie Dehn, April 18, 1930. One positive review came from Ralph Flint who said that "Mr. Dehn is easily among the very front-rankers of modern lithography in this country and his present showing includes some smartly handled scenes of New York by night. . . . If Mr. Dehn leans toward the Chinese manner in his landscapes, he is contrastingly Germanic in his figure pieces which have a hale and hearty Teutonic flavor akin to the Jugend type of work"; Flint, "Around the Galleries," *Creative Art*, May 1930, supplement, 120.

80. Dehn to Olivia Dehn, September 18, 1928.

81. Olivia Dehn Mitchell, interview with author, Woodstock, N.Y., May 29, 1975; Ruellan interview; Mura Dehn interview, November 30, 1985.

82. Mura Dehn interview, November 30, 1985. Henry McBride observed that Dehn would not become a popular or fashionable satirist because "his . . . manner of reporting . . . is rather tart and acrid. Graciousness and soft beguilement are not the specialities of Mr. Dehn. He has a northern and severe point of view"; McBride, quoted in *Art Digest*, May 15, 1940, p. 19.

83. On artists' troubles and the depression see Matthew Baigell, *The American Scene: American Painting of the 1930's* (New York: Praeger, 1974), 21–23.

84. Dehn to Olivia Dehn, October 11, 1930.

85. Dehn to Emilie Dehn, October 11, 1931; Dehn to Andrée Ruellan, April 13, 1932.

86. Olivia Dehn Mitchell interview.

87. Mura Dehn interview, November 30, 1985.

88. Olivia Dehn to Viola Dehn, December 26, 1931. Olivia asked her sister, Viola, to pass on the information about the broken marriage to their mother.

89. Dehn to Olivia Dehn, no date (1932).

90. Records of the Public Works of Art Project, Group 121, National Archives Correspondence of the Region 2

Office (New York area), 1933-34, Archives of American Art.

91. Dehn to George Biddle, April 1934.

92. Dehn to George Biddle, November 21, 1934; Dehn to Emilie Dehn, August 14, December 17, 1934, April 20, 1937.

93. Dehn to Olivia Dehn, June 29, 1936; he told her he was looking forward to the quiet country and mountains of Austria.

94. Dehn to Olivia Dehn, July 26, November 26, 1936.

95. E. Loran, "Adolf Dehn," *American Magazine of Art* 29 (January 1936): 25-27; Dehn to Emilie Dehn, March 6, 1936. In an upbeat mood, he commented to his mother, "I have plenty of work planned, most of it my own things — if I don't get cluttered up with new commissions which I want for the money but hate because I want to do some of my own things." At every stage in his career, save the last few years of his life, Dehn sought commercial jobs, sometimes finding them, sometimes not.

96. Dehn to Emilie Dehn, December 11, 1917.

97. Mura Dehn interview, November 30, 1985.

98. Several letters Zigrosser wrote to Dehn in the 1920s asked when Dehn would be sending him the new watercolors; see, for instance, Zigrosser to Dehn, June 4, 1926.

99. Dehn to Mura Dehn, May 21, 1929.

100. Dehn, interview with Seckler.

101. Dehn to Emilie Dehn, April 20, 1937.

102. Viola Dehn Tiala interview; Cameron Booth, interview with author, Minneapolis, October 16, 1976. Booth was born in Erie, Pennsylvania, studied at the Art Institute of Chicago, and moved to Minneapolis in 1921 to accept a teaching position at the Minneapolis School of Art.

103. Dehn, interview with Fortess.

104. On his third attempt, Dehn won a Guggenheim Fellowship in 1939. He expressed his disappointment at not winning an award earlier; see Dehn to Emilie Dehn, April 11, 1932, and Dehn to Viola Dehn, March 25, 1938.

105. Dehn to Emilie Dehn, August 9, 1939.

106. Ernest Watson, "Adolph Dehn's Watercolors of Navy Blimps," *American Artist*, March 1984, p. 25-27.

107. Joycelyn Pang Lumsdaine, "The Prints of Adolf Dehn and a Catalogue Raisonne" (Master's thesis, University of California at Los Angeles, 1974), 18.

108. Dehn to Emilie and Arthur Dehn, April 14, 1942, February 23, June 4, 1943.

109. Virginia Dehn, interview with author, New York, November 29, 1984.

110. Art critic Margaret Breuning waxed enthusiastic about Dehn's new cityscapes and landscapes, which demonstrated, she said, "the brilliant technical accomplishment long associated with his work. The shimmering veils of atmosphere from which objects seem to rise fortuitously, yet are essential factors of design, the majesty of peaks like carved monoliths, the rise and fall of earth masses in slow rhythms and the immensity of a world that lies dwarfed beneath a mountain's towering mass, all these appear . . . in a wealth of tonal richness and rectitude of scale. City scenes, such as *Central Park Night*, with an arabesque of pattern woven into an almost palpable darkness, or *Manhattan Night*, with the abysmal canyons of the streets with a few glimmering lights in the soaring building that hem them in, are other and equally felicitous aspects of Dehn's ability to pluck out the character of his subject in revealing terms"; Bruening, "Dehn Lithographs," *Art Digest*, May 1, 1947, p. 17.

111. Dehn, interview with Fortess.

112. Virginia Dehn, interview with author, New York, August 7, 1985, November 29, 1984.

113. *Adolf Dehn: Retrospective Exhibition of Lithographs, 1920-1963*, FAR Gallery, New York, March 9-29, 1964. The new serious side of Dehn related to the general existential mood of American art during the late 1940s; see Dore Ashton, *American Art Since 1945* (London: Thames and Hudson, 1982), 28-30.

114. Dehn to Emilie Dehn, October 31, November 20, 1939, January 2, 1940.

115. Virginia Dehn interview, August 7, 1985.

116. Johnson, *American Prints and Printmakers*, 54. See also Carlyle Burrows, "Artist Takes Mayan Theme for Series of Human Character," *New York Herald Tribune Book Review*, February 26, 1956, p. 13.

117. Virginia Dehn interview, August 7, 1985.

118. Virginia Dehn says that Adolf was circumspect around the Haitians, respectful of being outside their culture even as he was very friendly with the people. The dignity of the Haitians moved him; it was epitomized by one occasion when a Haitian woman, watching Dehn draw her family in the marketplace, approached the artist and quietly said, "You'll be kind to us, won't you"; Virginia Dehn interview, August 7, 1985.

119. Dehn to Olivia Dehn Mitchell, March 3, 1961.

120. Dehn, interview with Fortess.

121. Virginia Dehn interview, August 7, 1985.

122. Virginia Dehn interview, August 7, 1985.

123. Dehn to Viola Dehn Tiala, June 28, 1961.

124. He elaborated, "It's my fault for I do too much. I strain for too many nuances that won't print"; Dehn to Viola Dehn Tiala, August 6, 1961.

125. Dehn to Viola Dehn Tiala, October 15, 1961.

126. Dehn to Olivia Dehn Mitchell, February 5, 1962. Anticipating this success and to unwind from the months of steady labor at Desjobert, Dehn and Virginia traveled for five weeks through Spain in November 1961.

127. Dehn to Olivia Dehn Mitchell, August 11, 1963.

128. Dehn to Olivia Dehn Mitchell, August 14, 1963.

129. Dehn to Olivia Dehn Mitchell, September 1, 1963.

130. Virginia Dehn interview, August 7, 1985.

131. Dehn to Olivia Dehn Mitchell, April 3, 1967.

132. Virginia Dehn to Olivia Dehn Mitchell, April 28, 1967.

133. Virginia Dehn interview, August 7, 1985.

134. Fred Shane, "An Afterword," in *Adolf Dehn Drawings* (Columbia: University of Missouri Press, 1971), 207-8.

135. "Adolf Dehn Dies, Printmaker, 74," *New York Times*, May 20, 1968; *Minneapolis Tribune*, May 23, 1968, p. 26.

136. Dehn, interviews with Seckler and Fortess.

137. Ernest Brace, quoted in *Current Biography*, 1941, s.v. "Dehn, Adolf."

ADOLF DEHN: THE LITHOGRAPHS

CLINTON ADAMS

When in 1922 Adolf Dehn began a series of lithographs at the workshop of Meister Berger in Vienna, he was following in the path of other distinguished American artists – James McNeill Whistler, Joseph Pennell, and Albert Sterner among them – who, by force of circumstances, made lithographs abroad. Although during the nineteenth century lithography became a principal medium of expression among the artists of France, it did not achieve comparable acceptance in America where lithography was seen more as a business than an art. The European tradition of the painter-graver – the artist who makes original prints – was not well established in this country, and the lithographic printers who met the needs of American commerce perceived little profit in undertaking work for artists. Thus in the absence of printers, many American artists who were attracted to lithography did their work in England or elsewhere in Europe.[1]

While the principle of lithography is simple, depending upon the mutual repulsion of grease and water, in practice it requires the services of a highly skilled printer; thus since its invention in 1798 by Alois Senefelder most fine lithographs have been produced by the combined effort of an artist and a printer working collaboratively together. Among such artists, it was Sterner who became the first to provide direct stimulation to the development of lithography in the United States. While in Europe before World War I he created a series of lithographs in cooperation with fine printers in Munich and Paris and became thoroughly committed to the concept of the painter-printmaker. Upon his return to New York, he purchased a press, installed it in his studio, and set out to print for himself. Inevitably, because he had little knowledge of the chemistry of lithography, he was frustrated by problems that forced him to seek technical assistance. He received this assistance from George C. Miller, who was then employed as a commercial printer at the American Lithographic Company; shortly thereafter, at the behest of Sterner and other artists, Miller established the first lithographic workshop in America to exist, as did the ateliers of Europe, for the sole purpose of providing printing services to artists.[2] Bolton Brown, an artist of broad experience who was the second printer to open such a workshop, was likewise brought to lithography through Sterner's influence. Brown later wrote that it was an exhibition of Sterner's lithographs in New York in 1915 that gave "the

last push needed to send [him] . . . off to study lithography in London."[3]

In 1917 Sterner took the initiative in formation of the Painter-Gravers of America, a society of artists that included George Bellows, Childe Hassam, Boardman Robinson, and John Sloan among its founding members.[4] By the time the society's exhibitions resumed after an interruption forced by World War I, both Miller and Brown were printing lithographs for artists in New York.

Adolf Dehn, who had first come to New York before the war as a scholarship student at the Art Students League, returned to the city in 1919 after performing service required of him as a conscientious objector. Eager to resume his work as an artist, Dehn sought out his friend and mentor, Boardman Robinson. Born in 1876, "Mike" Robinson was forty-three in 1919; Dehn, who was twenty-four, saw the older artist in many ways as a "second father":

> Robinson's years of teaching began after my own art-school days, so I never had the good fortune to study with him. Nevertheless, he influenced me more than any of my instructors. His influence on me came through watching him at work, through many conversations, but chiefly through his paintings themselves. This influence went, beyond the principles of art, to the business of life—how to live, how to behave, how to work, and how to think.[5]

Robinson also provided concrete assistance. In January 1920 Dehn wrote to his mother in Minnesota:

> Again, and this pleases me as an artist— Michael [Robinson] is going to put my name in as his choice so that I can exhibit a lithograph or 2 at the annual show of the "Painter Gravers." This year they have it at the Anderson Galleries and it will be an important one. I am very eager to do this and I am already planning to work some things up. Yes, yes in a couple of years your son will be a fullfledged artist. The years of apprenticeship are long and strenuous but there is a time.[6]

Robinson made arrangements for Dehn to meet the printer George Miller. When, perhaps in Robinson's company, Dehn made his way to Miller's dingy studio on Manhattan's lower east side, he could not have been much impressed. Crowded into an inadequate space were Miller's small hand press, lithograph stones standing on edge in a series of racks, piles of paper and blot-

ters, and the printer's ill-organized desk. Perhaps because of Dehn's inexperience, perhaps for convenience, Miller provided him with transfer paper rather than with stones. While the transfer method is technically limited in comparison to stone lithography, transfer paper has the advantage of low expense; it permits trial and error and is readily portable. Dehn expected to make a number of drawings, then to pick one for his first lithograph.

By March he had selected two: "I have been real busy this past week," he wrote, "chiefly getting my lithographs ready for the exhibition. I will have *The Harvest* and *Mothers of the Revolution*. . . . I am figuring on doing a very large one—about 20 by 28 inches. I know of no one who has done one that large."[7]

Both lithographs, drawn in crayon on transfer paper, are in the social-realist tradition of Honoré Daumier and Théophile Steinlen; in style and execution they resemble the lithographs of Albert Sterner. The first, bitterly titled *The Harvest* [1], depicts three old women—ancestors of the bag ladies of the 1980s—rooting through the ash cans of New York; a rat perches on one can. The other, *Mothers of the Revolution* [2], portrays a group of faceless women, members of a silent Greek chorus, moving toward the smokestacks of industry in an otherwise darkened and empty world. Shortly thereafter, just in time for its inclusion in the Painter-Gravers exhibition, Dehn made his first drawing on stone, "a third lithograph which I like better than the other 2, entitled *Sunday Morning* [3]—lots of nuns going to church."[8]

Following the April opening of the exhibition, Dehn wrote again to his mother: "Wanda [Gág] and I went to the opening last night. Lots of big artists, lots of dress suits and evening gowns there. My things show up well. And I am told that lots of good things are said about them. My name was even mentioned in the newspapers."[9]

Dehn received praise for his work from Sterner, Robinson, and other artists he respected. Carl Zigrosser, who then ran a print gallery for the New York book dealer Erhard Weyhe, liked his prints and agreed to show them. Despite limitations of time and money, Dehn was encouraged by this response to go on with lithography:

> I am planning to do a set of about 10 lithographs of the East river during the next few months. . . . Michael is urging me to do this. He thinks they will sell. Miller will do them for me cheap but even then it will in-

volve some money, altho eventually I'll get it back many times over.[10]

But spring and summer went by before Dehn again made a lithograph. Not until October did he write that:

> I have a lithograph stone in the house now and I am drawing on it. A view of the Palisades on one side of it — and I am not sure what I shall put on the other. I think I shall exhibit — or rather submit 2 or 3 lithographs to the fall show of the Penn. Academy of Fine Arts to be held in November.[11]

Two weeks later he added:

> I have made a lithograph for the Penn. Academy Exhibition which is pretty good. A view which I took up the Hudson. I also made one today entitled *The Happy Family* — a weary husband and a forlorn emaciated mother with a baby in her arms rest after a day's toil — just a note of irony.[12]

As Dehn struggled to live in New York, supporting himself through a series of odd jobs and an occasional sale of a drawing or lithograph, his life was further complicated by romance. Since his return to the city, his long friendship with Wanda Gág had turned into a love affair. That he was torn between the conflicting demands of life and art is suggested by the title of his 1921 lithograph, *The Temptation of St. Anthony* [6], in which a fully clothed man sits on a bed, book in hand. He looks uncertainly at one of two nude women standing beside the bed as she poses provocatively, hand on hip, her immodest gaze directed at the viewer. Dehn knew himself well enough to know that he, like the "saint" on the bed, was capable of withstanding any force but temptation.

Given the problems of life in New York, it is not surprising that Dehn thought of escape to Europe. Receiving a promise of modest employment and financial support from Scofield Thayer, editor of *The Dial*, Dehn embarked in September 1921 and by the end of that year had established himself in Vienna.

He was resolved to pursue his work as an artist and, perhaps, to escape the complications of love. But that was not to be; soon after his arrival, in the winter of 1921–22, he met a young Russian dancer, Mura Ziperovitch, and began a passionate affair that would lead to marriage in 1926. In February he confessed his new love to Wanda Gág in a tortured letter replete with false starts and crossed out words.[13]

Beyond the diversions of love were the diversions of the city: the streets, the parks, the cafes, and the coffee houses. These, for Dehn, were diversions not to be resisted. "I was lazy," Dehn said in retrospect:

> It was not until I was nearly forty before I was un-lazy. It's really true. I didn't work much. I loafed. I learned how to live in Vienna. . . . For me, it was very important, because I was so damned shy, when I went over [to Europe]. But there I learned about living. It was a time, of course, when living in Vienna was fabulously cheap. In the early twenties it was just very, very cheap. And I could live well.[14]

Even so, Dehn found time for work. At some point in 1922 (we do not know the exact date) he found his way to the lithographic workshop of Meister Berger and during that year completed a series of nine lithographs [7–15]. All are crayon drawings, some drawn on transfer paper, others directly on stone. As a group they are more casual than the prints made with Miller in New York and less concerned with social themes.

Among the print media, lithography is the most flexible and autographic. Even within the range of simple crayon lithography (without use of tusche, a greasy liquid, or complex techniques of drawing) the possibilities are many, from delicacy to vigor. In Dehn's Vienna lithographs we see his exploration of this range, from a crayon that is sharp and hard to one that is blunt and soft, from pencil-like sketches to expressionistic drawings. "The very characteristics which help distinguish a lithograph are those which first attracted me to the medium," Dehn wrote:

> the infinite range of textures which arrive due to the grain of the stone and the ease and spontaneity in applying them. Primarily a black-and-white draftsman in the 1920s, I took to lithography naturally and my admiration for Daumier had much to do with my enthusiasm.[15]

The Vienna lithographs suggest rather more the influence of the Blaue Reiter artists than of Daumier. Among their subjects are two that refer directly to his relationship with Mura Ziperovitch — one of Mura with her mother [12] and another of her mother with a friend [7]. In a

third he refers again to the temptations of love. In this version of the *Temptation of St. Anthony* [13], the man on the New York bed has become a bearded Viennese seated at a cafe table; at the other tables are attractive women, who, if no longer nude, are voluptuous and aware, their legs crossed or spread apart.

As summer came to an end, Dehn faced reality; he was short of money. Although the cost of living in Vienna was lower than in New York, the winter of 1922–23 was cold and gray, and he could not afford coal for fire. He wrote Carl Zigrosser that he would soon move from Vienna to Berlin, a city that was "very alive" and also "cheaper than Austria." Pinning his financial hopes on a New York exhibition scheduled for April 1923, Dehn sent impressions of the Vienna lithographs to New York. With transparent optimism he told Zigrosser to "wait till my stuff is shown at the Weyhe galleries! I can see the line of art lovers standing in line stretched down Lexington till 42nd Street. [They'll] probably have special subway trains to [58th] Street."[16] When shown, the lithographs received no such public response, although they attracted comment in the press: "[Dehn's] scenes of the city, the kaleidoscope of cabarets and night life, of war profiteers and beggars, [are] presented with an unusual mastery of form and space and the utmost economy of line. There is humor in his trenchant observation of life."[17]

Aside from a brief trip to the United States in 1924, during which it was Dehn's hope to stimulate the sale of his drawings, he now lived principally in Berlin, where he was soon affected by the decadent vitality of that postwar city. In Berlin he encountered a generation of artists, George Grosz foremost among them, who "moulded by war and revolution had become realistic to the point of cynicism," and in whose postwar drawings and prints the "familiar figures of the day — profiteers, pimps, prostitutes, war cripples — and the vision of useless slaughter became a leitmotif for bitter moral harangues."[18] While Dehn shared many social views with the German artists, his wartime experience was far removed from theirs; while in some degree he shared their bitter disillusionment with the postwar world, Dehn was less a revolutionary than a reporter, less a judge than an observer. Commenting on the essential difference between Grosz and Dehn, Guy Pène du Bois saw Grosz as an artist who "rarely laughs. "By contrast, Dehn's satirical lithographs characteristically

> have a more Rabelaisian touch, larger, more heavy-handed. He has less of the intimate attack upon particular types which Grosz will carry through with a psychological research intensified, sharpened by hatred. . . . [With Dehn] there is a depth of laughter which can be made of nothing short of pure good-nature.[19]

For whatever reason — most likely lack of funds — Dehn made no lithographs between 1922 and 1926. In 1925, while back in Vienna, he began work on a series of twelve drypoints [16–18, 20–25, 28–30], printed by B. Stefferl. The needle-sharp line of the drypoint — in the use of which Dehn was perhaps directly influenced by the essentially linear character of Grosz's drawings and prints — proved at that time to be a better medium for him than was lithography; the three lithographs made with Meister Berger in 1926 [19, 26–27] represent no advance in his work. From Zigrosser came dismal reports as to sales: "The selling of artwork in USA is a weak reed to lean upon. I haven't been able to do a damn thing. I hope we will be able to do more with your watercolors than with your drawings. I am anxious to see the new etchings."[20]

Somehow, Dehn must have felt a need for change. He had visited Paris several times during his years in Vienna and Berlin; now he went there to work. He arranged to use the Paris studio of an artist friend, Andrée Ruellan, in the rue Vercingetorix, and during the next twenty-six months (December 1926 through January 1929) he made more than 125 lithographs in collaboration with one of the two great printers of Paris, Edmond Desjobert (the other was Fernand Mourlot).[21] The lithographs thus produced were an extraordinary body of work, sufficient beyond question to establish Dehn as a major figure in the history of American lithography.

Dehn had long since rejected conservative approaches to lithography:

> When I started drawing on stone, there was one traditional way of making a lithograph. It was the approach of the purist. Neatness and the smooth surface were the highest virtues. The student was cautioned, "Don't do this, don't do that." The only thing one was allowed to do was to sharpen the crayon, preferably a hard one, to the finest possible point and then stroke the stone for days on

end until a clean little design had been developed. It is of course evident that beautiful and great prints can be made in this manner . . . [but] this delicate and careful way of drawing was stifling for some of us. It killed the creative impulse, deadened the hand.[22]

Such an attitude was already evident in the Vienna lithographs, often drawn with a blunt, unsharpened crayon and in a rough or sketchlike manner. Now, in Paris, Dehn abandoned all caution. "I wanted to try anything and everything to see if it would print. We called it raping the stone. Luckily most of these experiments printed remarkably well."[23]

Dehn did not keep records that allow us to establish the sequence of his Paris lithographs. We can be certain, however, that it was not long after he began his work in Paris that he began his "rape" of the stone. Dehn later described it this way:

> [In 1927 I had drawn] a stone that was bad. I said to hell with it and I just scrubbed it all out. But it left a darkish-grey tone over the whole thing. And I worked into it somewhat with a razor blade, scraping out to lighten [areas] and even to get whites, and then I used black crayon over this. I think I learned more in lithography from that stone than [from] anything I ever did. Desjobert, when I took it to him, shook his head. He didn't think he could print it because he had never seen this sort of thing at that time. And then, when I came back — and in those days they didn't let you stay in the workshop to watch; they printed it, and by God that was it — . . . [Desjobert's] eye was just glistening when I came in. I knew he had succeeded, and he was happy. And I was very happy. That's still one of my favorite prints.[24]

The nature of Dehn's forward leap is best understood by comparing this lithograph, *Landscape* (or *Grey Mountain*) [39], with the landscape lithographs that preceded it; *Landschaft* [40] is typical. In the earlier print, trees and hills are quickly delineated (as in the Vienna landscapes) by simple strokes of the crayon; the artist is clearly striving for an impression of immediacy and spontaneity.

The radically different character of *Landscape* reminds one of Picasso's epigram: "A picture is a sum of destructions." The effect of Dehn's "scrubbing out" of the initial image was the destruction of the fresh but shallow style of drawing with

which he had formerly been contented. It was by building upon this process of destruction that he achieved the series of truly remarkable works drawn and printed in the late months of 1927 and in 1928: lithographs which attest not only to the creative energies of Dehn the artist but also to the technical skill of Desjobert the printer.[25]

With the experience of *Landscape* behind him, Dehn now characteristically began his work on a stone by creating what printmakers might describe as a plate tone, with the difference that he now did so deliberately rather than as the "accidental" outcome of a rejected image. Into the rubbed tone he cut with blade and scraper and drew with a rich, soft crayon, a process that he further developed and refined through a series of prints that included both satirical subjects and landscapes.[26]

If a critic were to select but one lithograph to summarize Dehn's technical and aesthetic achievement at this time it might well be *All for a Peice* [sic] *of Meat* [31],[27] which, although it lacks Dehn's typical seasoning of humor, is one of his finest prints. The bitterness with which Dehn assaults the gross figure of the man, his face stuffed with a fat cigar, reflects his memory of a visit to Karlsbad, described in a letter to Zigrosser: "I really can't think of a more disgusting place than this — full of fat toads and jaundiced ladies trying to get back youth and beauty and health. Sometime I hope to present you with a lithograph which will tell you more than my words can about this place."[28]

Dehn knew what he had accomplished; he was "on the road to something important."[29] In his letters home, he wrote without false modesty: "I must tell you that I don't know any Americans who have done such lithographs — I speak of them technically."[30] To his mother, he commented, "They are a great advance over my earlier ones."[31] And later to his sister, he added:

> Everyone praises my lithographs. . . . The man who teaches lithography at the League in N. Y. says that [they] excite him more than any he knows — and that he should like to work with me when I return. He says he cannot print mine they are so full of technical difficulties but he wants to experiment. My printer [Desjobert] says he has not printed such good lithographs in years. My new ones are knockouts.[32]

Great as was Dehn's satisfaction in his accomplishments, he had still to contend both with a

continuing lack of money and the complications of life with the Ziperovitch family, all of whom were now in Paris. The new lithographs, he thought, were both good and "sellable," and he counted heavily on the money they might bring. "I need money very badly," he wrote. "My lithographs will cost me about $250 . . . and I need a suit and overcoat."[33]

Although during Carl Zigrosser's visit to Paris, Dehn had sensed a puzzling lack of enthusiasm on Zigrosser's part, he was disappointed – and infuriated – by the long letter that now came from his friend and dealer:

> You are right in sensing a certain lack of sympathy with your recent work, an attitude that is shared by such old friends as Wanda Gág and John Flannagan. I was hoping to have a heart-to-heart talk with you in Paris, but the fates decreed otherwise. When I speak of sympathy I do not mean I have lost faith in you as an artist – not by a long shot. I believe very firmly in the solid core of you as an artist but there are certain superficial manifestations which are not to my taste. I think that for the time being you are on the wrong track. . . . The Paris of Montparnasse is not the exclusive background of research.[34]

As a final blow, Zigrosser said that Rockwell Kent, juror for the *Fifty Best Prints Exhibiton*, had "not deemed [any of Dehn's prints] sufficiently substantial . . . to be included in the show. . . . So this is one slight corroboration of my point of view."[35]

Dehn was hurt but not dissuaded. Despite Zigrosser's attitude, some of the prints sold well – although at very low prices – during an exhibition in Paris.[36] Through the spring of 1928 he worked actively on a suite entitled *Paris Lithographs* that he intended to publish as a group, complete with folio.

In their ease and fluency, these ten lithographs [96–105] demonstrate the artist's powers at their height. Acute in observation of Parisian life, vivid in drawing, and strong in composition, they constitute a catalogue of by now familiar Dehn "types" – the baldish beak-nosed man, the fat woman with frowzy hair and cigarette holder, the flapper with bobbed hair and dangling earrings, and the heavy, rocklike nun.

By September, Dehn was exhausted, both by work and a lingering illness. Mura was again away with the Coburg opera company. "I am sad most of the time," he wrote her:

> I earn no money . . . it goes slowly and I get depressed. . . . Three days ago like today I was so sad I did not know what to do. I went to the Luxembourg and the park dripping rain and leaves was so beautiful that after one hour I scurried home and made 3 large autumn landscape lithographs which I think have a new note in them. I am happy about them. I tell it all very badly but it was very wonderful, so very intense that one wanted to cry "patterns of pain."[37]

They are beautiful lithographs: dark, bleak, lonely, and expressive (*Afternoon in the Luxembourg* [50], *Autumn Day* [56], and *Autumn Evening* [57]).

Tired though he was, Dehn pressed himself to work long hours, from early morning until after dark. By November the folios for the suite of *Paris Lithographs* had been made, and a title page and colophon had been printed in the traditional French manner. Since beginning his work with Desjobert, he had completed more than ninety lithographs, and the last remaining editions were on the Desjobert presses. Throughout the holiday season in Paris he could think of little else but his forthcoming exhibition in New York and of what it might bring to him. He made plans for the Atlantic voyage.

When the exhibition opened at the Weyhe Gallery on February 25, 1929, it included thirty-four lithographs, among them *Beethoven's Ninth Symphony* [32], *All for a Peice* [sic] *of Meat* [31], *We Speak English* [47], *Lohengrin* [81], and a number of the landscapes. Dehn nervously awaited the opening.

The critical response, when it came, was all that Dehn could have wished for. "Sheer, distilled magic," reported the *New York Times*:

> In his lithographs Mr. Dehn curiously approaches the aspect of paint. Color weaves most graciously, without recourse to hues other than black, white and delicately harmonized grays. The scope of lithography seems to have become enlarged, thanks to the artist, by many leagues, and there is no telling what fresh expansion of a fascinating domain will manifest itself as time goes on. It should also be noted that Mr. Dehn succeeds where so many fail, in keeping satire within the circuit of beauty.[38]

Even Bolton Brown, an authority sparing in his praise, presented his compliments, stating that Dehn "had carried lithography further than anyone else."[39]

Such comments, coupled with substantial

sales, improved Dehn's spirits. The critical response served to quiet Zigrosser's misgivings about the Paris lithographs; the money enabled Dehn to pay his printing bills. He stayed on in New York through the spring, seeing old friends, visiting the burlesque shows and jazz clubs — often in the company of Reginald Marsh — and filling notebooks with sketches that would serve as the basis for a new series of lithographs.

In the summer of 1929, Dehn returned to Europe; in the fall he went to Berlin, prepared for an intensive period of work. But in contrast to the ease and fluency of his collaboration with Desjobert, his work with Meister Schulz got off to a rocky start: "I am having a difficult time with my lithographer," he wrote. "They have spoiled 4 or 5 stones and I shall have to go to Paris if they spoil more. One loses one's desire to work! I prefer staying here otherwise."[40] These technical problems are reflected in the lithographs, particularly those of 1929. The stones are sometimes coarsely grained, few of the editions are printed on the sensitive china paper typically used by Desjobert, and Dehn is seldom able to employ the full repertoire of complex technical effects that he had developed in Paris.

Beyond the difficulties Dehn encountered in regaining his creative stride, he was psychologically affected by the changes he saw in the German capital. No longer the Berlin of Brecht and Weill, the city increasingly came under Hitler's shadow. The Wall Street crash in October — and the ensuing collapse of major German and Austrian banks — provided the kind of opportunity to seize power that the Nazis had awaited. Dehn knew that the Nazi anti-Communist campaign would mean disaster for his left-wing, German artist friends:

> I have been with George Grosz and his crowd several times. He has changed much. He was the pride of the communists, their greatest propaganda artist. Now he may still do things which can be used as propaganda, but he does not deliberately set about doing. . . . I like him much better than I did. And incidentally feel very complimented for he says I am the best American draughtsman.[41]

Dehn's particular gift was his ability to perceive and record what was most characteristic about his subject. For him, drawing was a process not of abstraction but of empathy; he was at his best when closest to direct experience. In no

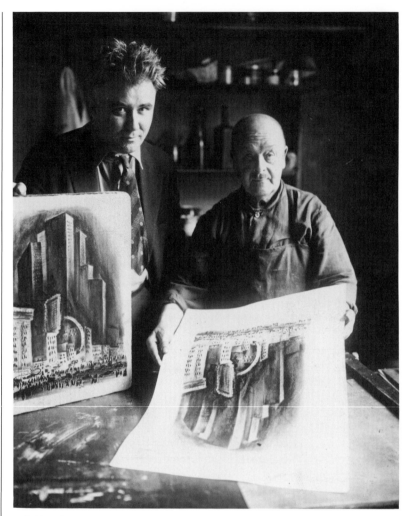

Adolf and printer Meister Schulz displayed the stone for and a print of New York Night *(1930).*

other group of Dehn's works are his strengths and weaknesses more clearly visible than in the series of more than seventy-five lithographs completed in Berlin between November 1929 and March 1930. Some are based upon his New York drawings; some are Berlin subjects; many are landscapes. By far the strongest are those that are most immediate: the scenes of life in Berlin, the streets, the cafes, the nightclubs, and the brothels. Dehn's stance is seldom that of social critic, although *We Men* [202] is a notable exception. More often he is jovial, good natured, and wryly sympathetic as in *The Old Whore* [186] and *Sex Appeal* [194]. Exceptionally fine in Dehn's "dark manner" is the vivid scene in a fantasy nightclub, *Love in Berlin* [177].

By contrast, the mountain landscapes seem contrived, less than fully realized, and the New York City subjects seem remote, less than fully convincing. The buildings of *Brooklyn Waterfront* [152], *New York Night* [182], and *On Eighth Avenue*

[187] are empty facades, generalized in form; the city does not come alive. In *Burlesque* (or *Brooklyn Burlesque*) [127], unlike the city subjects, location is irrelevant: showgirls are showgirls, whether in Brooklyn or Berlin.

When on April 7, 1930, an exhibition of fifty prints chosen from the Berlin lithographs opened at the Weyhe Gallery, it received prominent notice in the *New York Times*:

> When are caricatures not caricatures? Adolf Dehn's are not. He ridicules everything he sees, but he does so with a human sympathy that lifts his lithographs out of the realm of burlesque. In a way he relates what he sees to himself, no matter how remote that relationship may seem, and the spectator, being a sporting person, laughs not at but with, recognizing himself or recognizing what he would be under similar circumstances. . . .
>
> Dehn's human beings are more individual than his landscapes. Many another artist has created lyrical landscapes, although few have translated them into as beautiful a lithographic form.[42]

But beautiful or not, there were few purchasers for Dehn's new lithographs, and although Mura was now able for the first time to join him in New York, they had almost no money. Whatever illusions they may have had as to Mura's prospects for fame and fortune as a dancer in New York were soon replaced by hard reality.

Despite Dehn's addiction to lithography ("I am like a drunkard who, for a time, lays off the bottle, but sooner or later goes back on it"),[43] he knew that he must put it aside for a while. Because during 1930 he could afford neither to return to Europe nor to make lithographs in New York, he concentrated on drawing, eking out a precarious living through an occasional sale at the Weyhe Gallery or of an illustration to a magazine. His 1931 exhibition at the gallery consisted entirely of drawings.[44]

It is not clear how Dehn managed his 1931 trip to Vienna and Paris, but by November of that year he was again at Desjobert's:

> I am drawing lithographs. Many mountains and lake scenes with grand cloud and sky effects which interest me very much just now. Those are scenes from Austria but I am also doing American stuff. Waterville country

and today I did Mpls. grain elevator [253]. . . . The Albertina bought 2 or 3 lithos.[45]

Indeed, unlike the Berlin series of 1929–30, some of the finest of the 1931–32 lithographs are American subjects. Particularly notable are the scenes of Harlem night life: *Gladys at the Clam House* [213], *Harlem Orchids* [216], *We Nordics* [231], and *The Big Hearted Girls* [237]. A richly developed view of Lower Manhattan [217] was Dehn's most evocative New York landscape to date.

Dehn was demonstrably in top form. Paris and, as always, the collaboration with Desjobert brought out the best in him; he returned to New York in March with sufficient work for an April exhibition. It again opened to critical praise, one newspaper commenting on the "brilliancy of conception and emotional intensity" and the "subtle nuances of tones and superb draftsmanship."[46] But there was little other reward; sales barely covered expenses. "Everyone is in the same boat," Dehn reported to his mother in Minnesota.[47] Then, "We were just kicked out of our place for non-payment of rent for May."[48] Adding to the pain was the fact that Mura's long-planned dance recital (presented on April 10) had been a resounding disaster.

It was the end of the line; there was no option but retreat, and in June 1932 Dehn and Mura made their way to Waterville, another and different world from the disappointments of New York. Dehn reported to his friend George Biddle (then working in Italy):

> [I am] now 3 or 4 months in Minnesota getting a damn good tan. . . . I am working quite well . . . making pictures seems such a simple proposition. There are trees and hills and barns and water tanks and they stand around in happy relationships. Air and sun and clouds sail around and all you have to do is put it down. It's a big fight, of course, but a simple and direct affair! I never was very aware of theories, but am less aware than ever! . . . You may know that this depression has finally hit us hard—so hard that I very frankly do not [know] how I shall eat this winter! Not one goddamned thing doing.[49]

Ultimately, the year 1932 proved to be the low point for Dehn, and the hard times of 1931 and 1932 placed a strain on his marriage to Mura from which it would not recover. By late 1933 he was receiving some assistance from a federal art program, and the following year he was able to report that his sales had taken a modest upturn.

"[I even] stooped a few times to do real commercial art. . . . I regret it now," he later said.[50]

The Great Depression caused many American artists to question the traditional relationship between art and its audience. Throughout the 1930s the structure of the art market received a series of challenges from print-publishing ventures that sought, with varying success, to sell art directly to the public. One such venture was the Contemporary Artists Group, of which Dehn became a founding member in February 1933; the group published two portfolios, *American Scene No. 1* and *American Scene No. 2*, each consisting of six lithographs and each priced at fifteen dollars. Dehn's *Easter Parade* [270] was included in the first of the two folios.[51]

Although the Contemporary Artists Group had little success in sale of its portfolios, the idea that prints might be sold through direct marketing persisted in Dehn's mind. In November 1934 he wrote to Biddle describing his plans for "the Adolf Dehn Print Club":

> George, I am getting out 4 stones, editions of 100 prints each, to be sold by subscription, through a large mailing list which I am getting together chiefly through my friends. I shall have a brochure with small reproductions for prospective subscribers to pick from. The price per print will be $5.00.
>
> Harry Wickey [a prominent etcher] has done this successfully and has urged me to do it. Carl Zigrosser thinks it is a good idea. Its success will depend on the list of names I get, so altho I know it is a nuisance I am daring to trouble my friends, including yourself, for a list of people who might be interested. You know what economic pressures will drive me to![52]

But again Dehn's perennial optimism was frustrated by events. Prints were sold, it is true (sixty-nine in the first week after publication), but not in sufficient number to do much more than to cover expenses.

Other print ventures followed, among them the unlimited editions of the American Artists Group. While Carl Zigrosser strongly supported this project at the time, he would later accurately identify the reason that this and other publishing ventures of the 1930s so frequently failed:

> We tried to slant the subject matter of the prints for popular appeal—pictures for the masses. . . . We had two aims: to furnish works of art and to be popular . . . [but] our duality of purpose involved us in a certain amount of compromise, and as is often the case with half-measures, produced neither art nor popularity.[53]

The two Dehn lithographs made for the American Artists Group (*Morning on the Lake* [299] and *Feathered Friends* [296]) clearly suffer from compromise, as do most of the twelve lithographs he drew as publications of his print club. In the bucolic tranquility of such prints, Dehn catered deliberately to the taste of an unsophisticated and unadventurous public; in their simple and detailed execution he revealed an uncharacteristic technical caution. The result was a product of skill, but of very little spirit.

By far the most successful print-publishing project of the 1930s was that of Associated American Artists (AAA), organized in 1934 by Reeves Lewenthal:

> To popularize fine art by putting prints by the best American artists on sale at five dollars each in department stores throughout the country is the aim of Associated American Artists. The plan was launched on Monday, October 15th in fifty large cities. . . . "Here is the first real movement against the flood of cheap foreign prints of little artistic or other value," says one of the formal statements issued by the organization [as] a part of a campaign of education to convince the public that good pictorial art can be made available at a low price.[54]

AAA's intense advertising campaigns used language unfamiliar to the art world, but Lewenthal did not misrepresent what he sold. While some of the AAA prints were admittedly "popular subjects," others were among the finest of their time. Virtually all of the prominent artist-printmakers of the 1930s were commissioned to make prints for AAA beginning in 1934. Because Dehn's lithographs sold well, he received repeated commissions, which became a welcome source of income.[55]

It was the summer of 1936 before Dehn again returned to Europe, traveling to Vienna, Dubrovnik, and Venice before making a final stop in Paris. Although he took advantage of the opportunity to work briefly with Desjobert (he made four lithographs), lithography was no longer in the center of his thoughts. Repeatedly, Zigrosser (and others) had urged him to work in color ("If you'll just make color, we can sell a lot of them. Your black and whites, we sell some, but not as

well as we should").[56] Repeatedly, Dehn had backed away. But now, after many false starts, he was determined finally to meet the challenge of color:

> So [when] I came back [from Europe] I took myself in hand. I had painted a few watercolors but they were very feeble and anemic through several years. This time . . . I set up a John Marin watercolor reproduction and, you know, in about an hour-and-a-half or two hours, at least it was a painting. It wasn't a good painting but it was a painting. And after that hour-and-a-half I actually stood there with practically tears in my eyes, I was so happy. I had broken the ice, I figured. The next day I set up a George Grosz watercolor and did the same thing. [They weren't] at all like George Grosz or John Marin but . . . they were paintings! After that I threw them aside and started painting for myself. And in a few months I started painting tolerable watercolors. And ever since, I've been painting tolerable watercolors.[57]

In 1939, Dehn at long last received the Guggenheim Fellowship for which he had several times applied. It was his intention to travel in the American West and in Mexico, painting watercolors. Among the many places he planned to visit was Colorado Springs, where Boardman Robinson was then in his eighth year as director of the Colorado Springs Fine Arts Center School.[58]

Although Robinson's political views had made him an unlikely choice for the directorship of a school in conservative Colorado Springs ("the Newport of the Rockies"), he had already succeeded in establishing its national reputation. While still in New York, Robinson had demonstrated exceptional abilities as a teacher at the Art Students League; the Colorado school had become an image of his beliefs and personality. "In this school," Arnold Blanch wrote, "the students seemed to reflect the abundance and vigor of Mike's personality. In the classrooms there were violent discussions about art, science, music, marriage or anything that might come to mind."[59]

The school's curriculum likewise reflected Robinson's personal experience. Before completion of the Fine Arts Center's new building in 1936, instruction in lithography was limited,[60] but in the summer of that year Robinson invited Charles Locke, with whom he had worked at the Art Students League, to come to Colorado Springs as a visiting instructor. Locke brought with him the printer Theodore "Ted" Wahl, a former student of Bolton Brown. Among their students in the summer class was Lawrence Barrett, who, after Locke and Wahl returned to New York, became lithographic technician and printer at the Fine Arts Center School.[61] Barrett was thus in place and the lithographic workshop well established when Dehn first came to Colorado Springs in July 1939.

Earlier that summer Dehn had purchased his first car (a Chevrolet convertible) for $575 and had set out for Missouri with a friend to do the driving for him. Dehn would first teach a short class at Stephens College and while there would take driving lessons from his friend Victor Christ-Janer. Upon completion of his class, Dehn and Christ-Janer would drive to Colorado Springs for a visit with Mike Robinson and Arnold Blanch.

As always, Dehn had his sketchbook in hand. While he found little to interest him in the hot "endless waste" of the prairies, once he reached Colorado Springs he was struck by a "landscape so magnificent [that he] decided to stay."[62]

> Shortly after my arrival . . . I started to sketch the mountains. Mike, with a sharp glint in his eye, would pull his high-sounding line which went something like this: "Ah, so you're going to paint the mountains. Nobody can paint the mountains until he knows them; you can't know them till you have lived with them for ten years, and after you know them you know better than to try to paint them. . . . " To me this was perverse casuistry, and my retort was: " . . . I have painted manure piles in Minnesota. They, too, stand in time and place. If one can dare to paint a manure pile ten feet high, he can also dare to paint a mountain ten thousand feet high."[63]

And paint the mountains he did, not only in the immediate vicinity of Colorado Springs but also on visits to Central City and Cripple Creek. He made watercolors almost every morning, sketched in the afternoons, and drew two lithographs, both printed by Lawrence Barrett. One of these, he wrote, "seems to be a very good one."[64]

And indeed it was. In the rich and powerful *Spanish Peaks* [315], large in scale and complex in execution, one senses that Dehn, excited by the great Colorado landscape, also found a new excitement in lithography — an excitement that had

been all but absent in his prints of recent years. Dehn's brief collaboration with Barrett in 1939 suggested great possibilities for the future. Unlike George Miller (who was printing Dehn's commissioned prints in New York), Barrett was under no obligation to pay his bills through income from printing. He received a stipend from the school; the school maintained and supplied the workshop. In their work together on *Spanish Peaks*, Barrett—whose background was that of an artist, not a commercial printer—had welcomed Dehn's use of the unconventional techniques he had developed in Paris.

Dehn thus did not hesitate to accept Mike Robinson's invitation to return to Colorado Springs in the summer of 1940. He would again paint and draw in the Rockies and make lithographs with Barrett. "I will get a $150 just for being there and doing my lithographs for free," he wrote.[65] Beyond this, he found, he could live at the Colorado College Faculty Club—"2 rooms and a bath for $35.00. Cheaper than last year."[66]

It was a productive summer. Dehn and Barrett "starred" in a color film on lithography in which Dehn is first seen sketching, then drawing the stone for *Garden of the Gods* [324]; Barrett next etches the stone and prints it on the hand press, which has been moved for the occasion from the inside studio to an outdoor portico, so that sunlight may be used for the filming.[67]

Garden of the Gods is but one of several powerful landscapes Dehn drew on stone that summer. In this and succeeding summers (Dehn again taught in Colorado Springs in 1941 and 1942), he continued to respond with evident zest to the varied forms and changing moods of the Rocky Mountains. Never before had he produced a series of landscape compositions of such convincing strength as *Colorado Landscape* [319], *Sopris Peak* [328], and *Lake Tarryall* [330]. It would seem that his newly found vision as a painter—particularly the close and direct observation that the making of his watercolors entailed—may have infused his lithographs with a new spirit as well. Also in 1941 Barrett printed the very fine *Man from Orizaba* [331], a large print drawn with quiet dignity in Dehn's "dark manner."

Dehn took solid pleasure in his work, complaining only occasionally at the diversions of the school. "There are many picnics, dinners and parties. Too many," he wrote to his mother. "I try to avoid some of these."[68] Wartime rationing curtailed his gasoline supply and, as he remarked,

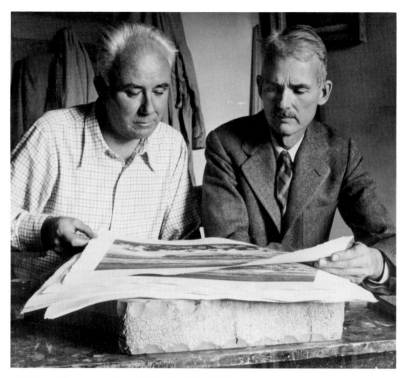

Adolf and Lawrence Barrett in the late 1940s

"our tires are not in very good shape [and] we need the car for sketching."[69]

Aside from Edmond Desjobert, Barrett was by now Dehn's favorite printer; they worked well together. Thus, when in 1945 Dehn received a welcome commission to undertake a series of lithographic illustrations for a deluxe edition of *Selected Tales of Guy De Maupassant*, it was natural that he would wish to work with Barrett. "To this reporter," Marshall Sprague wrote in the Colorado Springs newspaper, "there is an atmospheric affinity between the Dehn-Barrett work-rooms and the pathetic, horrible things de Maupassant had to say. The rooms, pungent with the stink of nitric acid, seem half paint-shop, half-cemetery."[70] If so, no cemetery had ever been livelier. The twenty lithographs for the de Maupassant book had been finished in less than five weeks, and Dehn and Barrett were now at work on a series of plates for a textbook on lithography. "I have a fever for work and am enjoying it. . . . I can't say how long this litho book will take—but it must be done well. . . . Perhaps 4 weeks."[71] Published by American Artists Group in 1950, the Dehn-Barrett book, *How to Draw and Print Lithographs*, provides in its plates and brief text considerable insight into the specialized techniques and processes that Dehn used in the drawing (and Barrett in the processing and printing) of his lithographs.[72]

During the first half of the twentieth century, American lithography was largely a black-and-white medium. Aside from the prints produced at the New York workshop of the Federal Art Project in the late 1930s, relatively few color lithographs had been made by American artists. Even in Paris, color lithography had not occupied a position of importance comparable to that achieved in the late nineteenth century; most of the lithographs printed by Desjobert and Mourlot between the two world wars had been in black and white.

Black-and-white lithography is an autographic process, essentially direct; the artist sees the image develop in the process of creating it. Color lithography, by contrast, is essentially indirect; the artist sees the image only at the end of proofing. The artist (through a psychologically difficult process of analysis that is unfamiliar to all but experienced printmakers) must draw a separate stone for each color; each stone must be drawn in black. Only when these stones have been printed in combined form, can the artist see the image.[73] These problems notwithstanding, color lithography gradually reemerged as an expressive medium when New York galleries began showing color lithographs by Chagall, Miró, and Picasso during the 1940s, and American artists made color lithographs with increasing frequency.[74]

When one studies Dehn's first full-color lithographs—the series printed by John Muench in the summer of 1952—one senses the strain between the two Dehns: the watercolorist and the lithographer. Although Dehn was now at ease with color in his paintings, he had continued until then (for reasons as much aesthetic as technical) to make his lithographs in black and white.[75] His watercolors were representational pictures—the farms and fields of the Midwest, the mountains of Colorado, the people of Cuba and Haiti; the color lithographs, influenced by the artist's psychological reaction and the technical complexities of the process, were much more abstract.

Like other American artists whose work remained essentially representational, Dehn felt somehow isolated from what was perceived to be the mainstream of American art. It was a curious and uncomfortable position in which to find himself. He had had substantial contact with the European modernists during the 1920s, and he had never been hostile to their work (he had long before urged his sister Olivia to see "modern paintings as much as you can . . . Picasso, Matisse, Derain, [and] Braque").[76] But now he felt overwhelmed by the attention given to Abstract Expressionism and was intensely discouraged to find that, in the climate of the 1950s, "all of us who paint in a figurative way are has-beens."[77]

Such was Dehn's frame of mind when he began his work with John Muench. He felt in firm command of his life, but his work and his market were unsettled. In 1947 he had married an attractive young artist, Virginia Engleman; in 1948 and 1949 they had traveled to Key West, Cuba, and Haiti, bringing back a series of paintings full of tropical light and color. In the fall of 1949, working with Barrett in Colorado, he had developed some of the Haitian subjects into black-and-white lithographs. Now, in the summer of 1952, Adolf and Virginia went to Maine to work with Muench; Dehn, still excited by recollections of the vivid Haitian color, eagerly accepted Muench's initiation into the complexities of color lithography. "He was like a kid with a new toy," Muench remembers.[78]

Dehn was never an artist to be unduly concerned about consistency of style. The 1952 color lithographs, including *Four Haitian Women* [478], *Haitian Ballet* [480], and *Haitian Caryatids* [481], are all more abstract than either Dehn's watercolors or the black-and-white prints that preceded them. They have a mannered, "modernist" character—a vocabulary of swooping curves and crescents, counterbalanced by force lines and angles, not unlike the College Art Cubist style adopted by many printmakers who were caught in a similar tension by the artistic climate of the 1950s.

From this point on, a substantial number of Dehn's lithographs were conceived and printed in color. Most important among his later works are the several series of lithographs printed at the Atelier Desjobert between 1958 and 1967, a total of more than one hundred editions. For Adolf and Virginia it was a period of extensive travel (in 1958 to Greece, Turkey, Afghanistan, and Kashmir; in 1961 and 1963 to Spain; in 1965 to Africa and Ireland), long periods of residence in Paris, and a mixture of good times and bad. Finally after his many years of poverty, Dehn was able to report in 1964, "I had the best year of my life as far as sales go."[79] With the sales came many honors, including a major retrospective exhibition of his lithographs in 1958, a succession of prizes

While in Afghanistan to do a poster for Ariana Afghan Airlines in July 1958, Adolf paused to sketch a village scene.

A page from one of Adolf's numerous sketchbooks

and awards, and election both to the National Academy of Design and the National Institute of Arts and Letters. Unfortunately, concurrent with the honors came the strains of illness and age.

Upon his return to Desjobert's in 1958, Dehn quickly discovered that the experience of working there was not what it once had been. In the years since World War II, the Parisian workshops had changed greatly. They had become larger and less personal, there was a constant turnover in staff, and among the printers were some who took little pride in their work. These changes were even more evident when, after the death of Edmond Desjobert in 1963, his son Jacques took over direction of the workshop.

Dehn recognized that, at best, color lithography "is a difficult and slow business. Painting is easy by comparison."[80] Even so, by 1963 the problems and frustrations Dehn encountered at

Desjobert's greatly outweighed his occasional feelings of achievement:

> My first ecstasy is gone, I feel all that I've done is dull, that I can't rise out of my low level, my lack of anything important to say. That even technically I flounder in my effort to do too much, which is ruinous for printing. The drawing on the stone looks fine – great subtlety and nuances that take your breath away – and all is lost in the finished print, for my manipulations of the stone simply will not print.[81]

The fault lay not entirely in Dehn's demands upon the stone. Virginia wrote sadly that "work has not gone well here. Adolf has scrapped 3 out of 5 prints. Part of the trouble has been careless workmanship on the part of the printer. And Adolf has been feeling terrible – headaches every day."[82] A comment made to Dehn by the printer Marcel Salinas described even more explicitly the deteriorating conditions in the workshop:

> [I did] my best to resist the vulgar and depressed atmosphere at Desjobert's. I can assure you that it was not easy at all and that nothing was done there to give me a chance to do good work. All that was important for them was to print as quickly as possible and to get the money. . . . If Desjobert is one day the last lithographic printshop in Paris, I will become an etcher, a taxi-driver or join the Salvation Army.
> In October I received an SOS from Mourlot: he had a terrible amount of work and needed me. I could not refuse, but I was immediately reduced to slavery.[83]

The cause of the problem, in part, was that the market for color lithographs had greatly expanded. Lithography had become big business, particularly in France; prospective purchasers sought out the lithographs of Marc Chagall, Antoni Clavé, Marino Marini, Paul Wunderlich, Zao Wou-Ki, and other fashionable artists who had achieved a certain "look" – a vocabulary of technical characteristics with which printers were now familiar and which, if permitted to do so, they would readily replicate in the work of other artists.

One senses in Dehn's color lithographs of the 1960s that he fought a constant battle to maintain his individuality as an artist and that it required great effort to persuade the printers to do as he wanted done rather than as they were used to doing. Only by constantly standing over the

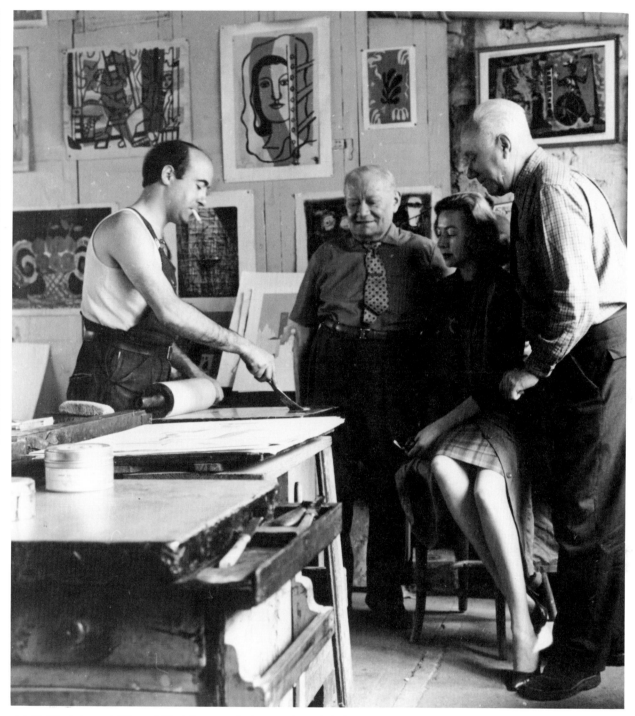

Adolf, Virginia, and Edmond Desjobert watched as a printer inked a stone in Paris in the early 1960s

printers, Dehn remarked several times, was he able to get the color and character of ink that he wanted in his prints. The printers, furthermore, were by now used to the fact that noted French artists were quite content to let the printers function as "colorists" (that is to draw the color stones), a practice that greatly reduced their willingness to accept what Dehn wished to do to his stones.

Among the 1961 lithographs are some in which the "French manner" intrudes upon Dehn's personal style. In the softness of its color, the character of its inks, and especially in the patterns made by water and solvents, the quite lovely *Four Caribs* [548] suggests the technical vocabulary of Clavé rather more than that of Dehn. Even in *Minnesota* [560], a more characteristic Dehn landscape, there is a feel of typically French color and of French printing.

Although the moods evident in Dehn's letters continued to swing between extremes, there was a growing sense of depression, particularly in

1965, the year in which Dehn approached his seventieth birthday. He had already endured a series of painful illnesses; now he was forced to face the sudden death of his long-time friend, Ernest Fiene, who was struck down by a heart attack while both artists were working at Desjobert's.

In spite of it all, Dehn kept his sense of humor. Among the many color prints of 1963 is one that sums things up very well — *Jerome Patinir and Mr. Adolf Dehn on the River Styx* [604.ii]. In front of the Patinir landscape, in the lurid glow of red flames, a horde of friendly devils crowds the shore and watches the small boat as it makes its way across the water, taking the dumpy figure of Mr. Dehn on his voyage to the great beyond.

The macabre wit of the *River Styx* would have been a fitting conclusion to Dehn's long career in lithography, but it was not yet over. In 1965, with incredible effort, he pushed thirty-four lithographs to completion, most in color, some in several states; in 1967, his failing health notwithstanding, he insisted on again returning to Paris. In that summer he made a final eight lithographs, all of them in color, the last of the more than six hundred editions he completed during his many years of devotion to art, to lithography, and, above all, to *la joie de vivre*.

NOTES

1. For a brief history of nineteenth-century lithography, see Clinton Adams, *American Lithographers 1900–1960: The Artists and Their Printers* (Albuquerque: University of New Mexico Press, 1983), 3–15. For additional information, see Alois Senefelder, *A Complete Course of Lithography* (reprinted, New York: Da Capo Press, 1977); Michael Twyman, *Lithography 1800–1850* (London: Oxford University Press, 1970); and Wilhelm Weber, *A History of Lithography* (New York: McGraw-Hill, 1966). For technical information see Garo Antreasian and Clinton Adams, *The Tamarind Book of Lithography: Art & Techniques* (New York: Abrams, 1971).

2. George C. Miller (1894–1965) was born into a family of professional printers; he became a lithographer's apprentice at the age of fifteen and began to print for Sterner at the age of twenty. Miller first established his workshop in 1917; he reopened the workshop in 1919 after a period of military service. For further information, see Janet Flint, *George Miller and American Lithography* (Washington: Smithsonian Institution, 1976).

3. Bolton Brown, "My Ten Years in Lithography," *Tamarind Papers* 5 (1981–82): 9. Unlike Miller, Bolton Brown (1864–1936) came to lithography late in life, at the age of fifty. Before studying lithography in England, he was a painter and teacher; he held faculty positions at Cornell and Stanford universities and was among the founders of the art colony at Woodstock. For further information, see Clinton Adams, "Bolton Brown, Artist-Lithographer," in David Tatham, ed., *Prints and Printmakers of New York State, 1825–1940* (Syracuse: Syracuse University Press, 1986).

4. The date of the founding of the Painter-Gravers of America is given incorrectly as 1915 in some accounts. See Richard S. Field et al., *American Prints, 1900–1950* (New Haven: Yale University Art Gallery, 1983), 21–22.

5. Adolf Dehn, "Boardman Robinson, the Artist," in Albert Christ-Janer, *Boardman Robinson* (Chicago: University of Chicago Press, 1946), 77.

6. Dehn to Emilie Dehn, January 21, 1920, Adolf Dehn Papers, Archives of American Art, Smithsonian Institution (microfilm copies, Minnesota Historical Society). Unless otherwise specified, all letters cited below are from this collection.

Dehn usually wrote in haste, often with a blunt pencil; words are often crossed out and are sometimes illegible. Punctuation is omitted or erratic. In quotations from Dehn's letters I have chosen to provide standard punctuation, correct misspellings, and to make other minor changes in the interest of clarity; titles of lithographs have been italicized even though Dehn may not have done so in his letters.

7. Dehn to Emilie Dehn, March 21, 1920.

8. Dehn to Emilie Dehn, no date (postmarked April 5, 1920).

9. Dehn to Emilie Dehn, no date (postmarked April 8, 1920).

10. Dehn to Emilie Dehn, no date (postmarked April 8, 1920).

11. Dehn to Emilie Dehn, October 3, 1920.

12. Dehn to Emilie Dehn, no date (postmarked October 16, 1920). On November 4 Dehn told his mother that his submissions to the Philadelphia exhibition had been

rejected. "However I have a lithograph at the Prints Exhibition held by the New York Public Library – contemporary American lithographs, which is quite an honor"; Dehn to Emilie Dehn, November 4, 1920.

Although only four lithographs made by Dehn in 1920 are included in this catalogue raisonné, it is evident that he made others. *The Happy Family* is one such lithograph. Whether impressions of such lithographs survive is unknown; if so, they have not been located. It is unlikely that Dehn carried through his plans to make either "a very large lithograph" or the series of ten lithographs based on his East River drawings.

13. Dehn to Wanda Gág, February 24, 1922.

14. Adolf Dehn, interview with Karl Fortess, New York, July 16, 1967, audio tape. I express my appreciation to Mr. Fortess for his courtesy in providing a copy of the tape recording.

15. Adolf Dehn, "A Lithograph Is Not an Etching," *Art News* 46 (May 1947): 29.

16. Dehn to Carl Zigrosser, November 24, 1922, Papers of the Philadelphia Archives of American Art, Archives of American Art, Smithsonian Institution.

17. Comment in the *New York Herald*, quoted by Frank Weitenkampf, in *American Graphic Art*, rev. ed. (New York: Macmillian, 1924), 177–78.

18. Werner Haftmann, *Painting in the Twentieth Century*, rev. ed. (New York: Praeger, 1965), 222.

19. Guy Pène du Bois, "Adolf Dehn," *Creative Art* 9 (July 1931): 34–35.

20. Carl Zigrosser to Dehn, June 4, 1926. Although Dehn may earlier have suggested to Zigrosser an intention to work in watercolor, his output in this period continued to be limited to black-and-white media.

21. Edmond Desjobert (1888–1963) was described by artist Emil Weddige as "not only one of the greatest printers of all time, but also a wonderful and sympathetic person with insight and wisdom. He could feel with deep concern the problems of the artist and his struggles for individual expression"; Emil Weddige, *Lithography* (Scranton, Penn.: International Textbook Co., 1966), 17.

22. Adolf Dehn, "Revolution in Printmaking," *College Art Journal* 9 (1949): 201–2.

23. Dehn, "Revolution in Printmaking," 201–2.

24. Dehn, interview with Fortess.

25. As much a factor as Dehn's willingness to "rape" the stone and Desjobert's ability to preserve and print images so drawn was the use of *chine collé*, alternatively called *papier collé* or *chine appliqué*, despite the fact that many of the papers used in such printing came from India. In this process a thin sheet of paper is printed and mounted simultaneously on a larger and heavier backing sheet. The way in which the smooth, thin paper subtly enriches the print is immediately visible when one compares the Dehn lithographs printed on *chine collé* with similar subjects printed directly on French paper. For further information about the process, see Antreasian and Adams, *Tamarind Book of Lithography*, 418–22.

26. Dehn provides detailed information about his rubbing technique in Adolf Dehn and Lawrence Barrett, *How to Draw and Print Lithographs* (New York: American Artists Group, 1950), 18–25.

27. In writing titles on his prints Dehn sometimes misspelled words (*Peice*, he wrote, not *Piece*).

28. Dehn to Carl Zigrosser, quoted in Zigrosser, *The Artist in America: Twenty-four Close-ups of Contemporary Printmakers* (New York: Alfred A. Knopf, 1942), 19.

29. Dehn to Andrée Ruellan, December 3, 1927, Andrée Ruellan personal files.

30. Dehn to Olivia Dehn, November 11, 1927.

31. Dehn to Emilie Dehn, December 16, 1927.

32. Dehn to Olivia Dehn, no date (postmarked December 27, 1927). Dehn probably refers to Eugene Fitsch, the artist and printer who taught the night classes in lithography at the Art Students League (Charles Locke taught the daytime classes). When Fitsch and Dehn later traded lithographs (January 1931), Fitsch inscribed his print: "To Adolf Dehn, the best lithographer in the U.S.A."

33. Dehn to Olivia Dehn, no date (postmarked December 27, 1927).

34. Carl Zigrosser to Dehn, January 13, 1928.

35. Carl Zigrosser to Dehn, January 13, 1928.

36. Dehn wrote to his sister: "My lithos are selling very well and I must charge somewhat more for them from now on. They are sold out too quickly at these ridiculously low prices"; Dehn to Olivia Dehn, no date (postmarked March 1928).

37. Dehn to Mura Dehn, no date.

38. E. A. J[ewell], "Dehn and Lemon," *New York Times*, March 3, 1929.

39. Dehn to Andrée Ruellan, February 25, 1929, Ruellan personal files.

40. Dehn to Emilie Dehn, no date (postmarked November 1929).

41. Dehn to Emilie Dehn, no date (postmarked November 1929).

42. Ruth Green Harris, "Adolf Dehn's Humanity," *New York Times*, April 13, 1930. Not all critics preferred the genre subjects; to the reviewer for the *New York Herald Tribune*, April 13, 1930, "the comparison [was] all in favor of the landscapes and their superior artistic vitality."

43. Dehn, quoted by Sandra Knox, *New York Times*, April 20, 1947.

44. In January 1931, perhaps at the suggestion of Eugene Fitsch, Dehn made several lithographs at the Art Students League; these were printed by the League's printer Grant Arnold (1904–). Arnold printed for Dehn again in December 1932, this time in Woodstock, N.Y., where between 1930 and 1936 Arnold maintained a press for the Woodstock Artists Association and printed for many artists.

45. Dehn to Emilie Dehn, December 10, 1931.

46. *New York Evening Post*, April 20, 1932.

47. Dehn to Emilie Dehn, April 30, 1932.

48. Dehn to Emilie Dehn, June 2, 1932.

49. Dehn to George Biddle, August 20, 1932, Biddle Papers, Archives of American Art, Smithsonian Institution.

50. Dehn, interview with Fortess.

51. For further information about this and other publishing ventures of the 1930s, see Adams, *American Lithographers*, 133–56, and Janet A. Flint, *Art for All: American Print Publishing between the Wars* (Washington: Smithsonian Institution, 1980).

52. Dehn to George Biddle, November 21, 1934, Biddle Papers. The four lithographs to which Dehn referred were *Art Lovers* [278], *Central Park at Night* [282], *Creek in Minnesota* [283], and *Menemsha Village* [285]. In all, Dehn made twelve lithographs for distribution through his print club.

53. Carl Zigrosser, *World of Art and Museums* (Philadelphia: The Art Alliance Press, 1975), 56–57.

54. "Making Fine Prints Popular," *Prints* 5 (November 1934): 17.

55. Perhaps because of the size of the AAA editions (250 unnumbered impressions plus 10 artist's proofs), Dehn modified both his style of drawing and his technical

execution, much as he had done in the prints for his print club. All of the AAA editions were printed by George Miller.

56. Zigrosser, quoted by Dehn, interview with Fortess.

57. Dehn, interview with Fortess.

58. Robinson moved to Colorado in 1930 to teach at the Fountain Valley School; in 1931 he was appointed director of the Broadmoor Art Academy (which in 1936 became the school of the Colorado Springs Fine Arts Center). Robinson retired in 1947 and died in 1952.

59. Arnold Blanch, "Boardman Robinson as a Teacher," in Christ-Janer, *Boardman Robinson*, 74.

60. For further information about lithography at the Colorado Springs Fine Arts Center, see Adams, *American Lithographers*.

61. Lawrence Barrett (1897–1973) was first a student at the Broadmoor Art Academy in 1920; he was seriously ill (tuberculosis) between 1921 and 1934 but returned to full-time study at the Fine Arts Center School shortly before beginning his study with Locke and Wahl. For more about Barrett, see Clinton Adams, "Lawrence Barrett: Colorado's Prophet of Stone," *Artspace*, Fall 1978, p. 38–43.

62. Dehn to Viola Dehn Tiala, July 29, 1939.

63. Dehn, "Boardman Robinson," 78.

64. Dehn to Emilie Dehn, August 27, 1939.

65. Dehn to Emilie and Arthur Dehn, June 9, 1940.

66. Dehn to Emilie and Arthur Dehn, July 8, 1940.

67. Adams, *American Lithographers*, 115.

68. Dehn to Emilie Dehn, July 21, 1941.

69. Dehn to Emilie and Arthur Dehn, May 25, 1942.

70. Marshall Sprague, "Dehn Finds Stone Excellent Medium for Eerie Illustrations," *Colorado Springs Gazette and Telegraph*, September 9, 1945.

71. Dehn to Olivia Dehn Mitchell, September 10, 1945.

72. The book by Dehn and Barrett is, however, less comprehensive and detailed than either of the two books that were then the standard American references on artists' lithography; see Bolton Brown, *Lithography for Artists* (Chicago: University of Chicago Press, 1930), and Grant Arnold, *Creative Lithography and How To Do It* (New York: Harper & Bros., 1941).

73. For technical information about color lithography, see Antreasian and Adams, *Tamarind Book of Lithography*, 163–227.

74. By 1950 it was possible for Gustave von Groschwitz (who had been supervisor of the Federal Arts Project workshop in New York, 1935–38) to assemble the first in a series of international biennial exhibitions of color lithography at the Cincinnati Art Museum. Included among the 235 lithographs were works by most of the masters of twentieth-century art, among them Braque, Chagall, Léger, Miró, and Picasso. See Adams, *American Lithographers*, 178.

75. Dehn had made limited use of color in lithographs printed by Barrett, first in 1940 and again in 1945 [322, 352].

76. Dehn to Olivia Dehn, no date (postmarked March 15, 1926).

77. Dehn, interview with Fortess.

78. John Muench, telephone conversation with author, February 24, 1986.

79. Dehn to Viola Dehn Tiala, August 28, 1964.

80. Dehn to Bruce and Olivia Dehn Mitchell, September 24, 1961.

81. Dehn to William A. Smith and family, no date, location of original unknown, photocopy in possession of Virginia Dehn.

82. Virginia Dehn to Viola Dehn Tiala, June 30, 1963.

83. Marcel Salinas to Adolf and Virginia Dehn, April 3, 1965.

PLATES

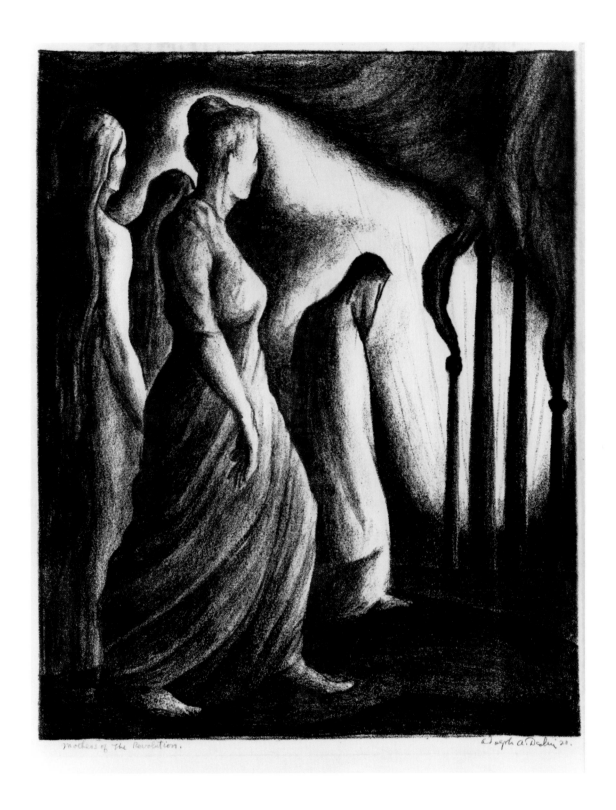

Plate 1. Mothers of the Revolution (or The Dawn)
(*see Cat. No. 2*)

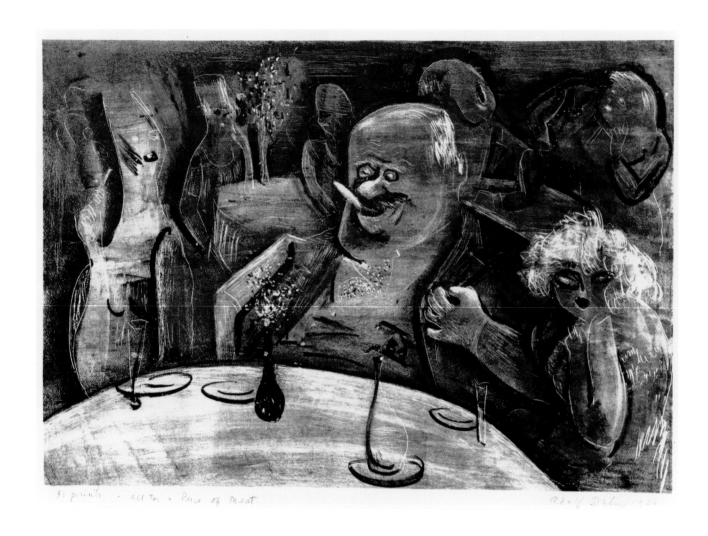

Plate 2. All for a Peice [*sic*] of Meat
(*see Cat. No. 31*)

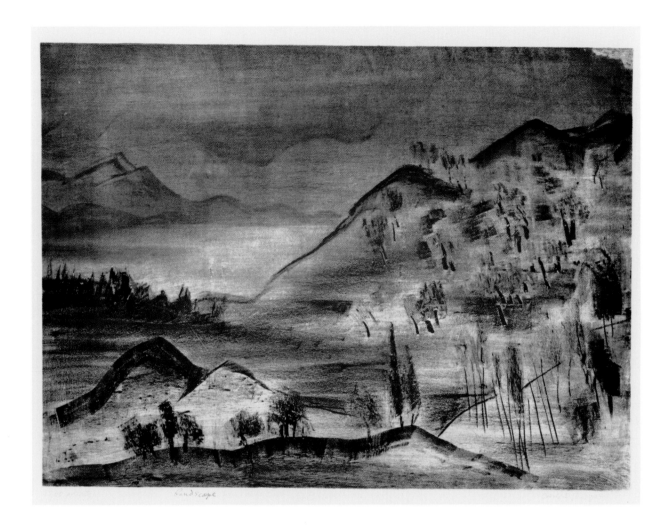

Plate 3. Landscape (or Grey Mountain)
(*see Cat. No. 39*)

Plate 4. Sisters
(*see Cat. No. 103*)

Plate 5. Die Walküre
(*see Cat. No. 201*)

Plate 6. Gladys at the Clam House
(*see Cat. No. 213*)

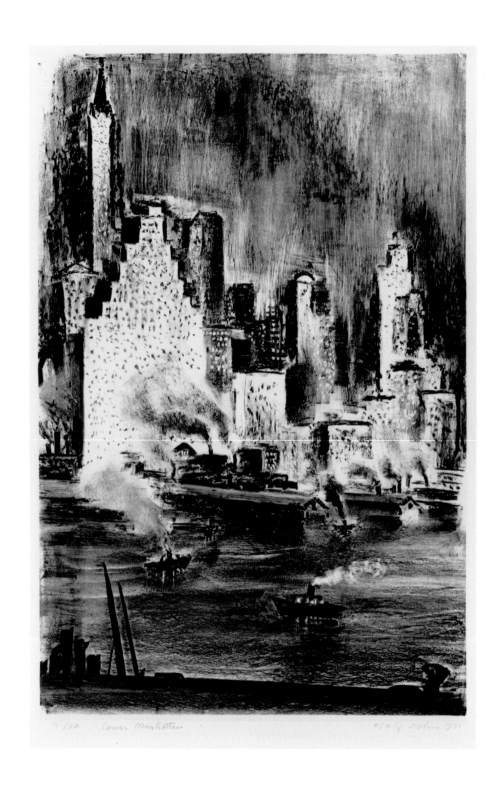

Plate 7. Lower Manhattan
(*see Cat. No. 217*)

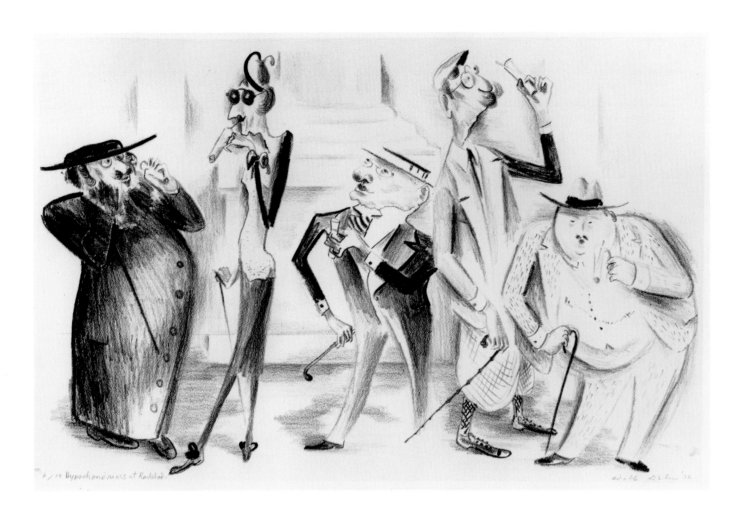

Plate 8. Hypochondriacs at Karlsbad
(*see Cat. No. 245*)

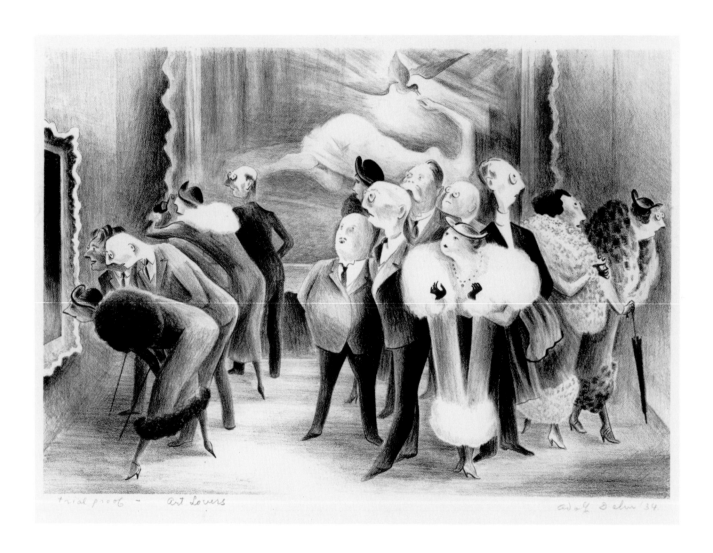

Plate 9. Art Lovers
(*see Cat. No. 278*)

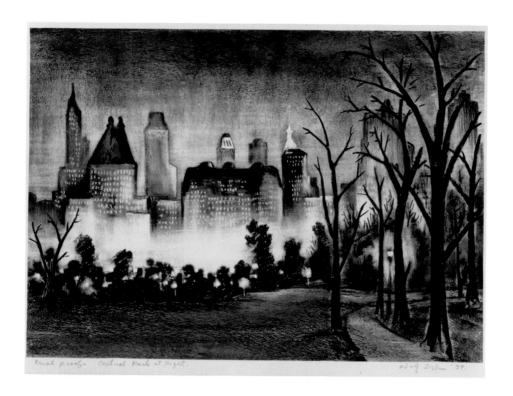

Plate 10. Central Park at Night
(*see Cat. No. 282*)

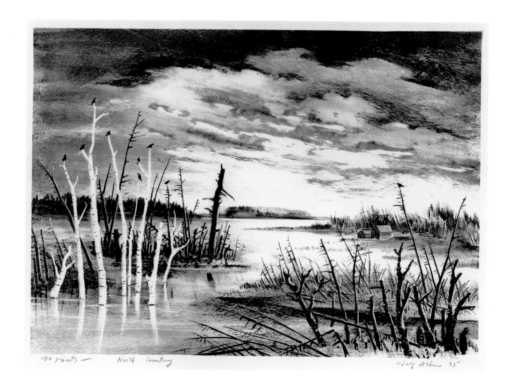

Plate 11. North Country
(*see Cat. No. 292*)

Plate 12. Love Labour Leisure
(*see Cat. No. 307*)

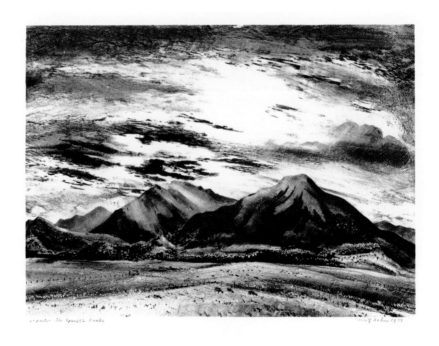

Plate 13. The Spanish Peaks
(*see Cat. No. 315*)

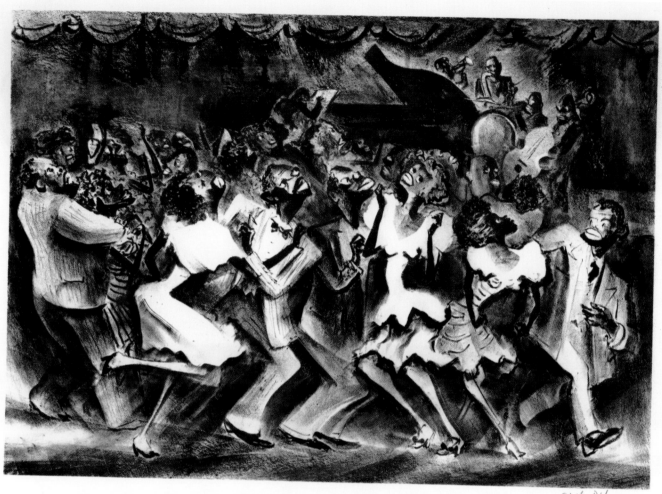

Plate 14. Swinging at the Savoy (or At the Savoy)
(*see Cat. No. 333*)

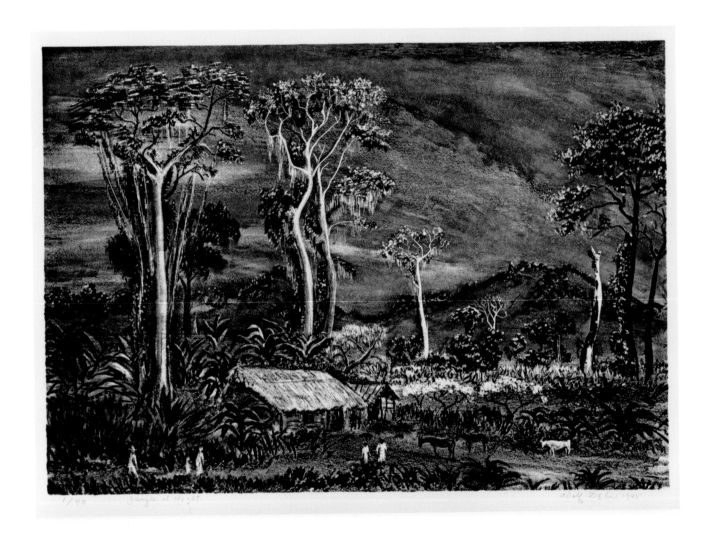

Plate 15. Jungle at Night
(*see Cat. No. 351*)

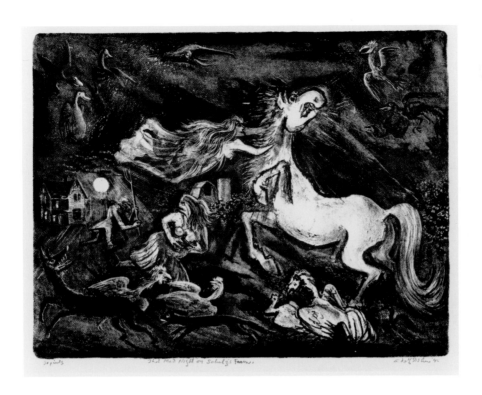

Plate 16. That Mad Night on Schulz's Farm
(*see Cat. No. 431*)

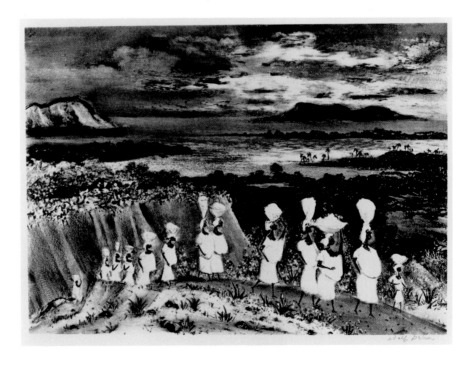

Plate 17. Caribbean Processional
(*see Cat. No. 499*)

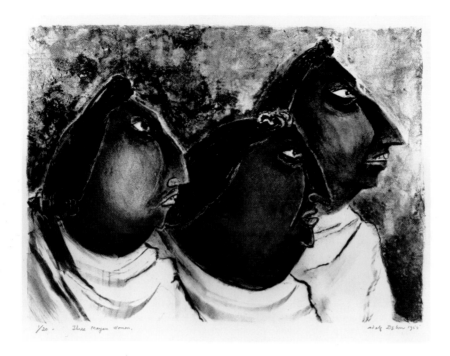

Plate 18. Three Mayan Women
(*see Cat. No. 508*)

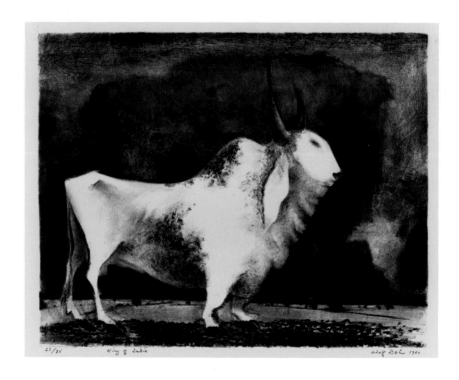

Plate 19. King of India
(*see Cat. No. 535*)

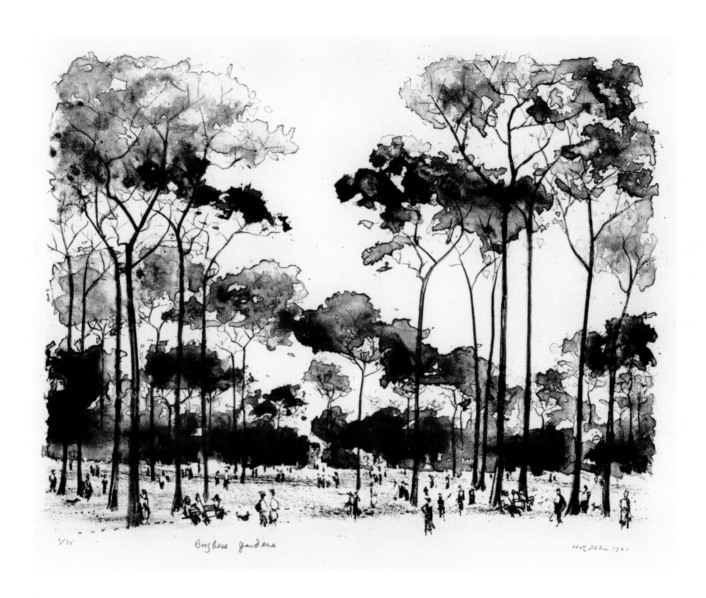

Plate 20. Borghese Gardens
(*see Cat. No. 539*)

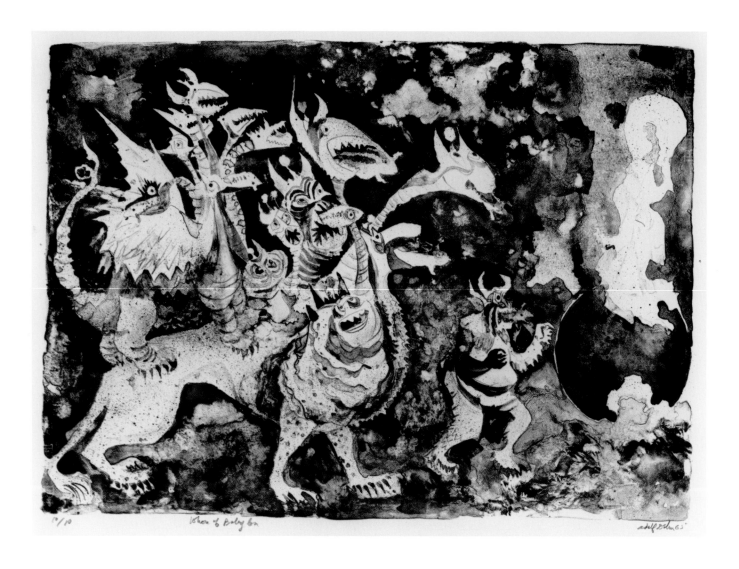

Plate 21. Whore of Babylon
(*see Cat. No. 657.i*)

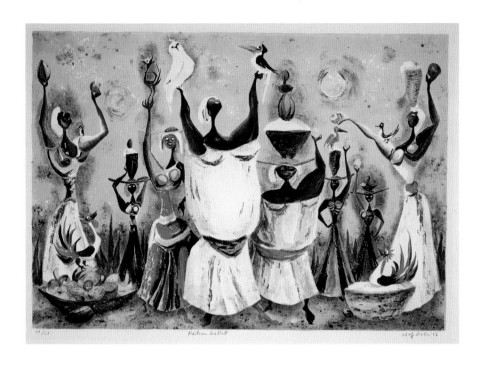

Plate 22. Haitian Ballet
(*see Cat. No. 480*)

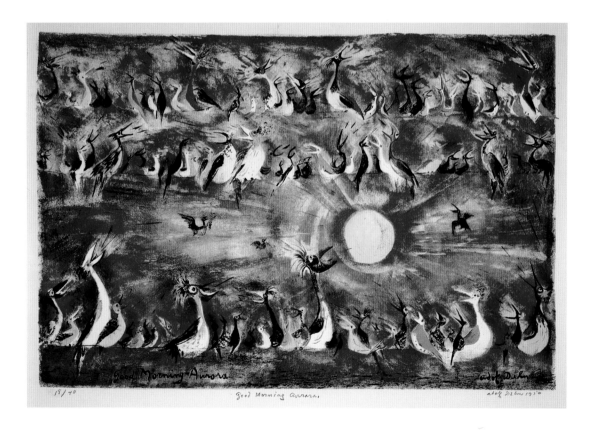

Plate 23. Good Morning Aurora
(*see Cat. No. 510.i*)

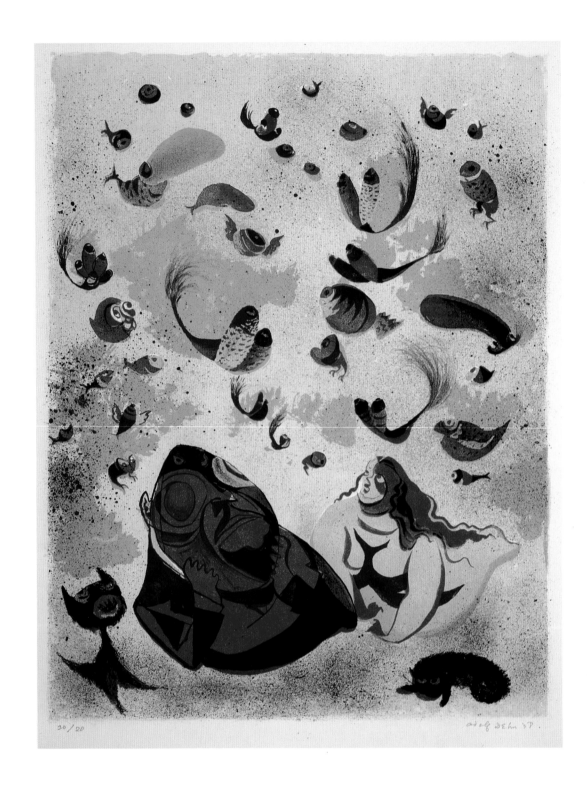

Plate 24. Invasion
(*see Cat. No. 524*)

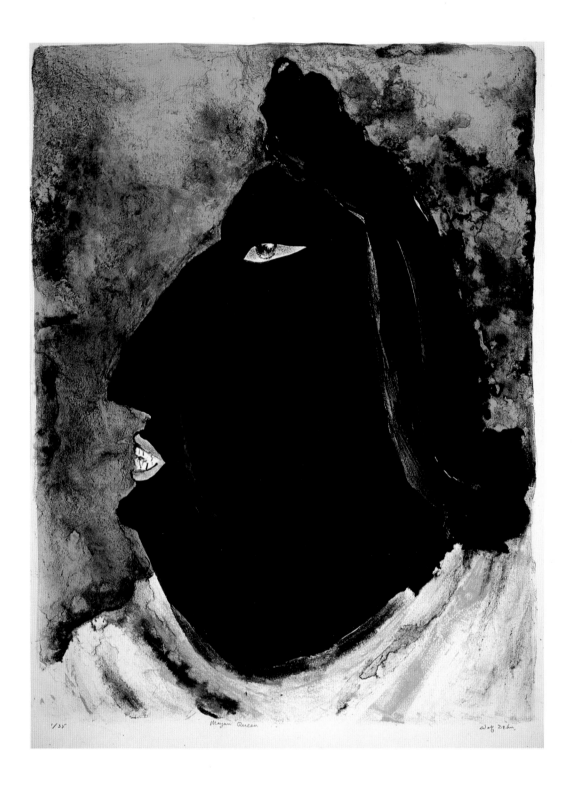

Plate 25. Mayan Queen
(*see Cat. No. 559*)

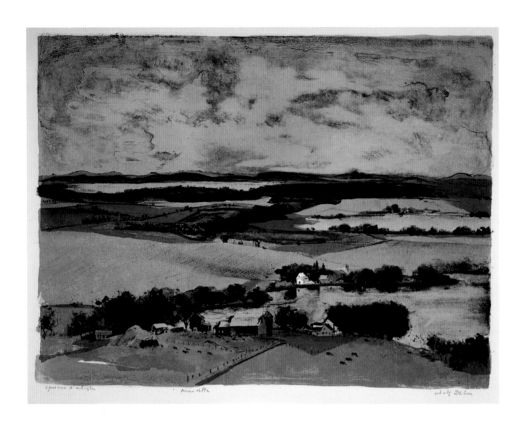

Plate 26. Minnesota
(*see Cat. No. 560*)

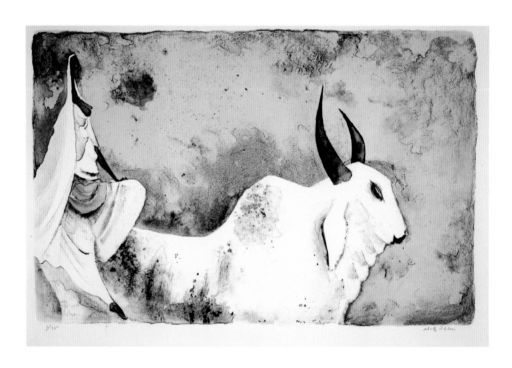

Plate 27. The White Bull (or Woman Riding Bull)
(*see Cat. No. 574*)

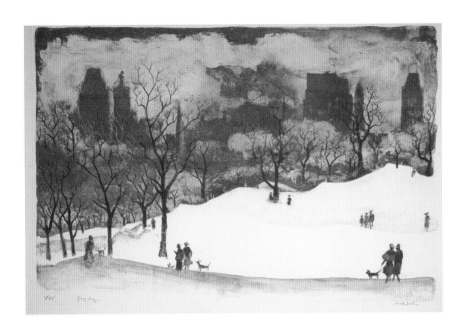

Plate 28. Grey Day
(*see Cat. No. 598*)

Plate 29. Homage à Hieronymous Bosch
(*see Cat. No. 600.ii*)

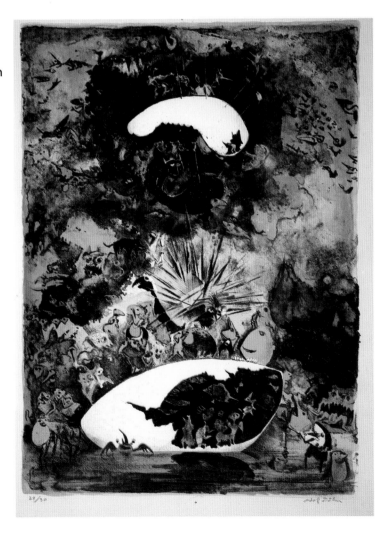

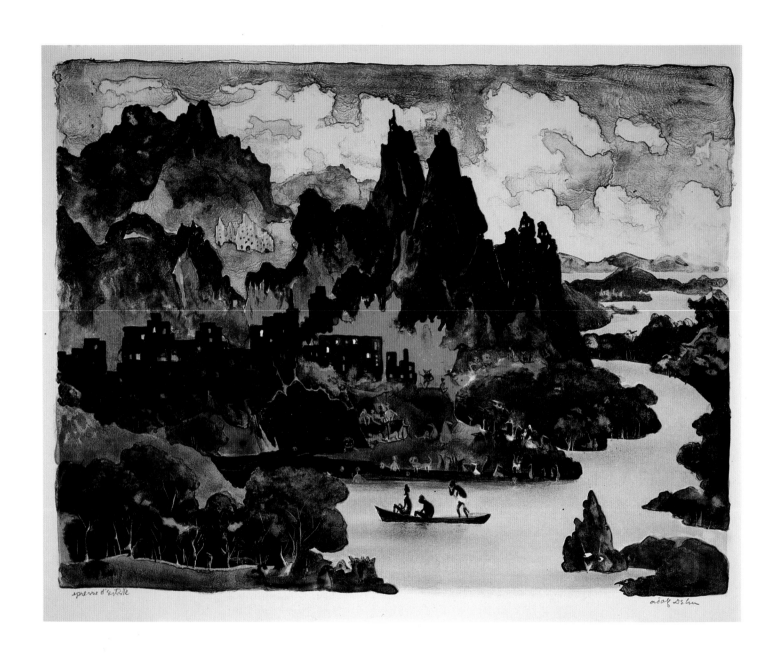

Plate 30. Jerome Patinir and Mr. Adolf Dehn on the River Styx
(*see Cat. No. 604.ii*)

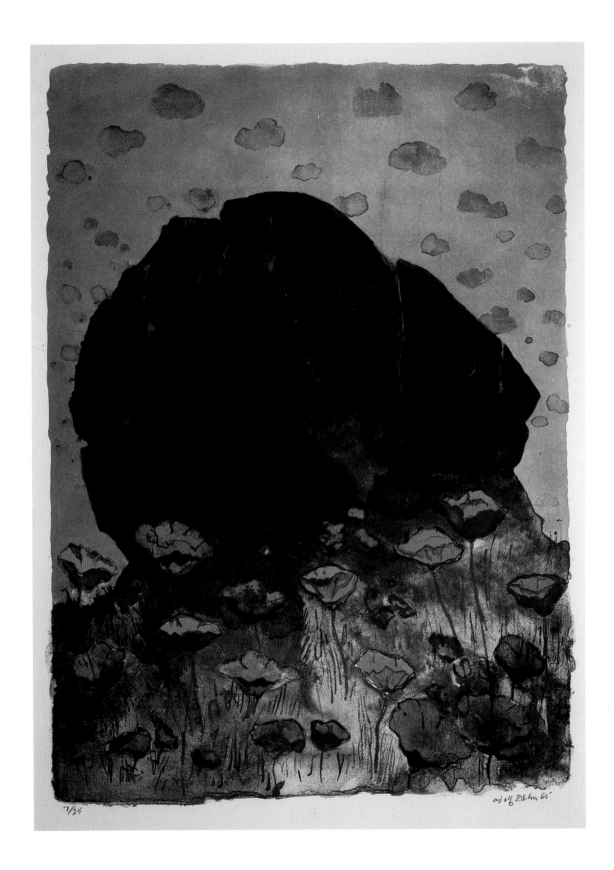

Plate 31. Beauty and the Beast
(*see Cat. No. 625*)

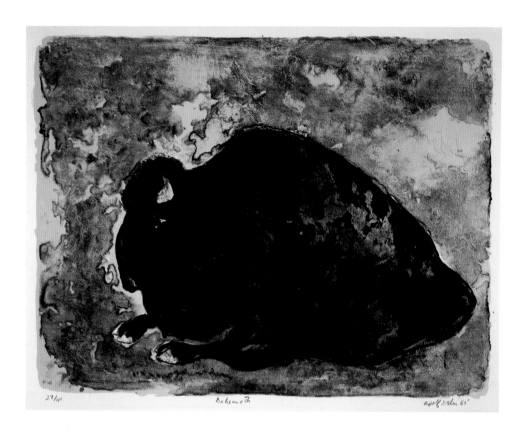

Plate 32. Behemoth
(*see Cat. No. 626.ii*)

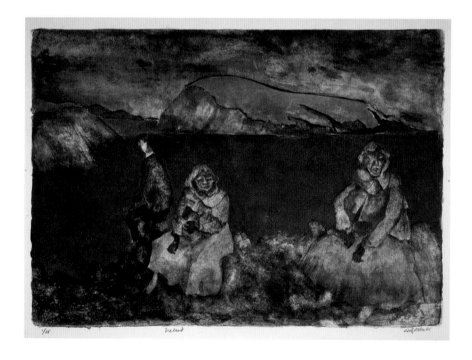

Plate 33. Ireland
(*see Cat. No. 638*)

CATALOGUE

ORGANIZATION OF THE CATALOGUE RAISONNÉ

THE CATALOGUE is organized chronologically, with prints arranged alphabetically by title within each year.

Dimensions are given for the image sizes of lithographs and serigraph; the etching and the drypoints are measured to the platemarks. Height precedes width; inches precede centimeters.

Adolf Dehn signed his prints in pencil and often added date, title, and edition. He noted editions variously in fraction form, such as "1/10," or as a total edition size, such as "Ed. 10" or "10 prints." Variations in title, date, or edition or the existence of trial proofs and artist's proofs are listed in the catalogue.

Three groups of prints may be noted as self-contained bodies of work. *Paris Lithographs* [96–105] is a portfolio of prints issued in 1928. In the 1940s, Dehn and master-printer Lawrence Barrett made a series of lithographs for *How to Draw and Print Lithographs* (1950) [369–389]. Some of these prints are small versions of familiar Dehn themes and illustrate technical points; others are not representations of subjects at all but are made to illustrate technical possibilities of the lithographic process. The third group consisting of twenty lithographs was made on commission for the Book-of-the-Month-Club edition of *Selected Tales of Guy De Maupassant* [390–409] published in 1945. To retain the cohesion of the three groups, exceptions have been made to the chronological and alphabetical order of the catalogue raisonné.

The numbering of prints in this catalogue raisonné differs from the numbering in the thesis done by Joycelyn Pang Lumsdaine, "The Prints of Adolf Dehn and a Catalogue Raisonne," at the University of California at Los Angeles in 1974. The numbers used in this catalogue and the corresponding numbers from Lumsdaine's thesis are listed at the end of this volume.

The majority of Dehn's lithographs were printed on heavy wove papers, such as BFK Rives paper. In the early years of his career, the *chine collé* process was used for many lithographs printed by Edmond Desjobert. While the use of the process was not consistent, even within an edition, *chine collé* contributed to Dehn's prints a distinctive surface quality that can be seen in Plate 2.

The prints here reproduced are from the collections of the Minnesota Historical Society and are gifts of Virginia Dehn, except as noted. Several prints could not be located; therefore, only a description is given.

THE CATALOGUE RAISONNÉ

1
The Harvest
1920
Transfer lithograph
9¾ x 15⅛ (24.7 x 38.4)
Edition: 15, plus trial proofs
Printed by George Miller, New York.
 This is probably Dehn's first lithograph.

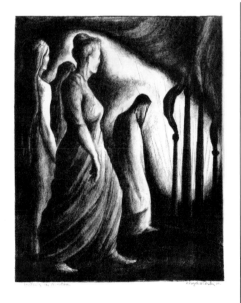

2
Mothers of the Revolution (or The Dawn) (*see Plate 1*)
1920
Lithograph
16¹³⁄₁₆ x 13⅝ (42.7 x 34.8)
Edition: 15, plus trial proofs
Printed by George Miller, New York.

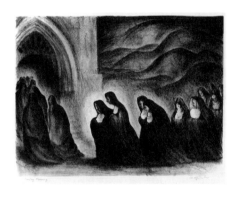

3
Sunday Morning
1920
Lithograph
12½ x 16¹³⁄₁₆ (31.8 x 42.8)
Edition: 20, plus trial proofs
Printed by George Miller, New York.
 This is Dehn's first lithograph on stone.

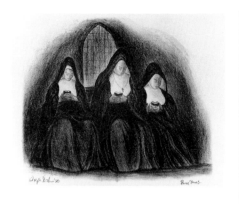

4
Three Nuns
1920
Lithograph
9 ⅛ x 11 (23.2 x 28.0)
Edition: Trial proofs only
Printed by George Miller, New York.

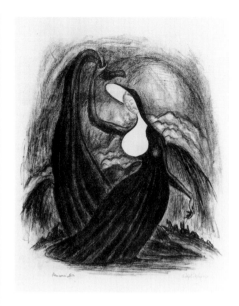

5
Renunciation
1921
Lithograph
14 ¼ x 12 ¼ (36.2 x 31.3)
Edition: Trial proofs only

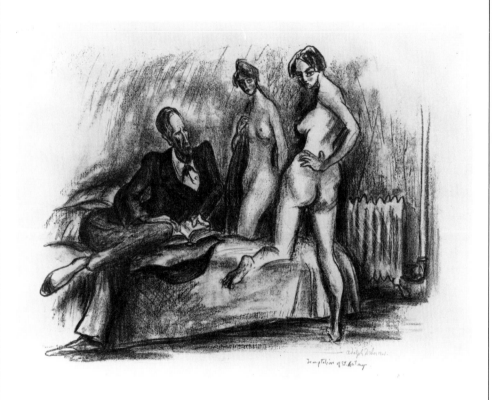

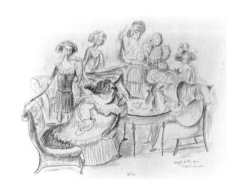

6
The Temptation of St. Anthony
1921
Lithograph
12 ¾ x 16 ⁹⁄₁₆ (32.3 x 42.0)
Edition: Artist's proofs only
Printed by George Miller, New York.

7
At Tea
1922
Lithograph
11 ¼ x 14 ¾ (28.8 x 37.4)
Edition: 12
Printed by Meister Berger, Vienna.

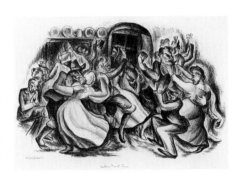

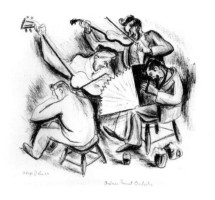

8
Austrian Peasant Dance
1922
Transfer lithograph
13 5/16 x 21 (33.9 x 53.4)
Edition: 12
Printed by Meister Berger, Vienna.

9
Austrian Peasant Orchestra
1922
Lithograph
10 x 11 1/2 (25.6 x 29.3)
Edition: 12
Printed by Meister Berger, Vienna.

10
Five O'Clock
1922
Lithograph
11 1/8 x 14 3/4 (28.3 x 37.5)
Edition: Undetermined

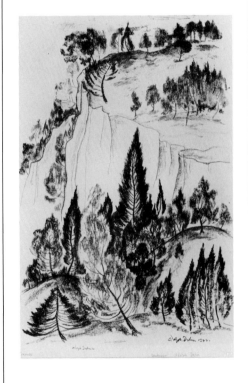

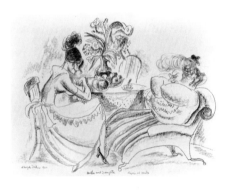

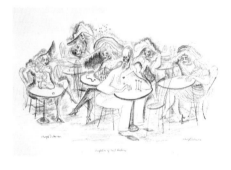

12
**Mother and Daughter (or Chapric &
 Murka)**
1922
Lithograph
11 1/4 x 15 3/16 (28.6 x 38.5)
Edition: 12
Printed by Meister Berger, Vienna.

13
Temptation of St. Anthony
1922
Lithograph
10 x 16 3/8 (25.7 x 41.8)
Edition: 12
Printed by Meister Berger, Vienna.

11
Landscape
1922
Lithograph
17 7/16 x 11 7/8 (44.3 x 30.3)
Edition: 12
Printed by Meister Berger, Vienna.

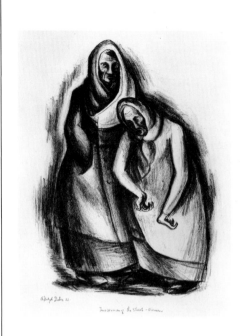

14
Two Women of the Streets—Vienna
1922
Lithograph
13 5/8 x 10 9/16 (34.7 x 26.8)
Edition: 12
Printed by Meister Berger, Vienna.

15
Viennese Veterans of the World War
1922
Lithograph
15 1/8 x 11 3/4 (38.4 x 29.8)
Edition: 12
Printed by Meister Berger, Vienna.

16
Cafe Table
1925
Drypoint
6 1/2 x 4 7/8 (16.5 x 12.4)
Edition: Trial proofs only
Printed by B. Stefferl, Vienna.

17
Afternoon Siesta (or Spring Sunshine in Vienna)
1926
Drypoint
9 1/2 x 11 11/16 (24.3 x 29.7)
Edition: 20, plus trial proofs
Printed by B. Stefferl, Vienna.

18
Au Sacre de Printemps
1926
Drypoint
9 3/4 x 11 15/16 (24.5 x 30.4)
Edition: 20, plus trial proofs
Printed by B. Stefferl, Vienna.

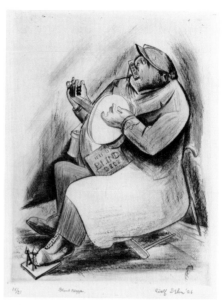

20
Blind Beggar (or **Viennese Beggar** or
Viennese Musician or **On the
Opera House Steps—Vienna**)
1926
Drypoint
11 x 8⁹⁄₁₆ (27.8 x 21.8)
Edition: 21, plus trial proofs
Printed by B. Stefferl, Vienna.

19
Bitt'chon (or **Bitt'schön meine Herr-
schaften!**)
1926
Lithograph
15¾ x 11¼ (40.2 x 28.7)
Edition: 15
Printed by Meister Berger, Vienna.

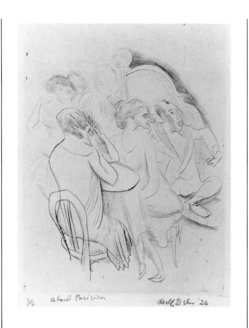

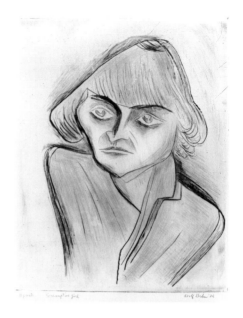

21
Cabaret Parisien
1926
Drypoint
9⁵⁄₁₆ x 6¹³⁄₁₆ (23.7 x 17.3)
Edition: 6, plus trial proofs
Printed by B. Stefferl, Vienna.

22
Consumptive Girl (or **TB**)
1926
Drypoint
12⅛ x 9⅝ (30.8 x 24.5)
Edition: 11 or 12
Printed by B. Stefferl, Vienna.

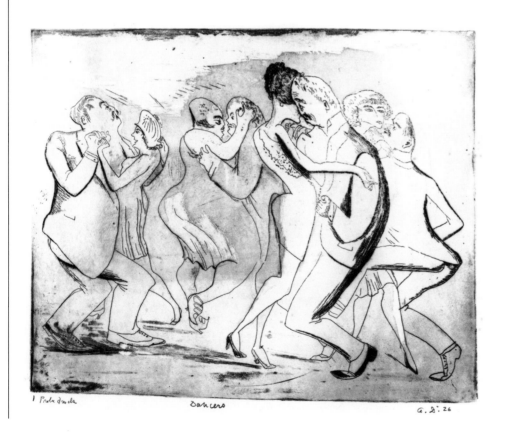

23
Dancers
1926
Drypoint
9⅝ x 12 (24.5 x 30.5)
Edition: Trial proofs only
Printed by B. Stefferl, Vienna.

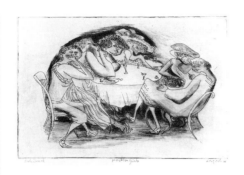

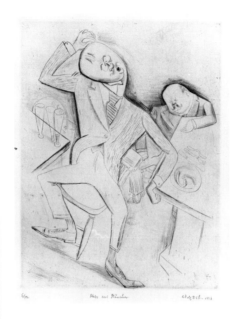

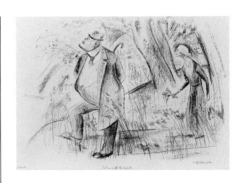

24
Harlem Girls
1926
Drypoint
7¾ x 11¾ (19.6 x 29.9)
Edition: Trial proofs only
Printed by B. Stefferl, Vienna.

25
Herr aus München
1926
Drypoint
11 x 8½ (28.1 x 21.4)
Edition: 12, plus trial proofs
Printed by B. Stefferl, Vienna.

26
In Tune with the Infinite
1926
Lithograph
12⅞ x 18⅛ (32.8 x 46.3)
Edition: 15
Printed by Meister Berger, Vienna.

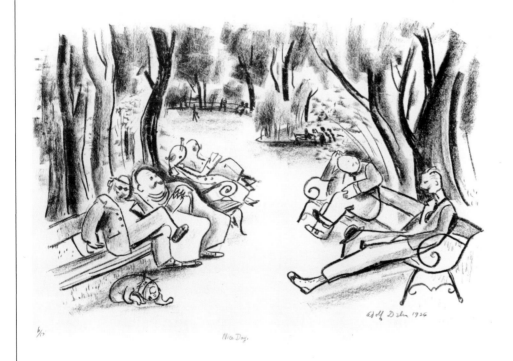

27
Nice Day (or **Afternoon in the Stadt-park**)
1926
Lithograph
11⅞ x 18¾ (30.0 x 48.0)
Edition: 15
Printed by Meister Berger, Vienna.

28
Old Roué
1926
Drypoint
7 ⅛ x 9 ¼ (18.0 x 23.5)
Edition: Trial proofs only
Printed by B. Stefferl, Vienna.

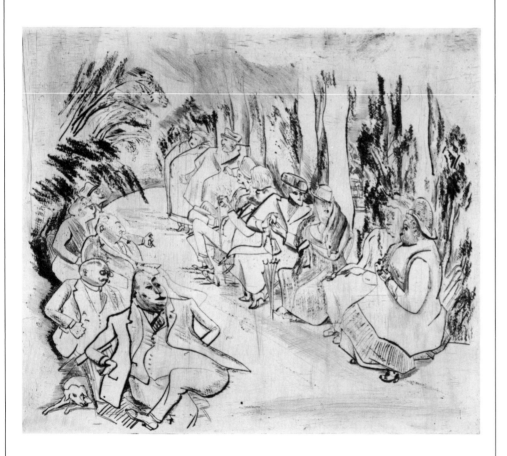

29
Untitled
Ca. 1926
Drypoint
15 ⅝ x 18 ¾ (39.6 x 47.5)
Edition: Undetermined

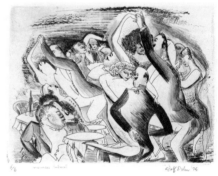

30
Viennese Cabaret (or Viennese Bar—Weiburg Bar, Vienna)
1926
Drypoint
7 x 9 ⅜ (17.8 x 23.9)
Edition: 6, plus trial proofs
Printed by B. Stefferl, Vienna.

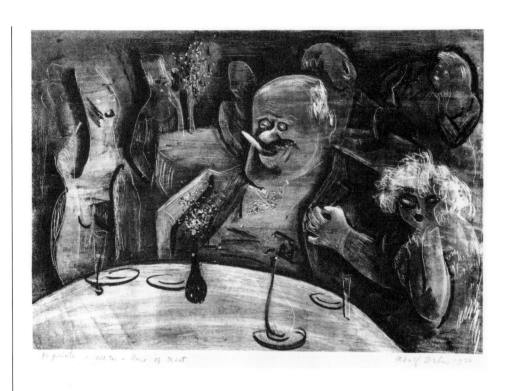

31
All for a Peice [*sic*] of Meat
(*see Plate* 2)
1927/1928
Lithograph
8 x 11⁹⁄₁₆ (20.3 x 29.3)
Edition: 25 or 30

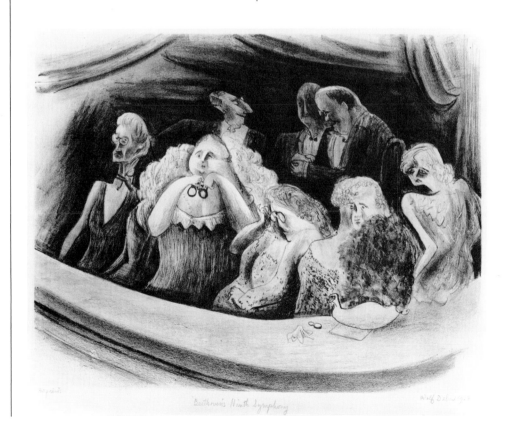

32
Beethoven's Ninth Symphony
1927
Lithograph
10¹¹⁄₁₆ x 13¹³⁄₁₆ (27.2 x 35.0)
Edition: 30

33
Church in the Valley of the
Chevreuse
1927
Lithograph
10 ¾ x 15 ¼ (27.3 x 38.7)
Edition: 30

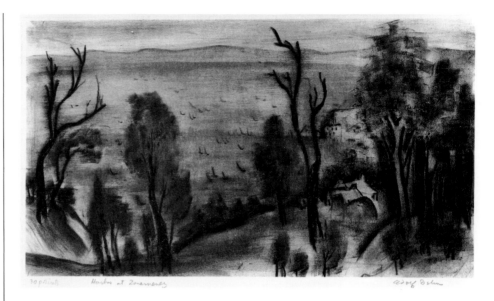

34
Harbor at Douarnenez
1927/1928
Lithograph
8 ⁷⁄₁₆ x 15 ⅛ (21.4 x 38.4)
Edition: 30
Printed by Edmond Desjobert, Paris.

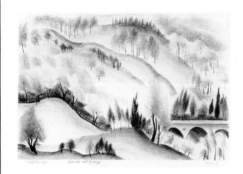

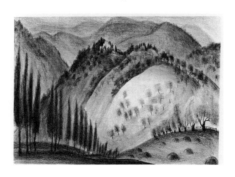

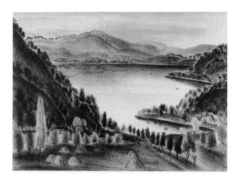

35
Hillside & Bridge
1927
Lithograph
8 ¾ x 13 ⅛ (22.2 x 33.3)
Edition: 12

36
Klamm bei Semmering
1927
Lithograph
10 ⁷⁄₁₆ x 14 ¹⁵⁄₁₆ (26.4 x 37.9)
Edition: 25

37
Lac Aiguebelette, Savoie
1927
Lithograph
11 ¼ x 15 ½ (28.6 x 39.4)
Edition: 25

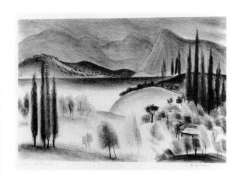

38
Lac Bourget
1927
Lithograph
10 3/16 x 15 1/16 (25.9 x 38.2)
Edition: 25

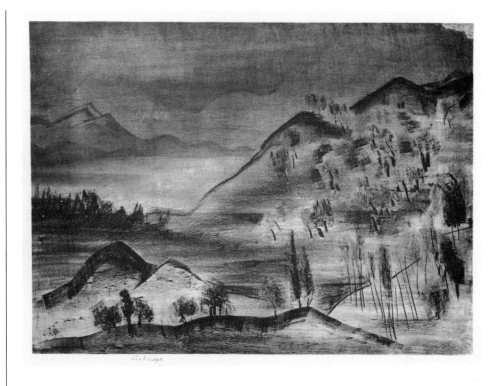

40
Landschaft
1927
Lithograph
11 1/4 x 15 1/2 (28.6 x 39.5)
Edition: 9

39
Landscape (or **Grey Mountain**)
(*see Plate 3*)
1927
Lithograph
10 3/4 x 14 3/4 (27.2 x 37.5)
Edition: 25 or 30
"Chinese Landscape, the Crucial Print"
 (handwritten comment on print folder
 in the artist's estate).

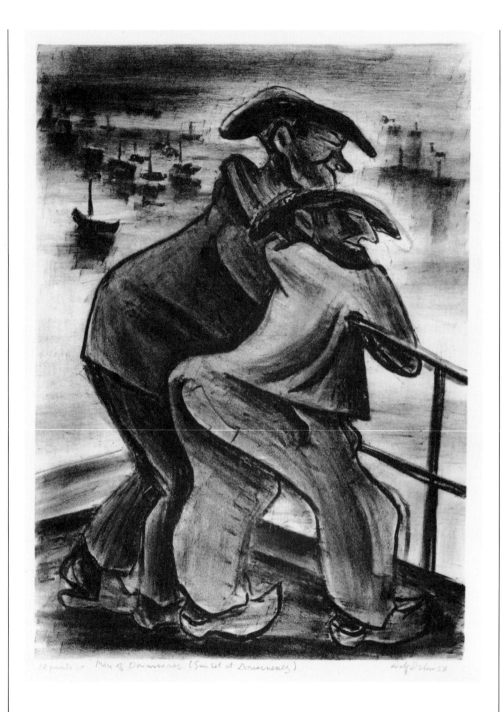

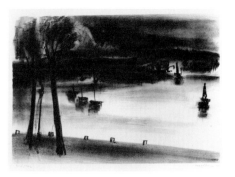

42
Moonrise at Concarneau
1927/1928
Lithograph
10 9/16 x 15 1/4 (26.8 x 38.7)
Edition: 10, plus trial proofs

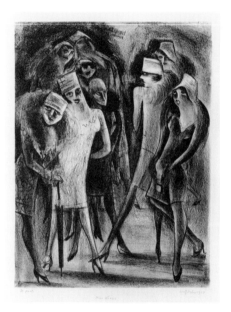

41
Men of Douarnenez (or Sunset at
 Douarnenez)
1927
Lithograph
15 x 10 15/16 (38.0 x 27.8)
Edition: 10

43
Nine Whores
1927
Lithograph
15 1/4 x 11 5/8 (38.7 x 29.6)
Edition: 25

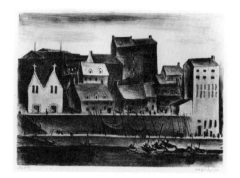

44
Pommeranian Potato Diggers
1927
Lithograph
10 5/16 x 15 3/16 (26.2 x 38.6)
Edition: 20

45
The Quai at Douarnenez (or The Harbor at Douarnenez)
1927
Lithograph
11 1/4 x 15 1/2 (28.6 x 39.5)
Edition: 20

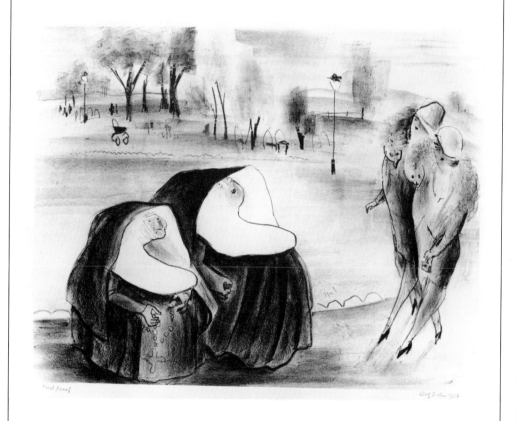

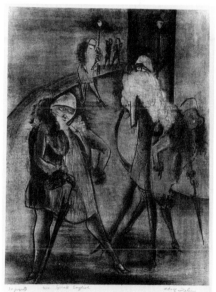

46
Sisters
1927
Lithograph
11 1/16 x 14 1/8 (28.0 x 35.9)
Edition: Trial proofs only

47
We Speak English
1927/1928
Lithograph
14 5/16 x 11 (36.4 x 28.0)
Edition: 30
Printed by Edmond Desjobert, Paris.

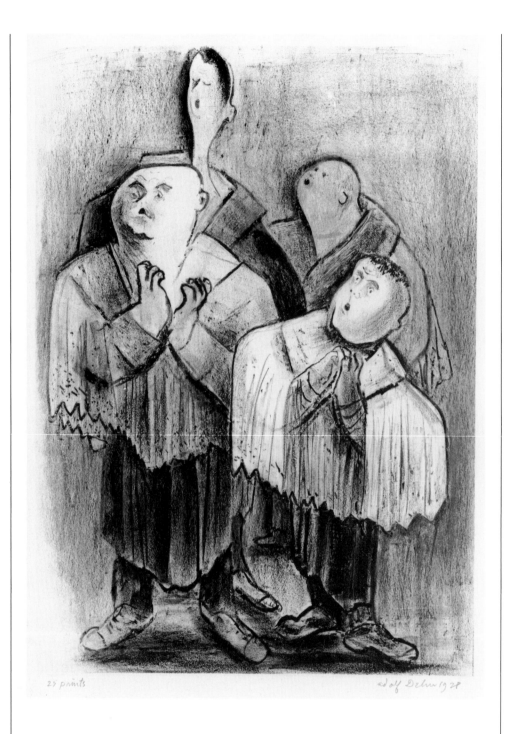

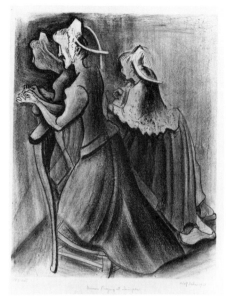

49
Women Praying at Quimper
1927
Lithograph
14 5/16 x 11 3/8 (36.3 x 29.0)
Edition: 20

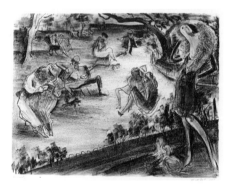

48
With God at Chartres
1927/1928
Lithograph
14 3/4 x 10 5/8 (37.3 x 27.0)
Edition: 25
Printed by Edmond Desjobert, Paris.
 "This composition was drawn directly
 without preliminary pencil sketching;
 then rubbed but much of the crayon
 texture remained" (Adolf Dehn and
 Lawrence Barrett, *How to Draw and
 Print Lithographs*, 46).

50
Afternoon in the Luxembourg
1928
Lithograph
10 7/8 x 14 3/16 (27.6 x 36.0)
Edition: 25
Printed by Edmond Desjobert, Paris.

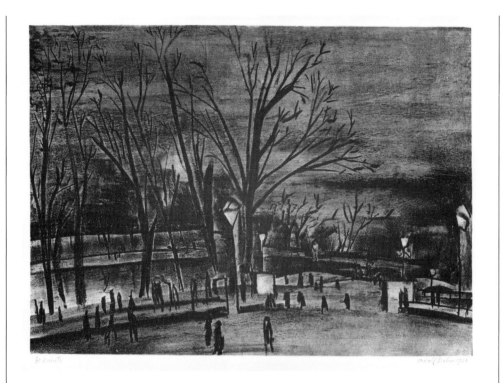

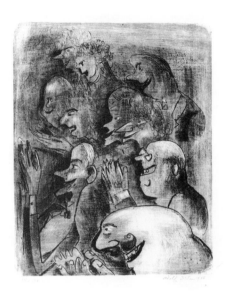

52
Applause
1928
Lithograph
10 15/16 x 8 15/16 (27.7 x 22.8)
Edition: 30, plus artist's proofs
Printed by Edmond Desjobert, Paris.

51
Along the Seine at Night
1928
Lithograph
11 1/8 x 15 3/8 (28.3 x 39.1)
Edition: 30
Printed by Edmond Desjobert, Paris.

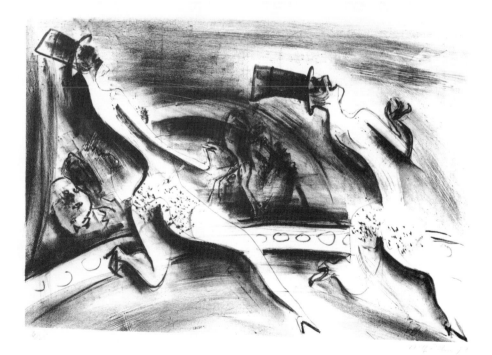

53
At the Palace (Sisters) (or Sisters at the Palace)
1928
Lithograph
9 x 13 1/8 (22.8 x 33.2)
Edition: 25
Printed by Edmond Desjobert, Paris.

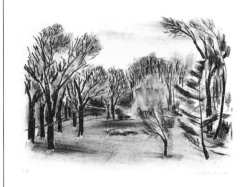

54
Austrian Alps (or Mountains near Semmering)
1928
Lithograph
10 13/16 x 14 (27.4 x 35.5)
Edition: 10, plus trial proofs
Printed by Edmond Desjobert, Paris.

55
Austrian Countryside
1928
Lithograph
10 3/4 x 15 (27.3 x 38.2)
Edition: 10, plus trial proofs
Printed by Edmond Desjobert, Paris.

56
Autumn Day (or Park in Autumn)
1928
Lithograph
10 7/16 x 14 7/8 (26.5 x 37.7)
Edition: 20
Printed by Edmond Desjobert, Paris.

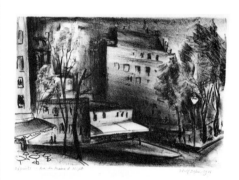

57
Autumn Evening
1928
Lithograph
10 7/8 x 15 (27.5 x 38.0)
Edition: 20, plus trial proofs
Printed by Edmond Desjobert, Paris.

58
Ave du Maine at Night
1928
Lithograph
9 1/16 x 13 1/8 (23.1 x 33.2)
Edition: 25
Printed by Edmond Desjobert, Paris.

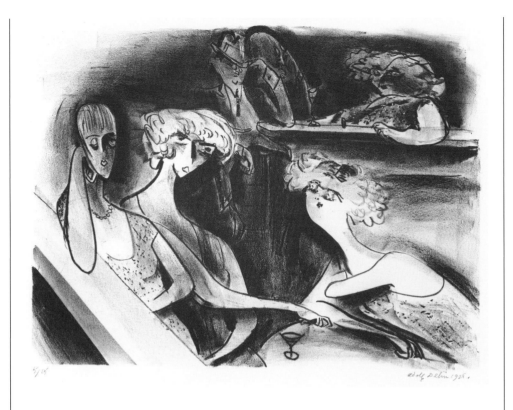

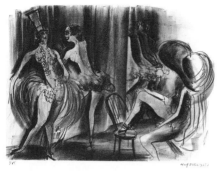

60
Behind the Scenes
1928
Lithograph
11 3/16 x 15 1/2 (28.4 x 39.3)
Edition: 15
Printed by Edmond Desjobert, Paris.

59
Bar Americain
1928
Lithograph
11 1/8 x 14 15/16 (28.3 x 38.0)
Edition: 15

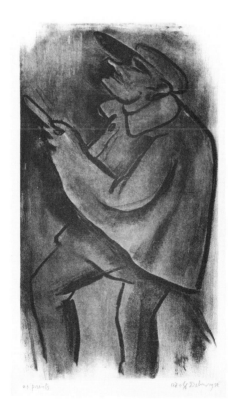

61
Blind Man of Montparnasse
1928
Lithograph
10 3/4 x 6 3/16 (27.4 x 15.7)
Edition: 25 or 30
Printed by Edmond Desjobert, Paris.

62
Breton Mourners
1928
Lithograph
11 3/8 x 16 13/16 (29.0 x 42.6)
Edition: 30

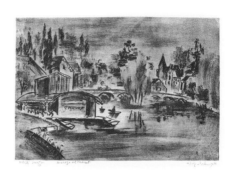

63
Bridge at Moret
1928
Lithograph
9 x 13 5/16 (22.8 x 33.9)
Edition: 30, plus artist's proofs
Printed by Edmond Desjobert, Paris.

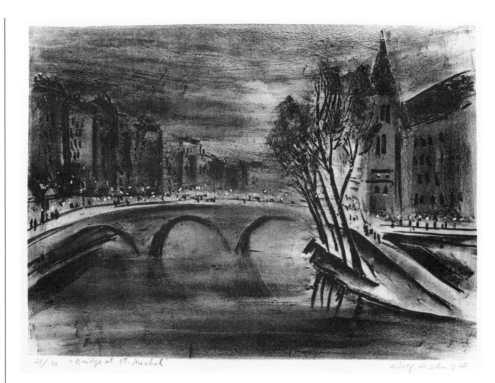

64
Bridge at St. Michel (or Pont St. Michel or The Seine at St. Michel)
1928
Lithograph
11 x 15 1/4 (27.9 x 38.8)
Edition: 30, plus trial proofs and artist's proofs
Printed by Edmond Desjobert, Paris.

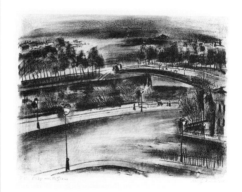

65
Bridge over the Seine
1928
Lithograph
10 5/8 x 14 1/4 (27.0 x 36.1)
Edition: 30
Printed by Edmond Desjobert, Paris.

66
Clowns
1928
Lithograph
9 3/8 x 13 1/8 (23.8 x 33.2)
Edition: 25 or 30
Printed by Edmond Desjobert, Paris.

67
Clowns #2
1928
Lithograph
11⅛ x 14¾ (28.2 x 37.5)
Edition: 15

68
Concierge
1928
Lithograph
14¹⁵⁄₁₆ x 10¹⁵⁄₁₆ (37.9 x 27.8)
Edition: Trial proofs only
Printed by Edmond Desjobert, Paris.

69
Curtain
1928
Lithograph
9⅝ x 13¼ (24.4 x 33.7)
Edition: 15
Printed by Edmond Desjobert, Paris.

70
Dessert (or **Salzburger Knockerl**)
1928
Lithograph
8½ x 13½ (21.6 x 34.2)
Edition: 20
Printed by Edmond Desjobert, Paris.

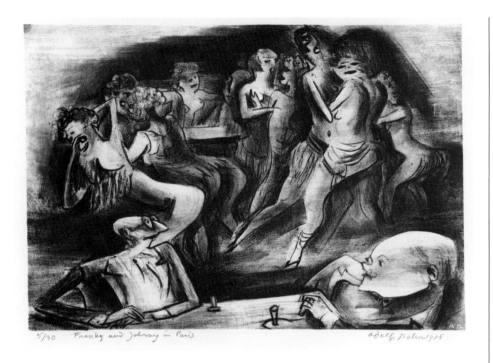

5/30 Franky and Johnny in Paris adolf Dehn 1928

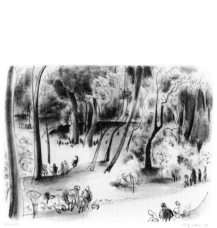

72
Girls
1928
Lithograph
11 x 15 (27.9 x 38.1)
Edition: 15, plus trial proofs
Printed by Edmond Desjobert, Paris.

71
Franky and Johnny in Paris
1928
Lithograph
8 ⅞ x 13 ⅛ (22.4 x 33.3)
Edition: 30, plus trial proofs
Printed by Edmond Desjobert, Paris.

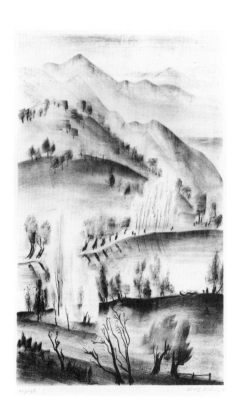

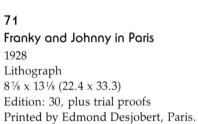

74
In the Bagatelle (or **Afternoon in the Bagatelle**)
1928
Lithograph
10 ³⁄₁₆ x 13 ⅞ (25.9 x 35.3)
Edition: 25
Printed by Edmond Desjobert, Paris.

73
Imaginary Landscape
1928
Lithograph
17 ¼ x 10 ⅝ (43.9 x 27.1)
Edition: 25
Printed by Edmond Desjobert, Paris.

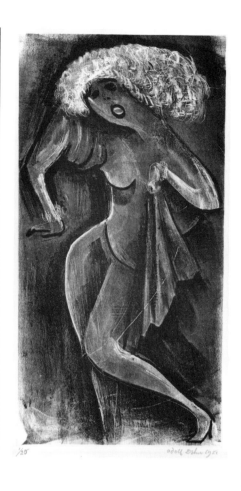

76
Landscape at La Varenne (or Loing, Moret)
1928
Lithograph
9 7/16 x 13 5/16 (24.0 x 33.8)
Edition: 30
Printed by Edmond Desjobert, Paris.

77
Landscape near Moret
1928
Lithograph
10 7/8 x 15 1/4 (27.6 x 38.6)
Edition: 30
Printed by Edmond Desjobert, Paris.

75
Jazz Baby
1928
Lithograph
11 1/4 x 5 7/8 (28.5 x 14.8)
Edition: 20
Printed by Edmond Desjobert, Paris.

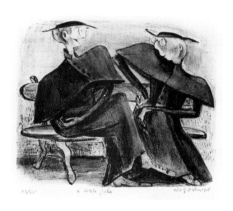

78
Landscape near Moret (or Loing at Moret)
1928
Lithograph
10 1/4 x 15 1/2 (26.0 x 39.3)
Edition: 20
Printed by Edmond Desjobert, Paris.

79
A Little Joke
1928
Lithograph
7 5/16 x 9 1/16 (18.5 x 23.0)
Edition: 25
Printed by Edmond Desjobert, Paris.

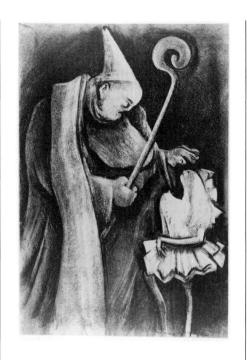

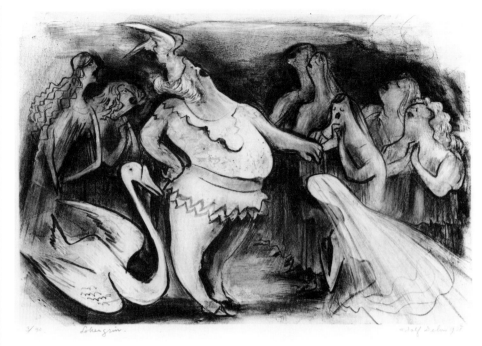

80
Little Sinner
1928
Lithograph
13 ³⁄₁₆ x 9 ⅛ (33.4 x 23.2)
Edition: 25
Printed by Edmond Desjobert, Paris.

81
Lohengrin
1928
Lithograph
10 ⁷⁄₁₆ x 15 ⅞ (26.5 x 40.3)
Edition: 30
Printed by Edmond Desjobert, Paris.
"This drawing was made directly on the stone, a wet cloth was then rubbed over the darks gently. Other areas were rubbed with the dry flannel. Accents and light areas were scraped with the blade" (Adolf Dehn and Lawrence Barrett, *How to Draw and Print Lithographs*, 58).

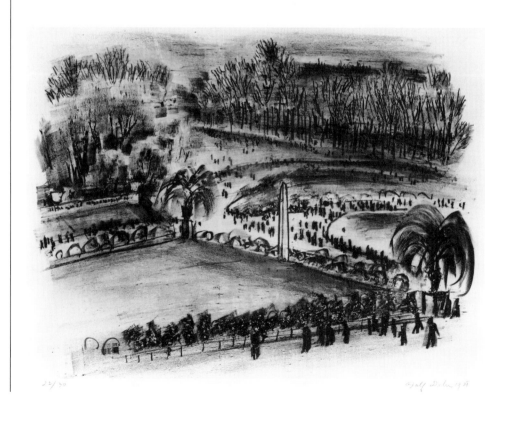

82
The Luxembourg
1928
Lithograph
11 ¼ x 14 ⅞ (28.5 x 37.8)
Edition: 30
Printed by Edmond Desjobert, Paris.

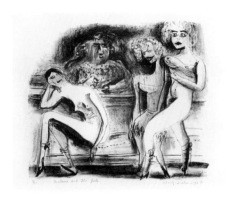

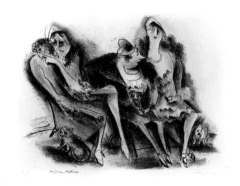

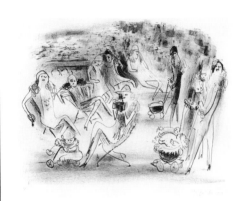

83
Madame and the Girls
1928
Lithograph
9 1/16 x 10 5/8 (23.0 x 27.0)
Edition: 30, plus trial proofs
Printed by Edmond Desjobert, Paris.

84
Modern Mothers
1928
Lithograph
10 3/8 x 14 1/8 (26.3 x 35.8)
Edition: 15
Printed by Edmond Desjobert, Paris.

85
**Mothers and Babies (or French
 Mothers and Babies or Mothers
 and Babies in the Luxembourg)**
1928
Lithograph
11 x 14 1/8 (27.8 x 36.0)
Edition: 15
Printed by Edmond Desjobert, Paris.

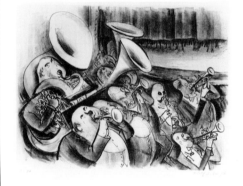

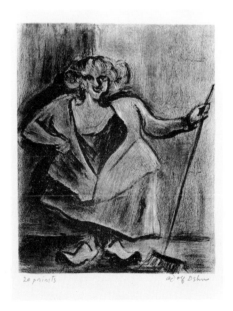

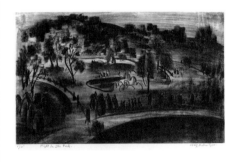

86
Music (or Orchestra)
1928
Lithograph
11 1/2 x 15 3/8 (29.2 x 39.0)
Edition: 20
Printed by Edmond Desjobert, Paris.

87
My Femme de Menage
1928
Lithograph
5 1/2 x 4 1/2 (14.0 x 11.4)
Edition: 20 or 25

88
Night in the Park (or Park at Night)
1928
Lithograph
9 1/4 x 15 7/16 (23.5 x 39.2)
Edition: 25 or 30
Printed by Edmond Desjobert, Paris.

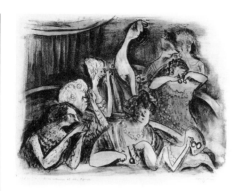

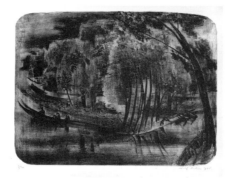

90
Nocturne (or **Night**)
1928
Lithograph
11 3/16 x 15 1/4 (28.4 x 38.7)
Edition: 30
Printed by Edmond Desjobert, Paris.

89
Nine Women at the Opera (or
 Entr'acte)
1928
Lithograph
11 3/8 x 15 5/16 (29.0 x 39.0)
Edition: 30
Printed by Edmond Desjobert, Paris.
 This lithograph was selected for *Fifty
 Prints of the Year* (1930).

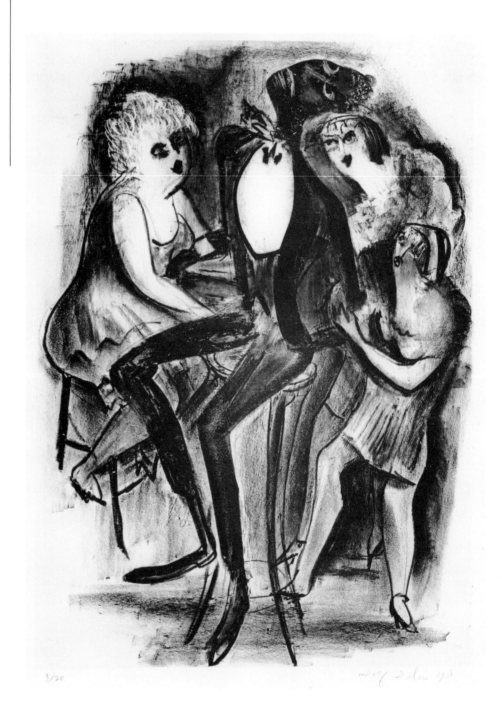

91
Nostalgia (or **Black Man in Paris**)
1928
Lithograph
13 1/2 x 9 3/4 (34.2 x 24.7)
Edition: 20, plus artist's proofs
Printed by Edmond Desjobert, Paris.

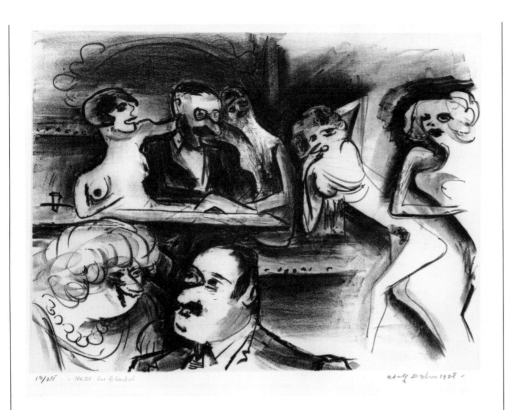

92
No. 25 Rue Blondel (or House on Rue Blondel)
1928
Lithograph
10 5/8 x 14 7/16 (26.9 x 36.7)
Edition: 25
Printed by Edmond Desjobert, Paris.

93
Nun
1928
Lithograph
9 11/16 x 10 11/16 (24.6 x 27.2)
Edition: 30
Printed by Edmond Desjobert, Paris.

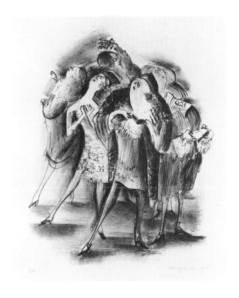

94
"Oh Haint the Cupids Lovely!"
1928
Lithograph
12 1/8 x 9 1/2 (30.8 x 24.3)
Edition: 20

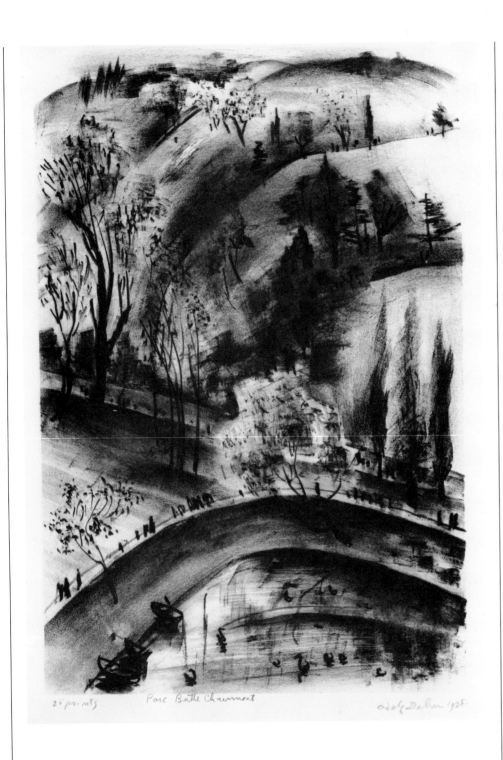

95

Parc Butte Chaumont (or Parc Mont-
souris)
1928
Lithograph
13 x 9 (33.0 x 22.8)
Edition: 25
Printed by Edmond Desjobert, Paris.

PARIS LITHOGRAPHS

PRINTED BY
EDMOND DESJOBERT,
PARIS

96
Aperitif Hour
1928
Lithograph
10 ¾ x 15 ⅛ (27.5 x 38.4)
Edition: 50, plus trial and artist's proofs
and special edition

97
At the Grand Guignol
1928
Lithograph
10 ½ x 15 ¹⁄₁₆ (26.7 x 38.3)
Edition: 50, plus trial and artist's proofs
and special edition
"The whole drawing was made quick-
ly and roughly with slight rubbing in
the darks" (Adolf Dehn and Lawrence
Barrett, *How to Draw and Print Litho-
graphs*, 80).

98
Bistro
1928
Lithograph
10 11/16 x 15 1/16 (27.2 x 38.2)
Edition: 50, plus trial and artist's proofs
and special edition

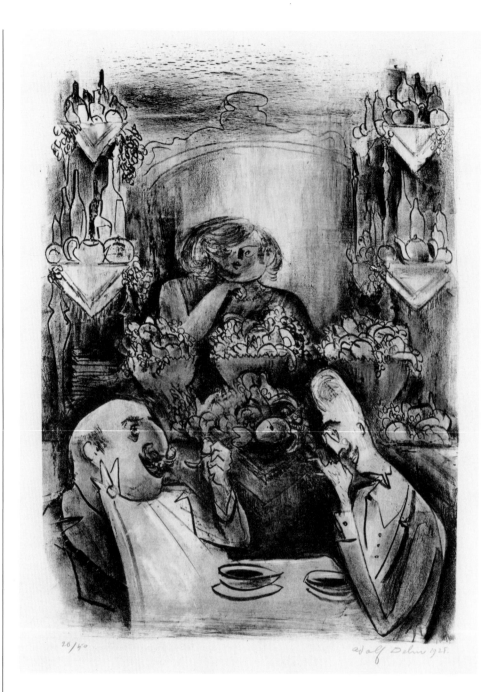

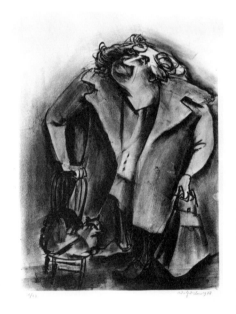

99
Concierge
1928
Lithograph
13 1/2 x 10 1/2 (34.5 x 26.7)
Edition: 50, plus trial and artist's proofs
and special edition

100
Cornucopia
1928
Lithograph
14 5/8 x 10 1/2 (37.2 x 26.8)
Edition: 50, plus trial and artist's proofs
and special edition

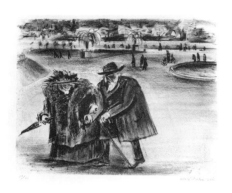

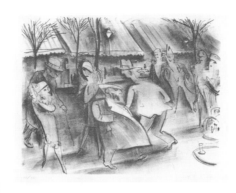

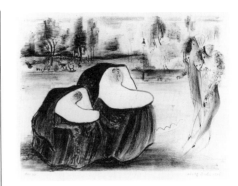

101
Dusk in the Luxembourg
1928
Lithograph
10 ¾ x 14 5⁄16 (27.4 x 36.4)
Edition: 50, plus trial and artist's proofs
and special edition

102
Promenade
1928
Lithograph
10 5⁄8 x 13 7⁄8 (27.0 x 35.1)
Edition: 50, plus trial and artist's proofs
and special edition

103
Sisters (*see Plate 4*)
1928
Lithograph
10 7⁄8 x 14 7⁄8 (27.6 x 37.9)
Edition: 50, plus trial and artist's proofs
and special edition

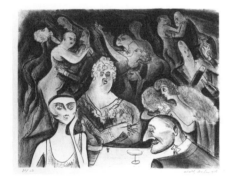

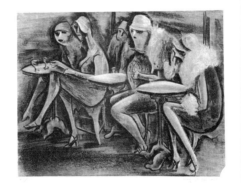

104
Tango at Zelli's
1928
Lithograph
10 15⁄16 x 14 5⁄16 (27.9 x 36.3)
Edition: 50, plus trial and artist's proofs
and special edition

105
Women of Montmartre
1928
Lithograph
11 3⁄16 x 14 9⁄16 (28.4 x 37.0)
Edition: 50, plus trial and artist's proofs
and special edition

End of
Paris Lithographs

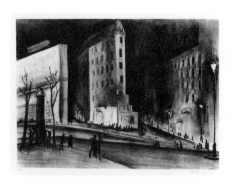

106
Paris Street (or **Paris Night** or **Place St. Denis**)
1928
Lithograph
10 13/16 x 15 1/8 (27.5 x 38.3)
Edition: 30, plus trial proofs
Printed by Edmond Desjobert, Paris.

107
Paris Street at Night (or **Paris Night**)
1928
Lithograph
9 1/8 x 13 1/16 (23.1 x 33.1)
Edition: 25
Printed by Edmond Desjobert, Paris.

108
Park (or **Entrance to Park**)
1928
Lithograph
7 1/8 x 9 7/16 (18.1 x 24.0)
Edition: 25, plus artist's proofs

109
Park (or **Summer Night**)
1928
Lithograph
8 x 13 5/8 (20.2 x 34.8)
Edition: 25
Printed by Edmond Desjobert, Paris.

110
Park #1
1928
Lithograph
4 7/16 x 6 1/8 (11.3 x 15.6)
Edition: 10
Printed by Edmond Desjobert, Paris.

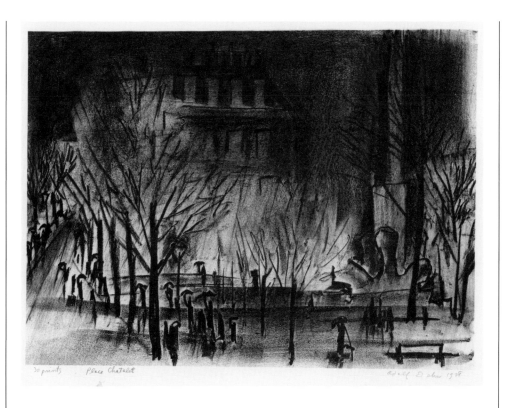

112
"Queer Looking These Americans!"
1928
Lithograph
8 ¾ x 11 ½ (22.2 x 29.0)
Edition: 20
Printed by Edmond Desjobert, Paris.

111
Place Chatalet (or Place Chatelet in the Rain)
1928
Lithograph
10 ¹³⁄₁₆ x 14 ⅞ (27.5 x 37.8)
Edition: 30
Printed by Edmond Desjobert, Paris.

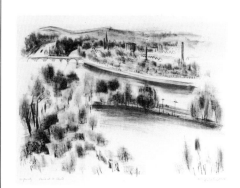

113
Raspail and Edgar Quinet
1928
Lithograph
11 ¼ x 15 (28.6 x 38.1)
Edition: 30
Printed by Edmond Desjobert, Paris.

114
The River (or The Loing at Moret)
1928
Lithograph
10 ⅞ x 8 ¹³⁄₁₆ (27.6 x 22.4)
Edition: 10
Printed by Edmond Desjobert, Paris.

115
Seine at St. Cloud
1928
Lithograph
10 ⅝ x 15 ¼ (27.1 x 38.7)
Edition: 25

116
Short Prayer in the Luxembourg
1928
Lithograph
11 ⅛ x 15 ⅛ (28.2 x 38.5)
Edition: 30
Printed by Edmond Desjobert, Paris.

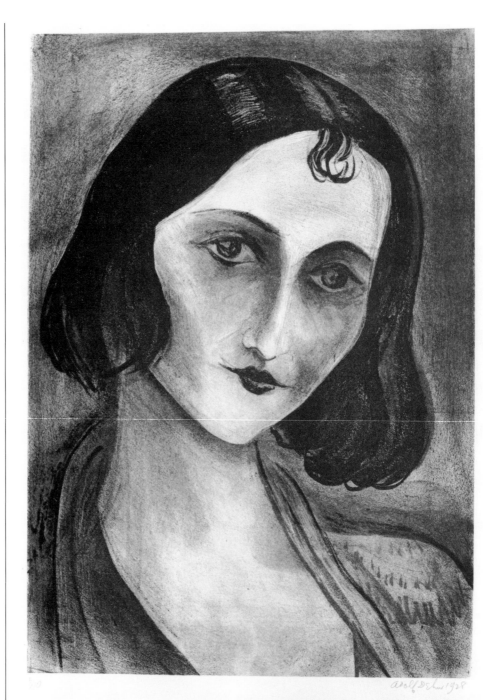

118
Spring Night
1928
Lithograph
9 x 13 ½ (22.8 x 34.4)
Edition: 10, plus trial proofs
Printed by Edmond Desjobert, Paris.

117
Spanish Girl (or Rosario)
1928
Lithograph
12 ⅞ x 9 ⅛ (32.6 x 23.2)
Edition: 10, plus trial proofs
Printed by Edmond Desjobert, Paris.

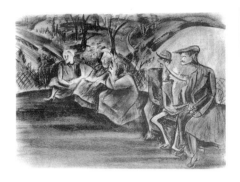

119
**Sunday Afternoon in Butte Chau-
mont**
1928
Lithograph
11 x 15 ¼ (27.9 x 38.7)
Edition: 15, plus trial proofs
Printed by Edmond Desjobert, Paris.

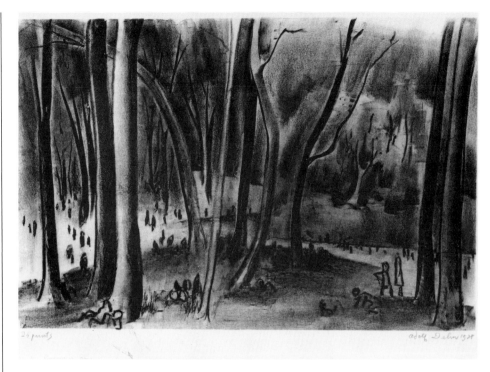

120
**Sunday Evening in Bois (or Sunday
Afternoon in the Bois)**
1928
Lithograph
9¾ x 14 ¹³⁄₁₆ (24.7 x 37.6)
Edition: 25, plus trial proofs
Printed by Edmond Desjobert, Paris.

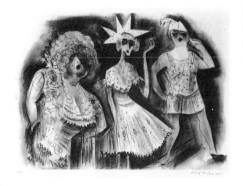

121
Three Songsters (or Three Singers)
1928
Lithograph
10 ¹¹⁄₁₆ x 15 (27.3 x 38.2)
Edition: 15
Printed by Edmond Desjobert, Paris.

122
**Three Virgins (or The Last of New
England)**
1928
Lithograph
12 ⁵⁄₁₆ x 8 ⅞ (31.3 x 22.5)
Edition: 20 or 25
Printed by Edmond Desjobert, Paris.

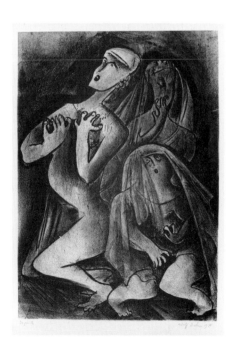

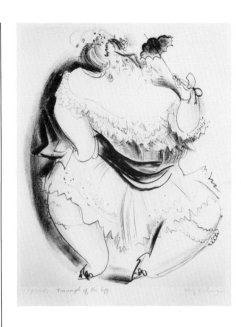

123
Triumph of the Egg
1928
Lithograph
10 ⅛ x 8 ¼ (25.8 x 20.9)
Edition: 15
Printed by Edmond Desjobert, Paris.

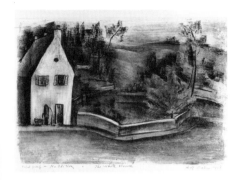

124
The White House
1928
Lithograph
9 x 13 ⅜ (22.9 x 34.1)
Edition: Trial proofs only
Printed by Edmond Desjobert, Paris.

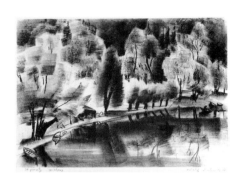

125
Willows
1928
Lithograph
8 ¹⁵⁄₁₆ x 13 ¹⁄₁₆ (22.6 x 33.1)
Edition: 20
Printed by Edmond Desjobert, Paris.

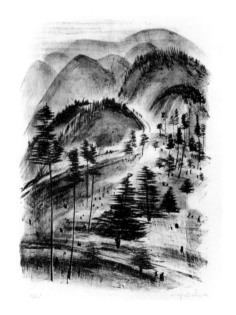

126
Bald Hills
1929
Lithograph
13 ¾ x 10 (34.8 x 25.5)
Edition: 25
Printed by Meister Schulz, Berlin.

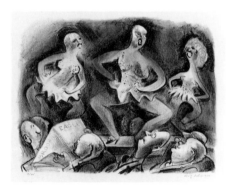

127
Burlesque (or Brooklyn Burlesque)
1929
Lithograph
13 ⅝ x 17 ⅞ (34.8 x 45.4)
Edition: 25
Printed by Meister Schulz, Berlin.

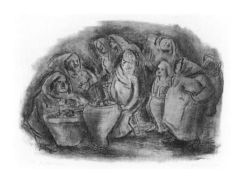

128
**Coburg Market Women (or Market
 Women in Coburg)**
1929
Lithograph
12 ¼ x 18 (31.5 x 45.7)
Edition: 15
Printed by Meister Schulz, Berlin.

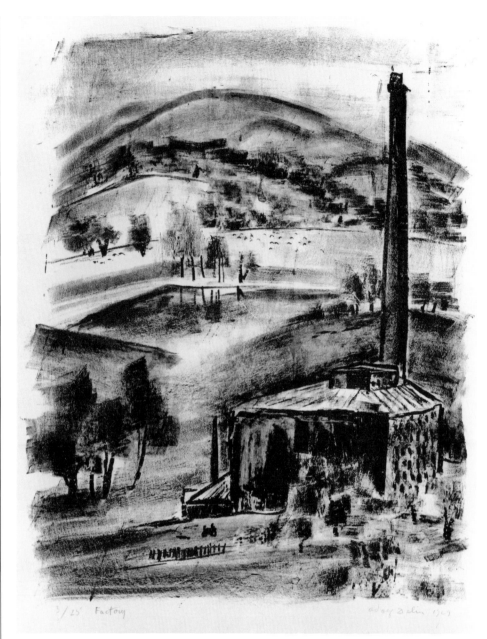

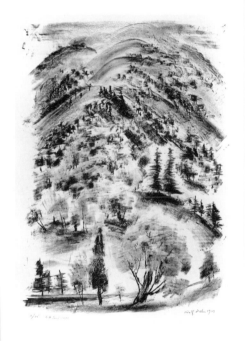

129
Factory
1929
Lithograph
13 ⅞ x 11 ¼ (35.3 x 28.6)
Edition: 25
Printed by Meister Schulz, Berlin.

130
Hill Landscape
1929
Lithograph
19 ½ x 14 (49.5 x 35.8)
Edition: 15
Printed by Meister Schulz, Berlin.

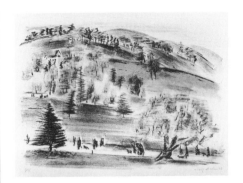

131
Hillside at Marienbad
1929
Lithograph
9 ³⁄₁₆ x 13 ¼ (23.4 x 33.6)
Edition: 15
Printed by Meister Schulz, Berlin.

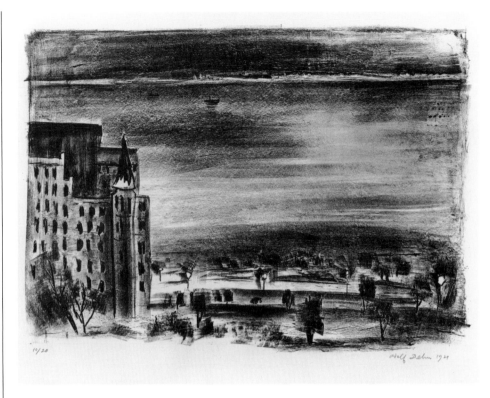

132
Hudson River at Night
1929
Lithograph
12 ⁵⁄₈ x 17 ¾ (32.2 x 45.0)
Edition: 20
Printed by Meister Schulz, Berlin.

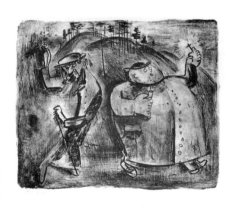

133
Jew & Gentile
1929
Lithograph
9 ³⁄₈ x 11 ¹¹⁄₁₆ (23.8 x 29.7)
Edition: 25, plus artist's proofs
Printed by Meister Schulz, Berlin.

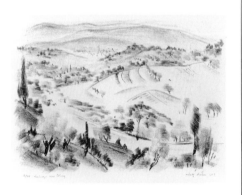

134
**Landscape near Coburg (or Land-
schaft bei Coburg)**
1929
Lithograph
11 ⅛ x 15 ¾ (28.1 x 40.1)
Edition: 30
Printed by Meister Schulz, Berlin.

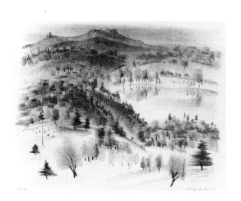

135
Landscape with Lake
1929
Lithograph
11 ⅛ x 13 ¹³⁄₁₆ (28.4 x 35.0)
Edition: 20
Printed by Meister Schulz, Berlin.

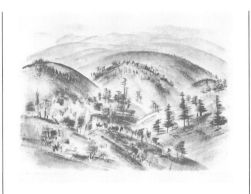

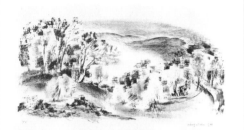

136
Landschaft bei Karlsbad
1929/1930
Lithograph
13 ½ x 19 ⅝ (34.4 x 49.8)
Edition: 10
Printed by Meister Schulz, Berlin.

137
Laub-Landschaft
1929
Lithograph
9 ⅞ x 19 ⅝ (25.1 x 49.9)
Edition: 5
Printed by Meister Schulz, Berlin.

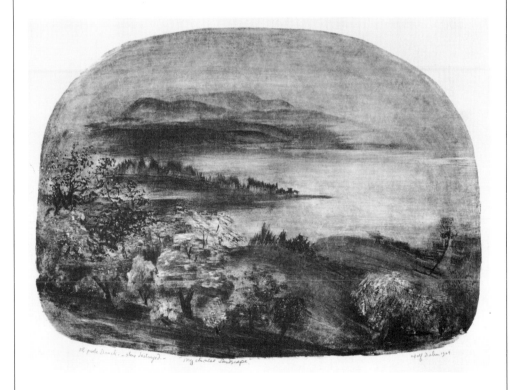

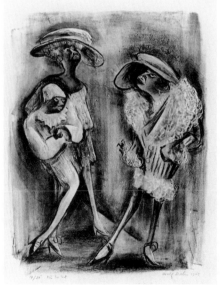

138
My Chinese Landscape
1929
Lithograph
12 ⁵⁄₁₆ x 17 ⅛ (31.4 x 43.4)
Edition: Trial proofs only
Printed by Meister Schulz, Berlin.

139
New Fur Coat
1929
Lithograph
16 ⁷⁄₁₆ x 13 (41.7 x 33.0)
Edition: 25
Printed by Meister Schulz, Berlin.

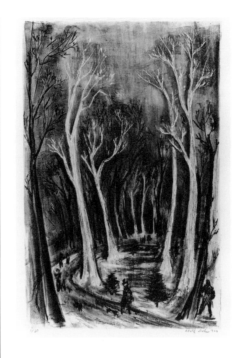

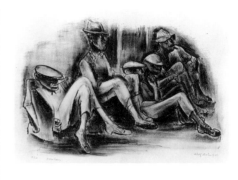

140
Night Fisher (or Die Nachtfischer)
1929
Lithograph
9 ¼ x 17 ⅛ (23.5 x 43.5)
Edition: 30
Printed by Meister Schulz, Berlin.

141a
Noon Hour
1929
Lithograph
12 ¾ x 20 (32.5 x 50.9)
Edition: 10
Printed by Meister Schulz, Berlin.

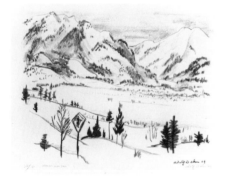

141
Night in the Tiergarten
1929
Lithograph
16 ⅞ x 11 ⅛ (42.8 x 28.4)
Edition: 20
Printed by Meister Schulz, Berlin.

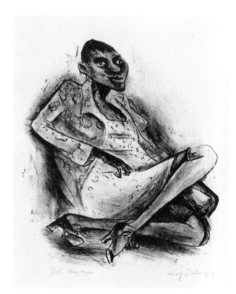

142
Oberammergau
1929
Transfer lithograph
9 ¾ x 12 ⅝ (24.9 x 32.1)
Edition: 30
Printed by Meister Schulz, Berlin.

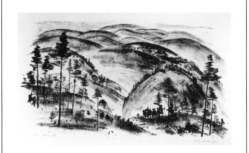

143
Rolling Hills
1929
Lithograph
12 ¾ x 24 (32.4 x 60.5)
Edition: 15
Printed by Meister Schulz, Berlin.

144
Sitting Negress
1929
Lithograph
10 ½ x 9 ⅛ (26.5 x 23.1)
Edition: 25
Printed by Meister Schulz, Berlin.

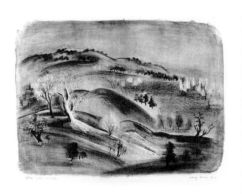

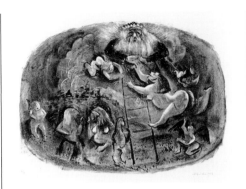

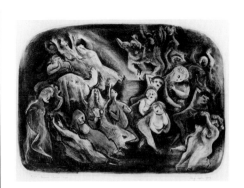

145
Spring Landscape
1929
Lithograph
14 ⅛ x 19 ¼ (36.0 x 48.9)
Edition: 30
Printed by Meister Schulz, Berlin.

146
The Virgin's Reward
1929/1930
Lithograph
14 ⅛ x 19 ⅝ (35.7 x 49.7)
Edition: 10

147
The Wise & Foolish Virgins
1929
Lithograph
16 ³⁄₁₆ x 23 ⅛ (41.0 x 58.8)
Edition: 30
Printed by Meister Schulz, Berlin.

148
Bayerische Buben
1930
Lithograph
10 ⅞ x 14 ⅜ (27.5 x 36.5)
Edition: 15, plus trial proofs
Printed by Meister Schulz, Berlin.

149
The Black Forest (or **Landschaft bei Oberammergau**)
1930
Lithograph
13 ½ x 18 ⅝ (34.4 x 47.4)
Edition: 30, plus trial proofs
Printed by Meister Schulz, Berlin.

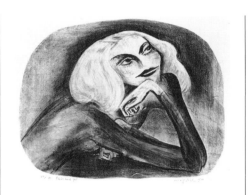

150
Blonde Haired Girl
1930
Lithograph
13 ⅛ x 17 ½ (33.4 x 44.3)
Edition: 20
Printed by Meister Schulz, Berlin.

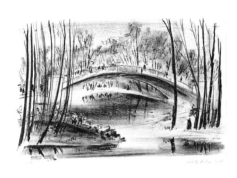

151
**Bridge in Tiergarten (or Brucke im
 Tiergarten)**
1930
Lithograph
8 ⅞ x 13 ½ (22.7 x 34.5)
Edition: 20
Printed by Meister Schulz, Berlin.

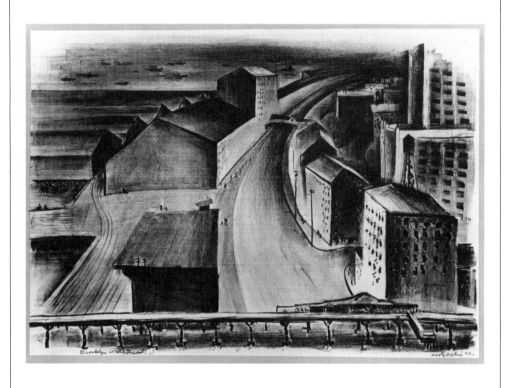

152
Brooklyn Waterfront
1930
Lithograph
13 ⅛ x 19 ⅛ (33.5 x 48.5)
Edition: Undetermined, plus artist's
 proofs
Printed by Meister Schulz, Berlin.

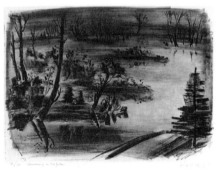

153
**Dammerung im Tiergarten (or
 Twilight in the Tiergarten)**
1930
Lithograph
12 ¹³⁄₁₆ x 17 ½ (32.5 x 44.5)
Edition: 20
Printed by Meister Schulz, Berlin.

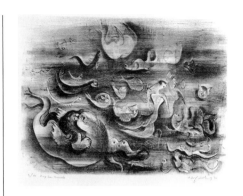

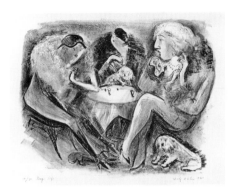

154
Deep Sea Animals
1930
Lithograph
12 ⅞ x 17 ⅛ (32.6 x 43.5)
Edition: 20
Printed by Meister Schulz, Berlin.

155
Dog's Life
1930
Lithograph
10 ⅝ x 13 ⅜ (27.0 x 34.0)
Edition: 20
Printed by Meister Schulz, Berlin.

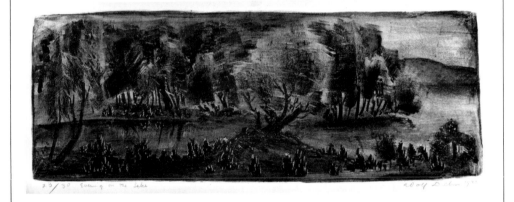

156
Evening on the Lake
1930
Lithograph
5 ⅞ x 15 ¾ (14.8 x 40.0)
Edition: 30
Printed by Meister Schulz, Berlin.

157
Fight
1930
Lithograph
8 ⅞ x 11 ⅝ (22.5 x 29.5)
Edition: 15, plus trial proofs
Printed by Meister Schulz, Berlin.

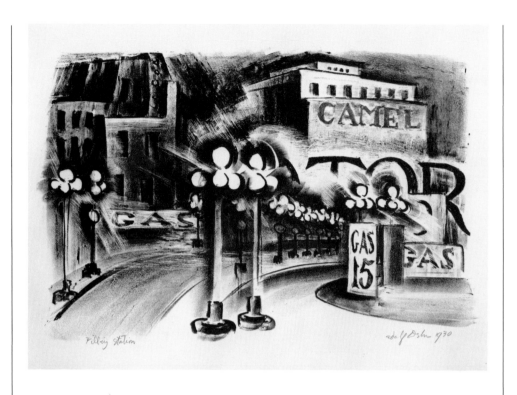

159
Fleur de Mal
1930
Lithograph
19 ½ x 11 ¾ (24.4 x 30.0)
Edition: 20, plus artist's proofs
Printed by Meister Schulz, Berlin.

158
Filling Station
1930
Lithograph
8 ¹³⁄₁₆ x 13 ½ (22.2 x 34.2)
Edition: 25
Printed by Meister Schulz, Berlin.

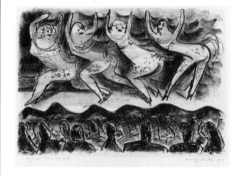

160
Foliage
1930
Lithograph
12 ⅝ x 16 ⅝ (32.2 x 42.2)
Edition: 25
Printed by Meister Schulz, Berlin.

161
Four End Girls
1930
Lithograph
9 ¼ x 13 ½ (23.5 x 34.2)
Edition: 20
Printed by Meister Schulz, Berlin.

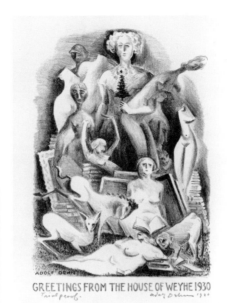

162
Greetings from Margaret de Silver
1930
Lithograph
6 ⅛ x 5 (15.6 x 12.7)
Edition: Undetermined
Printed as a Christmas card for Margaret
de Silver, Brooklyn, New York.

163
**Greetings from the House of Weyhe
1930**
1930
Lithograph
7 ¹/₁₆ x 5 (18.0 x 12.7) (including title)
Edition: Undetermined
Printed as a Christmas card for the
Weyhe Gallery, New York.

164
Grey Landscape
Ca. 1930
Lithograph
7 ¼ x 9 ½ (18.4 x 24.1)
Edition: Trial proofs only

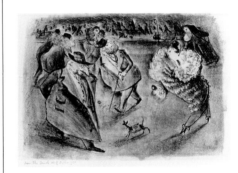

165
Hills and Valley
1930
Lithograph
12 ¾ x 17 ¾ (32.5 x 45.0)
Edition: 20
Printed by Meister Schulz, Berlin.

166
Hills near Brewster
1930
Lithograph
13 ⅛ x 17 ⅛ (33.4 x 43.6)
Edition: 25
Printed by Meister Schulz, Berlin.

167
Hurrying Along (or Promenade)
1930
Lithograph
9 ⁵/₁₆ x 13 ⅜ (23.6 x 34.0)
Edition: 15, plus artist's proofs
Printed by Meister Schulz, Berlin.

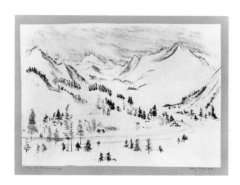

168

In the Bavarian Alps

1930

Lithograph

12¾ x 18⅞ (32.2 x 47.9)

Edition: 30

Printed by Meister Schulz, Berlin.

169

Innocence

1930

Lithograph

11½ x 9⅝ (29.2 x 24.2)

Edition: 25

Printed by Meister Schulz, Berlin.

170

Jewess

1930

Lithograph

16½ x 13⅝ (41.9 x 34.6)

Edition: 20

Printed by Meister Schulz, Berlin.

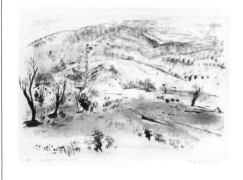

171

Landscape in Connecticut

1930

Lithograph

8¾ x 13⅜ (22.3 x 34.0)

Edition: 20

Printed by Meister Schulz, Berlin.

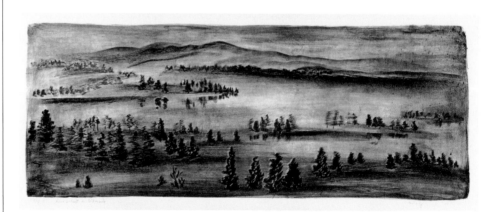

172

Landschaft in Eldorado

1930

Lithograph

9 x 23½ (22.8 x 59.7)

Edition: 30

Printed by Meister Schulz, Berlin.

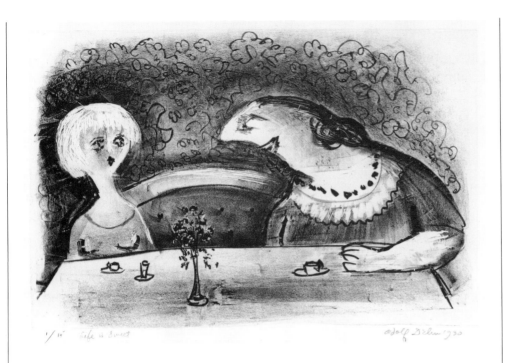

173
Life Is Sweet (or Poor Little Flower Girl)
1930
Lithograph
7 11/16 x 11 11/16 (19.6 x 29.8)
Edition: 15, plus trial proofs
Printed by Meister Schulz, Berlin.

"Many years ago, in a little night spot in Berlin, I saw the woman who owned the place talking to an innocent young blonde. The rapacious old gal was pointing out to the shy little thing how sweet and wonderful life in the club was for those who worked there—boy-friends with money, good clothes, champagne. The young girl was taking it all in. The contrast was unforgettable" (Adolf Dehn, "O Woman! O Frailty!" 49 *The Magazine of the Year*, February 1948, p. 133).

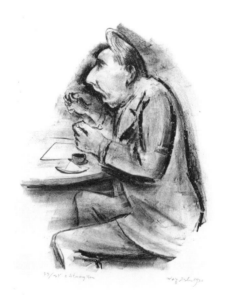

174
A Literary Man (or Theodore Dreiser at Child's)
1930
Lithograph
12 1/4 x 9 5/8 (31.2 x 24.5)
Edition: 25

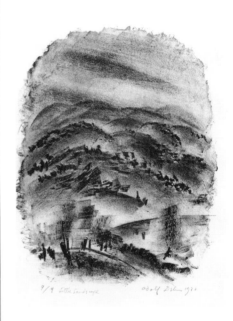

175
Little Landscape
1930
Lithograph
8 3/4 x 7 1/8 (22.2 x 18.0)
Edition: 9

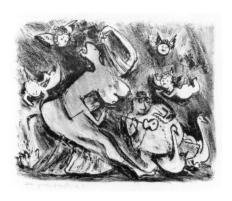

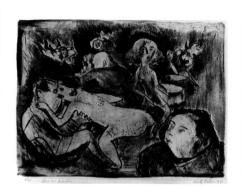

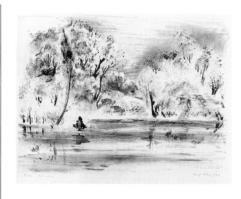

176
A Little Song and Dance
1930
Lithograph
7 1/16 x 9 1/8 (17.9 x 23.2)
Edition: 15, plus trial proofs

177
Love in Berlin
1930
Lithograph
11 x 15 1/8 (28.0 x 38.4)
Edition: 20

178
Midsummer (or Midsummer Landscape)
1930
Lithograph
14 5/8 x 19 1/4 (37.2 x 49.0)
Edition: 30
Printed by Meister Schulz, Berlin.

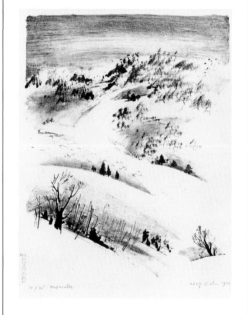

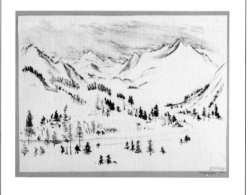

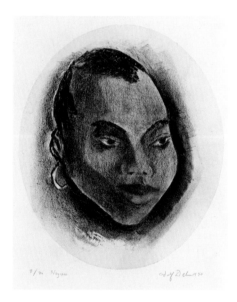

179
Midwinter (or Winter Landscape)
1930
Lithograph
13 1/4 x 10 3/4 (33.6 x 27.5)
Edition: 25, plus trial proofs
Printed by Meister Schulz, Berlin.

180
Mountains near Oberammergau
1930
Lithograph
13 x 18 7/8 (30.8 x 47.8)
Edition: 30
Printed by Meister Schulz, Berlin.

181
Negress
1930
Lithograph
8 3/4 x 7 1/4 (22.5 x 18.6)
Edition: 30
Printed by Meister Schulz, Berlin.

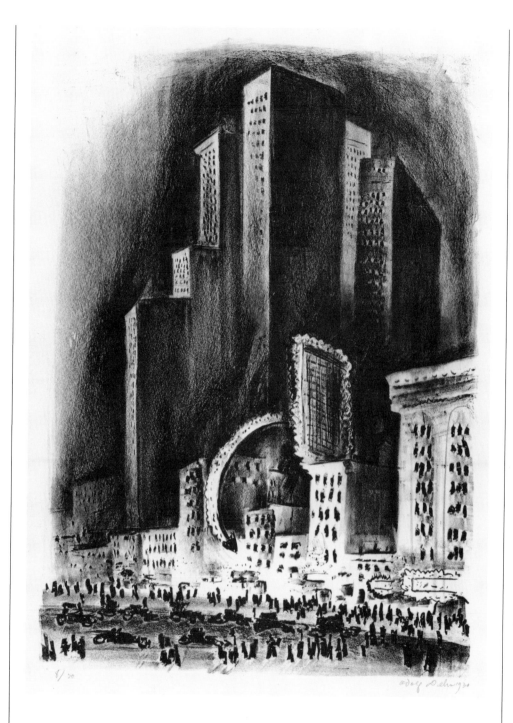

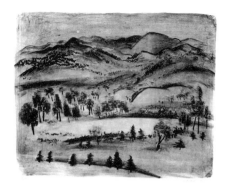

183
Night Landscape (or Nacht Land-
schaft)
1930
Lithograph
15 x 18⅞ (38.2 x 48.1)
Edition: 30
Printed by Meister Schulz, Berlin.

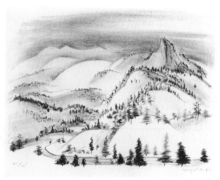

184
Oberammergau Hills in Winter
1930
Transfer lithograph
12¼ x 16⅝ (31.0 x 42.2)
Edition: 25

182
New York Night
1930
Lithograph
19⅛ x 13½ (48.5 x 34.2)
Edition: 30
Printed by Meister Schulz, Berlin.

185
The Old Rooster
1930
Lithograph
8 ¾ x 12 ⁷⁄₁₆ (22.3 x 31.6)
Edition: 20
Printed by Meister Schulz, Berlin.

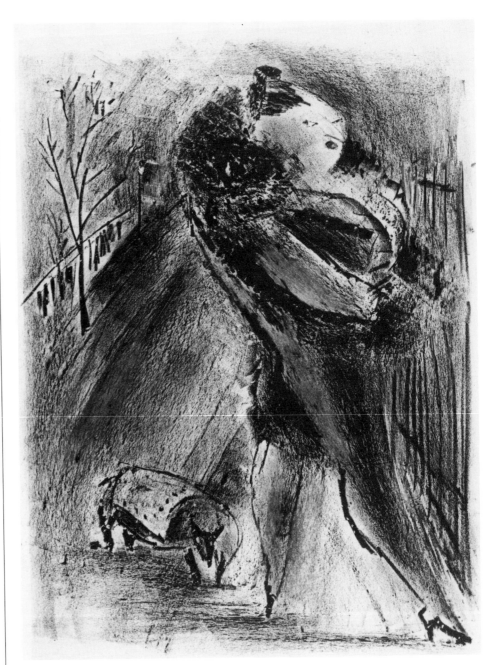

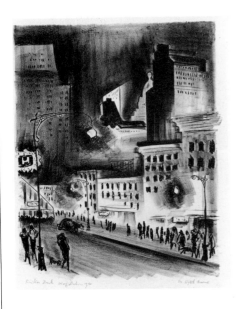

187
On Eighth Avenue
1930
Lithograph
18 ⅛ x 15 ⅛ (46.1 x 38.5)
Edition: 30, plus artist's proofs
Printed by Meister Schulz, Berlin.

186
The Old Whore (or Woman and Dog)
1930
Lithograph
11 ½ x 8 ¹³⁄₁₆ (29.0 x 22.4)
Edition: 20, plus trial proofs
Printed by Meister Schulz, Berlin.

188
Park at Marienbad
1930
Lithograph
14 ½ x 18 ½ (36.9 x 46.9)
Edition: 25
Printed by Meister Schulz, Berlin.

189
Der Professor
1930
Lithograph
8 ¾ x 6 (22.3 x 15.2)
Edition: Trial proofs only
Printed by Meister Schulz, Berlin.

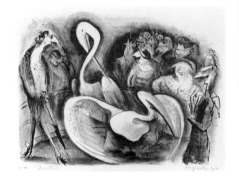

190
Queer Birds
1930
Lithograph
11 ⁷⁄₁₆ x 15 ⅝ (29.1 x 39.8)
Edition: 20
Printed by Meister Schulz, Berlin.

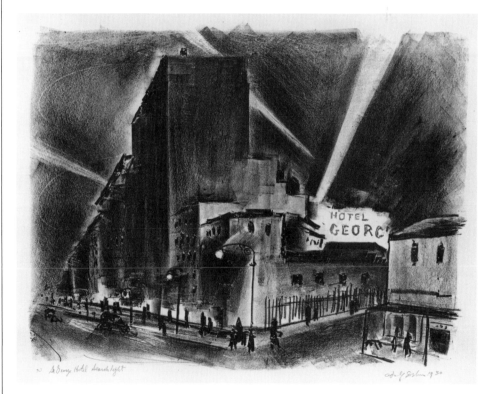

191
St. George Hotel Searchlight
1930
Lithograph
13 ½ x 17 ⅜ (34.2 x 44.2)
Edition: 30
Printed by Meister Schulz, Berlin.

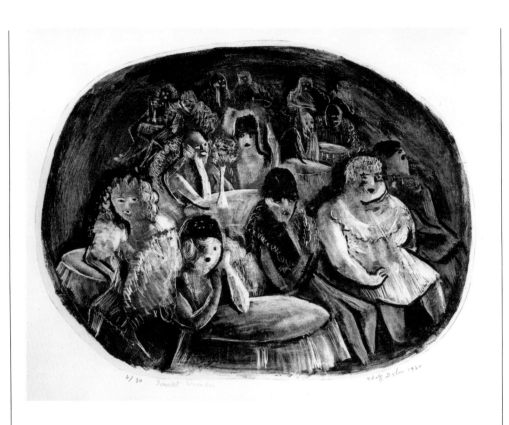

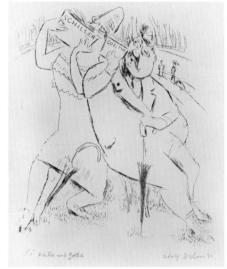

193

Schiller und Goethe (or **Goethe und Schiller**)

1930
Lithograph
8 ⅞ x 7 ½ (22.5 x 19.1)
Edition: 5
Printed by Meister Schulz, Berlin.

192

Scarlet Women

1930
Lithograph
10 ⅛ x 13 ⅝ (26.0 x 34.6)
Edition: 30, plus trial and artist's proofs
Printed by Meister Schulz, Berlin. "After the entire oval area was roughly covered with soft crayon[,] an uneven wash was made by rubbing it with a wet rag. The blacks in the figures were put in with the crayon and then white lines and light greys were drawn with the razor blade" (Adolf Dehn and Lawrence Barrett, *How to Draw and Print Lithographs*, 52).

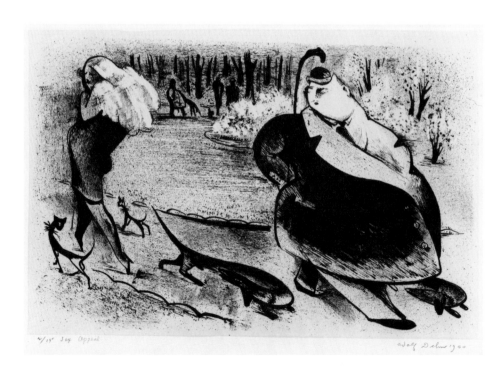

194

Sex Appeal

1930
Lithograph
8 ½ x 13 ⅛ (21.8 x 33.2)
Edition: 15
Printed by Meister Schulz, Berlin.

195
She Bitch
1930
Lithograph
13 ⅜ x 7 ½ (33.8 x 19.0)
Edition: 3 or 6
Printed by Meister Schulz, Berlin.

196
Skiing at Oberammergau
1930
Lithograph
10 ⅝ x 14 ⅞ (27.0 x 37.9)
Edition: 30
Printed by Meister Schulz, Berlin.

197
Snow
1930
Lithograph
13 ½ x 11 (34.1 x 28.1)
Edition: 30
Printed by Meister Schulz, Berlin. This
 lithograph was selected for *Fifty Prints
 of the Year* (1931).

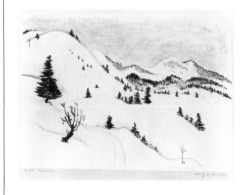

198
Snow Hills (or Snow Landscape)
1930
Lithograph
10 ⅝ x 14 ¾ (27.0 x 37.5)
Edition: 30
Printed by Meister Schulz, Berlin.

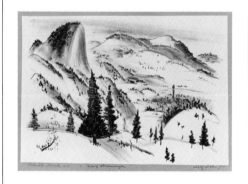

199
View of Oberammergau
1930
Lithograph
12 ½ x 17 ½ (31.9 x 44.5)
Edition: Undetermined, plus artist's
 proofs
Printed by Meister Schulz, Berlin.

200
View out of Flechtheim's Window
1930
Lithograph
10 ⅛ x 15 ⅛ (25.8 x 38.6)
Edition: 25
Printed by Meister Schulz, Berlin.

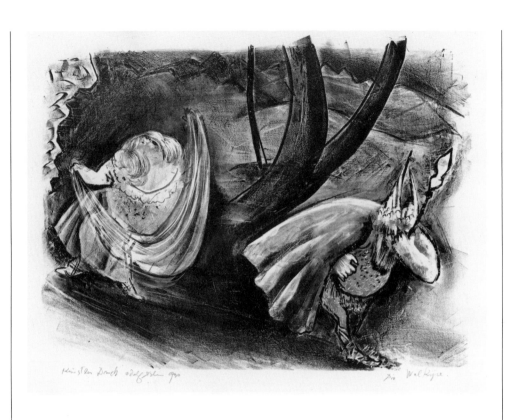

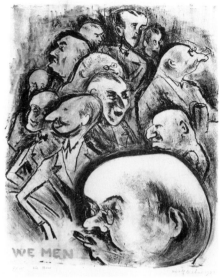

201
Die Walküre (*see Plate 5*)

1930
Lithograph
13 ⅜ x 18 (34.0 x 45.8)
Edition: 25, plus artist's proofs
Printed by Meister Schulz, Berlin.

202
We Men
1930
Lithograph
12 ⅞ x 10 ⅞ (32.6 x 27.6)
Edition: 15
Printed by Meister Schulz, Berlin.

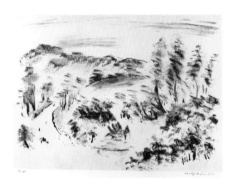

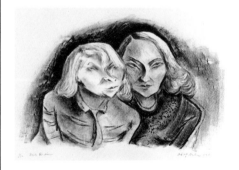

203
Winding Road
1930
Lithograph
10 ⅞ x 14 ¾ (27.6 x 37.5)
Edition: 20
Printed by Meister Schulz, Berlin.

204
Zwei Russinin
1930
Lithograph
9 ¼ x 14 ½ (23.5 x 36.8)
Edition: 10
Printed by Meister Schulz, Berlin.

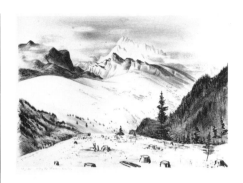

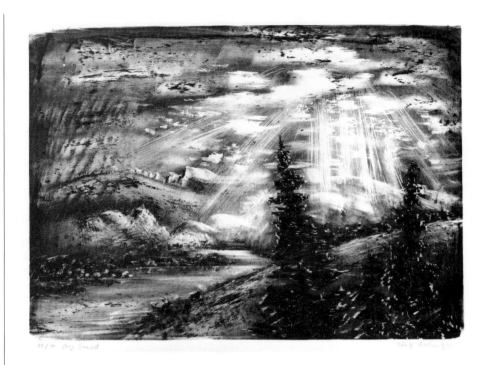

205
Along the Italien [*sic*] Border
1931
Lithograph
10 ⅝ x 15 ¼ (27.0 x 38.6)
Edition: 25
Printed by Edmond Desjobert, Paris.

206
Big Sunset
1931
Lithograph
10 ½ x 15 ¹/₁₆ (26.5 x 38.3)
Edition: 30
Printed by Edmond Desjobert, Paris.

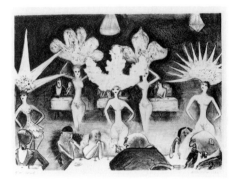

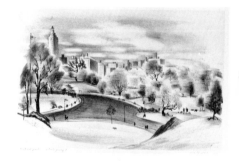

207
Burlesque Line
1931
Lithograph
9 ½ x 13 ⅛ (24.2 x 33.3)
Edition: Undetermined, plus trial and
 artist's proofs
Printed by Grant Arnold, Art Students
 League, New York.

208
Cabaret
1931/1932
Lithograph
10 ⅝ x 14 ¹¹/₁₆ (27.0 x 37.3)
Edition: 20
Printed by Edmond Desjobert, Paris.

209
Central Park
1931
Lithograph
8 ⁷/₁₆ x 13 ⅛ (21.6 x 33.3)
Edition: 20, plus artist's proofs
Printed by Edmond Desjobert, Paris.

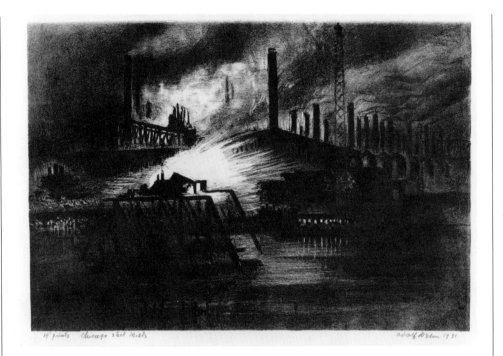

211
Christmas Eve
1931
Lithograph
8 ⅜ x 11 ⅛ (21.3 x 28.3)
Edition: 30

210
Chicago Steel Mills
1931
Lithograph
9 ½ x 14 (24.0 x 35.5)
Edition: 15, plus trial proofs
Printed by Grant Arnold, Art Students
 League, New York.

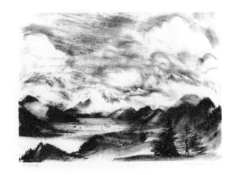

212
Cloudy Morning over the Lake
1931
Lithograph
8 ⅞ x 12 ½ (22.5 x 31.9)
Edition: 20, plus artist's proofs
Printed by Edmond Desjobert, Paris.

213
Gladys at the Clam House
(*see Plate 6*)
1931
Lithograph
10 x 15 ³⁄₁₆ (25.6 x 38.6)
Edition: 10, plus artist's proofs
Printed by Edmond Desjobert, Paris.

214
The Great Divide
1931/1932
Lithograph
9 5/16 x 15 1/8 (23.8 x 38.4)
Edition: 15
Printed by Edmond Desjobert, Paris.

215
Grey Day
1931
Lithograph
10 3/8 x 13 9/16 (26.3 x 34.5)
Edition: 20, plus artist's proofs
Printed by Edmond Desjobert, Paris.

216
Harlem Orchids
1931
Lithograph
8 5/8 x 13 (22.0 x 32.9)
Edition: 15
Printed by Edmond Desjobert, Paris.

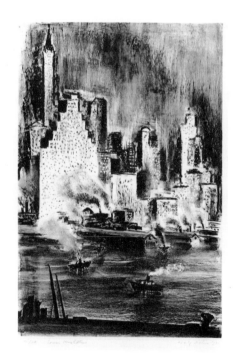

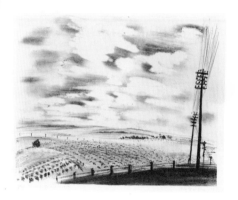

217
Lower Manhattan (*see Plate 7*)
1931
Lithograph
15 1/8 x 10 3/16 (38.5 x 25.8)
Edition: 20
Printed by Edmond Desjobert, Paris.
 This lithograph was selected for *Fifty Prints of the Year* (1933).

218
Minnesota Landscape
1931
Lithograph
8 3/4 x 10 13/16 (22.2 x 27.5)
Edition: 10
Printed by Edmond Desjobert, Paris.

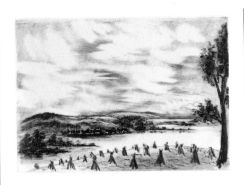

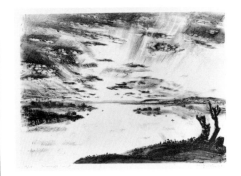

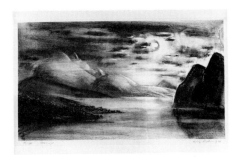

219
Minnesota Landscape (or Autumn in Minnesota)
1931
Lithograph
8 15/16 x 12 15/16 (22.8 x 32.8)
Edition: 20
Printed by Edmond Desjobert, Paris.

220
Minnesota Sunset
1931
Lithograph
10 1/4 x 14 7/16 (26.0 x 36.7)
Edition: 20
Printed by Edmond Desjobert, Paris.

221
Moonrise
1931
Lithograph
8 1/2 x 15 1/4 (21.5 x 38.6)
Edition: 20, plus artist's proofs
Printed by Edmond Desjobert, Paris.

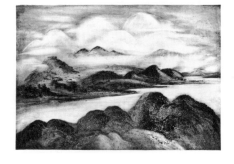

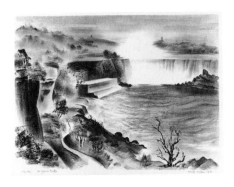

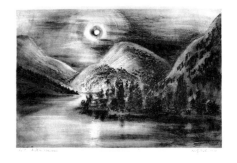

222
Mountains in the Clouds
1931
Lithograph
9 13/16 x 14 3/8 (24.8 x 36.6)
Edition: 10
Printed by Edmond Desjobert, Paris.

223
Niagara Falls
1931
Lithograph
10 13/16 x 14 7/8 (27.5 x 37.7)
Edition: 25, plus trial and artist's proofs
Printed by Grant Arnold, Art Students
 League, New York.

224
Night on Weissensee
1931
Lithograph
9 13/16 x 15 (25.0 x 38.1)
Edition: 10, plus artist's proofs
Printed by Edmond Desjobert, Paris.

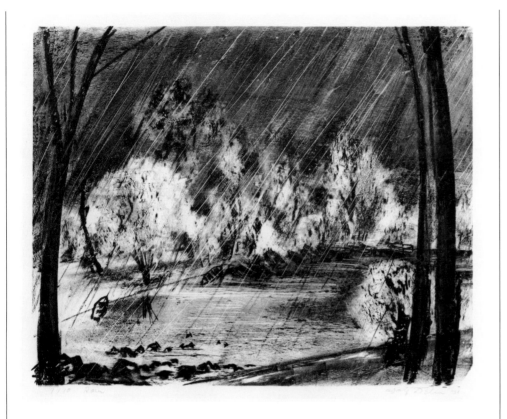

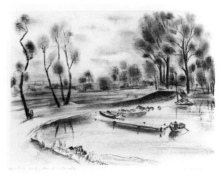

226
Road at Waterville
1931
Lithograph
9 ⅛ x 12 ½ (23.1 x 31.8)
Edition: 15, plus artist's proofs
Printed by Edmond Desjobert, Paris.

225
Rain
1931
Lithograph
8 ⅜ x 10 ⅝ (21.3 x 27.0)
Edition: 10, plus artist's proofs
Printed by Edmond Desjobert, Paris.

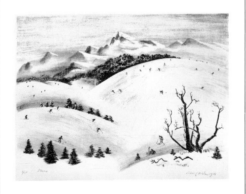

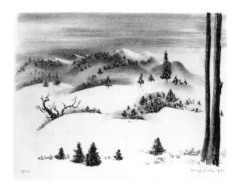

227
Skiers
1931
Lithograph
10 ⁷⁄₁₆ x 14 ½ (26.3 x 36.8)
Edition: 20
Printed by Grant Arnold, Art Students
 League, New York.

228
Snow in the Mountains (or **Winter** or
 Snow Hills)
1931
Lithograph
9 x 12 ⅞ (22.6 x 32.8)
Edition: 25 or 30, plus trial proofs
Printed by Grant Arnold, Art Students
 League, New York.

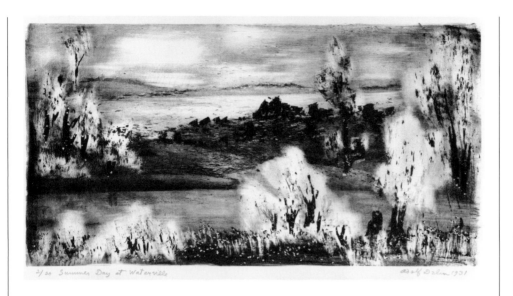

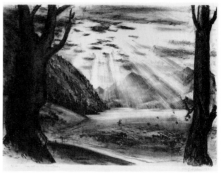

230
Sunset in the Mountains
1931
Lithograph
10¾ x 14¾ (27.3 x 37.5)
Edition: 10
Printed by Edmond Desjobert, Paris.

229
Summer Day at Waterville
1931
Lithograph
6¹¹⁄₁₆ x 12⅞ (16.9 x 32.8)
Edition: 20, plus artist's proofs
Printed by Edmond Desjobert, Paris.

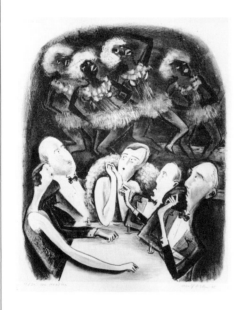

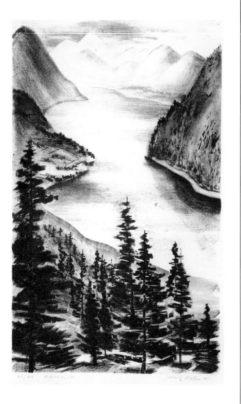

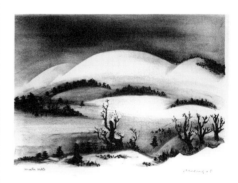

231
We Nordics
1931
Lithograph
13½ x 10¹⁵⁄₁₆ (34.4 x 28.0)
Edition: 25, plus artist's proofs
Printed by Edmond Desjobert, Paris.

232
Weissensee
1931
Lithograph
14½ x 8⅞ (36.8 x 22.6)
Edition: 25, plus artist's proofs
Printed by Edmond Desjobert, Paris.

233
Winter Hills
1931
Lithograph
9¹³⁄₁₆ x 13⅞ (25.0 x 35.2)
Edition: 25, plus trial proofs
Printed by Grant Arnold, Art Students
 League, New York.

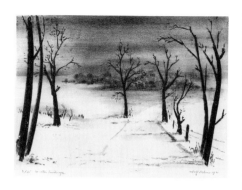

234
Winter Landscape
1931
Lithograph
10 ½ x 14 ⁹⁄₁₆ (26.5 x 37.0)
Edition: 25, plus artist's proofs
Printed by Grant Arnold, Art Students
League, New York.

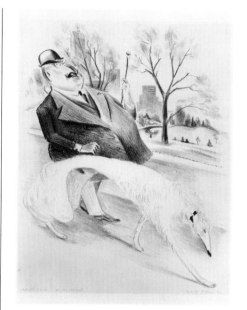

235
An Aristocrat
1932
Lithograph
12 ¾ x 10 ⅜ (32.5 x 26.3)
Edition: 10, plus artist's proofs
Printed by Edmond Desjobert, Paris.

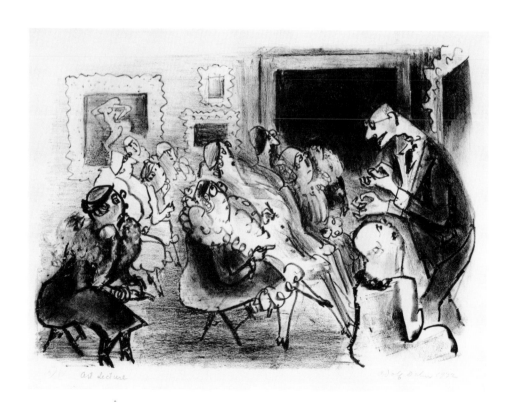

236
Art Lecture
1932
Lithograph
7 ⅞ x 11 (20.0 x 28.0)
Edition: 15
Printed by Edmond Desjobert, Paris.

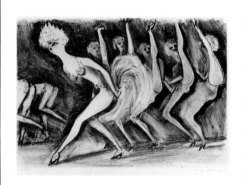

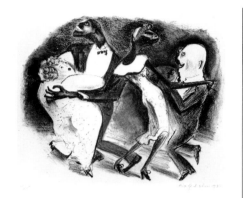

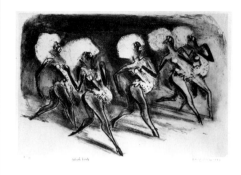

237
Big Hearted Girls
1932
Lithograph
10 ½ x 15 ¼ (26.7 x 38.9)
Edition: 10
Printed by Edmond Desjobert, Paris.

238
Black and White
1932
Lithograph
6 ½ x 8 ⅜ (16.6 x 21.2)
Edition: 10, plus artist's proofs
Printed by Edmond Desjobert, Paris.

239
Blackbirds
1932
Lithograph
9 ⅞ x 14 ⅞ (25.1 x 37.8)
Edition: 10
Printed by Edmond Desjobert, Paris.

240
Catholic Church at Waterville
1932
Lithograph
9 ⅝ x 13 ⅛ (24.5 x 33.2)
Edition: 15
Printed by Edmond Desjobert, Paris.

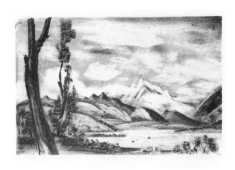

241
Cloudy Day at Weissensee (or Cloudy Day in the Mountains)
1932
Lithograph
9¾ x 15 (24.8 x 38.2)
Edition: 20, plus artist's proofs
Printed by Edmond Desjobert, Paris.

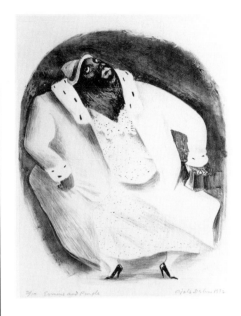

242
Ermine and Purple
1932
Lithograph
8 1/16 x 6¾ (20.5 x 17.1)
Edition: 10
Printed by Edmond Desjobert, Paris.

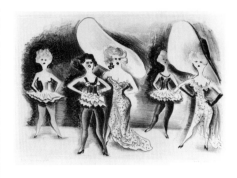

243
Flora Dora Girls (or Curtain)
1932
Lithograph
9⅞ x 14⅞ (25.1 x 37.8)
Edition: 10
Printed by Edmond Desjobert, Paris.

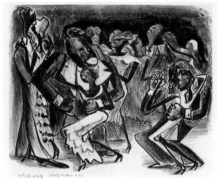

244
Harlem Night
1932
Lithograph
9 x 11⅛ (22.8 x 28.2)
Edition: 10, plus artist's proofs
Printed by Edmond Desjobert, Paris.

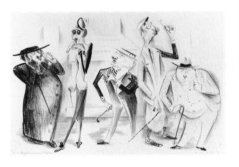

245
Hypochondriacs at Karlsbad
(*see Plate 8*)
1932
Lithograph
8¾ x 14⅛ (22.2 x 35.8)
Edition: 10
Printed by Edmond Desjobert, Paris.

246
The Immaculate Conception
1932
Lithograph
7⅞ x 10¼ (20.0 x 26.2)
Edition: 12, plus trial proofs
Printed by Edmond Desjobert, Paris.

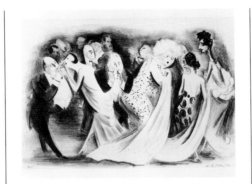

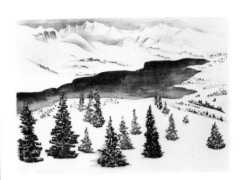

247
Impasse
1932
Lithograph
9 13/16 x 15 (24.8 x 38.2)
Edition: 15
Printed by Edmond Desjobert, Paris.

248
Lake in Winter Time
1932
Lithograph
10 3/8 x 15 1/16 (26.5 x 38.3)
Edition: 25
Printed by Edmond Desjobert, Paris.

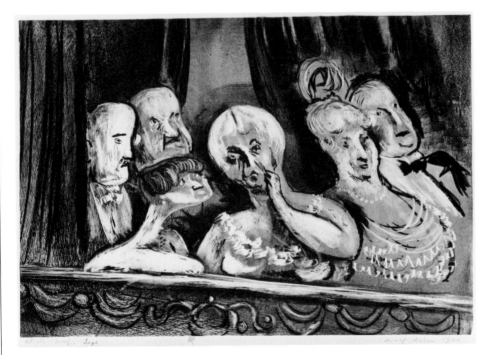

249
Loge
1932
Lithograph
9 3/4 x 14 1/2 (24.9 x 36.7)
Edition: 20, plus artist's proofs
Printed by Edmond Desjobert, Paris.
 "Before working[,] this stone was
 heated so that I could just manage to
 hold my hand on it. Blacks were then
 created with ease for the heat softened
 the greasy crayon. After rubbing hard
 the light areas were created by erasing
 and scraping. The heating makes for
 an especially juicy quality in the print"
 (Adolf Dehn and Lawrence Barrett,
 How to Draw and Print Lithographs, 58).

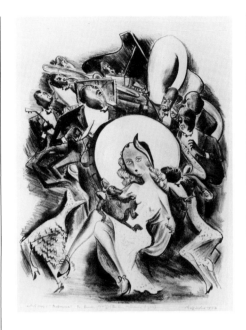

250
Madonna (or **Jazz Madonna**)
1932
Lithograph
13 ⅝ x 10 ¾ (34.7 x 27.3)
Edition: 25, plus artist's proofs
Printed by Edmond Desjobert, Paris.

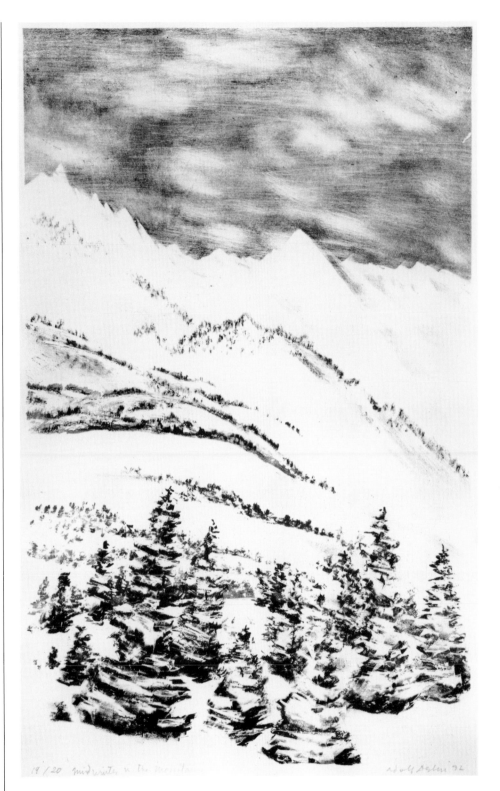

251
Me and My Wife
1932
Lithograph
6 ¾ x 8 ⅞ (17.2 x 22.5)
Edition: 10
Printed by Edmond Desjobert, Paris.

252
Midwinter in the Mountains
1932
Lithograph
15 ⁵⁄₁₆ x 9 ⅝ (39.0 x 24.4)
Edition: 20
Printed by Edmond Desjobert, Paris.

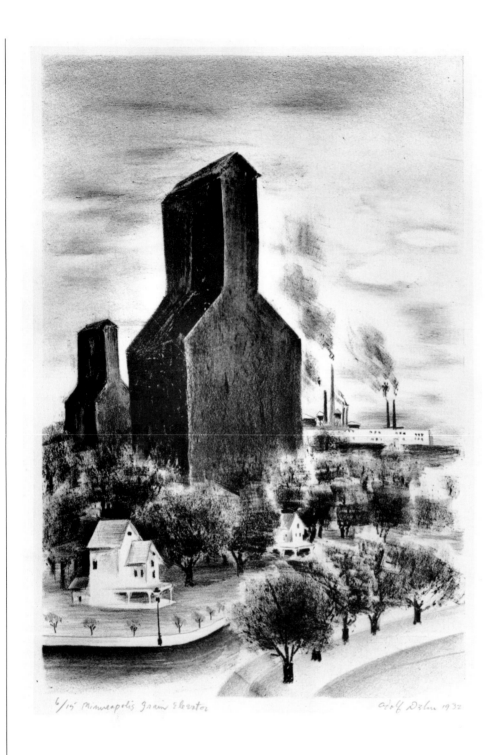

6/15 Minneapolis Grain Elevator Adolf Dehn 1932

253
Minneapolis Grain Elevator
1932
Lithograph
13 ⅜ x 9 ⅛ (33.9 x 23.2)
Edition: 15
Printed by Edmond Desjobert, Paris.

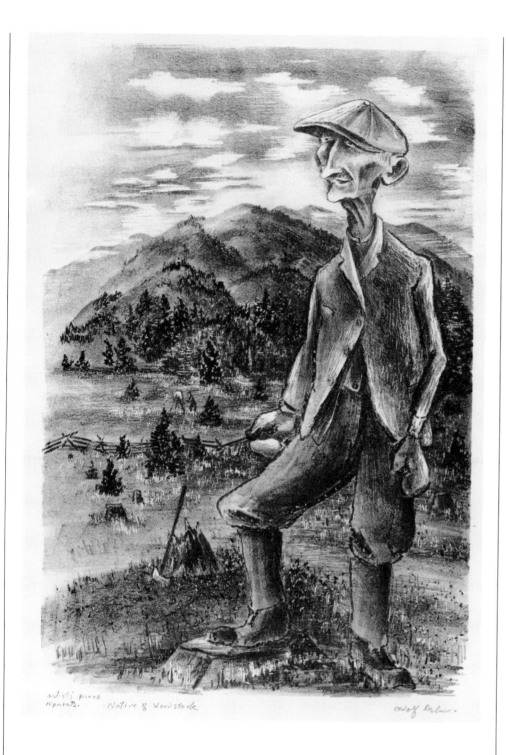

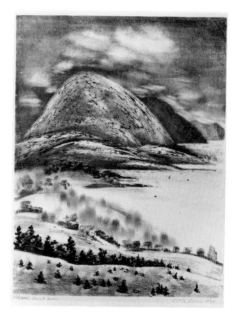

255
Round Hills
1932
Lithograph
13 ½ x 10 ½ (34.2 x 26.8)
Edition: 20, plus trial proofs
Printed by Edmond Desjobert, Paris.

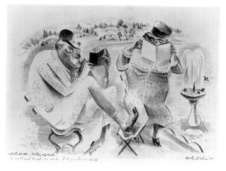

254
Native of Woodstock
1932
Lithograph
13 ⁹⁄₁₆ x 9 ¼ (34.4 x 23.5)
Edition: 12 or 15, plus artist's proofs
Printed by Grant Arnold, Art Students
 League, New York. This lithograph
 received first prize from the Philadel-
 phia Art Alliance in 1934.

256
Shelley and Keats
1932
Lithograph
8 ⅛ x 11 ¾ (20.8 x 29.8)
Edition: 20, plus artist's proofs
Printed by Edmond Desjobert, Paris.

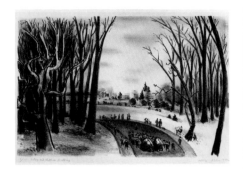

257
Sisters and Children Strolling
1932
Lithograph
9 ½ x 14 ¹³⁄₁₆ (24.2 x 37.8)
Edition: 10
Printed by Edmond Desjobert, Paris.

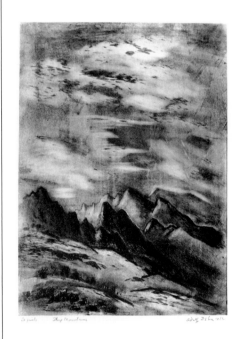

259
Steep Mountains (or Grey Landscape or Mountains)
1932
Lithograph
14 ⅛ x 10 ⁷⁄₁₆ (35.9 x 26.5)
Edition: 10 or 20
Printed by Edmond Desjobert, Paris.

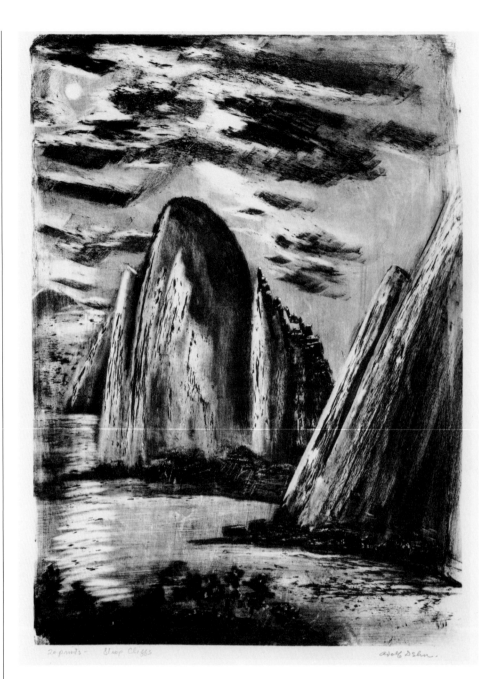

258
Steep Cliffs (or Moonlight or Steep Mountains)
1932
Lithograph
15 x 10 ⅞ (38.1 x 27.7)
Edition: 20
Printed by Edmond Desjobert, Paris.

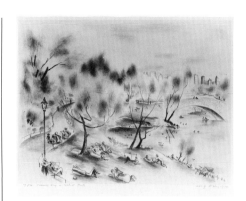

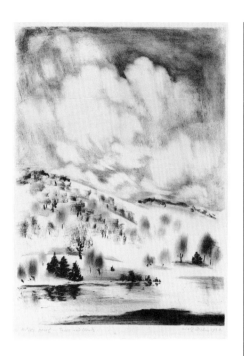

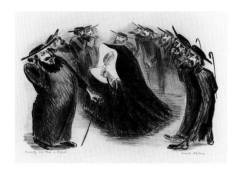

260
Summer Day in Central Park
1932
Lithograph
10 ¼ x 13 ⅞ (26.0 x 35.3)
Edition: 20
Printed by Edmond Desjobert, Paris.

261
Trees and Clouds
1932
Lithograph
14 ³⁄₁₆ x 10 ¼ (36.1 x 26.1)
Edition: 20, plus artist's proofs
Printed by Edmond Desjobert, Paris.

262
Twenty Six Men & a Girl
1932
Lithograph
9 ¼ x 14 ⅝ (23.5 x 37.7)
Edition: 20
Printed by Edmond Desjobert, Paris.

263
Under Brooklyn Bridge
1932
Lithograph
9 ¼ x 14 ⅞ (23.6 x 37.7)
Edition: 15
Printed by Edmond Desjobert, Paris.

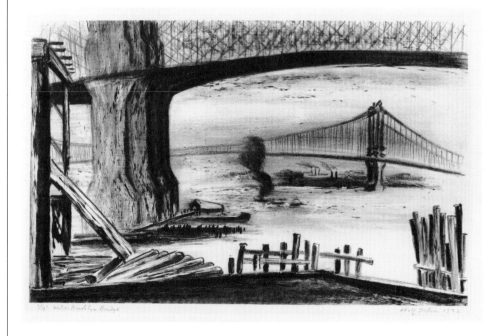

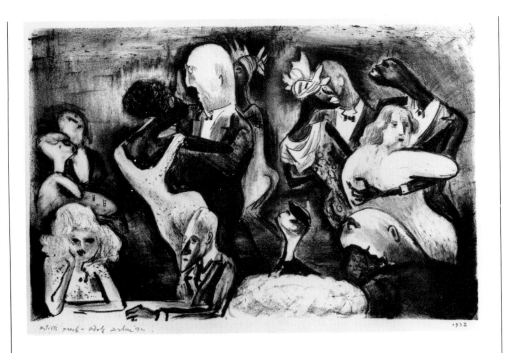

265
Village Church
1932
Lithograph
8 7/16 x 12 3/4 (21.4 x 32.4)
Edition: 20
Printed by Edmond Desjobert, Paris.

264
Up in Harlem
1932
Lithograph
8 3/4 x 13 3/4 (22.2 x 35.1)
Edition: 15, plus artist's proofs
Printed by Edmond Desjobert, Paris.

266
Wagon Bridge at Waterville
1932
Lithograph
9 3/4 x 15 1/8 (24.8 x 38.5)
Edition: 20
Printed by Edmond Desjobert, Paris.

267
Willows #2 (or **Willows**)
1932
Lithograph
8 1/2 x 12 9/16 (21.5 x 31.9)
Edition: 15, plus artist's proofs
Printed by Edmond Desjobert, Paris.

268
Beach on Martha's Vineyard (or Scene at Martha's Vineyard)
1933
Lithograph
5 x 9¾ (12.8 x 24.8)
Edition: 30

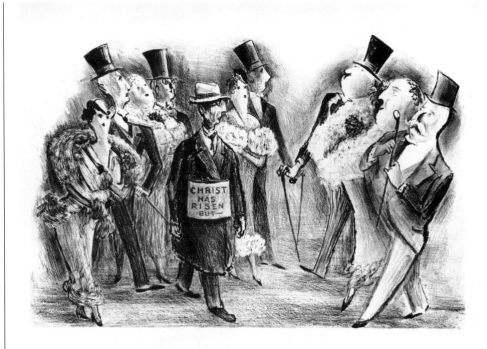

269
Christ Has Risen
Ca. 1933
Lithograph
9 x 13¾ (22.9 x 35.0)
Edition: Trial proofs only

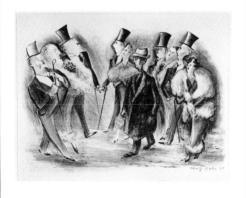

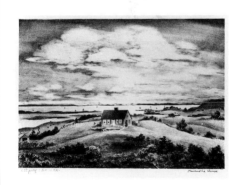

270
Easter Parade
1933
Lithograph
9⅞ x 13⅞ (25.0 x 35.3)
Edition: Contemporary Print Group edition, 300
Printed by George Miller, New York. This lithograph was a selection of the portfolio, *American Scene No. 1.*

271
Fishing Boats at Menemsha (or Fishing Docks at Menemsha)
Ca. 1933
Lithograph
8¹⁵⁄₁₆ x 13¹³⁄₁₆ (22.7 x 35.1)
Edition: Trial and artist's proofs only

272
Menemsha House
Ca. 1933
Lithograph
8⁵⁄₁₆ x 11¹³⁄₁₆ (21.0 x 30.1)
Edition: 70, plus trial proofs

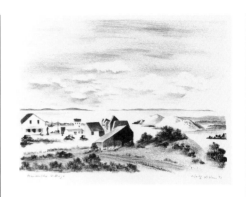

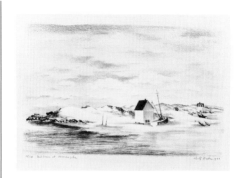

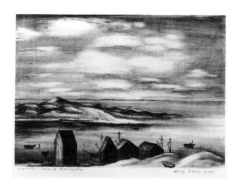

273
Menemsha Village
1933
Lithograph
10 ⅛ x 14 1/16 (25.7 x 35.6)
Edition: Undetermined

274
Sand Dunes at Menemsha
1933
Lithograph
10 x 15 ⅞ (25.4 x 40.4)
Edition: 20

275
Scene at Menemsha
1933
Lithograph
6 ⅞ x 9 ¾ (17.5 x 24.8)
Edition: 30

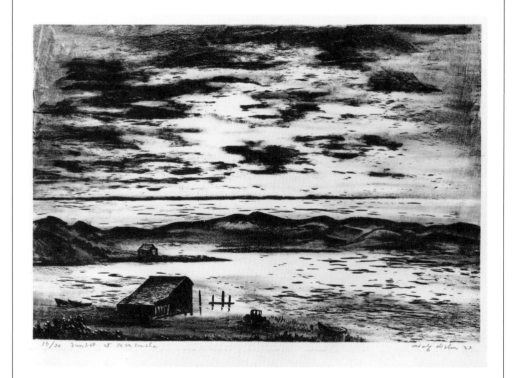

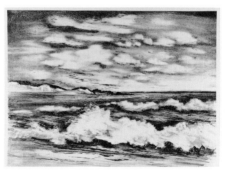

276
Sunset at Menemsha
1933
Lithograph
9 ⅜ x 13 ¾ (23.8 x 34.9)
Edition: 20

277
Waves
1933
Lithograph
10 ⅜ x 14 ¼ (26.4 x 36.2)
Edition: 20
Printed by George Miller, New York.

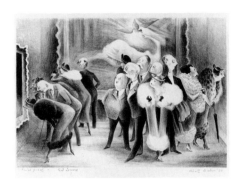

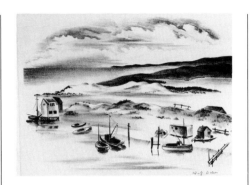

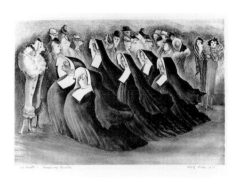

278
Art Lovers (*see Plate 9*)
1934
Lithograph
8 ⅞ x 12 ⅞ (22.6 x 32.8)
Edition: 100, plus trial proofs
Printed by George Miller, New York.
This lithograph was a selection of the
Adolf Dehn Print Club in 1934 and
1935.

279
Boats and Dunes, Martha's Vineyard
1934
Lithograph
9 ¾ x 13 ½ (24.6 x 34.4)
Edition: Associated American Artists
edition, 250; artist's edition, 10
Printed by George Miller, New York.

280
Broadway Parade
1934/1935
Lithograph
9 ¼ x 13 ⅞ (23.5 x 35.3)
Edition: 100, plus trial proofs
Printed by George Miller, New York.
This lithograph was a selection of the
Adolf Dehn Print Club in 1934 and
1935.

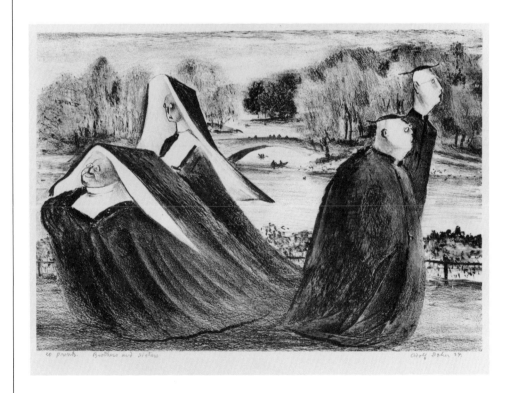

281
Brothers and Sisters
1934
Lithograph
9 9/16 x 13 ⅞ (24.4 x 35.1)
Edition: 20
Printed by George Miller, New York.

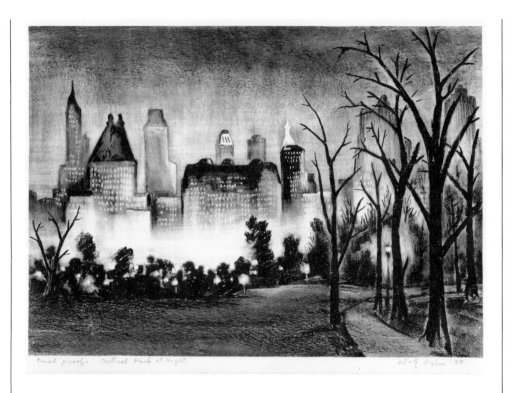

283
Creek in Minnesota
1934
Lithograph
8 13/16 x 12 15/16 (22.4 x 32.8)
Edition: 100
Printed by George Miller, New York.
This lithograph was a selection of the Adolf Dehn Print Club in 1934 and 1935.

282
Central Park at Night (*see Plate 10*)
1934
Lithograph
8 15/16 x 12 13/16 (22.7 x 32.5)
Edition: 100, plus trial proofs
Printed by George Miller, New York.
This lithograph was a selection of the Adolf Dehn Print Club in 1934 and 1935. "My lithographic problem was to try to get the velvet blacks of the foreground, the intense glow of light, and the dull glow of the sky with the skyscrapers towering, and yet marching across the format of my paper. This I tried to do by combining pure washes with rubbed tones, scratching and scraping these down to light grays and pure whites, and then drawing strong blacks over the rubbed and washed tones" (Thomas Craven, ed., *Treasury of American Prints* [New York: Simon and Schuster, 1939], n.p.).

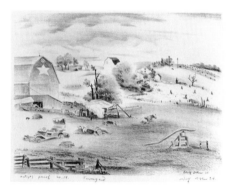

284
Farmyard
1934
Lithograph
9 3/4 x 12 15/16 (24.8 x 32.9)
Edition: Undetermined, plus artist's proofs
Printed by George Miller, New York.

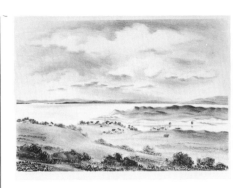

285
Menemsha Village
1934
Lithograph
8¹⁵⁄₁₆ x 13 (22.8 x 32.9)
Edition: 100
Printed by George Miller, New York.
This lithograph was a selection of the Adolf Dehn Print Club in 1934 and 1935.

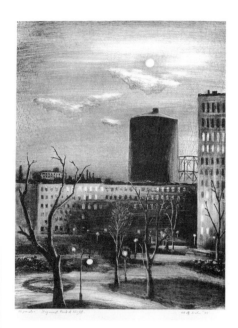

286
Stuyvesant Park at Night
1934
Lithograph
13³⁄₁₆ x 9¹⁵⁄₁₆ (33.5 x 25.2)
Edition: 25
Printed by George Miller, New York.

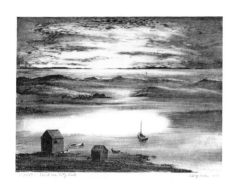

287
Sunset over Cuttyhunk
1934
Lithograph
9⅝ x 13¼ (24.4 x 33.7)
Edition: 25

288
Swans
1934
Lithograph
9½ x 13¹³⁄₁₆ (24.0 x 35.1)
Edition: 25 or 30
Printed by George Miller, New York.

289
Gayhead Cliffs
1935
Lithograph
9⅞ x 14⅛ (25.1 x 35.8)
Edition: 40

290
Gayhead Lighthouse
1935
Lithograph
9¹³⁄₁₆ x 13¹⁵⁄₁₆ (24.9 x 35.3)
Edition: 100, plus trial proofs
Printed by George Miller, New York.
This lithograph was a selection of the Adolf Dehn Print Club in 1936.

291
Minnesota Farm
1935
Lithograph
9 ⅜ x 13 ⅜ (23.8 x 34.0)
Edition: 100, plus trial proofs
Printed by George Miller, New York.
 This lithograph was a selection of the
 Adolf Dehn Print Club in 1936.

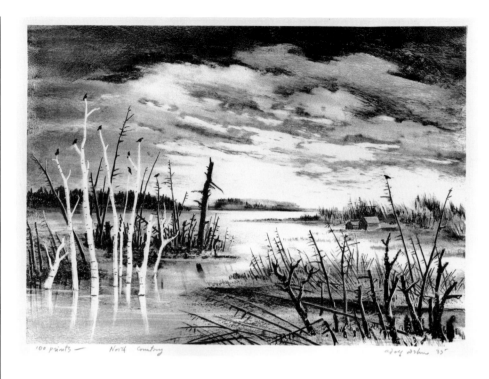

292
North Country (*see Plate 11*)
1935
Lithograph
9 ⁹⁄₁₆ x 13 ¹¹⁄₁₆ (24.4 x 34.8)
Edition: 100, plus trial proofs
Printed by George Miller, New York.
 This lithograph was a selection of the
 Adolf Dehn Print Club in 1936. "In
 this landscape after the sky was
 rubbed leaving greys and blacks the
 white parts were erased with an eraser
 and the lighter greys shaved off with a
 razor blade. This was true also of the
 lower water area. The dead white
 birches were dug out with the blade"
 (Adolf Dehn and Lawrence Barrett,
 How to Draw and Print Lithographs, 58).

293
Road to Gayhead
1935
Lithograph
10 ⅛ x 14 (25.7 x 35.5)
Edition: 40
Printed by George Miller, New York.

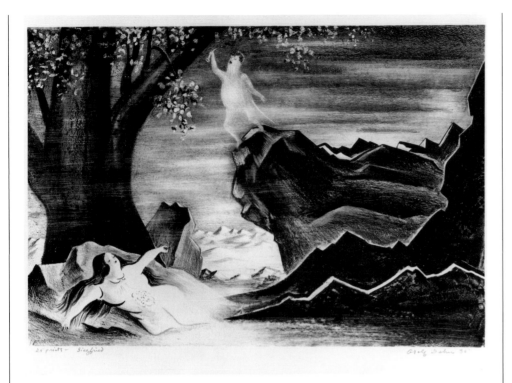

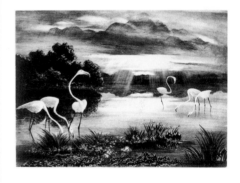

295
Tristan & Isolde
1935
Lithograph
9 7/16 x 14 5/16 (26.6 x 36.4)
Edition: 25
Printed by George Miller, New York.

294
Siegfried
1935
Lithograph
9 5/8 x 14 1/4 (24.5 x 36.2)
Edition: 25
Printed by George Miller, New York.

296
Feathered Friends
Ca. 1936
Lithograph
9 x 12 13/16 (22.9 x 32.6)
Edition: American Artists Group edition, undetermined

297
Flamingoes
1936
Lithograph
9 7/16 x 13 5/16 (24.0 x 33.8)
Edition: Associated American Artists edition, 203

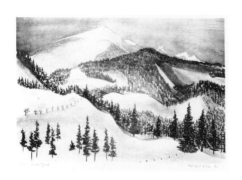

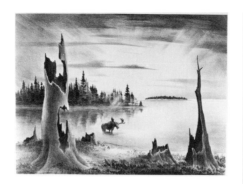

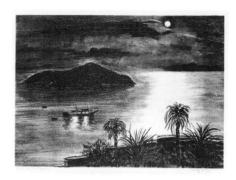

298
In the Tyrol
1936
Lithograph
9 ⅞ x 14 ¾ (25.2 x 37.5)
Edition: 15
Printed by Edmond Desjobert, Paris.

299
Morning on the Lake
1936
Lithograph
9 ¾ x 13 ⁵⁄₁₆ (24.8 x 33.8)
Edition: American Artists Group edition, undetermined

300
Night at Ragusa
1936
Lithograph
10 ¼ x 14 ⁷⁄₁₆ (26.0 x 36.7)
Edition: 20
Printed by Edmond Desjobert, Paris.

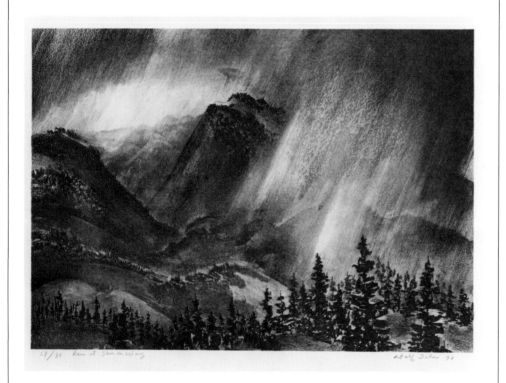

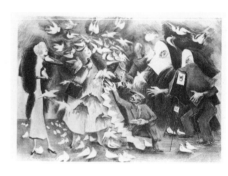

302
Venetian Scene
1936
Lithograph
10 ⅜ x 15 (26.4 x 38.0)
Edition: 15, plus artist's proofs
Printed by Edmond Desjobert, Paris.

301
Rain at Semmering
1936
Lithograph
10 ¼ x 14 ⅝ (26.0 x 37.2)
Edition: 30
Printed by Edmond Desjobert, Paris.

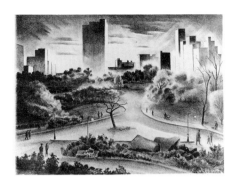

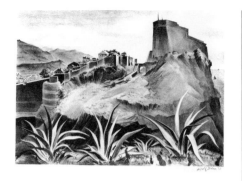

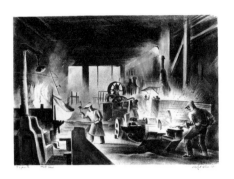

303
Afternoon in Central Park
Ca. 1937
Lithograph
9⅞ x 13¼ (25.1 x 33.7)
Edition: Undetermined

304
Doubrovnik
1937
Lithograph
9⅝ x 13⅜ (24.5 x 34.0)
Edition: 100
Printed by George Miller, New York.
 This lithograph was a selection of the
 Adolf Dehn Print Club in 1937.

305
Hot Saw
1937/1938
Lithograph
9¾ x 13⅞ (24.7 x 35.2)
Edition: 30 or 35
Printed by George Miller, New York.

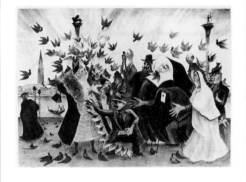

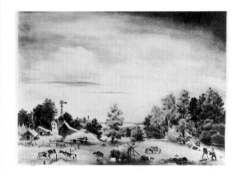

306
Innocence in Venice
1937
Lithograph
9⁵⁄₁₆ x 13 (23.6 x 33.0)
Edition: 100
Printed by George Miller, New York.
 This lithograph was a selection of the
 Adolf Dehn Print Club in 1937.

307
Love Labour Leisure (*see Plate 12*)
1937
Lithograph
9⁵⁄₁₆ x 13⅛ (23.7 x 33.3)
Edition: 100, plus trial proofs
Printed by George Miller, New York.
 This lithograph was a selection of the
 Adolf Dehn Print Club in 1937.

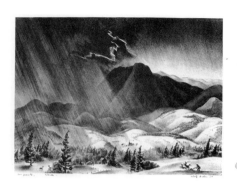

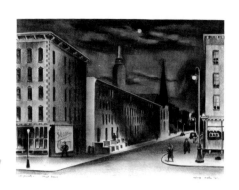

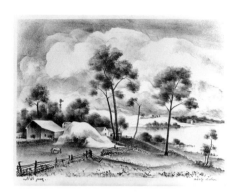

308
Storm (or **A Storm on the Mountain**)
1937
Lithograph
9 ⅜ x 12 ⅞ (23.8 x 32.7)
Edition: 100
Printed by George Miller, New York.
 This lithograph was a selection of the
 Adolf Dehn Print Club in 1937.

309
Street Scene
1937
Lithograph
9 ⅜ x 12 ¹⁵⁄₁₆ (23.8 x 32.9)
Edition: 100
Printed by George Miller, New York.
 This lithograph was a selection of the
 Adolf Dehn Print Club in 1937.

310
**Landscape with Straw Stack and
 Lake**
1938
Lithograph
9 ½ x 12 ⅞ (24.0 x 32.6)
Edition: Artist's proofs only

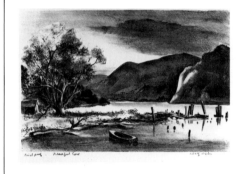

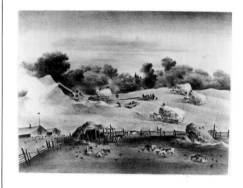

311
Peaceful Cove
1938
Lithograph
8 ⁵⁄₁₆ x 12 ¾ (21.1 x 32.4)
Edition: Associated American Artists
 edition, 161; artist's edition, 10, plus
 trial proofs

312
Threshing Scene
1938
Lithograph
9 ½ x 12 ¹³⁄₁₆ (24.2 x 32.5)
Edition: Associated American Artists
 edition, 162; artist's edition, 10, plus
 artist's proofs
Printed by George Miller, New York.

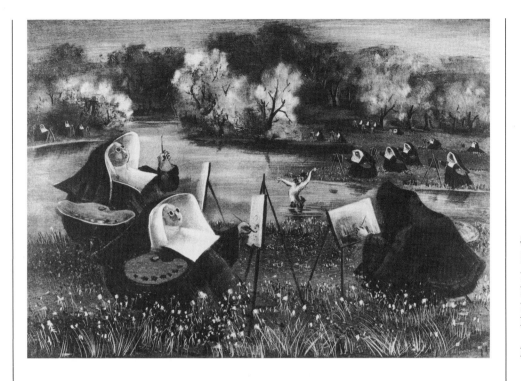

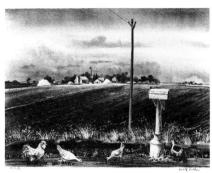

314

R.F.D.

1939

Lithograph

10 ⅜ x 13 ¹³⁄₁₆ (25.3 x 35.1)

Edition: Associated American Artists
edition, 250; artist's edition, 10

Printed by George Miller, New York.

313

Great God Pan

1939

Lithograph

9 ⅝ x 13 ⅝ (24.5 x 34.6)

Edition: 30

Printed by George Miller, New York.
This lithograph received the Mary S.
Collins Prize from The Print Club of
Philadelphia in 1940.

315

The Spanish Peaks (*see Plate 13*)

1939

Lithograph

12 ⁵⁄₁₆ x 17 ¹⁄₁₆ (30.8 x 43.2)

Edition: 50, plus trial proofs

Printed by Lawrence Barrett, Colorado
Springs. "The sky in this landscape is
a good example of what can be done
with the eraser and razor blade. Grays
and blacks were laid in and rubbed.
The whites were then erased out. The
jagged effect of the clouds comes from
erasing. The razor blade was used to
shave off some of the clouds which
were too dark, and the grays in the
mountains were shaved out of a solid
black" (Adolf Dehn and Lawrence Bar-
rett, *How to Draw and Print Lithographs*,
40).

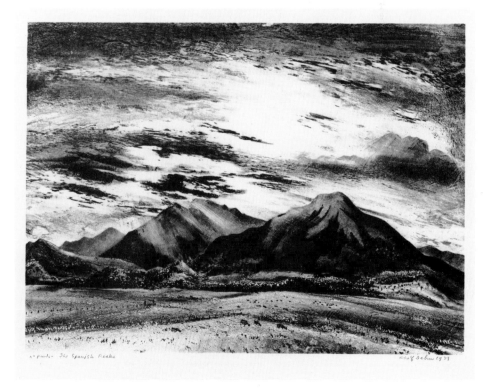

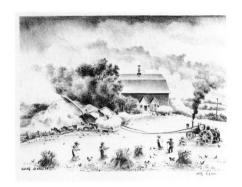

316
Threshing near Kilkenny
1939
Lithograph
9 5⁄8 x 13 5⁄16 (24.5 x 33.8)
Edition: Undetermined

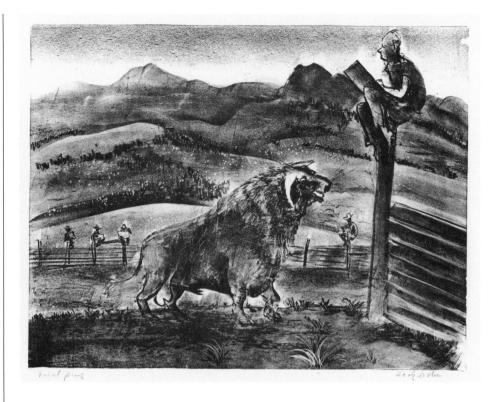

317
The Artist and the Bull
Ca. 1940
Lithograph
10 11⁄16 x 14 1⁄8 (27.1 x 35.8)
Edition: Trial proofs only
Printed by Lawrence Barrett, Colorado
 Springs.

318
Auctioneer
1940
Lithograph
15 3⁄4 x 11 3⁄4 (40.0 x 30.0)
Edition: Trial and artist's proofs only
Printed by Lawrence Barrett, Colorado
 Springs.

319
Colorado Landscape
1940
Lithograph
12 5⁄16 x 17 1⁄2 (31.2 x 44.3)
Edition: 40 or 50, plus trial proofs
Printed by Lawrence Barrett, Colorado
 Springs.

320
Commodore Peak
1940/1942
Lithograph
17 3/16 x 13 1/2 (43.6 x 34.2)
Edition: 30
Printed by Lawrence Barrett, Colorado
 Springs.

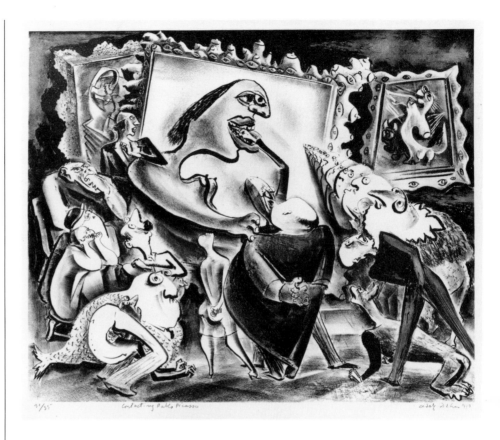

322
Famous Annual Fine Arts Center Artists Festival & Auction
1940
Lithograph in two colors
17 3/8 x 12 1/8 (44.1 x 30.8)
Edition: Undetermined
Printed by Lawrence Barrett, Colorado
 Springs. This was probably Dehn's
 first color lithograph.

321
Contacting Pablo Picasso
1940
Lithograph
15 7/8 x 19 3/4 (40.3 x 50.2)
Edition: 35, plus artist's proofs
Printed by Lawrence Barrett, Colorado
 Springs. "This is a straight crayon
 drawing, with the texture of the stone
 remaining in the light areas, the
 darker grays resulting from strong
 rubbing" (Adolf Dehn and Lawrence
 Barrett, *How to Draw and Print Litho-
 graphs*, 70).

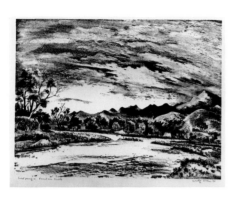

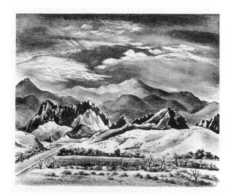

324
Garden of the Gods
1940
Lithograph
13½ x 16⁹⁄₁₆ (34.2 x 42.1)
Edition: 60, plus trial proofs
Printed by Lawrence Barrett, Colorado
 Springs. "This print is a good example
 of the rubbing technique, including
 the use of the razor blade and the
 eraser. The sky and the mountains
 were drawn in roughly and heavily,
 and then rubbed. The whites were
 erased out. The lighter gray sections
 were shaved off with the blade, and
 the whites in the cliffs were scraped
 off with the corner of the blade. The
 for[e]ground was given a partial rub,
 so that most of the granular surface
 remained" (Adolf Dehn and Lawrence
 Barrett, *How to Draw and Print Litho-
 graphs*, 46).

323
Fountain Creek (or Fountain Creek, Colorado)
1940
Lithograph
12⅞ x 17¼ (32.6 x 43.8)
Edition: 10, plus trial proofs
Printed by Lawrence Barrett, Colorado
 Springs.

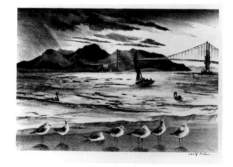

325
The Golden Gate
1940
Lithograph
9⁵⁄₁₆ x 13⅝ (23.7 x 34.7)
Edition: Associated American Artists
 edition, 189; artist's edition, 10, plus
 artist's proofs

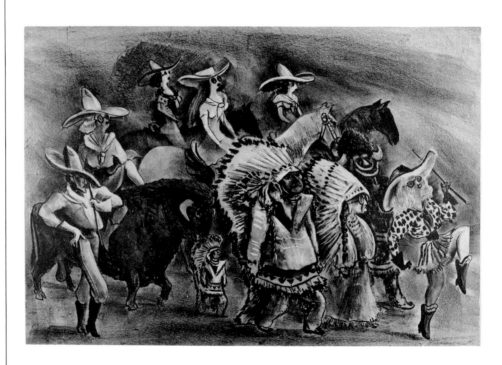

326
Good Americans, All
1940
Lithograph
12³⁄₁₆ x 17¹⁵⁄₁₆ (30.9 x 45.6)
Edition: 50
Printed by Lawrence Barrett, Colorado
 Springs.

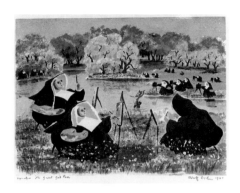

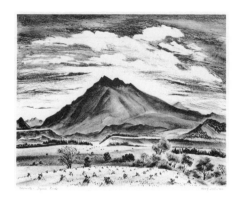

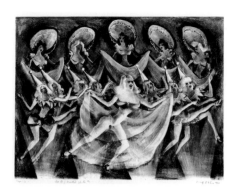

327
The Great God Pan
1940
Serigraph
9 13/16 x 13 5/8 (25.0 x 34.6)
Edition: 50, plus trial and artist's proofs
Printed at studio of Hyman Warsager,
 New York.

328
Sopris Peak
1940
Lithograph
13 3/4 x 17 3/8 (35.1 x 44.2)
Edition: 40
Printed by Lawrence Barrett, Colorado
 Springs.

329
The Big-Hearted Girls (or The Last Veil)
1941
Lithograph
13 9/16 x 18 1/16 (34.4 x 45.9)
Edition: 30, plus trial and artist's proofs
Printed by Lawrence Barrett, Colorado
 Springs. "A burlesque number! For
 men only! For men who get tired of
 being noble, upright, and lonely. A
 couple hours of sublimation before go-
 ing home to a dull or empty bed. In
 this picture, I tried to make the garish
 setting, the vulgar attempt to stimu-
 late the audience, and the awkward
 pattern of the dancers a part of the de-
 sign" (Adolf Dehn, "O Woman! O
 Frailty!" 49 The Magazine of the Year,
 February 1948, p. 133).

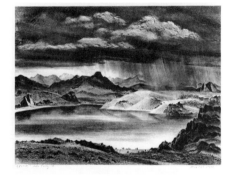

330
Lake Tarryall
1941
Lithograph
13 3/16 x 17 3/4 (33.5 x 44.9)
Edition: 40 or 45
Printed by Lawrence Barrett, Colorado
 Springs. This lithograph received the
 Eyre Medal at the Pennsylvania
 Academy of Fine Arts, Philadelphia,
 in 1944.

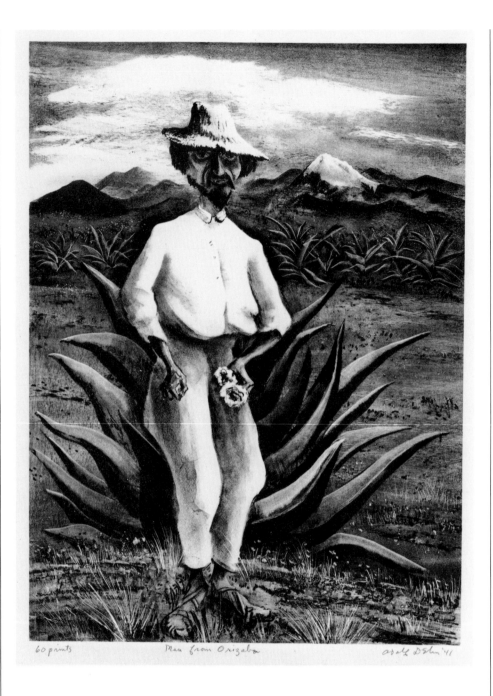

 Man from Orizaba adolf Dehn '41

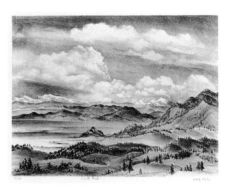

332

South Park (or South Park—Colorado)

1941

Lithograph

13 ½ x 17 ¹³⁄₁₆ (34.2 x 45.2)

Edition: 40, plus trial proofs

Printed by Lawrence Barrett, Colorado Springs. "This panoramic view of the Rockies is almost a pure crayon drawing. I used the razor blade to bring out the whites in the clouds and in the snow-capped mountains. The stone was rubbed gently, pulling the grays together a little" (Adolf Dehn and Lawrence Barrett, *How to Draw and Print Lithographs*, 52).

331

Man from Orizaba

1941

Lithograph

17 ⁵⁄₁₆ x 13 (43.8 x 32.9)

Edition: 60

Printed by Lawrence Barrett, Colorado Springs. "Everything in this design was rubbed after the drawing was laid in, except the man himself. The sky was erased and shaved with the razor blade. The man's face was modeled with the razor blade, as were the cacti and the white-capped mountain" (Adolf Dehn and Lawrence Barrett, *How to Draw and Print Lithographs*, 40).

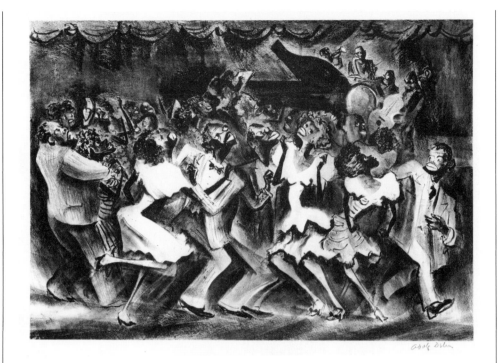

334
Trout Fishing on the Gunnison
1941
Lithograph
13 x 17 3/16 (33.0 x 43.7)
Edition: 40, plus artist's proofs
Printed by Lawrence Barrett, Colorado
 Springs.

333
Swinging at the Savoy (or **At the Savoy**) (*see Plate 14*)
1941
Lithograph
12 7/16 x 17 13/16 (31.6 x 45.3)
Edition: 30, plus trial proofs
Printed by Lawrence Barrett, Colorado
 Springs.

335
Western Sunflowers (or **Colorado Sunflowers**)
1941
Lithograph
10 1/8 x 13 7/8 (25.7 x 35.2)
Edition: Associated American Artists
 edition, 189; artist's edition, 10
Printed by George Miller, New York.

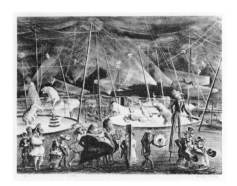

336
Circus
1942/1943
Lithograph
12¹⁵/₁₆ x 17⅜ (32.8 x 44.0)
Edition: 30, 40, or 50
Printed by Lawrence Barrett, Colorado
 Springs. "The razor blade did a big
 part of this drawing. All the lights in
 the upper part of the tent were shaved
 out of the blacks. The little figures and
 the ropes were scraped out. The
 clowns were drawn with the crayon,
 and then all white accents were drawn
 with the blade" (Adolf Dehn and
 Lawrence Barrett, *How to Draw and
 Print Lithographs*, 64).

337
Circus at Colorado Springs (or **Circus
 in the Mountains**)
Ca. 1942
Lithograph
13¹/₁₆ x 17½ (33.1 x 44.4)
Edition: 30, plus trial and artist's proofs
Printed by Lawrence Barrett, Colorado
 Springs.

338
Oh Ewigkeit Du Donner Wort (or **Oh
 Eternity, Thou Thunderword**)
1942
Lithograph
13 x 17¼ (33.0 x 43.7)
Edition: 20
Printed by Lawrence Barrett, Colorado
 Springs. "After this drawing was laid
 in with the soft crayon, there was
 much rubbing throughout. Then the
 razor blade was used to get the flat,
 smooth grays of the ground, as well
 as to pick out the whites of the sun
 flowers and the hair on the intellectual
 Centaur" (Adolf Dehn and Lawrence
 Barrett, *How to Draw and Print Litho-
 graphs*, 80).

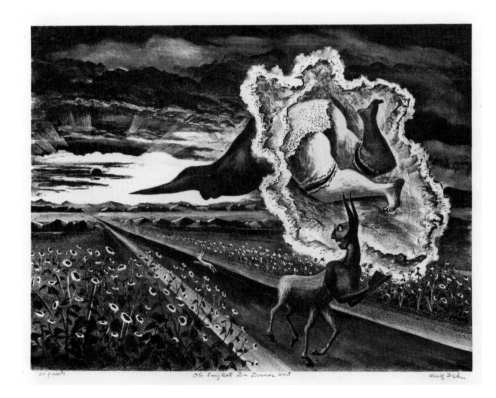

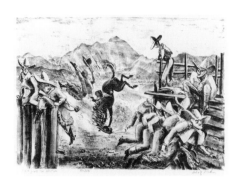

339
Quiet Waters (or Cranes at Night)
1942
Lithograph
10 x 13¹³⁄₁₆ (25.4 x 35.0)
Edition: Associated American Artists
 edition, 250; artist's edition, 10

340
Rodeo
Ca. 1942
Lithograph
11 x 15⁹⁄₁₆ (27.9 x 39.5)
Edition: Trial proofs only
Printed by Lawrence Barrett, Colorado
 Springs.

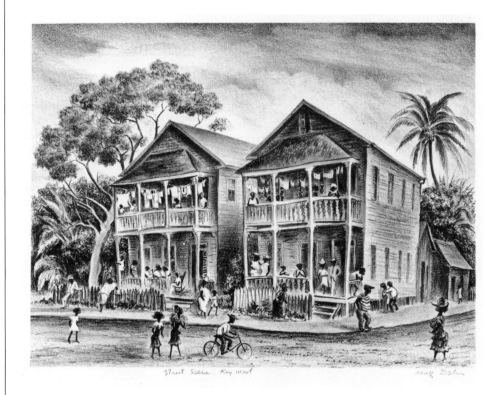

341
**Street Scene, Key West (or Life at
 Key West)**
1942
Lithograph
12¹⁵⁄₁₆ x 17⁵⁄₁₆ (32.8 x 44.0)
Edition: 30, plus trial proofs
Printed by Lawrence Barrett, Colorado
 Springs.

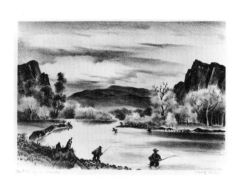

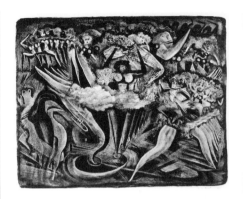

342
Fishing in Colorado
1944
Lithograph
9 ¼ x 13 ½ (23.5 x 34.2)
Edition: Associated American Artists
 edition, 250; artist's edition, 10

343
Ballet
1945
Lithograph
12 x 15 ⅜ (30.6 x 39.1)
Edition: 40, plus artist's proofs
Printed by Lawrence Barrett, Colorado
 Springs.

344
Beach at Port de la Cruz
1945
Lithograph
11 ½ x 17 ⁵⁄₁₆ (29.2 x 43.9)
Edition: 30, plus artist's proofs
Printed by Lawrence Barrett, Colorado
 Springs.

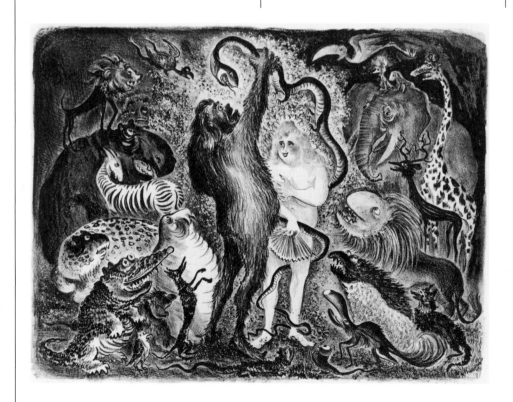

345
Before the Fall
1945
Lithograph
12 ⅞ x 17 ⅛ (32.7 x 43.5)
Edition: 50, plus trial and artist's proofs
Printed by Lawrence Barrett, Colorado
 Springs.

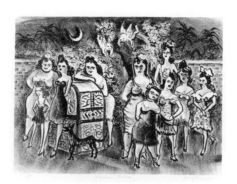

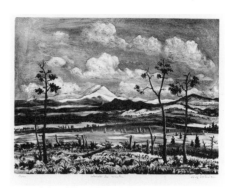

346
Brave New World (or Onward and Upward)
1945
Lithograph
14⅝ x 11⅟₁₆ (37.0 x 28.0)
Edition: 30, plus artist's proofs
Printed by Lawrence Barrett, Colorado Springs.

347
Carribean [*sic*] Belles
1945
Lithograph
11⁵⁄₁₆ x 15⁷⁄₁₆ (28.7 x 39.1)
Edition: 20, plus artist's proofs
Printed by Lawrence Barrett, Colorado Springs.

348
Colorado in Winter
1945
Lithograph
12¼ x 16⅝ (31.1 x 42.2)
Edition: 40, plus artist's proofs
Printed by Lawrence Barrett, Colorado Springs. "*Colorado in Winter*, a litho tint, illustrates a rather unusual treatment. It involves the use of liquid tusche and brushes. . . . The litho tint has great fascination for the lithographer. Unique effects are possible but the washes are hard to control. . . . Also, the litho tint is hard to print; the light grays often disappear and the dark grays tend to go black" (Adolf Dehn, "Don't Let Lithography Frighten You," *American Artist*, June 1952, p. 57).

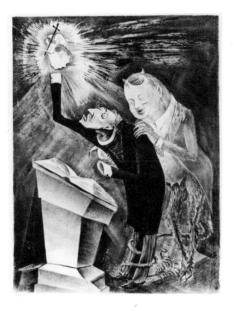

349
"Get Thee Behind Me" (or "Satan and the Preacher")
1945
Lithograph
14¾ x 11⅜ (37.4 x 28.9)
Edition: 30, plus artist's proofs

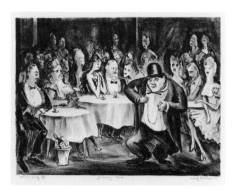

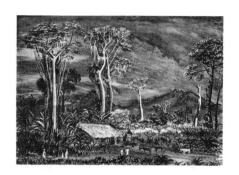

350
Jimmy Savo (or Jimmy Savo and His Peice [*sic*] of String)
1945
Lithograph
12½ x 16¾ (31.8 x 42.4)
Edition: 30, plus artist's proofs

351
Jungle at Night (*see Plate 15*)
1945
Lithograph
12 1/16 x 17 ¼ (30.6 x 43.9)
Edition: 40
Printed by Lawrence Barrett, Colorado Springs. This lithograph received the Joseph and Elizabeth Robins Pennell Purchase Prize at the fourth National Exhibition of Prints at the Library of Congress in 1946, the Purchase Prize at the second National Prints Annual at the Brooklyn Museum in 1948, and first prize at the 150th Anniversary of Lithography Exhibition at the University of Rochester Memorial Art Gallery in 1948.

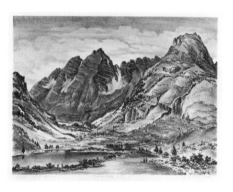

352.i
Maroon Lake
1945
Lithograph
12¾ x 17⅛ (32.3 x 43.5)
Edition: 250
Printed by Lawrence Barrett, Colorado Springs. This lithograph was the 1945–46 members' print for the Colorado Springs Fine Arts Center.

352.ii
Maroon Lake
1945
Lithograph in two colors
12¾ x 17⅛ (32.3 x 43.5)
Edition: 50, plus trial and artist's proofs
Printed by Lawrence Barrett, Colorado Springs.

353
Men Must Dream—The Beasts
1945
Lithograph
14 1/16 x 10⅝ (35.6 x 27.0)
Edition: 30, plus artist's proofs
Printed by Lawrence Barrett, Colorado Springs.

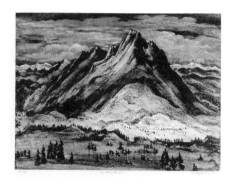

354
The Mountain
1945
Lithograph
12 ⅜ x 16 ¾ (31.5 x 42.6)
Edition: 40

355
Naked Truth Pursued by Bare Facts
1945
Lithograph
11 ⅝ x 16 ½ (29.5 x 42.0)
Edition: 40
Printed by Lawrence Barrett, Colorado Springs. "Here is a direct improvisation on the stone. After the female figure was lightly indicated, the entire area was slashed in with soft crayon. Then washes were made with brush and water which were not satisfactory, so they were rubbed and scraped with the razor blade. At the same time, the monsters were created, drawing them with a blade and the crayon. The lady was modeled with a flannel full of soft crayon" (Adolf Dehn and Lawrence Barrett, *How to Draw and Print Lithographs*, 76).

356
Night Flowers
1945
Lithograph
15 ¾ x 11 ⅜ (40.1 x 29.0)
Edition: 50, plus trial and artist's proofs
Printed by Lawrence Barrett, Colorado Springs. "After I had spent a month in the jungles of Venezuela, the little town of Port de la Cruz looked good, and the two girls, glowing in the sultry night, seemed alluring. Coming closer, I found that the poetry and glamor of these two night flowers was not what it seemed, that this was romance at so much per hour. Nevertheless, it was still alluring!" (Adolf Dehn, "O Woman! O Frailty!" *49 The Magazine of the Year*, February 1948, p. 134).

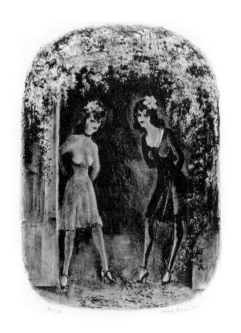

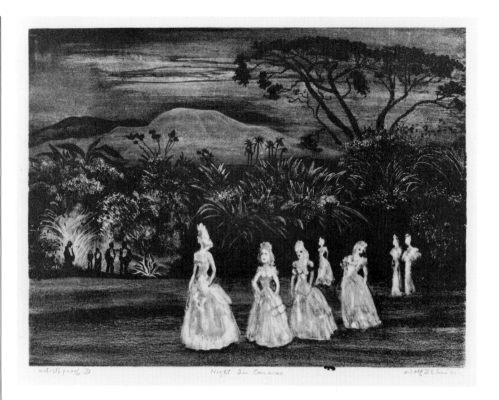

357
Night in Caracas
1945
Lithograph
12½ x 16¾ (31.7 x 42.5)
Edition: 40, plus trial and artist's proofs
Printed by Lawrence Barrett, Colorado Springs. "With dark grays to pure black, the three big areas – sky, foliage and ground – were laid in first. Then, very carelessly, a wash was made out of the whole. The ground remained, but I rewashed the sky four times. The light mountain was made with the flat of the razor blade. Next, the blacks of the trees were drawn in and the lights picked out with the blade, with the gelatine sheet, and by tapping with the pointed crayon. Last, the ladies were eaten back to a filmy, gray white, with a fine brush and high-test gasoline. Next, I laid a gray wash over these white areas, and then scraped the whites in the faces and dresses" (Adolf Dehn and Lawrence Barrett, *How to Draw and Print Lithographs*, 40).

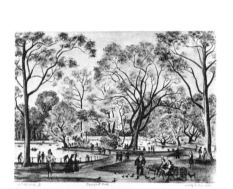

358
Prospect Park
1945
Lithograph
10¹⁵⁄₁₆ x 15⅛ (27.7 x 38.3)
Edition: 30, plus artist's proofs

359
September Morn (or Sunday Painters)
1945
Lithograph
11³⁄₁₆ x 17 (28.3 x 43.0)
Edition: 50, plus trial and artist's proofs
Printed by Lawrence Barrett, Colorado Springs.

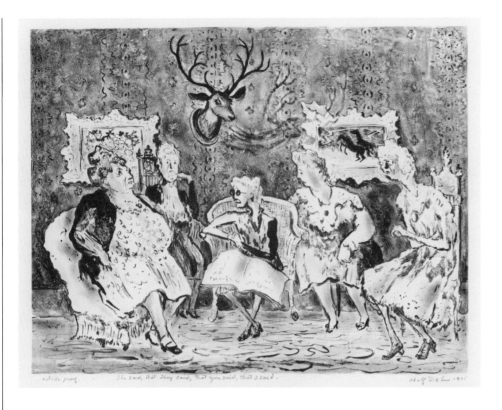

360
She Said, That They Said, That You Said, That I Said
1945
Lithograph
12⅞ x 16¾ (32.8 x 42.5)
Edition: 30, plus artist's proofs
Printed by Lawrence Barrett, Colorado Springs. "This stone was drawn freely with a brush and tusche. The light grays in the figures and the floor were rubbed with a flannel charged with much soft No. 00 crayon" (Adolf Dehn and Lawrence Barrett, *How to Draw and Print Lithographs*, 46).

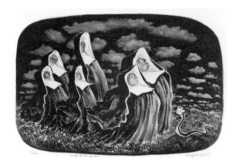

361
Snake in the Grass (or Onward and Upward)
1945
Lithograph
11¼ x 17 (28.6 x 43.2)
Edition: 40, plus artist's proofs
Printed by Lawrence Barrett, Colorado Springs.

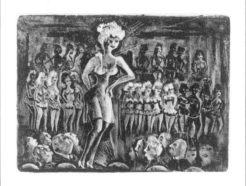

362
The Star
1945
Lithograph
9¹⁵⁄₁₆ x 13¹⁵⁄₁₆ (25.2 x 35.4)
Edition: 30, plus artist's proofs

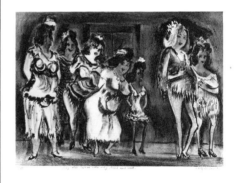

363
They Also Serve Who Only Stand and Wait (or Seven Girls Waiting)
1945/1946
Lithograph
11¹⁄₁₆ x 15⁷⁄₁₆ (28.0 x 39.2)
Edition: 27
Printed by George Miller, New York.

364
**Time & Space Befuddled by the
 Immediate Now**
1945
Lithograph
10 ⅞ x 14 ⅛ (27.6 x 36.2)
Edition: 30, plus artist's proofs
Printed by Lawrence Barrett, Colorado
 Springs.

365
To My Valentine
1945
Lithograph
12 ½ x 16 ⅝ (31.7 x 42.1)
Edition: 33, plus trial and artist's proofs
Printed by Lawrence Barrett, Colorado
 Springs.

366
Tomorrow's Sunrise
1945
Lithograph
12 ¹¹⁄₁₆ x 16 ¹¹⁄₁₆ (32.3 x 42.4)
Edition: 30, plus artist's proofs

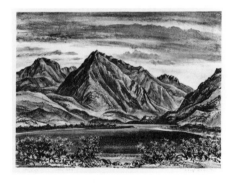

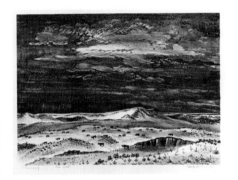

367
Twin Lakes
1945
Lithograph
12 ¼ x 16 ⅝ (31.0 x 42.2)
Edition: 30, plus trial proofs

368
The West (or Austin Bluffs)
1945
Lithograph
11 ½ x 16 ¹⁄₁₆ (29.2 x 40.3)
Edition: 10, plus trial proofs

HOW TO
DRAW
AND PRINT
LITHOGRAPHS

PRINTED BY LAWRENCE BARRETT

How to Draw
and Print
LITHOGRAPHS

Drawing on the Stone
by ADOLF DEHN

Printing from the Stone
by LAWRENCE BARRETT

AMERICAN ARTISTS GROUP, inc.
New York

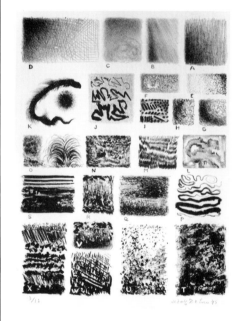

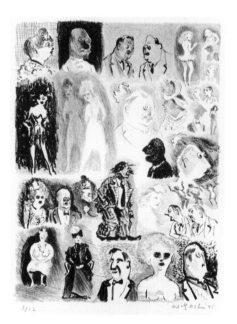

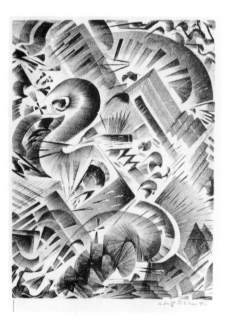

369
Untitled
1945
Lithograph
9 ⅞ x 7 ½ (25.0 x 19.2)
Edition: 12, plus trial and artist's proofs
This lithograph appeared as Plate 1.

370
Untitled
1945
Lithograph
9 ¾ x 7 7/16 (24.7 x 19.0)
Edition: 12, plus trial and artist's proofs
This lithograph appeared as Plate 2.

371
Untitled
1945
Lithograph
9 11/16 x 7 ⅜ (24.6 x 18.6)
Edition: 12
This lithograph appeared as Plate 3.

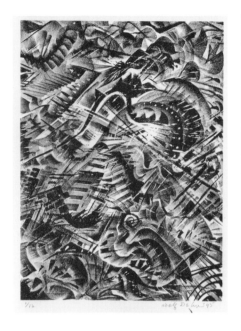

372
Untitled
1945
Lithograph
9¾ x 7⁵⁄₁₆ (24.6 x 18.6)
Edition: 12
This lithograph appeared as Plate 4.

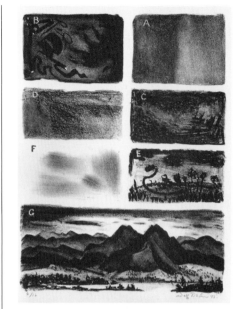

373
Untitled
1945
Lithograph
9¹⁵⁄₁₆ x 7½ (25.3 x 19.0)
Edition: 12, plus artist's proofs
This lithograph appeared as Plate 5.

374
Untitled
1945
Lithograph
9¹⁵⁄₁₆ x 7⁷⁄₁₆ (25.3 x 18.9)
Edition: 12, plus artist's proofs
This lithograph appeared as Plate 6.

375
Untitled
1945
Lithograph
9⅞ x 7⅜ (25.1 x 18.8)
Edition: 12, plus trial and artist's proofs
This lithograph appeared as Plate 7.

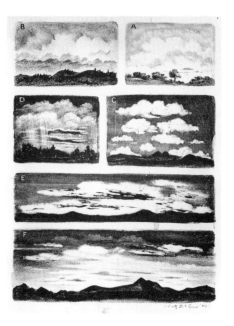

377
Untitled
1945
Lithograph
10 x 7 ½ (25.3 x 19.1)
Edition: 12
This lithograph appeared as Plate 9.

376
Untitled
1945
Lithograph
10 ¹⁄₁₆ x 7 ⅜ (25.6 x 18.8)
Edition: 12, plus trial and artist's proofs
This lithograph appeared as Plate 8.

378
Untitled
1945
Lithograph
9 ⅞ x 7 ½ (25.2 x 19.1)
Edition: 12, plus trial proofs
This lithograph appeared as Plate 10.

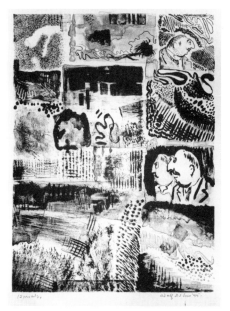

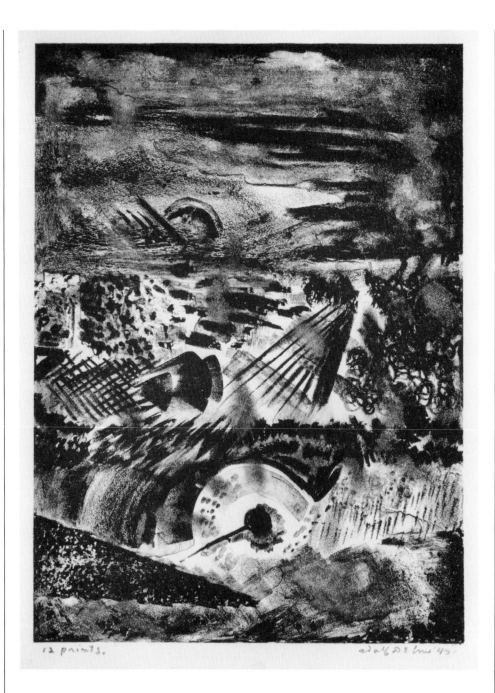

379
Untitled
1945
Lithograph
9¹⁵⁄₁₆ x 7⅜ (25.2 x 18.8)
Edition: 12
This lithograph appeared as Plate 11.

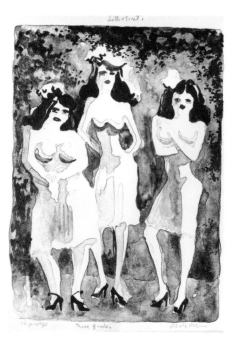

380
Three Girls
1945
Lithograph
9⅞ x 7⁵⁄₁₆ (25.0 x 18.6)
Edition: 12, plus trial proofs
This lithograph appeared as Plate 12.

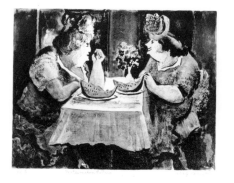

381
Watermelon Eaters
1945
Lithograph
7½ x 9¹³⁄₁₆ (18.9 x 24.8)
Edition: 12, plus trial proofs
This lithograph appeared as Plate 13.

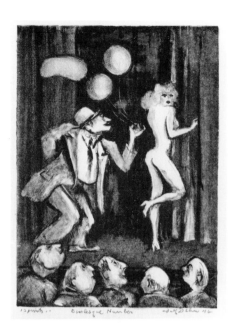

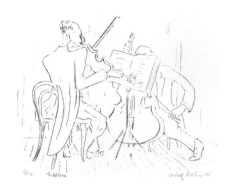

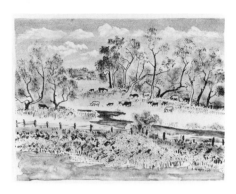

383
Fiddlers
1945
Lithograph
7 ⅛ x 9 ¼ (18.0 x 23.5)
Edition: 12, plus artist's proofs
This lithograph was not used in the book.

384
Landscape
1946
Lithograph
7 ¼ x 9 ¹³⁄₁₆ (18.5 x 24.8)
Edition: 12
This lithograph was not used in the book.

382
Burlesque Number
1946
Lithograph
9 ¹³⁄₁₆ x 7 ³⁄₁₆ (25.0 x 18.3)
Edition: 12
This lithograph appeared as Plate 14.

385
Man and Girl Drinking
1946
Lithograph
5 ½ x 5 ⅞ (14.0 x 14.9)
Edition: Undetermined
This lithograph was not used in the book.

386
Night Club
1945
Lithograph
8 ¾ x 13 ⅛ (22.1 x 33.4)
Edition: 20, plus trial proofs
This lithograph was not used in the book.

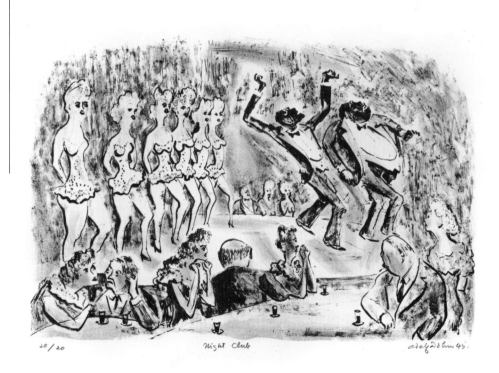

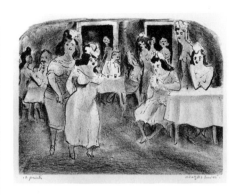

387

Venezuelan Girls

1945

Lithograph

7 5/16 x 9 7/8 (18.6 x 25.2)

Edition: 12

This lithograph was not used in the book.

388

Woman on Bench

1946

Lithograph

7 1/16 x 5 13/16 (18.0 x 14.8)

Edition: Undetermined

This lithograph was not used in the book.

389

Woman on Bench

1946

Lithograph

9 1/4 x 7 1/16 (23.3 x 18.0)

Edition: 12

This lithograph was not used in the book.

**End of
How to Draw and
Print Lithographs**

SELECTED TALES OF GUY DE MAUPASSANT

PRINTED BY LAWRENCE BARRETT

THESE ORIGINAL LITHOGRAPHS

by Adolf Dehn were executed in the Summer and Autumn of 1945 and printed on hand-made paper by Lawrence Barrett of Colorado Springs, Colorado. Each lithograph has been numbered and signed by the artist. An edition of two hundred and fifty folios has been issued, of which this is Number *Sixty nine*

adolf Dehn

The portfolio includes lithographs based on the following tales of Guy de Maupassant

MADEMOISELLE FIFI · THE SIGNAL · MADAME TELLIER'S EXCURSION (1) · MADAME TELLIER'S EXCURSION (2) · VAIN BEAUTY · BALL-OF-FAT · SAVED · JULIE ROMAIN IN THE MOONLIGHT · THE MARQUIS DE FUMERAL · STORY OF A FARM GIRL THAT PIG OF A MORIN · THE DIAMOND NECKLACE · THE PIECE OF STRING · TOINE UGLY · WAS IT A DREAM · THE DEVIL · ONE PHASE OF LOVE · BABETTE

390
Babette
1945
Lithograph
14 9/16 x 11 1/4 (37.0 x 28.8)
Edition: 250, plus trial proofs

392
The Devil
1945
Lithograph
13 ¾ x 11 ⅛ (34.7 x 28.3)
Edition: 250, plus artist's proofs

391
Ball of Fat
1945
Lithograph
13 ¹¹⁄₁₆ x 9 ¼ (34.8 x 23.5)
Edition: 250, plus artist's proofs

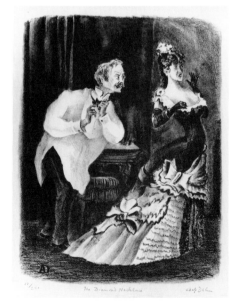

393
The Diamond Necklace
1945
Lithograph
14 ½ x 11 ⅛ (36.7 x 28.3)
Edition: 250

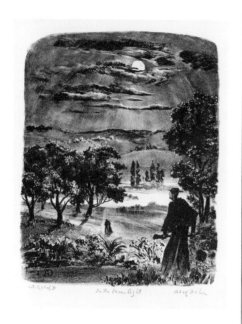

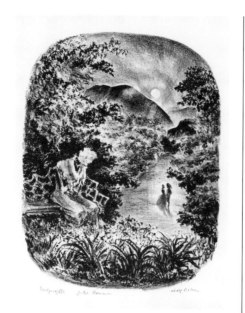

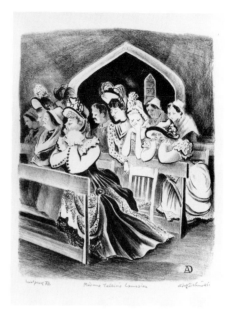

394
In the Moonlight
1945
Lithograph
13 ⅞ x 11 (35.1 x 28.0)
Edition: 250, plus artist's proofs

395
Julie Romain
1945
Lithograph
13 ¾ x 10 ¾ (34.9 x 27.4)
Edition: 250, plus artist's proofs

396
Madame Tellier's Excursion
1945
Lithograph
13 ⅝ x 11 (34.6 x 28.0)
Edition: 250, plus trial proofs

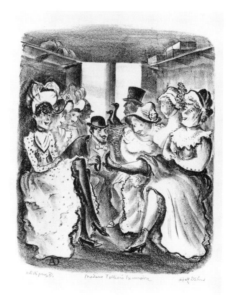

397
Madame Tellier's Excursion
1945
Lithograph
13 ⁷⁄₁₆ x 11 (34.2 x 28.0)
Edition: 250, plus artist's proofs

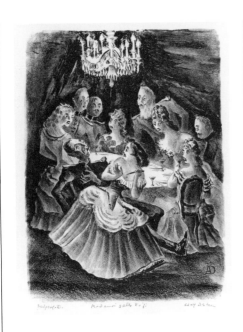

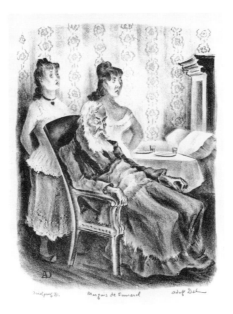

399
Marquis de Fumerol
1945
Lithograph
14 7/16 x 11 1/4 (36.7 x 28.6)
Edition: 250, plus trial proofs

398
Mademoiselle Fifi
1945
Lithograph
14 5/8 x 11 (37.1 x 28.0)
Edition: 250, plus trial proofs

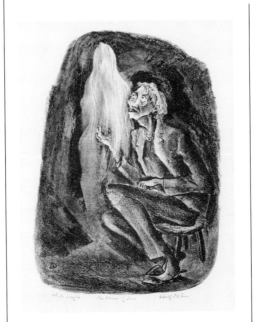

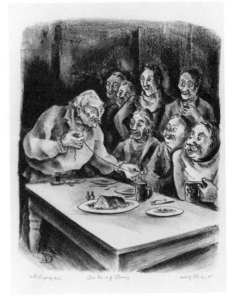

400
One Phase of Love
1945
Lithograph
14 1/4 x 10 1/2 (36.1 x 26.5)
Edition: 250, plus artist's proofs

401
The Peice [*sic*] **of String**
1945
Lithograph
13 5/8 x 11 1/8 (34.6 x 28.2)
Edition: 250, plus artist's proofs

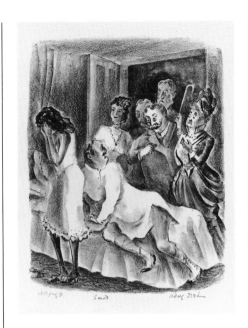

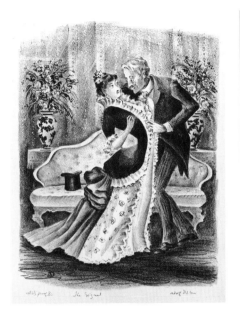

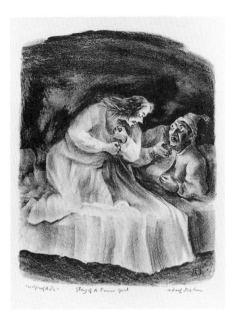

402
Saved
1945
Lithograph
14 x 11 1/16 (35.5 x 28.1)
Edition: 250, plus artist's proofs

403
The Signal
1945
Lithograph
14 9/16 x 11 3/16 (37.0 x 28.5)
Edition: 250, plus artist's proofs

404
Story of a Farm Girl
1945
Lithograph
13 3/4 x 11 (34.8 x 28.0)
Edition: 250, plus trial proofs

405
That Pig of a Morin
1945
Lithograph
13 5/8 x 11 (34.6 x 28.0)
Edition: 250, plus artist's proofs

406
Toine
1945
Lithograph
13 15/16 x 11 (35.3 x 28.0)
Edition: 250, plus artist's proofs

407
Ugly
1945
Lithograph
13 x 11 (32.9 x 28.0)
Edition: 250, plus trial proofs

408
Vain Beauty
1945
Lithograph
14 x 11 1/4 (35.5 x 28.5)
Edition: 250, plus trial proofs

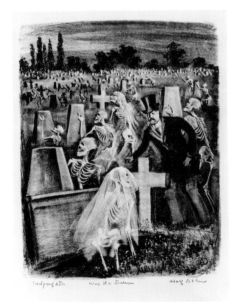

409
Was It a Dream
1945
Lithograph
13 7/8 x 11 1/8 (35.4 x 28.3)
Edition: 250, plus trial proofs

End of
Selected Tales of
Guy De Maupassant

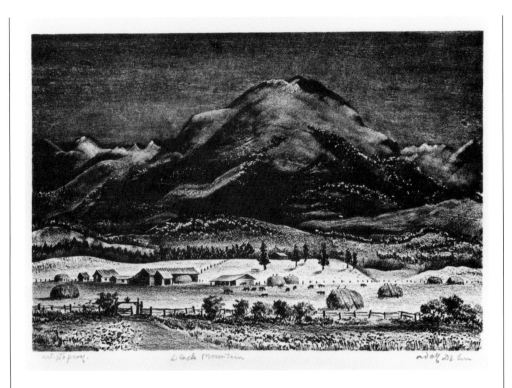

410
Black Mountain
1946
Lithograph
8⅞ x 12¹⁵⁄₁₆ (22.5 x 32.9)
Edition: Associated American Artists
 edition, 250; artist's edition, 10, plus
 artist's proofs

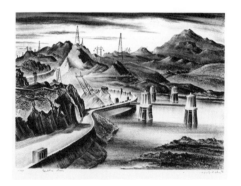

411
Boulder Dam
1946
Lithograph
15⅛ x 20⅞ (38.3 x 53.1)
Edition: 40 or 50
Printed by Lawrence Barrett, Colorado
 Springs.

412
Central Park Night
1946
Lithograph
12⅜ x 17½ (31.5 x 44.5)
Edition: 40, plus trial proofs

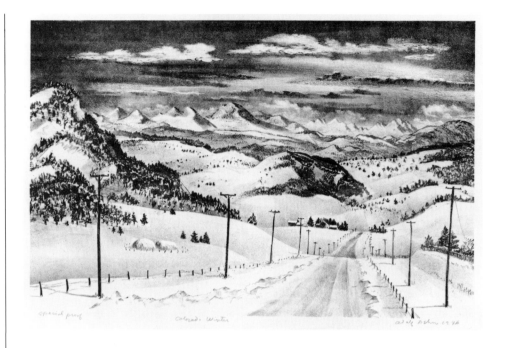

413
Colorado Winter
1946
Lithograph
11⅜ x 17¹¹⁄₁₆ (29.8 x 45.0)
Edition: 40 or 50

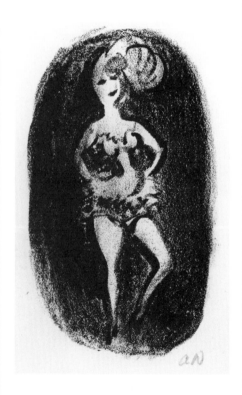

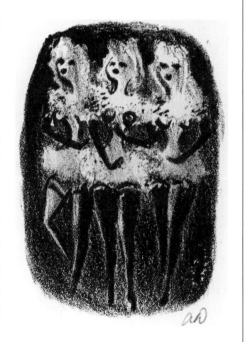

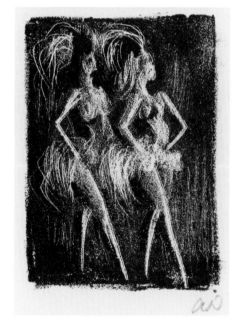

414
Dancer
Ca. 1946
Lithograph
3¾ x 2³⁄₁₆ (9.4 x 5.4)
Edition: Associated American Artists
 edition, 250
Printed by George Miller, New York.

415
Dancers
Ca. 1946
Lithograph
3⁵⁄₁₆ x 2⅜ (8.4 x 6.0)
Edition: Associated American Artists
 edition, 250
Printed by George Miller, New York.

416
Dancers
Ca. 1946
Lithograph
2¹¹⁄₁₆ x 1⅞ (6.7 x 4.8)
Edition: Associated American Artists
 edition, 250
Printed by George Miller, New York.

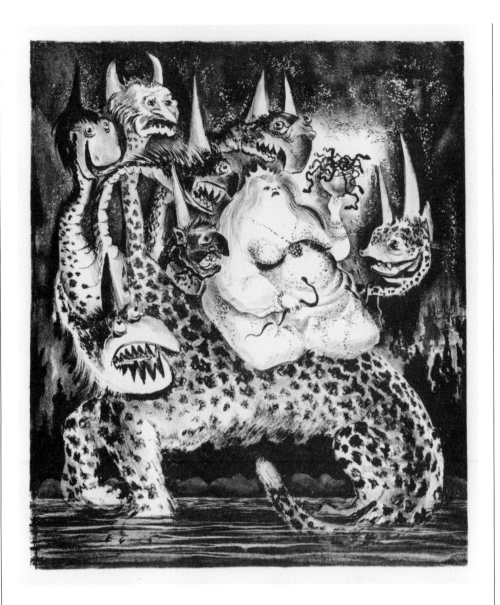

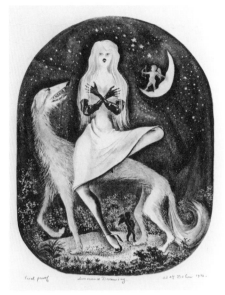

418
Innocence Dreaming (or Miss Innocence)
1946
Lithograph
15 ½ x 12 ⅛ (39.3 x 30.8)
Edition: 30, plus trial proofs

417
Harlot of Babylon
1946
Lithograph
15 ¾ x 13 ½ (39.8 x 34.2)
Edition: 40, plus trial and artist's proofs

419
Lancaster County (or Summer Clouds)
1946
Lithograph
3 ½ x 5 (8.8 x 12.6)
Edition: Associated American Artists edition, 200
Printed by George Miller, New York.

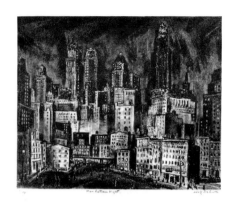

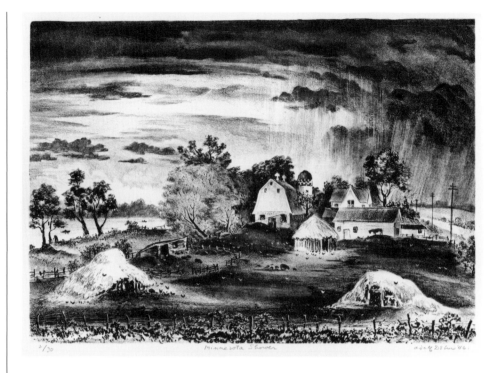

420
Manhattan Night
1946
Lithograph
13⁹⁄₁₆ x 16⁹⁄₁₆ (34.4 x 42.1)
Edition: 40, plus trial proofs
Printed by Lawrence Barrett, Colorado Springs. "This lithograph was drawn quickly and violently, the composition being arranged as the picture developed. There was much rubbing, and scraping with the razor blade" (Adolf Dehn and Lawrence Barrett, *How to Draw and Print Lithographs*, 46).

421
Minnesota Shower (or Minnesota Farm)
1946
Lithograph
12³⁄₈ x 17⁵⁄₈ (31.4 x 44.8)
Edition: 30, plus trial proofs

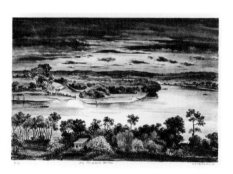

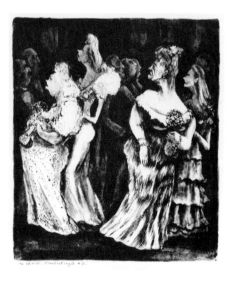

422
The Missouri River
1946
Lithograph
11⁵⁄₈ x 17¾ (29.6 x 44.5)
Edition: 30, plus trial proofs

423
Mothers and Daughters
1946
Lithograph
15⅛ x 12³⁄₁₆ (38.4 x 33.5)
Edition: Trial proofs only

424

Mothers & Daughters

1946
Lithograph
15 11/16 x 12 3/4 (39.8 x 32.5)
Edition: 20 or 30
Printed by Lawrence Barrett, Colorado
 Springs.

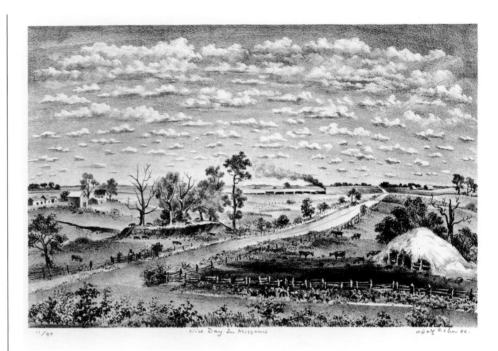

425

Nice Day in Missouri (or **Fine Day in Missouri**)

1946
Lithograph
11 5/16 x 17 3/8 (28.7 x 44.2)
Edition: 40, plus trial proofs
Printed by Lawrence Barrett, Colorado
 Springs. "Here is a straight grain
 drawing. The whole sky was laid in
 with a few strokes of a long, flat No. 5
 crayon. The white clouds were
 scraped out with the razor blade, and
 the dark parts were shaded with a
 pointed crayon. The foreground foli-
 age was enlivened by much tapping of
 the crayon. The foreground fence was
 lifted out of the dark ground with a
 corner edge of a short piece of crayon"
 (Adolf Dehn and Lawrence Barrett,
 How to Draw and Print Lithographs, 76).

426

Nocturnal Music (or **The Soloist**)

1946
Lithograph
12 15/16 x 17 1/16 (32.8 x 43.3)
Edition: 30, plus trial proofs
Printed by Lawrence Barrett, Colorado
 Springs.

427
Nocturnal Visitors
1946
Lithograph
13 ⅛ x 17 ¼ (33.3 x 43.8)
Edition: 40 or 50, plus trial proofs
Printed by Lawrence Barrett, Colorado Springs. This lithograph received the H. F. J. Knobloch Prize for lithograph- ic originality in the 33rd Annual Exhibition of the Society of American Etchers, Gravers, Lithographers and Woodcutters in 1949.

428
Rocky Mountains (or Twilight in the Rockies)
1946
Lithograph
3 ⁷⁄₁₆ x 4 ⅞ (8.7 x 12.5)
Edition: Associated American Artists edition, 200
Printed by George Miller, New York.

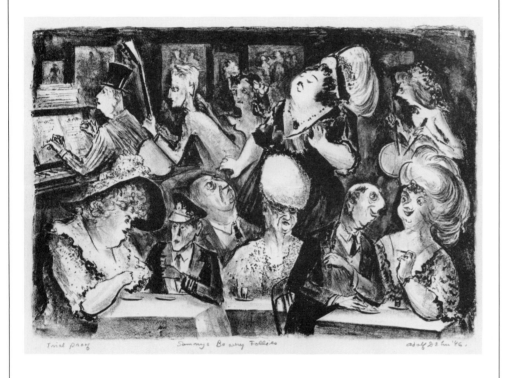

430
The Susquehanna (or Winding River)
Ca. 1946
Lithograph
3 ½ x 4 ¹⁵⁄₁₆ (8.9 x 12.6)
Edition: Associated American Artists edition, 250
Printed by George Miller, New York.

429
Sammy's Bowery Follies
1946
Lithograph
11 ⅝ x 17 ⅛ (29.4 x 43.4)
Edition: 20, plus trial proofs

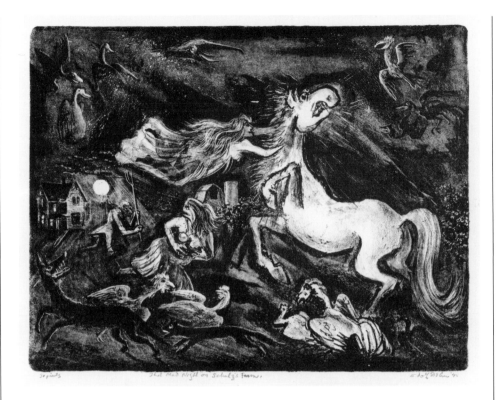

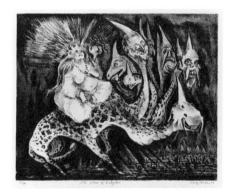

432
Venezuelan Village
1946
Lithograph
9 3/16 x 13 (23.4 x 33.1)
Edition: Associated American Artists
 edition, undetermined, plus artist's
 proofs

431
That Mad Night on Schulz's Farm
(*see Plate 16*)
1946
Lithograph
13 1/16 x 17 1/8 (33.1 x 43.6)
Edition: 30, plus trial proofs
Printed by Lawrence Barrett, Colorado
 Springs.

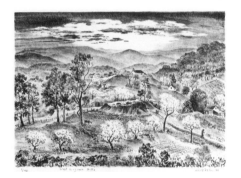

433
West Virginia Hills
1946
Lithograph
12 x 16 13/16 (30.4 x 42.8)
Edition: 40, plus trial and artist's proofs

434
The Whore of Babylon
1946
Lithograph
13 5/8 x 17 3/16 (34.5 x 43.7)
Edition: 20 or 30, plus trial proofs

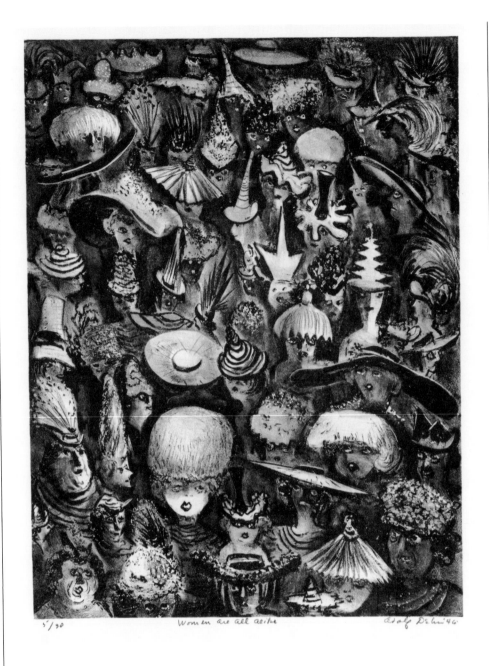

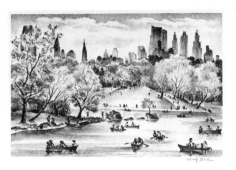

436
Central Park Lake and Skyline (or Lake in Central Park)
1947
Lithograph
8¾ x 13⁵⁄₁₆ (22.2 x 33.9)
Edition: Associated American Artists edition, 250; artist's edition, 10, plus artist's proofs

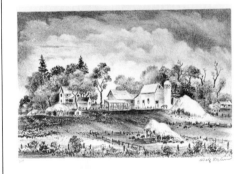

435
Women Are All Alike
1946
Lithograph
16¾ x 12¹⁵⁄₁₆ (42.5 x 32.9)
Edition: 30, plus trial proofs
"I always enjoy women's hats. My aim in making this picture was simple – to concoct 'creations' of my own and to put together a design that would be both decorative and preposterous. That's all" (Adolf Dehn, "O Woman! O Frailty!" 49 *The Magazine of the Year*, February 1948, p. 134).

437
Farmyard (or Minnesota Farmyard)
1947
Lithograph
8¾ x 13⅛ (22.2 x 33.4)
Edition: Associated American Artists edition, 250; artist's edition, 10

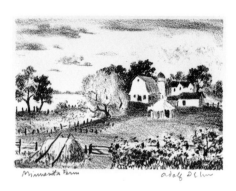

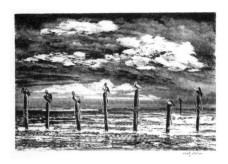

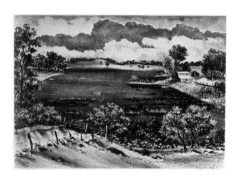

438
Minnesota Farm (or **Farm in Summer**)
1947
Lithograph
3 ½ x 5 (8.8 x 12.6)
Edition: Associated American Artists
 edition, 250
Printed by George Miller, New York.

439
Pelicans at Key West (or **Key West Beach**)
1947
Lithograph
8 ¾ x 13 ¼ (22.3 x 33.6)
Edition: Associated American Artists
 edition, 250; artist's edition, 10

440
Lake in Minnesota (or **The Lake**)
1948
Lithograph
9 ⁵⁄₁₆ x 13 ⁵⁄₁₆ (23.6 x 34.0)
Edition: Associated American Artists
 edition, 250; artist's edition, 10, plus
 artist's proofs

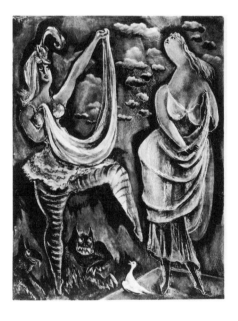

442
Prudence and Scarlet
1948
Lithograph
15 ⅛ x 11 ¹¹⁄₁₆ (38.4 x 29.7)
Edition: 40, plus artist's proofs
Printed by George Miller, New York.

441
Pennsylvania Farm
1948
Lithograph
8 ⅞ x 13 ⁷⁄₁₆ (22.6 x 34.1)
Edition: Associated American Artists
 edition, 250; artist's edition, 10, plus
 artist's proofs

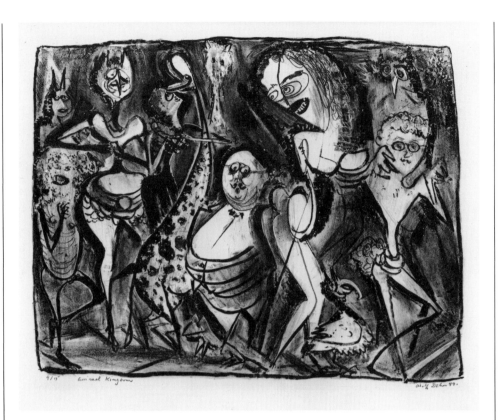

444
Beauty and the Beast
1949
Lithograph
12 ½ x 16 ⅝ (31.7 x 42.4)
Edition: 20, plus artist's proofs

443
Animal Kingdom
1949
Lithograph
14 x 18 (35.5 x 45.8)
Edition: 15, plus trial proofs

445
Black and White Ballet (or Black Ballet)
1949
Lithograph
12 ¾ x 17 ⅛ (32.3 x 43.5)
Edition: 20, plus artist's proofs

446
Christ in Haiti (or **White Christ in Haiti**)
1949
Lithograph
16¾ x 13 5/16 (42.6 x 33.8)
Edition: 33

447
The Clean and the Unclean
1949
Lithograph
16⅞ x 14¼ (42.7 x 36.3)
Edition: Trial proofs only

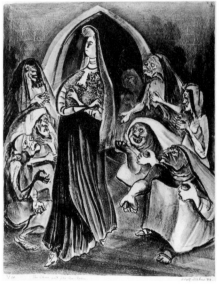

448
The Clean and the Unclean
1949
Lithograph
17 5/16 x 13 15/16 (43.9 x 35.4)
Edition: 20, plus artist's proofs

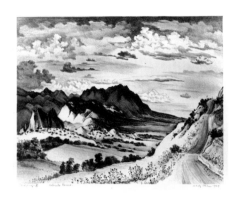

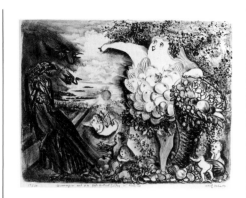

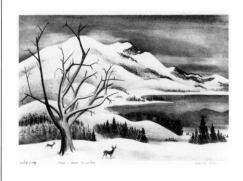

449
Colorado Rococo
1949
Lithograph
13 5/16 x 17 (33.8 x 43.2)
Edition: 30, plus trial and artist's proofs

450
**Cornucopia and Her Pestilential
Sister—Famine**
1949
Lithograph
12 7/8 x 17 1/4 (32.6 x 43.8)
Edition: 30, plus artist's proofs

451
Deer & Snow Mountain
1949
Lithograph
9 1/16 x 13 1/2 (23.0 x 34.3)
Edition: Associated American Artists
edition, 250; artist's edition, 10, plus
artist's proofs

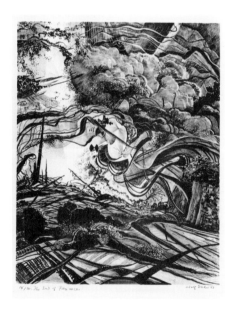

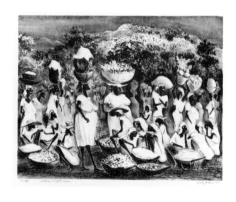

453
Haitian Market Women
1949
Lithograph
13 1/4 x 17 1/8 (33.6 x 43.5)
Edition: 30, plus artist's proofs

452
**The End of Romance (or High Class
Doodle or Ordered Disorder)**
1949
Lithograph
16 5/8 x 13 7/16 (42.3 x 34.1)
Edition: 20, plus artist's proofs

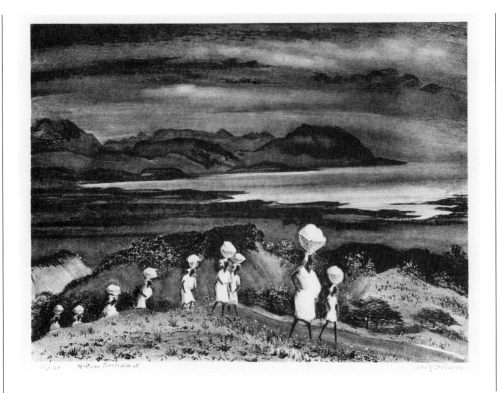

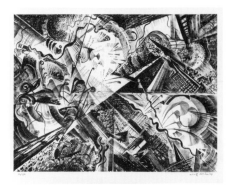

455

Into and Out Of (or **Into the Center**)
1949
Lithograph
12¾ x 17⅛ (32.3 x 43.5)
Edition: 20, plus artist's proofs

454

Haitian Processional
1949
Lithograph
12⅞ x 17³⁄₁₆ (32.8 x 43.7)
Edition: 30, plus trial and artist's proofs

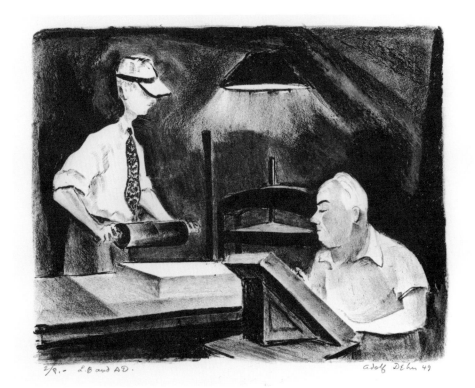

456

L. B. and A. D.
1949
Lithograph
9⅞ x 12⅝ (25.1 x 32.0)
Edition: 8
Printed by Lawrence Barrett, Colorado
 Springs. The artist and printer are the
 subjects of this lithograph.

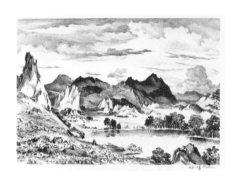

457

Lake in the Garden of the Gods

1949

Lithograph

9 5/16 x 13 3/8 (23.7 x 34.0)

Edition: Associated American Artists
 edition, 250; artist's edition, 10, plus
 artist's proofs

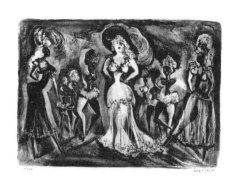

458

Leading Lady (or **Show Girls**)

1949

Lithograph

9 15/16 x 14 (25.2 x 35.6)

Edition: 20, plus trial and artist's proofs

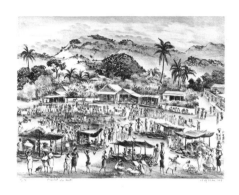

459

Market in Haiti (or **Market Place at
 Petionville**)

1949

Lithograph

12 7/8 x 17 (32.7 x 43.1)

Edition: 35, plus trial proofs

460

Moon over South Park

1949

Lithograph

13 1/2 x 17 7/16 (34.3 x 44.2)

Edition: 27, plus artist's proofs

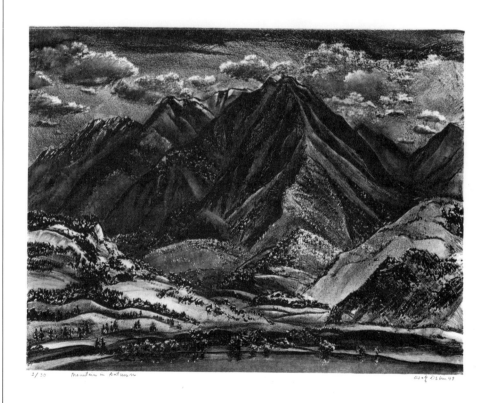

461

Mountain in Autumn

1949

Lithograph

13 x 17 1/8 (33.1 x 43.5)

Edition: 30, plus artist's proofs

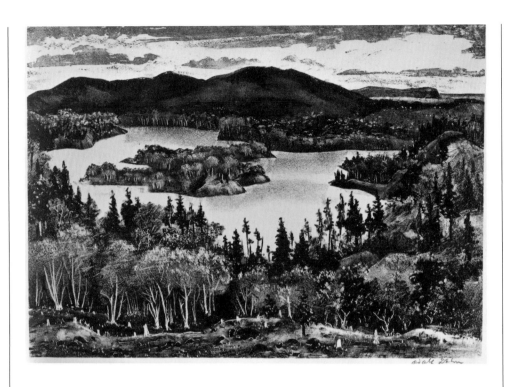

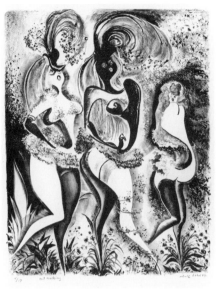

462
Northern Lake (or North Country
 Lake)
1949
Lithograph
9 ½ x 13 ⁵⁄₁₆ (24.1 x 33.8)
Edition: Associated American Artists
 edition, 250

463
Out Walking
1949
Lithograph
16 ¾ x 13 ½ (42.6 x 34.3)
Edition: 10 or 19

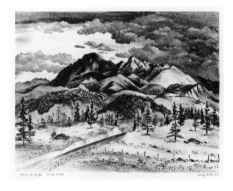

464
Pike's Peak
1949
Lithograph
13 ¹⁄₁₆ x 17 ⅛ (33.1 x 43.6)
Edition: 20, plus artist's proofs

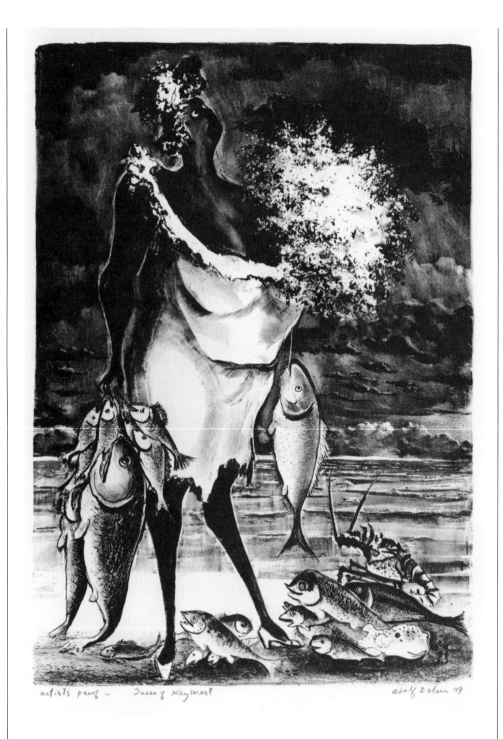

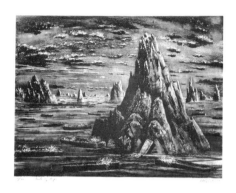

466
Rock of Ages
1949
Lithograph
13 ⅛ x 17 ⅜ (33.4 x 44.2)
Edition: 20

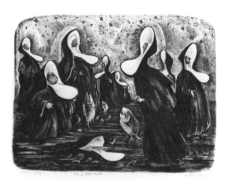

467
She of Little Faith (or **She Had No Faith**)
1949
Lithograph
13 ½ x 18 (34.3 x 45.6)
Edition: 35, plus artist's proofs

465
Queen of Key West
1949
Lithograph
17 ¾ x 12 ⅝ (44.9 x 32.1)
Edition: 15, plus artist's proofs

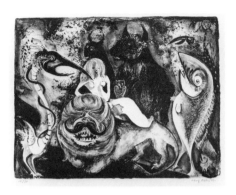

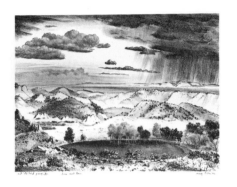

468
A Star Is Born (or **Girl Waiting with**
 Friends or **Girl Waiting**)
1949
Lithograph
13 9/16 x 17 15/16 (34.3 x 45.5)
Edition: 20, plus artist's proofs

469
Sun and Rain
1949
Lithograph
12 3/4 x 17 1/8 (32.4 x 43.5)
Edition: 25, plus artist's proofs

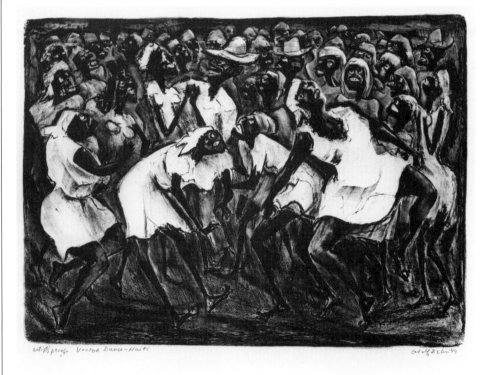

470
Time & Tide
1949
Lithograph
17 x 12 5/8 (43.2 x 32.1)
Edition: 20, plus trial and artist's proofs

471
Voodoo Dance—Haiti
1949
Lithograph
12 1/2 x 17 1/4 (31.8 x 43.9)
Edition: 20, plus artist's proofs

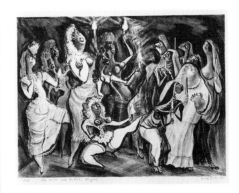

472
The Wise and Foolish Virgins
1949
Lithograph
13 ⅛ x 17 ½ (33.2 x 44.4)
Edition: 20, plus artist's proofs

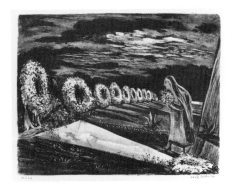

473
Yesterday and Tomorrow
1949
Lithograph
13 ⅛ x 17 ⅛ (33.4 x 43.4)
Edition: 22, plus artist's proofs

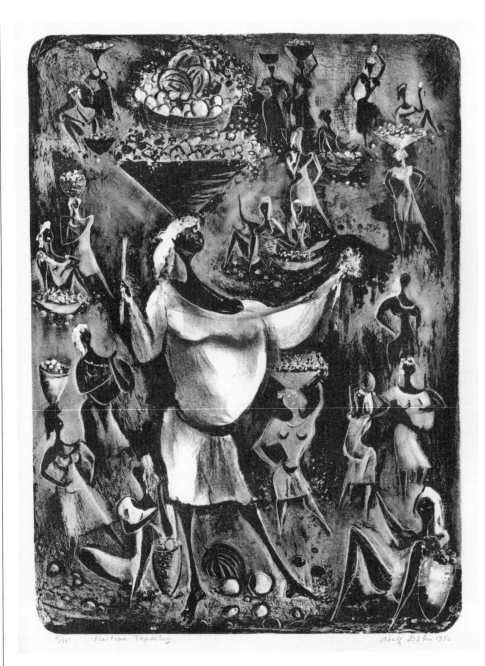

474
Haitian Tapestry
1950
Lithograph
17 x 12 ⅝ (43.2 x 32.1)
Edition: 15, plus trial proofs
Printed by Robert Blackburn, New York.

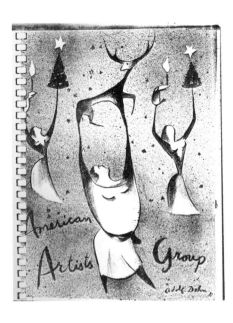

475
American Artists Group Advertise-
ment
1951
Lithograph
12 x 9 (30.4 x 22.9)
Edition: 2000, plus trial proofs
Printed for *Improvisations II*, a souvenir
booklet for the Artist's Equity
Masquerade Ball, May 4, 1951.

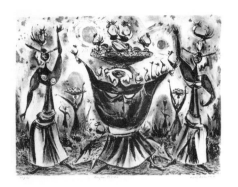

476
Bonjour M'sieu
1952
Lithograph
12 x 15⅞ (30.4 x 40.3)
Edition: 25

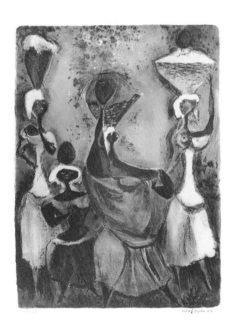

478
Four Haitian Women
1952
Lithograph in four colors
15⁵⁄₁₆ x 11⅝ (38.9 x 29.4)
Edition: 23, plus trial proofs
Printed by John Muench, Lovell, Maine.

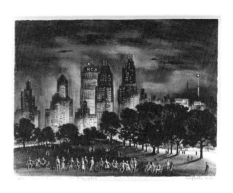

477
Central Park South (or Central Park
South Skyline)
1952
Lithograph
11⅞ x 15⅞ (30.1 x 40.4)
Edition: 30, plus artist's proofs
Printed by George Miller, New York.

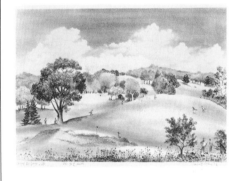

479
The Golf Hills
1952
Lithograph
9⅜ x 13⅜ (23.8 x 34.1)
Edition: Undetermined, plus trial proofs
Printed by George Miller, New York, for
the Buck Hill Falls (Pennsylvania)
Country Club.

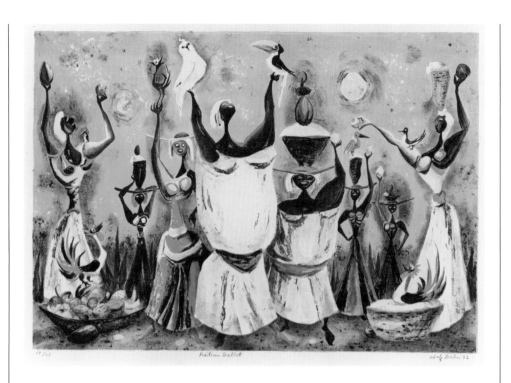

480
Haitian Ballet (*see Plate 22*)
1952
Lithograph in five colors
14 ¾ x 21 ¼ (37.5 x 54.0)
Edition: 27, plus trial proofs
Printed by John Muench, Lovell, Maine.

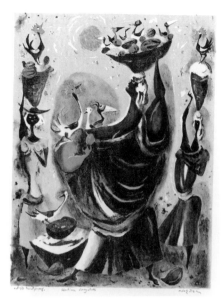

481
Haitian Caryatids
1952
Lithograph in four colors
16 x 12 ⅛ (40.5 x 30.7)
Edition: International Graphic Arts Society edition, 200; artist's edition, 10, plus trial and artist's proofs
Printed by John Muench, Lovell, Maine.

482
Haitian Waterfront Girls (or Island Ladies)
1952
Lithograph
10 ⅞ x 15 (27.6 x 38.1)
Edition: Trial proofs only
Printed by George Miller, New York.

483
Haitian Women
Ca. 1952
Lithograph
16 ½ x 12 ½ (41.9 x 31.8)
Edition: Trial proofs only

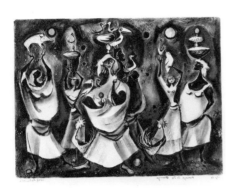

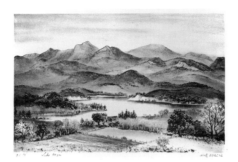

484
Homage to the Orange
1952
Lithograph
11⅞ x 16 1/16 (30.2 x 40.7)
Edition: 20
Printed by George Miller, New York.

485
Lake Kezar
1952
Lithograph
11¼ x 17 9/16 (28.5 x 44.6)
Edition: 15, plus artist's proofs
Printed by John Muench, Lovell, Maine.

486
Loomcraft, J. Schneierson and Sons, Inc., Advertisement
1952
Lithograph
12 x 9 (30.4 x 22.9)
Edition: 2000
Printed for *Improvisations III*, a souvenir booklet for the Artist's Equity Masquerade Ball, May 15, 1952.

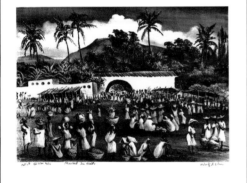

487
Market in Haiti
1952
Lithograph
9⅝ x 13½ (24.5 x 34.4)
Edition: Associated American Artists edition, 250; artist's edition, 10

488
Minnesota Landscape
1952
Lithograph
9¼ x 13⅜ (23.4 x 34.0)
Edition: Associated American Artists edition, 250; artist's edition, 10, plus artist's proofs

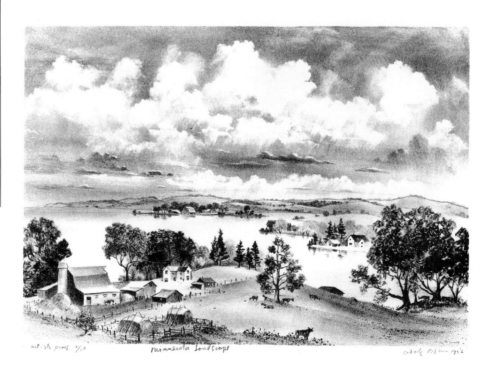

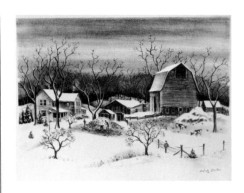

489
Moose Lake — The Farm
1952
Lithograph
9 3/8 x 13 5/8 (23.8 x 34.6)
Edition: Undetermined

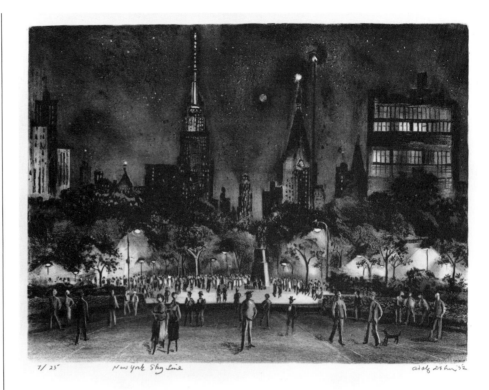

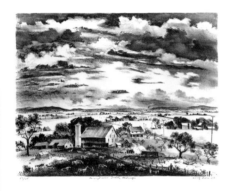

491
Pennsylvania Dutch Landscape
1952
Lithograph
13 7/8 x 18 (35.2 x 45.7)
Edition: 35
Printed by George Miller, New York.

490
New York Sky Line
1952
Lithograph
11 7/8 x 15 7/8 (30.1 x 40.3)
Edition: 25
Printed by George Miller, New York.

492
Road to Port au Prince
1952
Lithograph
12 x 15 7/8 (30.4 x 40.4)
Edition: 25, plus artist's proofs
Printed by George Miller, New York.
"This *Port au Prince* lithograph was
planned as a demonstration. My de-
sire was to show the beauty of pure
whites and gentle rubbed tones merg-
ing into darker grain textures made by
using the pointed and flat side of the
crayon along with rubbed tones varied
by the use of razor blades and an ink
eraser" (Adolf Dehn, "Don't Let
Lithography Frighten You," *American
Artist*, June 1952, p. 54).

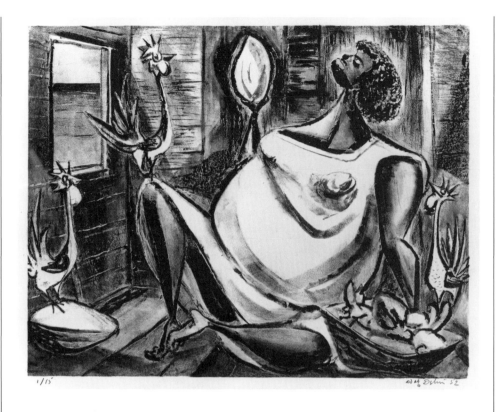

493
Sitting Balancing
1952
Lithograph
11 13/16 x 15 5/16 (30.0 x 38.8)
Edition: 15, plus artist's proofs
Printed by John Muench, Lovell, Maine.

494
Standing Balancing
1952
Lithograph
18 3/4 x 12 (47.7 x 30.6)
Edition: 15
Printed by John Muench, Lovell, Maine.

495
Tropical Jugglers
1952
Lithograph in three colors
16 1/16 x 12 1/16 (40.7 x 30.6)
Edition: 30, plus trial proofs
Printed by George Miller, New York.

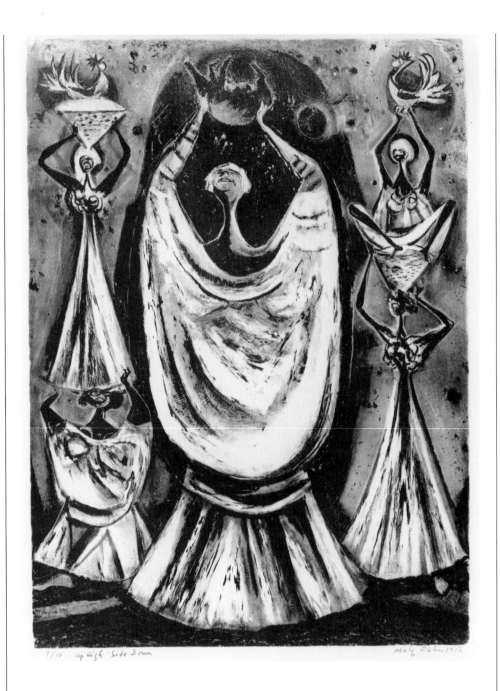

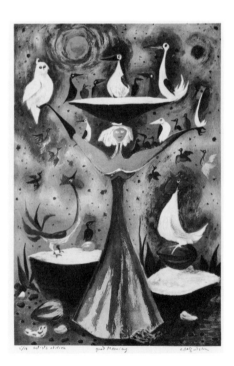

496
Up High Side Down
1952
Lithograph
15 11/16 x 11 13/16 (39.8 x 30.0)
Edition: 10
Printed by George Miller, New York.

497
**Water Water Everywhere but What a
Drop to Drink—Schenley Advertise-
ment**
1952
Lithograph in five colors
12 x 9 (30.4 x 22.9)
Edition: 2000
Printed for *Improvisations III*, a souvenir
 booklet for the Artist's Equity
 Masquerade Ball, May 15, 1952.

498
Good Morning
1953
Bourges process paintagraph
17 1/8 x 11 3/8 (43.5 x 28.9)
Edition: Associated American Artists
 edition, undetermined; artist's edition,
 10

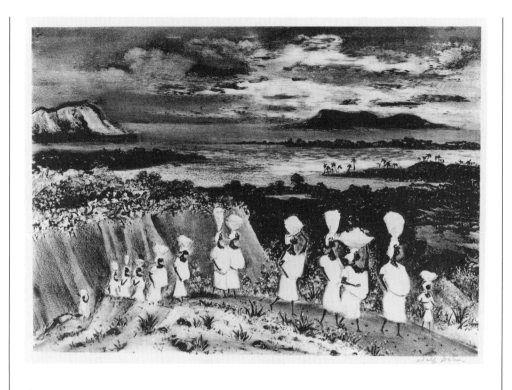

500
Demonstration Print
1954
Lithograph
11 ¼ x 16 ³⁄₁₆ (28.5 x 41.0)
Edition: Trial proofs only
Printed by Reginald Neal, Woodstock,
 New York.

499
Caribbean Processional (*see Plate 17*)
1954
Lithograph
9 ¹³⁄₁₆ x 13 ¹³⁄₁₆ (24.9 x 35.0)
Edition: Associated American Artists
 edition, 250; artist's edition, 10
Printed for the twentieth anniversary of
 Associated American Artists.

501
**Fishing in Minnesota (or Fishing near
 Morristown or Summer Day)**
1954
Lithograph
9 ⅝ x 13 ¹¹⁄₁₆ (24.4 x 34.8)
Edition: Associated American Artists
 edition, 250; artist's edition, 10

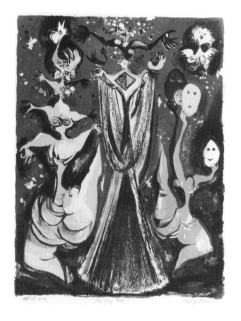

502
The Gay Ones
1954
Lithograph in four colors
15 ⅝ x 12 ⅛ (39.6 x 30.8)
Edition: 20, plus trial and artist's proofs
Printed by Reginald Neal, Woodstock,
 New York.

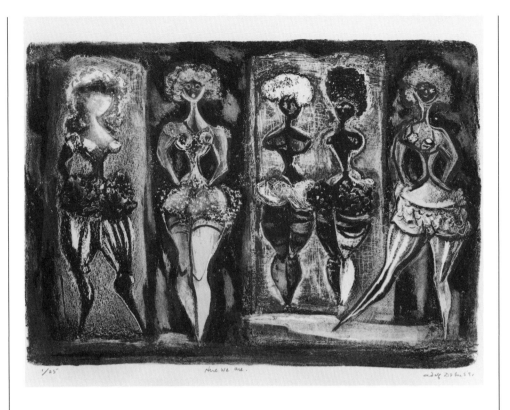

503
Here We Are
1954
Lithograph in two colors
11 ⅛ x 16 (28.3 x 40.6)
Edition: 25, plus trial proofs
Printed by Reginald Neal, Woodstock, New York.

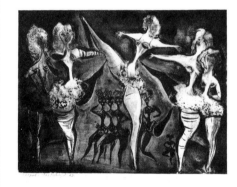

504
Nice Summer Day (or Fine Day on the Farm)
1954
Lithograph
9 ⁷⁄₁₆ x 13 ⁵⁄₁₆ (23.9 x 33.8)
Edition: Associated American Artists edition, 250; artist's edition, 10

505
Central Park
1955
Lithograph
9 ⅝ x 13 ⅝ (24.5 x 34.7)
Edition: Associated American Artists edition, undetermined; artist's edition, 10, plus artist's proofs

506
Dancers
1955
Lithograph
11 ⅞ x 15 ¹¹⁄₁₆ (30.2 x 39.8)
Edition: Trial proofs only
Printed by George Miller, New York.

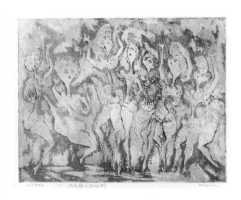

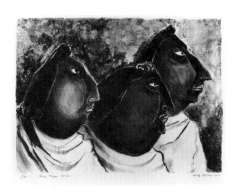

507
Ped, Bi & Tripeds
Ca. 1955
Etching
8 15/16 x 11 5/8 (22.7 x 29.6)
Edition: Trial proofs only
Printed by Federico Castellón.

508
Three Mayan Women (*see Plate 18*)
1955
Lithograph
10 7/8 x 15 (27.6 x 38.1)
Edition: 20
Printed by George Miller, New York.

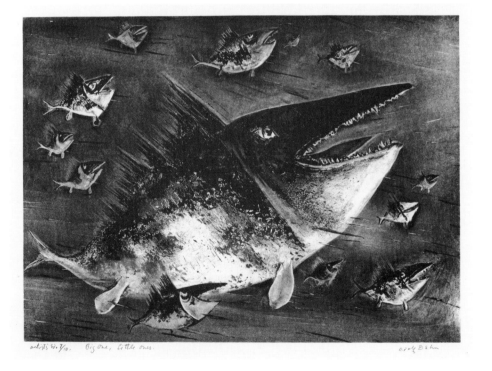

509
Big One, Little Ones
1956
Lithograph
10 11/16 x 14 13/16 (27.1 x 37.6)
Edition: Society of American Graphic
 Artists edition, undetermined; artist's
 edition, 10
Printed by George Miller, New York.
 This lithograph was the 1956 Presenta-
 tion Print for the fortieth annual exhi-
 bition of the Society of American
 Graphic Artists.

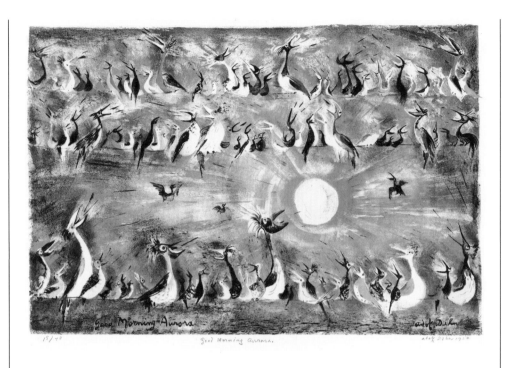

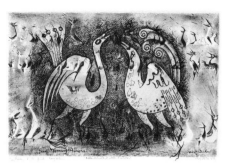

510.ii
Biddle, Dehnelle, Birdelle, Printelle
1956
Lithograph in four colors
13⅛ x 19½ (33.2 x 49.4)
Edition: Artist's proofs only
Printed by George Miller, New York.
This lithograph is a collaboration between Dehn and George Biddle, who printed over proofs of Dehn's *Good Morning Aurora*.

510.i
Good Morning Aurora
(*see Plate 23*)
1956
Lithograph in four colors
13¹/₁₆ x 19¾ (33.2 x 50.1)
Edition: 40, plus artist's proofs
Printed by George Miller, New York.

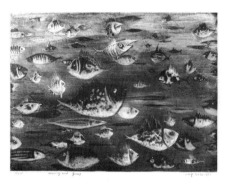

511
Coming and Going
1957
Lithograph
11¾ x 16 (29.8 x 40.6)
Edition: 15
Printed by George Miller, New York.

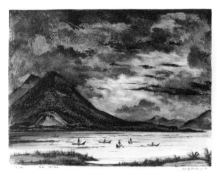

513
Lake Atitlan
1957
Lithograph
11 ¹³⁄₁₆ x 15 ⅞ (30.1 x 40.4)
Edition: 20
Printed by George Miller, New York.

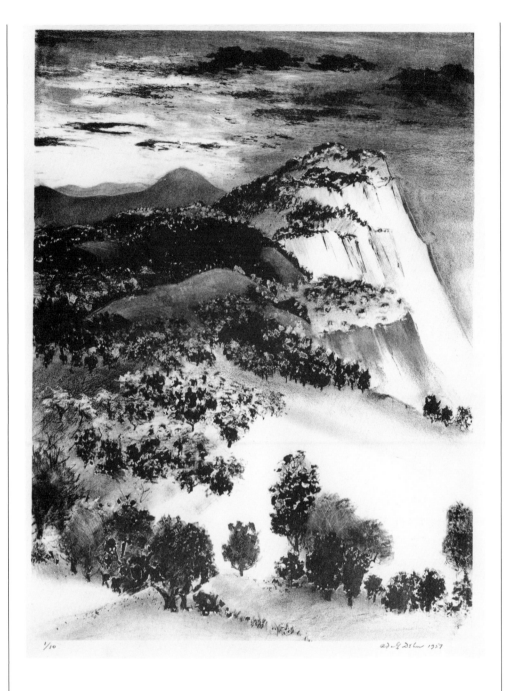

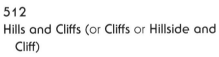

512
Hills and Cliffs (or **Cliffs** or **Hillside and
 Cliff**)
1957
Lithograph
15 ¹³⁄₁₆ x 11 ¹³⁄₁₆ (40.2 x 30.0)
Edition: 10
Printed by George Miller, New York.

514
Men of Chichicastenango
1957
Lithograph
11 ⅞ x 16 (30.3 x 40.7)
Edition: 20
Printed by George Miller, New York.

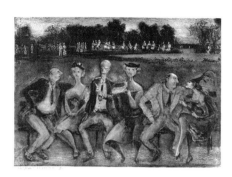

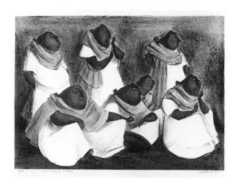

515
Parakeets with Baroque Background
1957
Lithograph
14⅜ x 11¾ (36.4 x 29.8)
Edition: Trial proofs only
Printed by George Miller, New York.

516
Park Bench
1957
Lithograph
11 1/16 x 15⅞ (28.0 x 40.3)
Edition: Trial proofs only
Printed by George Miller, New York.

517
Seven Mayan Women
1957
Lithograph in three colors
12¾ x 17⅞ (32.4 x 45.4)
Edition: 20, plus trial and artist's proofs
Printed by George Miller, New York.

518
Tomorrow Is Forever (or Always Tomorrow)
1957
Lithograph
11⅛ x 15 13/16 (28.3 x 40.2)
Edition: 20
Printed by George Miller, New York.

519
Watching the Birds
1957
Lithograph
11½ x 15⅞ (29.2 x 40.3)
Edition: 20
Printed by George Miller, New York.

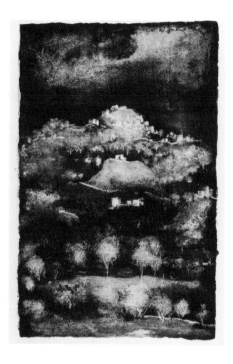

520
Christmas Card Design
Ca. 1958
Lithograph in two colors
11⅞ x 7¾ (30.1 x 19.8)
Edition: Trial proofs only

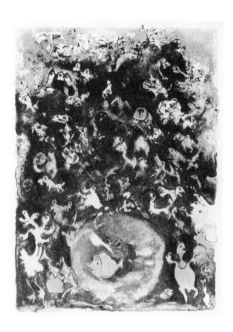

521
Christmas Card Design
Ca. 1958
Lithograph in two colors
7⁹⁄₁₆ x 5½ (19.2 x 14.1)
Edition: Trial proofs only

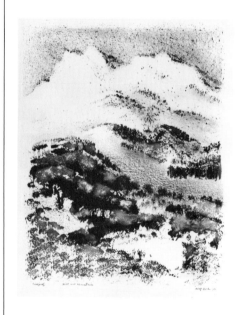

522
Hill and Mountain
1958
Lithograph
19 x 15⅛ (48.0 x 38.3)
Edition: 20, plus trial and artist's proofs
Printed at Atelier Desjobert, Paris. This
 lithograph received the E. P. Stauffer
 Award at the Audubon Artists Exhibi-
 tion in 1959.

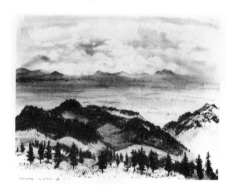

523
The Himalayas
1958
Lithograph
13¾ x 18 (35.0 x 45.7)
Edition: Trial proofs only
Printed at Atelier Desjobert, Paris.

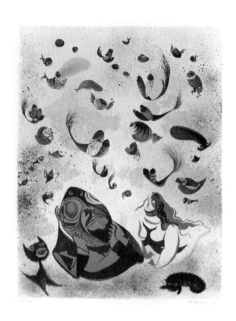

524
Invasion (*see Plate 24*)
1958
Lithograph in six colors
18 ¼ x 14 ¼ (46.2 x 36.2)
Edition: 20, plus trial and artist's proofs
Printed at Atelier Desjobert, Paris.

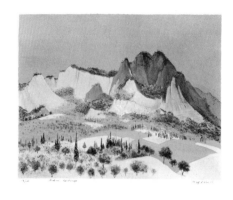

525
Italian Landscape
1958
Lithograph in three colors
14 ³⁄₁₆ x 18 ⅛ (36.0 x 46.0)
Edition: 20, plus trial proofs
Printed at Atelier Desjobert, Paris.

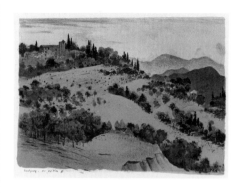

526
Italian Landscape
1958
Lithograph in four colors
13 ⁷⁄₁₆ x 18 ¼ (34.2 x 46.5)
Edition: Trial proofs only
Printed at Atelier Desjobert, Paris.

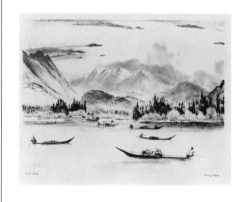

527
Lake Dal, Kashmir
1958
Lithograph
13 ⅛ x 17 ⅞ (33.3 x 45.4)
Edition: 20, plus trial proofs
Printed at Atelier Desjobert, Paris.

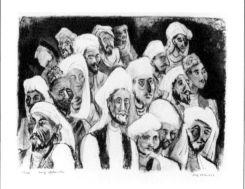

528
Men of Afghanistan
1958
Lithograph
13 ¼ x 18 ⅜ (33.6 x 46.6)
Edition: 20, plus trial proofs
Printed at Atelier Desjobert, Paris.

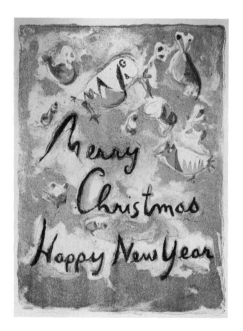

529
Merry Christmas Happy New Year
Ca. 1958
Lithograph in two colors
7 ½ x 5 ⁹⁄₁₆ (19.1 x 14.1)
Edition: Trial proofs only

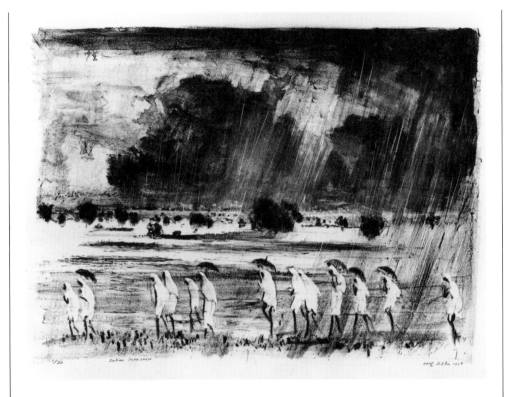

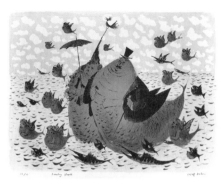

531
Sunday Stroll
1958
Lithograph in four colors
12 x 16 ⅛ (30.5 x 40.8)
Edition: 15, plus trial and artist's proofs
Printed at Atelier Desjobert, Paris.

530
Monsoon (or Indian Monsoon)
1958
Lithograph
13 ⅞ x 19 ¼ (35.3 x 48.9)
Edition: 20, plus trial proofs
Printed at Atelier Desjobert, Paris.

532
**Ancient Quadruped (or Together-
ness)**
1960
Lithograph in two colors
14 ⅜ x 18 ¼ (36.5 x 46.3)
Edition: 30, plus artist's proofs
Printed at Atelier Desjobert, Paris.

533
India
1960
Lithograph
18 ⅛ x 14 ⅛ (46.0 x 36.0)
Edition: 25
Printed by Burr and George Miller, New
York.

534
Italian Hill
1960
Lithograph
13 ⅞ x 17 ⅞ (35.3 x 45.3)
Edition: 25, plus trial proofs
Printed by Burr and George Miller, New
York.

535
King of India (*see Plate 19*)
1960
Lithograph
14 x 17 ¾ (35.5 x 45.2)
Edition: 25, plus trial proofs
Printed by Burr and George Miller, New
York.

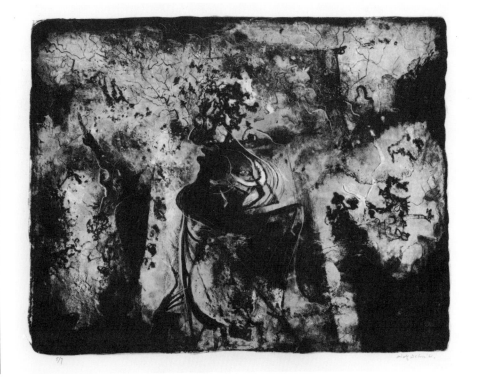

536.i
Abstraction
1961
Lithograph
14 ⅛ x 18 ⁷⁄₁₆ (35.8 x 46.9)
Edition: 7
Printed at Atelier Desjobert, Paris.

536.ii
Abstraction (or **Time**)
1961
Lithograph in two colors
14 ¼ x 18 ½ (36.2 x 47.1)
Edition: 7, plus trial and artist's proofs
Printed at Atelier Desjobert, Paris.

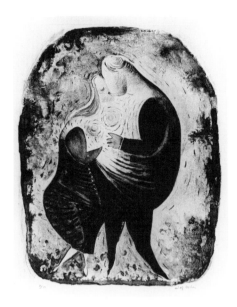

537
"Baisser-Moi" (or The Kiss)
1961
Lithograph
15 7⁄16 x 12 3⁄8 (39.2 x 31.5)
Edition: 11, plus artist's proofs
Printed at Atelier Desjobert, Paris.

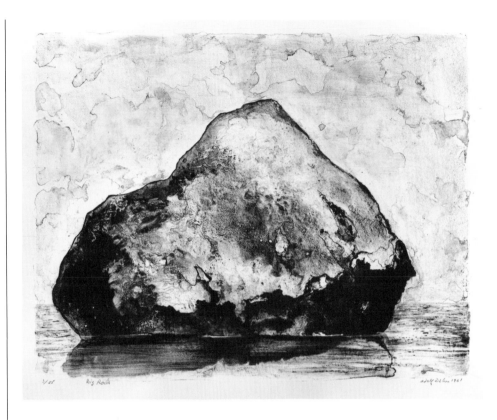

538
Big Rock
1961
Lithograph
14 1⁄8 x 18 1⁄4 (35.8 x 46.3)
Edition: 25
Printed at Atelier Desjobert, Paris.

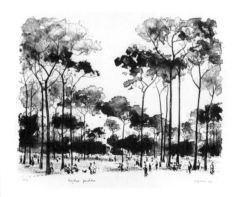

539
Borghese Gardens (*see Plate 20*)
1961
Lithograph
14 1⁄8 x 18 1⁄2 (35.5 x 47.0)
Edition: 35
Printed at Atelier Desjobert, Paris.

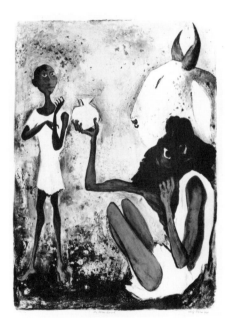

540
The Brass Bowl
1961
Lithograph in three colors
25 1⁄2 x 18 5⁄8 (64.7 x 47.3)
Edition: 35, plus artist's proofs
Printed at Atelier Desjobert, Paris.

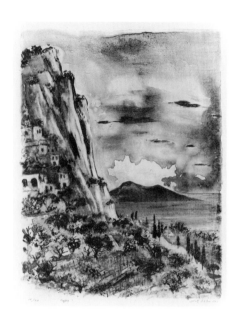

541
Capri
1961
Lithograph
19¼ x 14⅞ (48.8 x 37.7)
Edition: 20, plus artist's proofs
Printed at Atelier Desjobert, Paris.

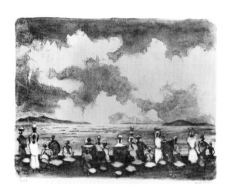

542
Caribbean Merchants
1961
Lithograph in four colors
14⅛ x 18¼ (35.7 x 46.3)
Edition: 35, plus artist's proofs
Printed at Atelier Desjobert, Paris.

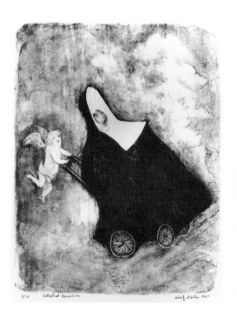

544
Celestial Excursion
1961
Lithograph
14¾ x 11¾ (37.5 x 30.0)
Edition: 10, plus trial proofs
Printed by Burr Miller, New York.

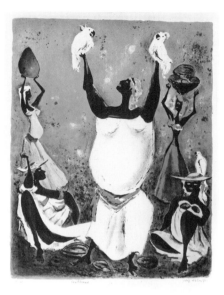

543
Caribbeans
1961
Lithograph in four colors
21⅝ x 17½ (55.0 x 44.4)
Edition: 40; artist's edition, 10, plus trial
and artist's proofs
Printed at Atelier Desjobert, Paris.

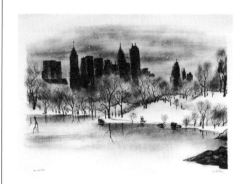

545
Central Park Lake — Winter
Ca. 1961
Lithograph
15⅞ x 23 (40.4 x 58.2)
Edition: Trial proofs only

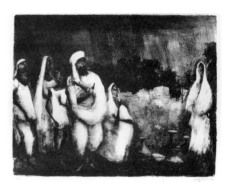

547
First Rain
1961
Lithograph
13 15/16 x 18 1/8 (35.4 x 46.3)
Edition: 10, plus trial proofs
Printed by Burr Miller, New York.

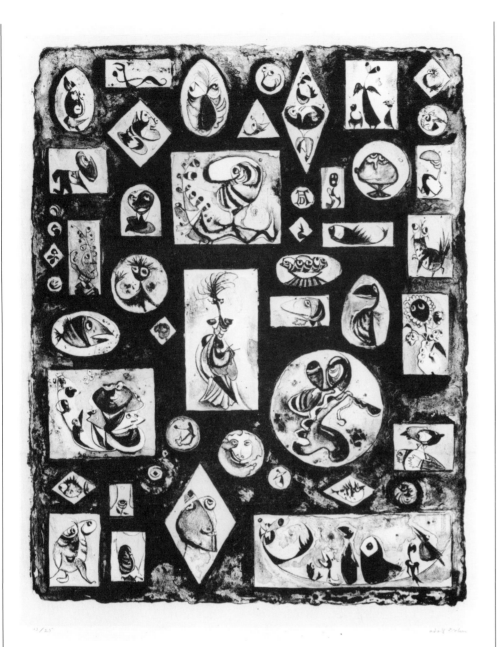

546
Conversation Peice [*sic*]
1961
Lithograph in two colors
21 7/8 x 17 7/16 (55.6 x 44.2)
Edition: 25
Printed at Atelier Desjobert, Paris.

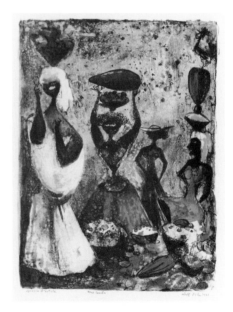

548
Four Caribs
1961
Lithograph in four colors
19 3/8 x 14 15/16 (49.4 x 38.0)
Edition: 35, plus trial and artist's proofs
Printed at Atelier Desjobert, Paris.

549
Great Hillside (or Italian Hillside)
1961
Lithograph
14 ⅜ x 18 ⅝ (36.5 x 47.3)
Edition: 30, plus artist's proofs
Printed at Atelier Desjobert, Paris.

550
Grey Night (or Winter in Central Park)
Ca. 1961
Lithograph in three colors
14 ½ x 19 ⅜ (37.0 x 49.2)
Edition: Trial proofs only
Printed at Atelier Desjobert, Paris.

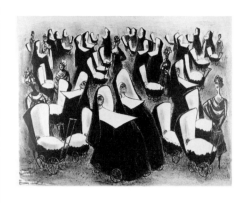

551
Habits
1961
Lithograph
14 x 18 ¾ (35.6 x 47.6)
Edition: 30, plus trial proofs
Printed by Burr Miller, New York.

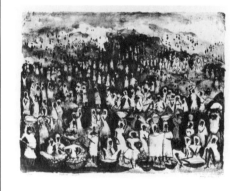

552
Haitian Night (or Haitian Hill)
1961
Lithograph
14 ¾ x 19 ¼ (37.3 x 49.1)
Edition: 30, plus artist's proofs
Printed at Atelier Desjobert, Paris.

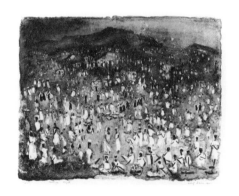

553.i
Haitian Night
1961
Lithograph
14 ⅛ x 18 (35.8 x 45.8)
Edition: 25
Printed at Atelier Desjobert, Paris.

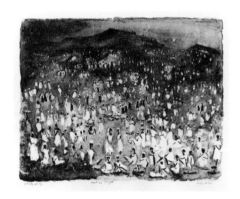

553.ii
Haitian Night
1961
Lithograph in two colors
14 ⅛ x 18 (35.8 x 45.8)
Edition: International Graphic Arts Society edition, 200; artist's edition, 10, plus trial and artist's proofs
Printed at Atelier Desjobert, Paris.

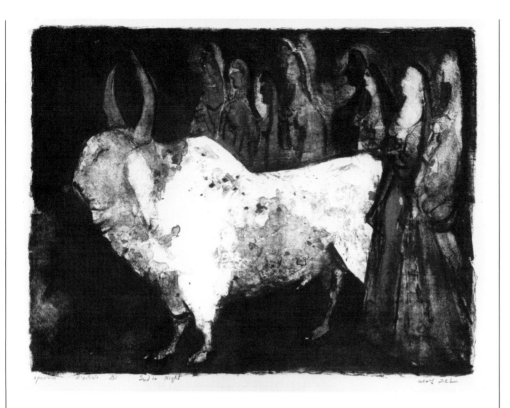

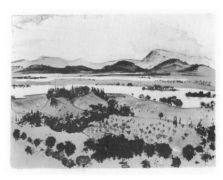

555
Italian Landscape (or Italian Landschaft)
1961
Lithograph in four colors
14 x 19⅜ (35.6 x 49.2)
Edition: 40, plus artist's proofs
Printed at Atelier Desjobert, Paris.

554
India Night
1961
Lithograph in two colors
14¹¹⁄₁₆ x 19⅜ (37.3 x 49.4)
Edition: 35, plus trial and artist's proofs
Printed at Atelier Desjobert, Paris.

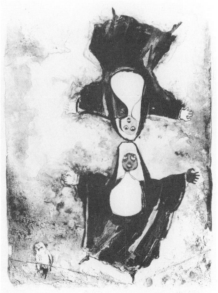

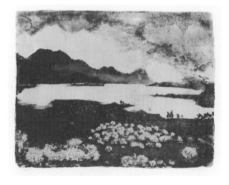

557
The Lake
1961
Lithograph in three colors
13¾ x 18¼ (35.1 x 46.3)
Edition: 40, plus artist's proofs

556
It's Easy
1961
Lithograph
16½ x 12³⁄₁₆ (42.0 x 31.0)
Edition: 35
Printed at Atelier Desjobert, Paris.

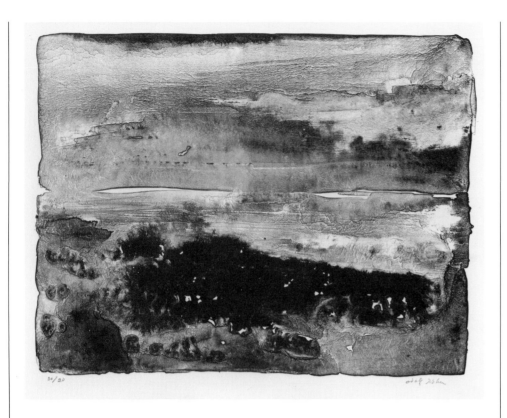

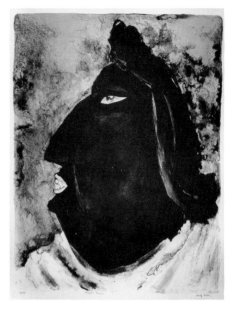

559
Mayan Queen (*see Plate 25*)
1961
Lithograph in three colors
27 ¾ x 21 ¼ (70.4 x 54.0)
Edition: 35, plus artist's proofs
Printed at Atelier Desjobert, Paris.

558
Landscape (or **Grey Landscape**)
1961
Lithograph
13 ¹³⁄₁₆ x 18 ⁵⁄₁₆ (35.0 x 46.6)
Edition: 20, plus artist's proofs
Printed at Atelier Desjobert, Paris.

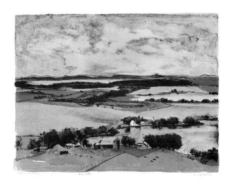

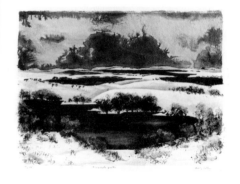

560
Minnesota (*see Plate 26*)
1961
Lithograph in four colors
14 ⁷⁄₁₆ x 19 ⅜ (36.7 x 49.1)
Edition: 20, plus artist's proofs
Printed at Atelier Desjobert, Paris.

561
Minnesota Winter
1961
Lithograph in three colors
14 ¼ x 19 ¼ (36.1 x 49.0)
Edition: 25, plus artist's proofs
Printed at Atelier Desjobert, Paris.

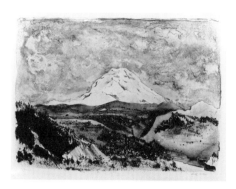

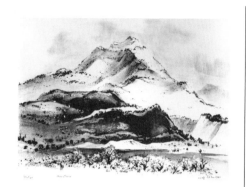

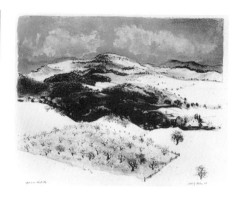

562
Mount Rainier
1961
Lithograph
14 ⅜ x 19 ¼ (36.3 x 49.0)
Edition: 12
Printed at Atelier Desjobert, Paris.

563
Mountain
1961
Lithograph
15 ¼ x 19 (39.0 x 48.2)
Edition: 40, plus artist's proofs
Printed at Atelier Desjobert, Paris.

564
Pennsylvania Winter
1961
Lithograph in three colors
14 ⅛ x 18 ¼ (35.6 x 46.2)
Edition: Trial and artist's proofs only
Printed at Atelier Desjobert, Paris.

565.i
Sacred Ride
1961
Lithograph
14 ⅛ x 18 ⁵⁄₁₆ (35.7 x 46.5)
Edition: 20
Printed at Atelier Desjobert, Paris.

565.ii
Bull and Woman (or Sacred Ride)
1961
Lithograph in two colors
14 ¼ x 18 ½ (36.1 x 46.9)
Edition: 33, plus artist's proofs
Printed at Atelier Desjobert, Paris.

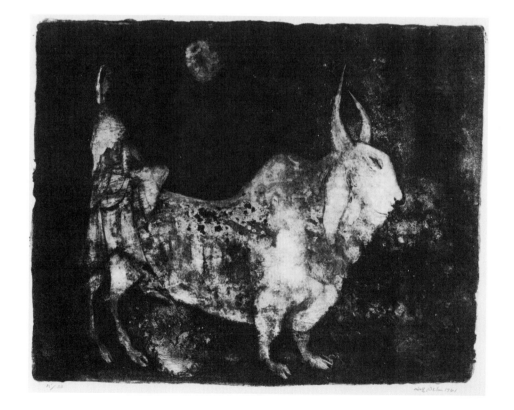

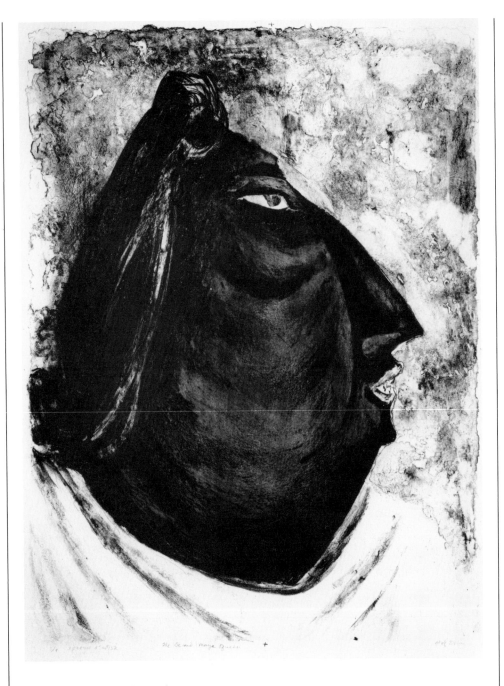

566
Second Mayan Queen
1961
Lithograph
27¾ x 21¼ (70.5 x 53.7)
Edition: 9, plus artist's proofs
Printed at Atelier Desjobert, Paris.

567
Seven Indian Women in Procession
1961
Lithograph in two colors
14 x 19⅝ (35.6 x 49.9)
Edition: Trial proofs only
Printed at Atelier Desjobert, Paris.

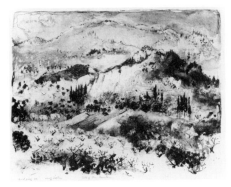

568
Side of the Mountain
1961
Lithograph
14¹⁵⁄₁₆ x 19⅜ (38.0 x 49.2)
Edition: 40, plus trial proofs
Printed at Atelier Desjobert, Paris.

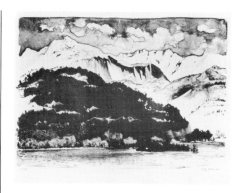

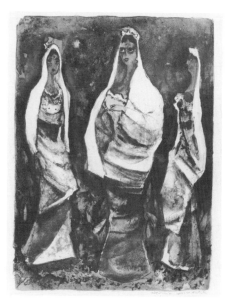

569
Swiss Mountains (or **Switzerland**)
1961
Lithograph
12 ¾ x 18 ⁷⁄₁₆ (32.3 x 46.8)
Edition: 25
Printed at Atelier Desjobert, Paris.

570
Three Indian Ladies (or **Three Indian Girls** or **Three Indian Women**)
1961
Lithograph
16 ¼ x 12 ⁵⁄₁₆ (41.6 x 31.2)
Edition: 10, plus artist's proofs in various three-color combinations
Printed at Atelier Desjobert, Paris.

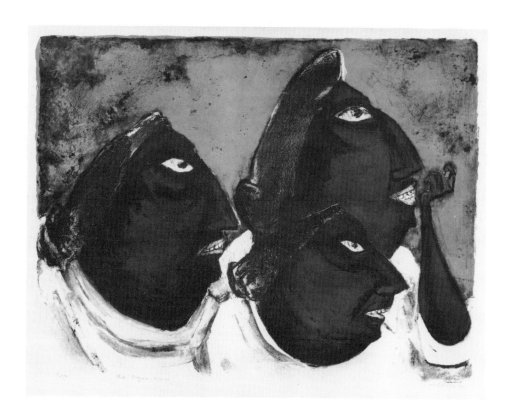

571
Three Mayan Women
1961
Lithograph in three colors
19 ⅛ x 25 ½ (48.6 x 64.4)
Edition: 40, plus artist's proofs
Printed at Atelier Desjobert, Paris.

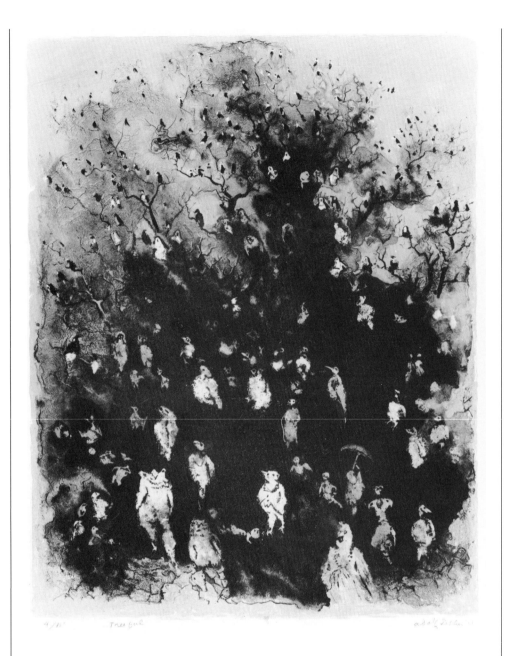

573
Up Hill at Assissi [*sic*]
1961
Lithograph in three colors
14 ½ x 18 ⅜ (36.7 x 46.6)
Edition: 10, plus artist's proofs
Printed at Atelier Desjobert, Paris.

572
Treeful
1961
Lithograph in three colors
19 ⅜ x 15 ½ (49.2 x 39.3)
Edition: 15, plus trial and artist's proofs
Printed at Atelier Desjobert, Paris.

574
The White Bull (or **Woman Riding
Bull**) (*see Plate 27*)
1961
Lithograph in three colors
12 ⅜ x 19 ¹⁄₁₆ (31.4 x 48.5)
Edition: 35, plus artist's proofs
Printed at Atelier Desjobert, Paris.

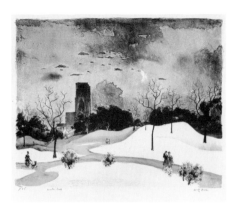

575
Winter Park
1961
Lithograph in three colors
16 ½ x 20 ⅝ (41.9 x 52.3)
Edition: 35, plus trial and artist's proofs
Printed at Atelier Desjobert, Paris.

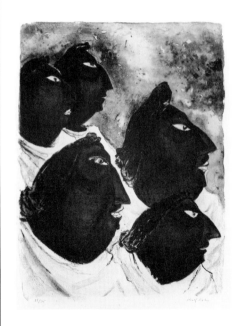

577
Women of Uxmal
1961
Lithograph in three colors
18 ⁹⁄₁₆ x 14 ⅜ (47.5 x 36.4)
Edition: 35, plus artist's proofs
Printed at Atelier Desjobert, Paris.

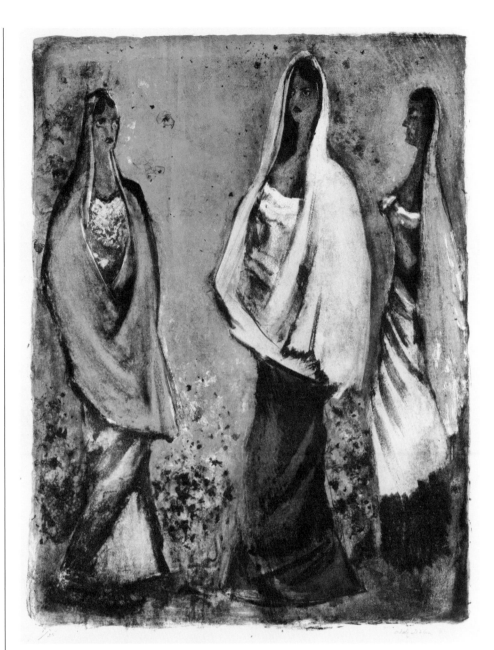

576
Women of Jaipur
1961
Lithograph in four colors
19 ⅜ x 15 (49.1 x 38.0)
Edition: 25, plus artist's proofs
Printed at Atelier Desjobert, Paris.

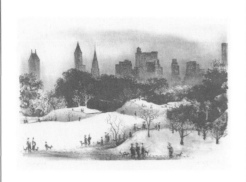

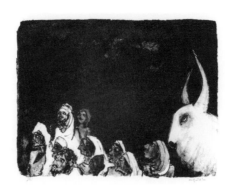

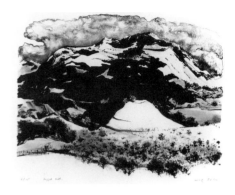

578
Central Park (or City Park)
1962
Lithograph
11 ⅜ x 18 ⅛ (29.0 x 46.0)
Edition: 20, plus trial proofs
Printed by Burr Miller, New York.

579
Hindu Bull and Beggars
1962
Lithograph
13 ⅝ x 17 ⅞ (34.8 x 45.5)
Edition: 15
Printed by Burr Miller, New York.

580
Rugged Hill
1962
Lithograph
14 x 18 1/16 (35.2 x 46.0)
Edition: 15, plus trial proofs
Printed by Burr Miller, New York.

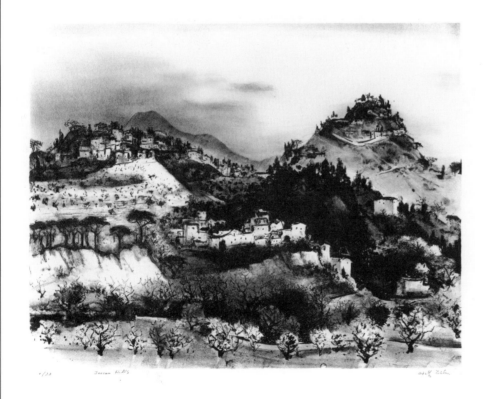

581
Tuscan Hills
1962
Lithograph
13 ¾ x 17 15/16 (35.0 x 45.5)
Edition: 20, plus trial proofs
Printed by Burr Miller, New York.

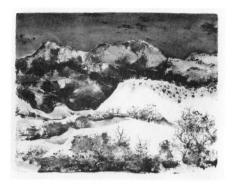

583
White Cliff
1962
Lithograph
14 x 18 ¼ (35.5 x 46.3)
Edition: 10
Printed by Burr Miller, New York.

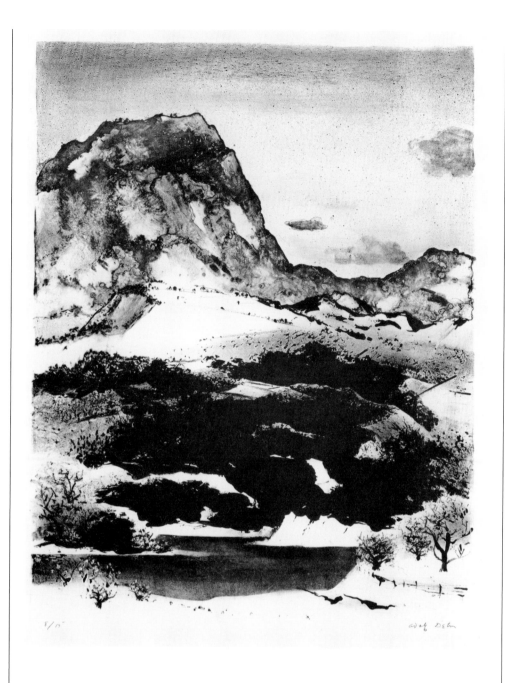

582
Upland Lake (or **Large Cliff**)
1962
Lithograph
17 ⅞ x 14 ⅛ (45.4 x 36.0)
Edition: 15
Printed by Burr Miller, New York.

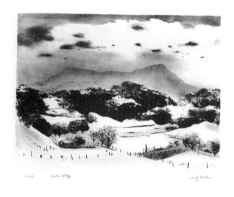

584
Winter Valley
1962
Lithograph
13 ½ x 17 ⅞ (34.4 x 45.5)
Edition: 15 or 20
Printed by Burr Miller, New York.

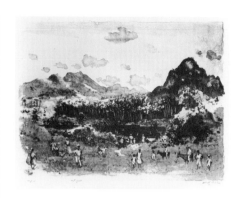

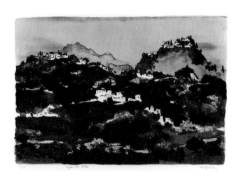

585
Antigua
1963
Lithograph
14 ⅛ x 18 ¹³/₁₆ (35.9 x 47.8)
Edition: 15, plus artist's proofs
Printed at Atelier Desjobert, Paris.

586.i
Appenine [*sic*] **Hills**
1963
Lithograph in three colors
12 ¹⁵/₁₆ x 18 ¹⁵/₁₆ (32.8 x 48.1)
Edition: 11 (numbered with Roman numerals)
Printed at Atelier Desjobert, Paris.

586.ii
Appenine [*sic*] **Hills**
1963
Lithograph in three colors
13 x 19 (32.9 x 48.3)
Edition: 11 (numbered with Arabic numerals), plus artist's proofs
Printed at Atelier Desjobert, Paris.

587
Banares [*sic*] **Beggars** (or **Beggars of Benares**)
1963
Lithograph
15 ¼ x 21 ¼ (38.7 x 54.1)
Edition: 20, plus trial and artist's proofs
Printed at Atelier Desjobert, Paris.

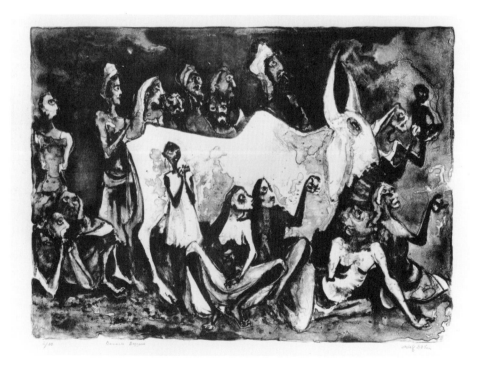

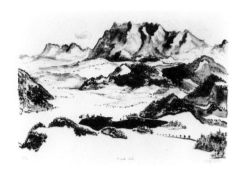

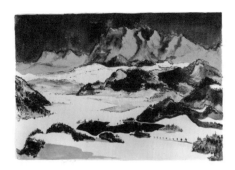

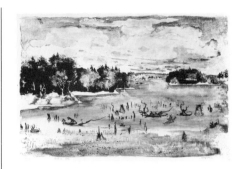

588.i
Black Lake
1963
Lithograph
13 ⅛ x 19 ⅜ (33.4 x 49.3)
Edition: 15
Printed at Atelier Desjobert, Paris.

588.ii
Tyrol Night (or **Black Lake**)
1963
Lithograph in four colors
13 ½ x 19 ⅝ (34.4 x 49.8)
Edition: 50, plus artist's proofs
Printed at Atelier Desjobert, Paris.

589
Canadian Lake
1963
Lithograph
15 ⅜ x 23 ⅜ (38.9 x 59.9)
Edition: 10, plus artist's proofs in two or
 three colors
Printed at Atelier Desjobert, Paris.

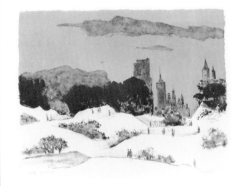

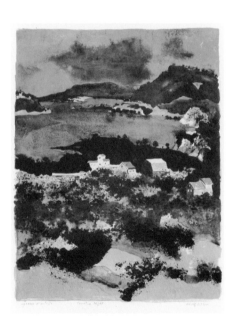

590
Central Park Night
1963
Lithograph in three colors
14 ⅝ x 19 ¼ (37.1 x 49.1)
Edition: Trial proofs only
Printed at Atelier Desjobert, Paris.

591.i
Country Night
1963
Lithograph
18 x 14 ¼ (45.8 x 36.3)
Edition: 10
Printed at Atelier Desjobert, Paris.

591.ii
Country Night
1963
Lithograph in four colors
18 x 14 ⁵⁄₁₆ (45.8 x 36.4)
Edition: International Graphic Arts Soci-
 ety edition, 200, plus artist's proofs
Printed at Atelier Desjobert, Paris.

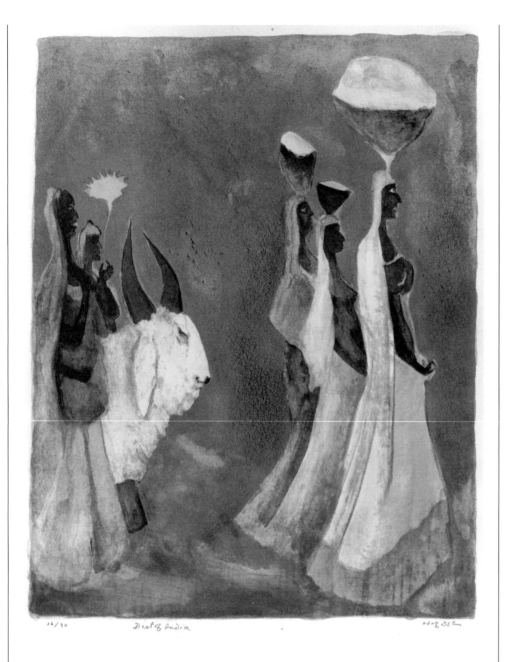

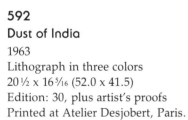

592
Dust of India
1963
Lithograph in three colors
20 ½ x 16 ⁵/₁₆ (52.0 x 41.5)
Edition: 30, plus artist's proofs
Printed at Atelier Desjobert, Paris.

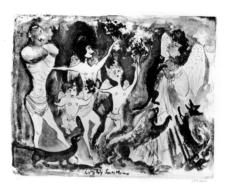

593
Everybody Loves Momo
1963
Lithograph
14 ⅞ x 19 (37.8 x 48.4)
Edition: 25, plus artist's proofs
Printed at Atelier Desjobert, Paris.

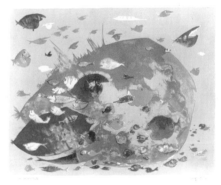

594
Fish
1963
Lithograph in three colors
14 ⅞ x 18 ¼ (36.7 x 46.4)
Edition: Artist's proofs only
Printed at Atelier Desjobert, Paris.

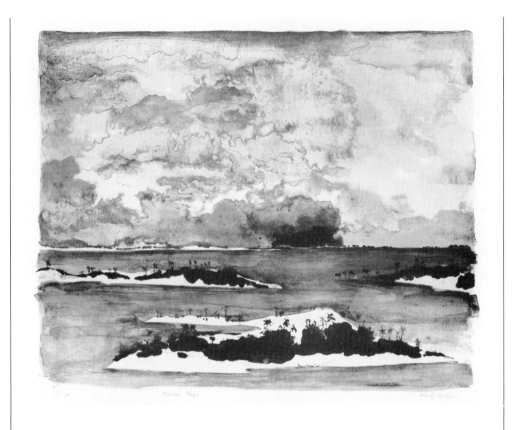

595.i
Florida Keys
1963
Lithograph
14 ⅝ x 18 ¼ (37.2 x 46.4)
Edition: 10
Printed at Atelier Desjobert, Paris.

595.ii
Florida Keys
1963
Lithograph in four colors
14 ¾ x 18 ¾ (37.4 x 47.6)
Edition: 20, plus artist's proofs
Printed at Atelier Desjobert, Paris.

596.i
Good Morning
1963
Lithograph in four colors
17 ¹³⁄₁₆ x 13 ¹⁵⁄₁₆ (45.2 x 35.5)
Edition: 12
Printed at Atelier Desjobert, Paris.

596.ii
Good Morning
1963
Lithograph in four colors
17 ⅞ x 13 ¹⁵⁄₁₆ (45.4 x 35.5)
Edition: 13, plus artist's proofs
Printed at Atelier Desjobert, Paris.

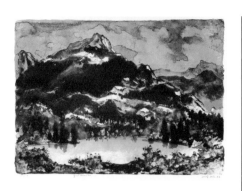

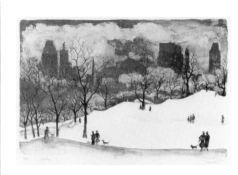

597.i
Great Mountain
1963
Lithograph
16⅜ x 23 (42 x 58.4)
Edition: 10 (numbered with Roman numerals)
Printed at Atelier Desjobert, Paris.

597.ii
Great Mountain
1963
Lithograph in three colors
16⁹⁄₁₆ x 23¼ (42.1 x 59.0)
Edition: 50, plus artist's proofs
Printed at Atelier Desjobert, Paris.

598
Grey Day (*see Plate 28*)
1963
Lithograph in three colors
15½ x 23¼ (39.4 x 59.1)
Edition: 25, plus artist's proofs
Printed at Atelier Desjobert, Paris.

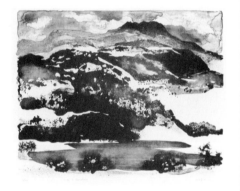

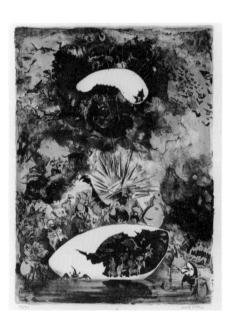

599
Hill to Mountain
1963
Lithograph
14 x 18 (35.5 x 45.5)
Edition: 10, plus artist's proofs
Printed at Atelier Desjobert, Paris.

600.i
Homage à Hieronymous Bosch
1963
Lithograph
22½ x 16½ (52.1 x 41.9)
Edition: 10
Printed at Atelier Desjobert, Paris.

600.ii
Homage à Hieronymous Bosch
(*see Plate 29*)
1963
Lithograph in four colors
22⅝ x 16⅝ (57.4 x 42.2)
Edition: 30, plus artist's proofs
Printed at Atelier Desjobert, Paris.

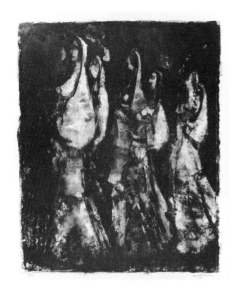

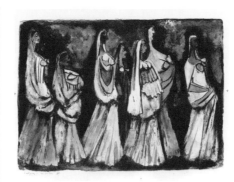

602
Indian Women in Procession
Ca. 1963
Lithograph in three colors
14¼ x 19¹³⁄₁₆ (36.0 x 50.3)
Edition: Trial proofs only
Printed at Atelier Desjobert, Paris.

601
Indian Women (or **Indian Ladies**)
1963
Lithograph
19 x 15¾ (48.5 x 40.0)
Edition: 5
Printed at Atelier Desjobert, Paris.

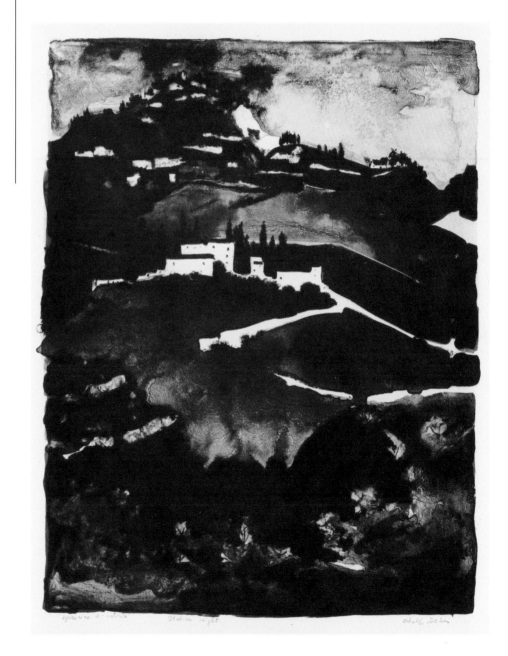

603
Italian Night
1963
Lithograph in three colors
18¼ x 14³⁄₁₆ (46.3 x 36.0)
Edition: Philadelphia Print Club edition,
 30; artist's edition, 10, plus artist's
 proofs

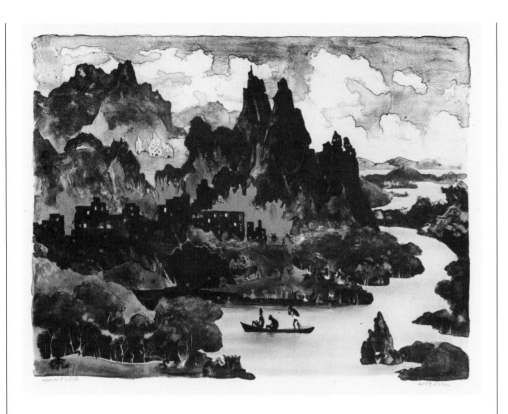

604.i
Jerome Patinir and Adolf Dehn
1963
Lithograph
14¾ x 19⅜ (37.3 x 49.2)
Edition: 10
Printed at Atelier Desjobert, Paris.

604.ii
**Jerome Patinir and Mr. Adolf Dehn
on the River Styx** (*see Plate 30*)
1963
Lithograph in four colors
14¾ x 19⅜ (37.3 x 49.2)
Edition: 30, plus artist's proofs
Printed at Atelier Desjobert, Paris.

605
Lake in the Hills
1963
Lithograph
16¼ x 23⅛ (41.4 x 58.7)
Edition: 10, plus artist's proofs in two
colors
Printed at Atelier Desjobert, Paris.

606.i
Lake in the Tyrol
1963
Lithograph
14 ¼ x 19 ¼ (36.2 x 48.9)
Edition: 20
Printed at Atelier Desjobert, Paris.

606.ii
Lake in the Tyrol
1963
Lithograph in two colors
14 ⅜ x 19 ¼ (36.4 x 48.9)
Edition: 10, plus artist's proofs
Printed at Atelier Desjobert, Paris.

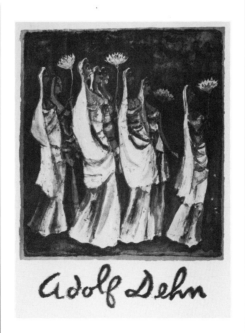

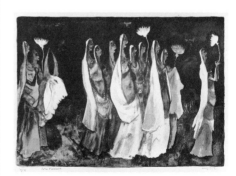

607.i
Lotus in the Night (or Lotus Ladies)
1963
Lithograph in two colors
17 ⅞ x 16 ¼ (45.4 x 41.3)
Edition: 100
Printed at Atelier Desjobert, Paris.

607.ii
Poster for Exhibition at FAR Gallery,
　　New York
1963
Lithograph in two colors
21 ½ x 16 ¼ (54.5 x 41.2)
Edition: Undetermined
Printed at Atelier Desjobert, Paris.

608
Lotus Procession
1963
Lithograph in three colors
16 x 23 3/16 (40.6 x 59.0)
Edition: 35, plus artist's proofs
Printed at Atelier Desjobert, Paris.

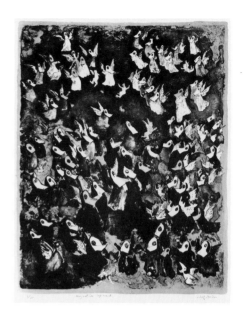

609
Magic Rocks
1963
Lithograph in three colors
14 ½ x 18 ¼ (36.8 x 46.4)
Edition: Artist's proofs only
Printed at Atelier Desjobert, Paris.

610
Migration Upward
1963
Lithograph in two colors
18 ⅜ x 14 ¾ (46.6 x 37.4)
Edition: 20
Printed at Atelier Desjobert, Paris.

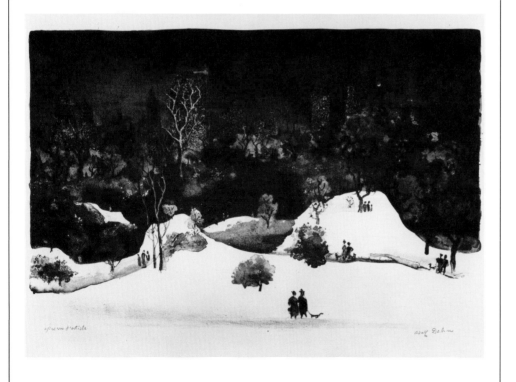

611.i
Park Night (or Winter Park at Night)
1963
Lithograph
15 ⅛ x 23 ½ (38.4 x 59.6)
Edition: 10
Printed at Atelier Desjobert, Paris.

611.ii
Park Night (or Winter Park at Night)
1963
Lithograph in three colors
15 ⅛ x 23 ½ (38.4 x 59.6)
Edition: 40, plus artist's proofs
Printed at Atelier Desjobert, Paris.

612
Procession (or Ten Hindu Ladies)
1963
Lithograph
13 ¾ x 18 ¼ (35.0 x 46.4)
Edition: Artist's proofs only
Printed at Atelier Desjobert, Paris.

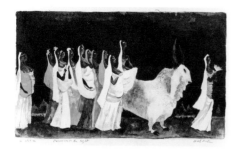

613
Procession in the Night
Ca. 1963
Lithograph in two colors
15 ½ x 26 ⁷⁄₁₆ (39.4 x 67.0)
Edition: Trial proofs only

614
Proud Bull
1963
Lithograph in three colors
18 ¼ x 14 ¼ (46.3 x 36.3)
Edition: 20, plus artist's proofs
Printed at Atelier Desjobert, Paris.

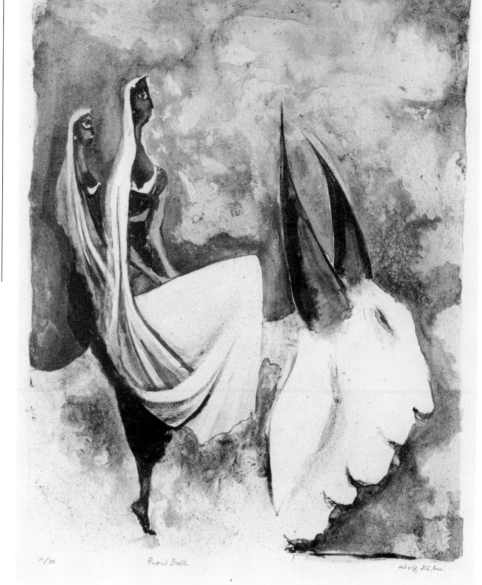

615
Roman Forum
1963
Lithograph in three colors
14 ⁵⁄₁₆ x 18 ⁵⁄₈ (36.4 x 47.3)
Edition: Artist's proofs only
Printed at Atelier Desjobert, Paris.

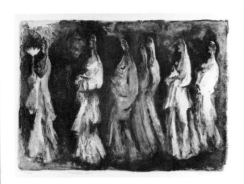

616
Seven Indian Ladies
1963
Lithograph in four colors
14 ⅞ x 21 ¼ (37.7 x 53.8)
Edition: 35, plus artist's proofs
Printed at Atelier Desjobert, Paris.

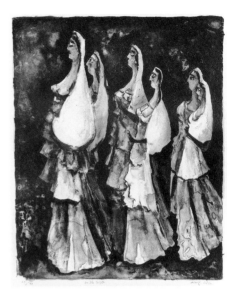

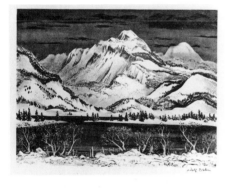

617.i
Six Brahmin Ladies
1963
Lithograph
18 ⅞ x 15 ½ (47.9 x 39.4)
Edition: 5
Printed at Atelier Desjobert, Paris.

617.ii
In the Night
1963
Lithograph in three colors
19 ⅛ x 15 ¾ (48.5 x 40.0)
Edition: 30, plus artist's proofs

618
Snow Mountain
Ca. 1963
Lithograph
9 ¾ x 13 (25.0 x 33.0)
Edition: Undetermined; artist's edition,
 10

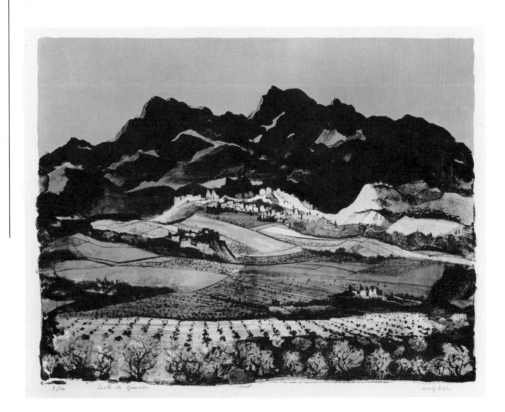

619
South to Granada
1963
Lithograph in three colors
14 ¼ x 18 ⁷⁄₁₆ (36.2 x 46.8)
Edition: 20, plus artist's proofs
Printed at Atelier Desjobert, Paris.

620.ii
Still Life
1963
Lithograph in three colors
18 9/16 x 15 (47.2 x 38.0)
Edition: 6 (numbered with Roman
 numerals)
Printed at Atelier Desjobert, Paris.

621
Toucans
1963
Lithograph in two colors
19 1/2 x 15 5/8 (49.5 x 40.0)
Edition: Artist's proofs only
Printed at Atelier Desjobert, Paris.

620.i
Still Life
1963
Lithograph in three colors
18 9/16 x 15 (47.2 x 38.0)
Edition: 20
Printed at Atelier Desjobert, Paris.

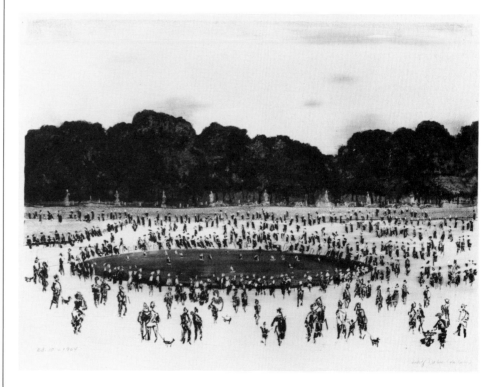

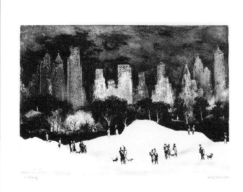

622
Dark Night
1964
Lithograph
13 7/8 x 19 13/16 (35.1 x 50.5)
Edition: 15, plus trial proofs
Printed by Burr Miller, New York.

623
Jardin des Luxembourg
1964
Lithograph
13 7/8 x 19 7/8 (35.4 x 50.4)
Edition: 10
Printed by Burr Miller, New York.

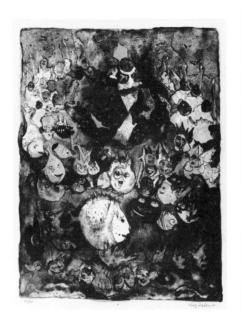

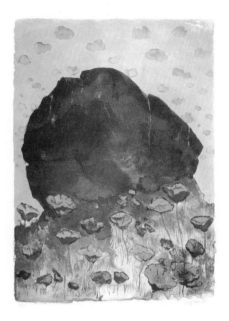

624
The Ascension Non-Stop
1965
Lithograph in four colors
19 ⅛ x 14 ⅞ (48.5 x 37.8)
Edition: 25, plus trial proofs
Printed at Atelier Desjobert, Paris.

625
Beauty and the Beast (*see Plate 31*)
1965
Lithograph in two colors
19 ⅛ x 14 ¼ (48.5 x 36.1)
Edition: 25, plus trial and artist's proofs
Printed at Atelier Desjobert, Paris.

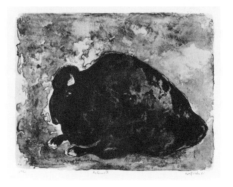

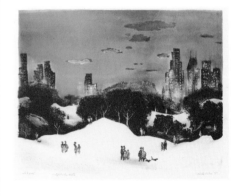

626.i
Behemoth
1965
Lithograph
14 ½ x 18 ¾ (36.7 x 47.7)
Edition: 20
Printed at Atelier Desjobert, Paris.

626.ii
Behemoth (*see Plate 32*)
1965
Lithograph in three colors
14 ⅜ x 18 ⅞ (36.5 x 48.0)
Edition: 40, plus trial and artist's proofs
Printed at Atelier Desjobert, Paris.

627
Central Park Winter
1965
Lithograph in three colors
14 x 18 (35.5 x 45.8)
Edition: Sears, Roebuck and Company
 edition, 50; artist's edition, 5, plus
 artist's proofs
Printed at Atelier Desjobert, Paris.

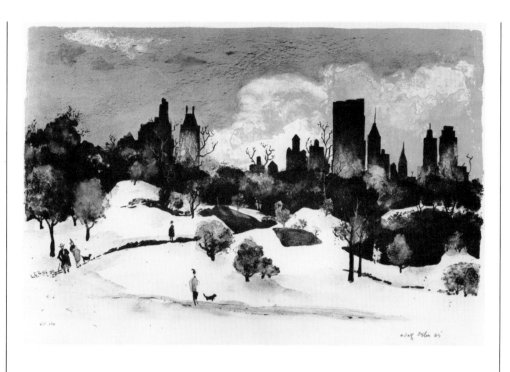

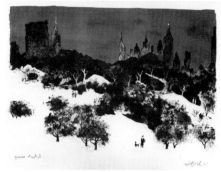

629

Clear Night in Winter (or **Snow** or
 Sombre City)
1965
Lithograph in three colors
13 x 19 (33.0 x 48.2)
Edition: 20, plus trial and artist's proofs
Printed at Atelier Desjobert, Paris.

628

Central Park Winter (or **Snow in
 Central Park**)
1965
Lithograph in three colors
14⅞ x 23⅝ (37.8 x 60.2)
Edition: 150
Printed at Atelier Desjobert, Paris.

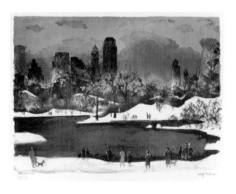

630

Cold Winter (or **Nocturne** or **Christ-
mas Eve** [Central Park])
1965
Lithograph in three colors
14³⁄₁₆ x 19½ (36.1 x 49.4)
Edition: 30, plus trial and artist's proofs
Printed at Atelier Desjobert, Paris.

631

Destry Rides Again (or **Dream World**
 or **Horns of a Dilemma**)
1965
Lithograph in three colors
14⁷⁄₁₆ x 18⅞ (36.5 x 48.0)
Edition: 15, plus trial proofs
Printed at Atelier Desjobert, Paris.

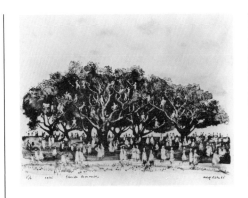

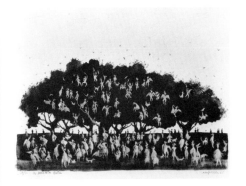

632.i
Florida Promenade
1965
Lithograph
14 ⅛ x 19 ⅛ (35.8 x 48.5)
Edition: 6, plus trial proofs
Printed at Atelier Desjobert, Paris.

632.ii
Les Hommes Betes (or Beasts and Birds)
1965
Lithograph
11 ¹¹⁄₁₆ x 19 ⅛ (29.7 x 48.6)
Edition: 10, plus trial and artist's proofs
Printed at Atelier Desjobert, Paris.

632.iii
Beasts and Birds (or Les Hommes Betes)
1965
Lithograph in two colors
13 ⅞ x 19 ⅛ (35.2 x 48.5)
Edition: 20, plus trial and artist's proofs
Printed at Atelier Desjobert, Paris.

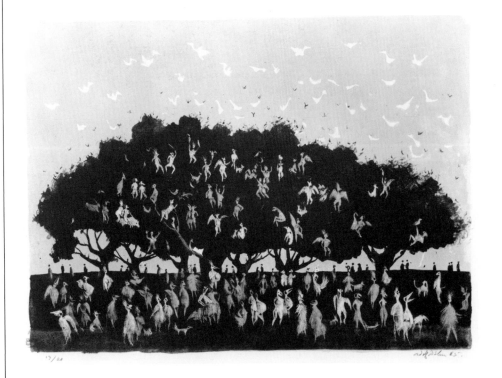

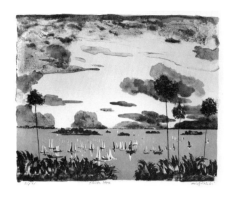

633
Florida Shore
1965
Lithograph in two colors
14⅝ x 18³⁄₁₆ (37.2 x 46.2)
Edition: 35, plus trial and artist's proofs
Printed at Atelier Desjobert, Paris.

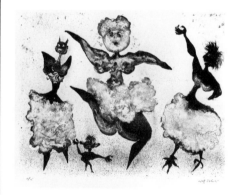

634
The Gay Ones
1965
Lithograph
14¾ x 18⅞ (37.4 x 48.0)
Edition: 15, plus artist's proofs
Printed at Atelier Desjobert, Paris.

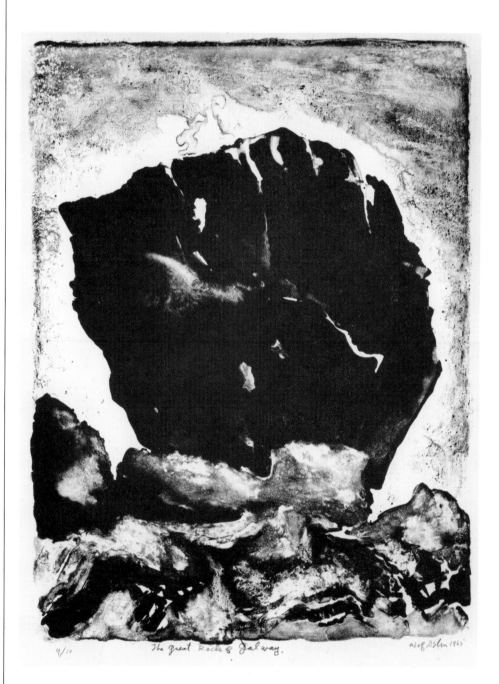

635.i
The Great Rock of Galway
1965
Lithograph
18¾ x 14¼ (47.6 x 36.2)
Edition: 10
Printed at Atelier Desjobert, Paris.

635.ii
The Great Rock of Galway
1965
Lithograph in three colors
18¾ x 14³⁄₁₆ (47.6 x 36.1)
Edition: 25, plus trial proofs
Printed at Atelier Desjobert, Paris.

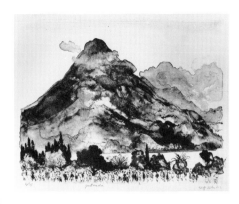

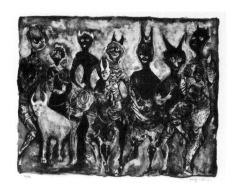

636
Guatemala (or **Guatemala Volcano**)
1965
Lithograph
14½ x 18½ (36.8 x 47.4)
Edition: 15, plus trial proofs
Printed at Atelier Desjobert, Paris.

637
Horns of a Dilemma
1965
Lithograph in two colors
15¼ x 19¹¹⁄₁₆ (38.7 x 50.1)
Edition: 20, plus trial and artist's proofs
Printed at Atelier Desjobert, Paris.

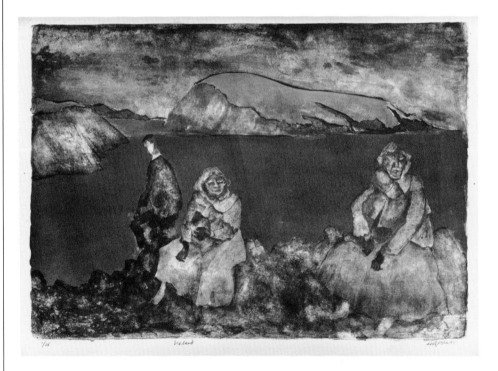

638
Ireland (*see Plate 33*)
1965
Lithograph in two colors
16¼ x 23¼ (41.2 x 59.1)
Edition: 20, plus trial and artist's proofs
Printed at Atelier Desjobert, Paris. This
 lithograph received the Cannon Prize
 at the 144th exhibition, National
 Academy of Design, New York, 1969.

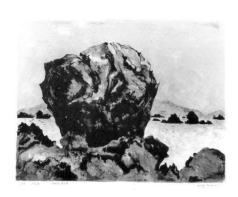

639
Irish Rock
1965
Lithograph in three colors
14 ¼ x 19 ⅛ (36.2 x 48.4)
Edition: Trial proofs only
Printed at Atelier Desjobert, Paris.

640
Italian Landscape (or Italian Hill)
1965
Lithograph in three colors
15 ¼ x 20 ⅜ (38.6 x 51.8)
Edition: 21
Printed at Il Bisonte Workshop, Florence.

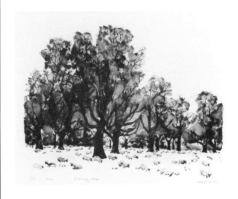

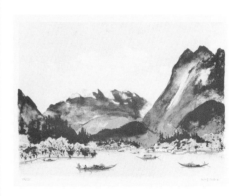

641
Killarney Sheep
1965
Lithograph
14 ⅛ x 18 ⅞ (35.9 x 48.0)
Edition: Trial proofs only
Printed at Atelier Desjobert, Paris.

642
Lake Dal
1965
Lithograph in four colors
13 ⅞ x 19 ⅛ (35.2 x 48.5)
Edition: 20, plus trial and artist's proofs
Printed at Atelier Desjobert, Paris.

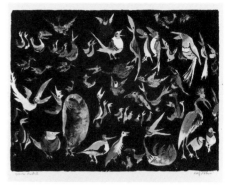

644
Many Birds
1965
Lithograph in four colors
14 ¼ x 18 ¹⁵⁄₁₆ (36.2 x 48.1)
Edition: 35, plus trial and artist's proofs
Printed at Atelier Desjobert, Paris.

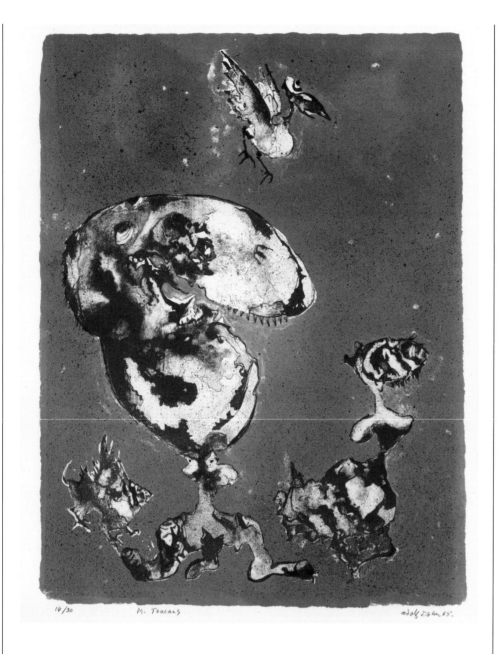

643
M. Toucans
1965
Lithograph in two colors
18 ⅞ x 14 ⅝ (48.0 x 37.1)
Edition: 20, plus trial and artist's proofs
Printed at Atelier Desjobert, Paris.

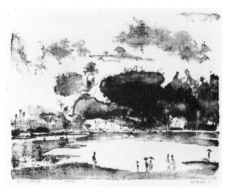

645.i
Monsoon
1965
Lithograph
13 ¹⁵⁄₁₆ x 17 ¹⁵⁄₁₆ (35.5 x 45.5)
Edition: 10, plus artist's proofs
Printed at Atelier Desjobert, Paris.

645.ii
Monsoon
1965
Lithograph in three colors
14 x 17 ¹⁵⁄₁₆ (35.5 x 45.5)
Edition: 30, plus trial proofs
Printed at Atelier Desjobert, Paris.

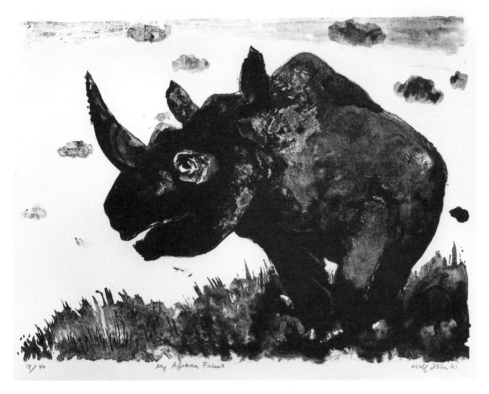

647

My Chinese Landscape

1965
Lithograph in two colors
17 x 21¼ (43.0 x 54.0)
Edition: 30, plus trial and artist's proofs
Printed at Atelier Desjobert, Paris.

646

My African Friend (or My Friend the African)

1965
Lithograph
14¼ x 19⅛ (36.1 x 48.4)
Edition: 40
Printed at Il Bisonte Workshop, Florence.

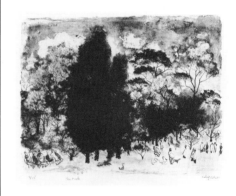

648

New Hope Winter

1965
Lithograph in four colors
13¹⁵⁄₁₆ x 19⅜ (35.4 x 49.2)
Edition: 25
Printed at Atelier Desjobert, Paris.

649

The Park

1965
Lithograph
14½ x 19 (36.9 x 48.3)
Edition: 15, plus artist's proofs
Printed at Atelier Desjobert, Paris.

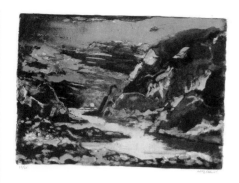

650
The Rosy Fingered Dawn
1965
Lithograph in three colors
13 ⅜ x 18 ⅞ (34.0 x 48.0)
Edition: 25, plus trial and artist's proofs
Printed at Atelier Desjobert, Paris.

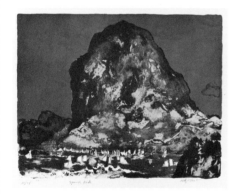

652
Spanish Rock
1965
Lithograph in three colors
14 ⅝ x 18 ⅝ (37.1 x 47.5)
Edition: 25, plus trial and artist's proofs
Printed at Atelier Desjobert, Paris.

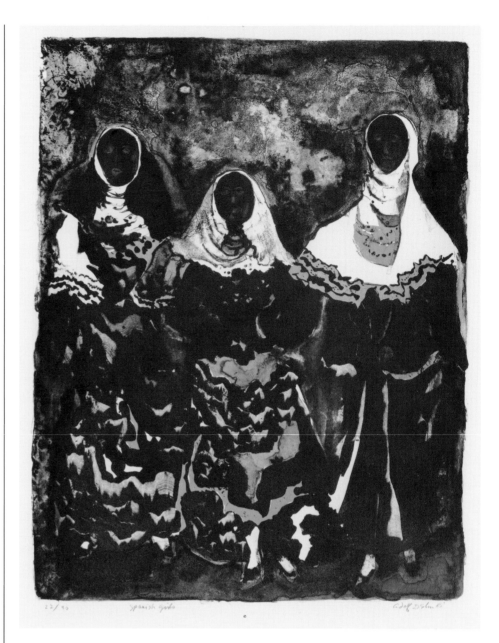

651
Spanish Girls
1965
Lithograph in three colors
18 ¼ x 14 ⅝ (46.4 x 37.2)
Edition: 30; International Graphic Arts
 Society edition, 200; artist's edition,
 10, plus trial proofs
Printed at Atelier Desjobert, Paris.

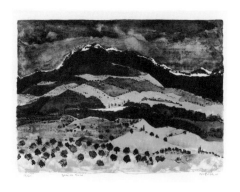

653.i
Spanish Snow (or Spanish Hills)
1965
Lithograph
13 ⅜ x 19 ¼ (33.9 x 49.0)
Edition: 20
Printed at Atelier Desjobert, Paris.

653.ii
Spanish Snow
1965
Lithograph in four colors
13 ¹³⁄₁₆ x 19 ¹⁄₁₆ (35.1 x 48.4)
Edition: 25, plus trial and artist's proofs
Printed at Atelier Desjobert, Paris.

654
Taj Mahal
1965
Lithograph
14 ⅜ x 18 ¾ (36.5 x 47.6)
Edition: 20, plus trial and artist's proofs
Printed at Atelier Desjobert, Paris.

655
Temptation of St. Anthony
1965
Lithograph
13 ¹⁵⁄₁₆ x 18 (35.4 x 45.6)
Edition: 20, plus trial proofs
Printed by Burr Miller, New York.

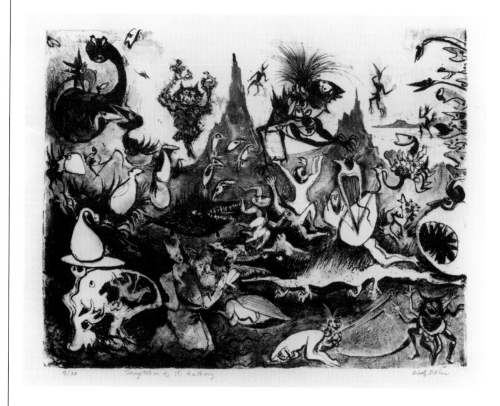

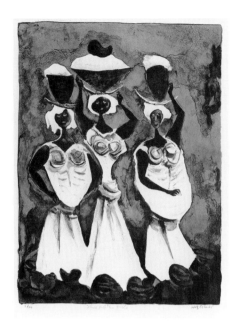

656
Three Haitian Girls
1965
Lithograph in three colors
18⁹⁄₁₆ x 14 (47.2 x 35.5)
Edition: 25, plus trial proofs
Printed at Atelier Desjobert, Paris.

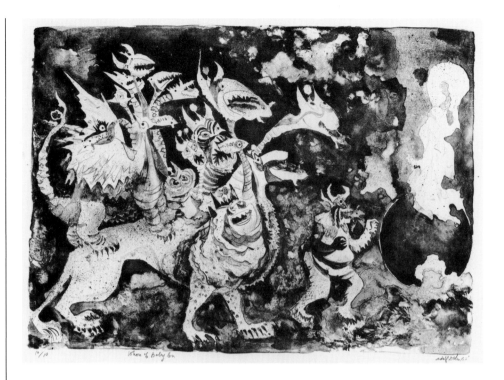

657.i
Whore of Babylon (*see Plate 21*)
1965
Lithograph
17¹⁄₁₆ x 24 (43.3 x 61.0)
Edition: 10, plus trial proofs
Printed at Atelier Desjobert, Paris.

657.ii
Whore of Babylon
1965
Lithograph in three colors
16⅞ x 24 (42.8 x 61.0)
Edition: 25, plus trial and artist's proofs
Printed at Atelier Desjobert, Paris.

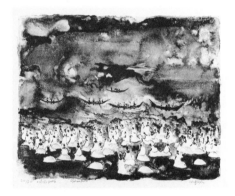

658
African Shore
1967
Lithograph in two colors
14⅝ x 18¹¹⁄₁₆ (37.1 x 47.5)
Edition: 20; International Graphic Arts
 Society edition, 200; artist's edition,
 10, plus artist's proofs
Printed at Atelier Desjobert, Paris.

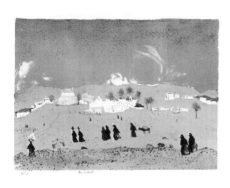

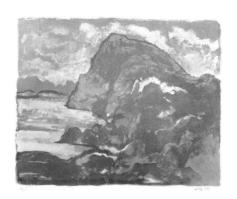

659
The Desert
1967
Lithograph
13 1/4 x 18 3/8 (33.6 x 46.7)
Edition: 15, plus trial proofs
Printed at Atelier Desjobert, Paris.

660
Irish Mountains
1967
Lithograph in three colors
14 3/4 x 18 5/8 (37.5 x 47.5)
Edition: 15, plus artist's proofs
Printed at Atelier Desjobert, Paris.

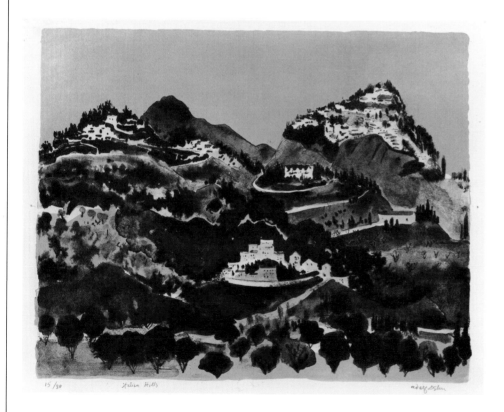

661
Italian Hills (or **Italian Mountains and Hills**)
1967
Lithograph in three colors
14 5/8 x 18 7/8 (37.2 x 48.0)
Edition: 20, plus artist's proofs
Printed at Atelier Desjobert, Paris.

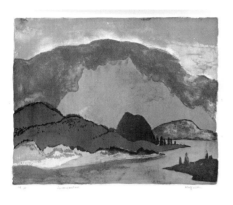

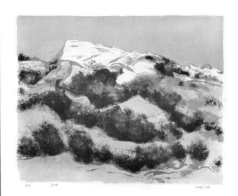

662
Lavender Mountains
1967
Lithograph in five colors
14⅞ x 18¹⁵⁄₁₆ (37.7 x 48.2)
Edition: 20, plus trial and artist's proofs
Printed at Atelier Desjobert, Paris.

663
Snow
1967
Lithograph in three colors
14¾ x 18¾ (37.5 x 47.7)
Edition: 10, plus artist's proofs
Printed at Atelier Desjobert, Paris.

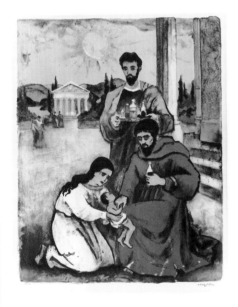

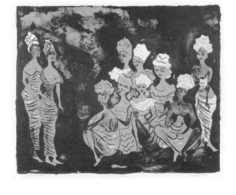

665
Women of Gunée (or African Women)
1967
Lithograph in three colors
14¹¹⁄₁₆ x 18⅝ (37.4 x 47.3)
Edition: Artist's proofs only
Printed at Atelier Desjobert, Paris.

664
Untitled
1967
Lithograph in four colors
21½ x 17¼ (54.5 x 43.7)
Edition: 3750; special edition with added color, 175
Printed at Atelier Desjobert, Paris, for the Libbey-Owens Company, Illinois.

INDEX

OF

TITLES

PRINTS are listed in alphabetical order by both main and alternate titles. Alternate titles are in parentheses following main titles; main titles are in brackets following alternate titles.

SELECT BIBLIOGRAPHY

Adams, Clinton. *American Lithographers, 1900–1960: The Artists and Their Printers*. Albuquerque: University of New Mexico Press, 1983.

Adolf Dehn: 1895–1968. Introduction by Mahonri Sharp Young. Columbus: Columbus Gallery of Fine Arts, 1969.

Adolf Dehn: Retrospective Exhibition of Lithographs, 1920–1963. New York: FAR Gallery, March 9–29, 1964.

Adolf Dehn Drawings. Columbia: University of Missouri Press, 1971.

Adolf Dehn: 30 Years of Lithography, 1927–1957. New York: Krasner Gallery, 1958.

Brace, Ernest. "Adolf Dehn." *American Magazine of Art* 29 (February 1936): 92–99.

Brown, Milton. *American Painting from the Armory Show to the Depression*. Princeton, N.J.: Princeton University Press, 1955.

Bruening, Margaret. "Dehn Lithographs." *Art Digest*, May 1, 1947, p. 17.

Cox, Richard W. "Adolf Dehn: The Minnesota Connection." *Minnesota History* 45 (Spring 1977): 166–86.

_____. "Adolf Dehn: Satirist of the Jazz Age." *Archives of American Art Journal* 18 (1978): 11–18.

Craven, Thomas, ed. *Treasury of American Prints: A Selection of One Hundred Etchings and Lithographs by the Foremost Living American Artists*. New York: Simon and Schuster, 1939.

Dehn, Adolf. "Boardman Robinson, the Artist." In *Boardman Robinson* by Albert Christ-Janer. Chicago: University of Chicago Press, 1946.

_____. "Don't Let Lithography Frighten You." *American Artist* 16 (June 1952): 52–57, 87.

_____. "A Lithograph Is Not an Etching." *Art News* 46 (May 1947): 23–29, 58–59.

_____. "O Woman! O Frailty!" 49 *The Magazine of the Year*, February 1948, p. 133.

_____. Papers. Archives of American Art, Smithsonian Institution, Washington, D.C. (microfilm, Minnesota Historical Society, St. Paul, Minn.).

_____. "Revolution in Printmaking." *College Art Journal* 9 (1949): 201–3.

_____. *Water Color, Gouache, and Casein Painting.* New York: Studio Publications, Inc., in association with Thomas Y. Crowell Co., 1955.

_____. *Water Color Painting.* New York: Thomas Y. Crowell and Co., 1945.

Dehn, Adolf, and Lawrence Barrett. *How to Draw and Print Lithographs.* New York: American Artists Group, Inc., 1950.

Gág, Wanda. *Growing Pains: Diaries and Drawings for the Years 1908–1917.* New York: Coward McCann, 1940. Reprint. St. Paul: Minnesota Historical Society Press, Borealis Books, 1984.

Guitar, Mary Anne. "Adolf Dehn." In *Twenty-two Famous Painters and Illustrators Tell How They Work*, 45–52. New York: David McKay Co., Inc., 1964.

Johnson, Una E. *American Prints and Printmakers: A Chronicle of over 400 Artists and their Prints from 1900 to the Present.* Garden City, N.Y.: Doubleday, 1980.

Loran, E. "Adolf Dehn." *American Magazine of Art* 29 (January 1936): 25–27.

Lumsdaine, Joycelyn Pang. "The Prints of Adolf Dehn and a Catalogue Raisonne." Master's thesis, University of California at Los Angeles, 1974.

De Maupassant, Guy. *Selected Tales of Guy De Maupassant.* Edited by Saxe Commins; illustrated by Adolf Dehn. New York: Random House, Book-of-the-Month Club, 1945.

Pearson, Ralph. "Adolf Dehn." In *The Modern Renaissance in American Art*, 77–81. New York: Harper and Brothers, 1954.

Pène du Bois, Guy. "Adolf Dehn." *Creative Art* 9 (July 1931): 32–36.

Salpeter, Harry. "Adolf Dehn: Happy Artist." *Esquire*, May 1941, p. 94–95, 162–64.

Scherman, Katharine. *The Slave Who Freed Haiti: The Story of Toussaint L'Ouverture.* Illustrated by Adolf Dehn. New York: Random House, 1954.

Watrous, James. *American Printmaking: A Century of American Printmaking, 1880–1980.* Madison: University of Wisconsin Press, 1984.

Watson, Ernest. "Adolf Dehn's Watercolors of Navy Blimps." *American Artist*, March 1984, p. 25–27.

Weitenkampf, Frank. *American Graphic Art.* 1924. Reprint. New York: Johnson Reprint, 1970.

Zigrosser, Carl. "Adolf Dehn." In *The Artist in America: Twenty-four Close-ups of Contemporary Printmakers*, 14–23. New York: Alfred A. Knopf, 1942.

_____. "Graphic Arts of the Twentieth Century." In *Arts of the United States, A Pictorial Survey.* Edited by William H. Pierson and Martha Davidson. Athens: University of Georgia Press, 1960.

CHRONOLOGY

1895 Adolph Arthur Dehn, only son and eldest of three children, born to Arthur Clark and Emilie Haase Dehn in Waterville, Minnesota, November 22.

1914 Valedictorian of graduating class of Waterville High School.

1914–17 Attended Minneapolis School of Art; exhibited twenty-one drawings at student exhibit in 1915.

1917 First published drawing appeared in *The Masses*; accepted scholarship to Art Students League, New York.

1918 Spent four months in guardhouse of camp at Spartanburg, South Carolina, for refusing to serve when drafted; after armistice, spent eight months as a volunteer teaching drawing and painting at a rehabilitation hospital in Asheville, North Carolina.

1919 Returned to Art Students League for another year of study.

1920 Made first lithograph, probably *The Harvest*.

1921 First exhibition of lithographs, Weyhe Gallery, New York.

To Europe, most time spent in vicinity of Berlin, Paris, London, and Vienna, where he eventually settled.

1923 Returned to United States for first one-artist exhibition, Weyhe Gallery, New York, April 2–25.

Returned to Europe for three years; spent one month in Italy.

1925 Made first drypoint, *Cafe Table*.

Changed name to "Adolf."

1926 Married Mura Ziperovitch, Vienna; marriage terminated approximately five years later.

1927 To Brittany (Douarnenez, Quimper, Concarneau).

1928 Most prolific year of lithographic production, working with printer Edmond Desjobert; issued *Paris Lithographs*, a portfolio of ten prints.

1929 Returned to United States.

Winter 1929–30	To Berlin. Produced over forty "Large Berlin Lithographs" with Meister Schulz of Birkholz.
Winter 1931–32	To Paris, produced lithographs with Desjobert.
1933	Returned to United States. Joined The Contemporary Print Group; *Easter Parade* was included in the first volume of *The American Scene*.
1934	Established the Adolf Dehn Print Club.
	Founder-member artist in the print program of the Associated American Artists, New York.
	Illustrated *Men Are Clumsy Lovers* by Edith Stern.
	Illustrated *Romeo Reverse* by Edward Dean Sullivan (Hardy Allen, pseud.).
1936	Selected by *Prints* magazine as one of the ten best printmakers in the United States.
	To Europe, primarily Austria and Yugoslavia, Summer and Fall.
1937?	Started painting watercolors upon return to United States.
	Worked in the graphic arts division of the Federal Art Project.
1937	Final year of the Adolf Dehn Print Club.
1938	Art instructor, Stephens College, Columbia, Missouri, Summer.
	First public showing of watercolors.
1939	Art instructor, Stephens College, Columbia, Missouri, Summer.
	Guggenheim Fellowship; traveled to Far West and Mexico, July–December.
1940	Critic in etching and lithography, Colorado Springs Fine Arts Center, Summer.
	Made only known serigraph, *The Great God Pan*.
1941	Instructor, Colorado Springs Fine Arts Center, Summer.
1942	Instructor, Colorado Springs Fine Arts Center, Summer.

1943	Citation from United States Treasury Department for "Distinguished Service Rendered in Behalf of War Savings Program."
1944	To Baton Rouge, Louisiana, and Venezuela. Produced fourteen watercolors for Standard Oil of New Jersey and three watercolors for Abbott Laboratories.
1945	Published *Water Color Painting*.
	Produced twenty lithographs for and illustrated *Selected Tales of Guy De Maupassant*.
1946	Produced nine paintings of Missouri for Scruggs-Vandervoort-Barney, Inc., reproduced 1947 in *Missouri, Heart of the Nation*.
1947	Married Virginia Engleman.
1948	In Key West, Florida, January–March.
1949	To Cuba and Haiti, January–March.
	To Colorado Springs where he made some Haitian prints, Fall.
1950	Published *How to Draw and Print Lithographs* with Lawrence Barrett.
1950–51	Guest watercolorist, Norton Gallery and School of Art, West Palm Beach, Florida.
1951	Second Guggenheim Fellowship; to Cuba, March.
1953	Produced *Good Morning*, a Bourges process paintagraph.
1954	Illustrated children's book, *The Slave Who Freed Haiti: The Story of Toussaint L'Ouverture* by Katharine Scherman.
1955	Published *Watercolor, Gouache and Casein Painting*.
	Summer at Yaddo Foundation, Saratoga Springs, New York.
	To Yucatan and Guatemala, Winter.
1957	Wrote article on technique of watercolor painting for *Encyclopaedia Britannica*.

1958 Eight-month trip to Europe and Asia:
 Italy, Greece, Turkey, Iran, Lebanon,
 Afghanistan, India, Austria, Germany;
 in France worked at Atelier Desjobert for
 several weeks.

1961 To Spain with printer Federico Castel-
 lón; worked on prints in Paris several
 months at Atelier Desjobert.

 Elected full academician, National
 Academy of Design.

1963 With Federico Castellón to Spain, Major-
 ca, and southern France; in Paris
 worked at Atelier Desjobert.

1965 Much of the year spent in travel: Egypt,
 Ethiopia, Morocco, Kenya, Guinea,
 Spain, Portugal, Ireland; work at Atelier
 Desjobert, Paris.

 Elected to membership in the National
 Institute of Arts and Letters.

1967 Final visit to Paris; three months at
 Atelier Desjobert making lithographs.

1968 Died of complications following heart at-
 tack, May 19.

LIST OF
MAJOR
EXHIBITIONS

1915 Student exhibition, Minneapolis Institute of Arts, included twenty-one drawings by the artist.

1921 Largest graphic exhibition of the year, Weyhe Gallery, New York, included two lithographs by the artist.

1923 First one-artist exhibition, *Drawings and Lithographs by Adoph Dehn*, Weyhe Gallery, New York, April 2–25.

Exhibition, Würthle und Sohn, Vienna, included work by the artist.

1925 *Drawings by Adolph Dehn*, Weyhe Gallery, New York, January 16–31.

1928 Exhibition, Paris.

1929 *Drawings and Lithographs by Adolf Dehn*, Weyhe Gallery, New York, thirty-four lithographs and fifteen drawings, February 25–March 16.

Exhibition of lithographs, Berlin, included work by the artist.

1930 *50 New Lithographs by Adolf Dehn*, Weyhe Gallery, New York, April 7–26.

1931 India ink drawings by the artist, Weyhe Gallery, New York, Spring.

1932 *Lithographs by Adolf Dehn*, Weyhe Gallery, New York, April 11–30.

Exhibition, American Contemporary Art Gallery, included *Niagara*.

1933 *Fifty Prints of 1933*, American Institute of Graphic Arts, included *Lower Manhattan*. *20th Century New York in Paintings and Prints*, Whitney Museum of American Art, New York, included work by the artist.

1934 First Print Prize, Philadelphia Art Alliance, for *Native of Woodstock*.

1935 *American Genre – 20th Century*, Whitney Museum of American Art, New York, included work by the artist.

One-artist show, Weyhe Gallery, New York.

1936 First Prize, Philadelphia Art Alliance. Exhibition, The American Group Exhibition, included a watercolor by the artist. *Artists' Congress Show*, New York, included *Beethoven's Ninth Symphony* and *Art Lovers*.

1937 Exhibition, Society of American Etchers, National Arts Club, included *Road to Gayhead*, February.

Artists' Congress Show, New York.

Award, The Print Club of Philadelphia.

1938 First one-artist show of the artist's watercolors, Weyhe Gallery, New York, Spring. Annual Exhibition, Whitney Museum of American Art, New York, included work by the artist. Also in annual exhibitions in 1939, 1940, 1941, 1942, 1943, 1945, 1946, 1947, 1948, 1949, 1950, 1951, 1952, 1954, 1955, 1956, 1957, 1959, and 1962.

1939 Award, The Print Club of Philadelphia.

One-artist exhibition, Weyhe Gallery, New York.

1940 *12th Annual Exhibition of American Lithography*, The Print Club of Philadelphia, included *Great God Pan*, which was awarded the Mary S. Collins Prize, January–February 3.

Watercolors by Adolf Dehn, Weyhe Gallery, New York, April 29–May 18.

International Water Color Show, Chicago, included work by the artist.

1941 *The Satirical and the Lyrical*, Associated American Artists, New York, one-artist show of fifty-two watercolors and forty lithographs, May 12–31.

This is Our City—Greater New York, Whitney Museum of American Art, New York, included work by the artist.

200 American Watercolors, selected from a National Competition Held by the Society of Fine Arts, Washington, D.C., Whitney Museum of American Art, New York, included work by the artist.

1942 *A History of American Watercolor Painting*, Whitney Museum of American Art, New York, included work by the artist.

Between Two Wars: Prints by American Artists 1914–1941, Whitney Museum of American Art, New York, included work by the artist.

1943 First Prize, *International Watercolor Exhibit*, Art Institute of Chicago.

University of Arizona Collection, Whitney Museum of American Art, New York, included work by the artist.

1944 Exhibition on necessity of oil for the war effort, sponsored by Standard Oil of New Jersey, Brooklyn Museum, September 29–November 12.

Exhibition on United States Navy acitivities, sponsored by Abbott Laboratories, on tour to the National Gallery and the Metropolitan, Boston, and Springfield (Mass.) art museums, included three watercolors by the artist.

Four American Water Colorists, Museum of Modern Art, New York, included work by the artist.

Eyre Medal, Pennsylvania Academy of Fine Arts, for *Lake Tarryall*.

1945 One-artist exhibition, Caracas, Venezuela.

1946 *4th National Exhibition of Prints (Made during the Current Year)*, Library of Congress, Washington, D.C., included *Jungle at Night*, which received the J. and E. R. Pennell Collection Purchase Prize, May 1–August 1.

18th Annual Exhibition of American Lithography, The Print Club of Philadelphia, included *Tomorrow's Sunrise*, which received Honorable Mention.

1947 *Lithographs by Adolf Dehn*, Smithsonian Institution, Washington, D.C., February 3–March 2.

Adolf Dehn: New Lithographs, Associated American Artists, New York, one-artist show of sixty-one lithographs, April 14–May 3.

1948 *Second National Print Annual*, Brooklyn Museum, included *Jungle at Night*, which received a purchase prize.

150th Anniversary Exhibition of Lithography, Memorial Art Gallery, University of Rochester, included *Jungle at Night*, which received the B. Forman Company Prize, April.

An Exhibition of the Art of Lithography (Commemorating the Sesquicentennial of Its Invention, 1798–1948), Cleveland Museum of Art, included *Promenade* and *Road to Gayhead*, November 11, 1948–January 2, 1949.

War Assets Administration Exhibition, Whitney Museum of American Art, New York, included work by the artist.

1949 *33rd Annual Exhibition of the Society of American Etchers, Gravers, Lithographers, and Woodcutters, Inc.*, included *Central Park at Night* and *Nocturnal Visitors*, which received the H. F. J. Knobloch Prize for Lithography.

Commemorative Exhibition of Adolf Dehn's Twenty-Five Years' Work in Lithography, Associated American Artists, New York, September.

Oeuvres graphiques américaines, Centre Américain de Documentation (United States Embassy), Paris, included *Sunday Painters*, October 18–28.

124th Annual Exhibition, National Academy of Design, New York, included *Haitian Night*, which received an anonymous award, to December 11.

Juliana Force and American Art, Whitney Museum of American Art, New York, included work by the artist.

1950 *8th National Exhibition of Prints*, Library of Congress, Washington, D.C., included *Yesterday and Tomorrow*.

1951 Sao Paulo Biennial, Sao Paulo, Brazil, included work by the artist.

30 Lithographs by Adolf Dehn, University of Maine, Orono, November 1–30.

One-artist show of Haitian subjects and first showing of oil paintings, Associated American Artists, New York, November.

1952 *17th Exhibition of the Society of Washington Printmakers*, American Institute of Architects, Washington, D.C., included *Four Haitian Women*, November 16–December 18.

1954 *Prints from 1942 to '52*, Smithsonian Institution tour, included *Haitian Night*.

3rd International Biennial of Contemporary Color Lithography, Cincinnati Art Museum, included *Four Haitian Girls* and *Haitian Ballet*.

1956 One-artist show of paintings, Associated American Artists, New York, February 20–March 10.

40th Annual Exhibition, Society of American Graphic Artists, included *Three Mayan Women*, which received an award.

1957 One-artist show of paintings, Milch Gallery, New York, March 4–23.

1958 *Adolf Dehn: 30 Years of Lithography, 1927–1957*, Krasner Gallery, New York, one-artist show of sixty-three lithographs, February 3–28.

Adolf Dehn Retrospective, University of Missouri Art Department Gallery, Columbia, February 20–March 10.

5th International Biennial of Contemporary Lithography, Cincinnati Art Museum, included *Seven Mayan Women*, February 28–April 15.

16th National Exhibition of Prints Made during the Current Year, Library of Congress, Washington, D.C., included *Seven Mayan Women*, which was purchased for the J. and E. R. Pennell Collection.

Friends Loan Exhibition, Whitney Museum of American Art, New York, included work by the artist.

1959 *Graphics 1959*, sponsored by the Pratt Contemporary Graphic Art Centre and affiliated artists, Riverside Museum, New York, included work by the artist, February.

42nd Annual Exhibition of the Society of American Graphic Artists, Riverside Museum, New York, included *Monsoon*, September 10–27.

American Prints Today, Print Council of America, concurrent showings in various cities, included *Hill and Mountain*.

Audubon Artists Show, National Academy, New York, included *Hill and Mountain*, which received the Stauffer Award.

1960 *135th Annual Exhibition*, National Academy of Design, New York, in which the artist received an award for his graphic work, to March 20.

75th Grabadores Norte Americanos, Museo de Bellas Artes, Caracas, Venezuela, included *King of India*, September.

One-artist show of casein paintings, Milch Gallery, New York, October 10–29.

1961 *Adolf Dehn Retrospective*, University of Missouri Art Department Gallery, Columbia, one-artist show of seventy-five lithographs, February 20–March 10.

Exhibition of painters and sculptors, National Institute of Arts and Letters, included painting by the artist.

Contemporary Graphic Arts, selected and assembled by the Society of American Graphic Artists, Free Library of Philadelphia, included *King of India*, March 15–April 29.

1962 Award, American Watercolor Society, New York.

44th Annual Exhibition of the Society of American Graphic Artists, sponsored by Associated American Artists, New York, included work by the artist, February–March 17.

26 New Lithographs by Adolf Dehn (all made in 1961 in Paris), Associated American Artists, New York, April 2–21.

American Prints Today, Print Council of America, concurrent showings in eight cities, included *India Night*.

1963 Award, Society of American Graphic Artists.

Award, *20th American Drawing Annual*, Norfolk (Va.) Museum of Arts and Sciences.

Contemporary American Printmakers 5th Annual Exhibition, De Pauw University Art Center, Greencastle, Indiana, included *Four Caribs*, January 2–30.

Exhibition of the Month: The Lithographs of Adolf Dehn, University of Maine, Orono, April.

19th National Exhibition of Prints, Library of Congress, Washington, D.C., included *Sacred Ride*, to September.

60 Years of American Art, Whitney Museum of American Art, New York, included work by the artist.

1964 Award, American Watercolor Society, New York.

American Prints in Russia, American Institute of Graphic Arts, included *India Night*, January 14–21.

Adolf Dehn Retrospective Exhibition of Lithographs, 1920–1963, show of seventy-three lithographs, FAR Gallery, New York, March 9–29.

1965 One-artist show of watercolors, Milch Gallery, New York, Spring.

1968 Retrospectives at the FAR Gallery and The Century Association, New York.

Adolf Dehn Paintings and Lithographs, Capricorn Galleries, Bethesda, Maryland, March 8–31.

Manhattan Observed, Museum of Modern Art, New York, included *Die Walküre*, March 22–May 12.

1969 *144th Annual Exhibition*, National Academy of Design, New York, included *Ireland*, which won the Cannon Prize.

The Adolf Dehn Exhibition, The Carlin Galleries, Fort Worth, Texas, July 13–August 4.

Adolf Dehn, 1895–1968, retrospective museum tour organized by the Columbus Gallery of Fine Arts, 1969–70, included 102 pieces of various media.

CATALOGUE NUMBER CONVERSION LIST

IN THE LEFT COLUMN are the numbers used in this catalogue; the corresponding numbers from Lumsdaine's thesis are in the right column. A * indicates a print was not included in Lumsdaine's thesis.

1 = L1	26 = L18	51 = L39
2 = L2	27 = L16	52 = L40
3 = L3	28 = D10	53 = L102
4 = L4	29 = *	54 = L41
5 = L5	30 = D11	55 = L109
6 = L6	31 = L33	56 = L42
7 = L7	32 = L19	57 = L43
8 = L8	33 = L20	58 = L44
9 = L9	34 = L34	59 = L45
10 = L10	35 = L22	60 = L46
11 = L11	36 = L23	61 = L47
12 = L12	37 = L24	62 = L48
13 = L13	38 = L25	63 = L49
14 = L14	39 = L21	64 = L50
15 = L15	40 = L26	65 = L51
16 = D1	41 = L27	66 = L52
17 = D2	42 = L28	67 = L53
18 = D3	43 = L29	68 = L91
19 = L17	44 = L30	69 = L54
20 = D4	45 = L31	70 = L55
21 = D5	46 = L92	71 = L58
22 = D6	47 = L35	72 = L60
23 = D7	48 = L36	73 = L62
24 = D8	49 = L32	74 = L37
25 = D9	50 = L38	75 = L63

76 = L64	84 = L73
77 = L65	85 = L59
78 = L70	86 = L74
79 = L67	87 = L75
80 = L68	88 = L76
81 = L69	89 = L56
82 = L110	90 = L77
83 = L72	91 = L78
	92 = L61
	93 = L79
	94 = L80
	95 = L96
	96 = L81
	97 = L82
	98 = L83
	99 = L84
	100 = L85
	101 = L86
	102 = L87
	103 = L88
	104 = L89
	105 = L90
	106 = L93
	107 = L94
	108 = L57
	109 = L104
	110 = L95
	111 = L97
	112 = L98
	113 = L99
	114 = L71
	115 = L100
	116 = L101

117 = L111	182 = L168	247 = L234	312 = L295
118 = L103	183 = L166	248 = L236	313 = L298
119 = L105	184 = L169	249 = L237	314 = L301
120 = L106	185 = L170	250 = L235	315 = L299
121 = L107	186 = L171	251 = L238	316 = L300
122 = L66	187 = L172	252 = L239	317 = L310
123 = L108	188 = L173	253 = L240	318 = L302
124 = L112	189 = L174	254 = L242	319 = L303
125 = L113	190 = L175	255 = L243	320 = L318
126 = L114	191 = L176	256 = L244	321 = L304
127 = L115	192 = L177	257 = L245	322 = L308
128 = L125	193 = L148	258 = L241	323 = L305
129 = L116	194 = L178	259 = L230	324 = L306
130 = L117	195 = L179	260 = L246	325 = L317
131 = L118	196 = L180	261 = L247	326 = L307
132 = L119	197 = L181	262 = L248	327 = S1
133 = L120	198 = L182	263 = L249	328 = L309
134 = L121	199 = L185	264 = L250	329 = L311
135 = L122	200 = L184	265 = L251	330 = L312
136 = L123	201 = L186	266 = L252	331 = L313
137 = L124	202 = L187	267 = L253	332 = L314
138 = L126	203 = L188	268 = L254	333 = L315
139 = L127	204 = L189	269 = L260	334 = L316
140 = L128	205 = L191	270 = L261	335 = L446
141 = L129	206 = L193	271 = L262	336 = L323
142 = L130	207 = L215	272 = L263	337 = L321
143 = *	208 = L220	273 = L255	338 = L320
144 = L131	209 = L194	274 = L256	339 = L324
145 = L132	210 = L195	275 = L257	340 = L322
146 = L134	211 = L196	276 = L258	341 = L319
147 = L133	212 = L197	277 = L259	342 = L325
148 = L135	213 = L198	278 = L264	343 = L326
149 = L136	214 = L199	279 = L265	344 = L327
150 = L137	215 = L200	280 = L274	345 = L328
151 = L138	216 = L201	281 = L266	346 = L329
152 = L139	217 = L202	282 = L267	347 = L330
153 = L183	218 = L203	283 = L268	348 = L331
154 = L140	219 = L192	284 = L269	349 = L332
155 = L141	220 = L204	285 = L270	350 = L333
156 = L142	221 = L205	286 = L271	351 = L334
157 = L143	222 = L206	287 = L272	352.i & ii = L335 a & b
158 = L144	223 = L207	288 = L273	353 = L336
159 = L145	224 = L208	289 = L275	354 = L337
160 = L146	225 = L209	290 = L276	355 = L338
161 = L147	226 = L210	291 = L277	356 = L340
162 = L150	227 = L211	292 = L284	357 = L339
163 = L149	228 = L212	293 = L278	358 = L342
164 = L190	229 = L213	294 = L279	359 = L343
165 = L151	230 = L214	295 = L280	360 = L344
166 = L152	231 = L216	296 = L287	361 = L341
167 = L153	232 = L217	297 = L288	362 = L345
168 = L154	233 = L218	298 = L281	363 = L346
169 = L155	234 = L219	299 = L282	364 = L347
170 = L156	235 = L221	300 = L283	365 = L348
171 = L157	236 = L222	301 = L285	366 = L349
172 = L158	237 = L223	302 = L286	367 = L350
173 = L159	238 = L224	303 = *	368 = L351
174 = L160	239 = L225	304 = L289	369 = L352
175 = L161	240 = L226	305 = L294	370 = L352
176 = L162	241 = L227	306 = L290	371 = L353
177 = L163	242 = L229	307 = L291	372 = L353
178 = L164	243 = L228	308 = L292	373 = L354
179 = L165	244 = L231	309 = L293	374 = L354
180 = *	245 = L232	310 = L296	375 = L355
181 = L167	246 = L233	311 = L297	376 = L355

377 = L356	442 = L412	507 = E2	572 = L540
378 = L357	443 = L416	508 = L480	573 = L542
379 = L358	444 = L417	509 = L482	574 = L543
380 = L359	445 = L418	510.i & ii = L483 a & b	575 = L544
381 = L360	446 = L419	511 = L486	576 = L545
382 = L400	447 = L441	512 = L485	577 = L546
383 = L361	448 = L420	513 = L487	578 = L550
384 = L403	449 = L421	514 = L488	579 = L554
385 = L401	450 = L422	515 = L489	580 = L552
386 = L362	451 = L447	516 = L491	581 = L553
387 = L358	452 = L423	517 = L490	582 = L551
388 = L402	453 = L425	518 = L484	583 = L555
389 = L403	454 = L426	519 = L492	584 = L556
390 = L363	455 = L427	520 = L502	585 = L557
391 = L364	456 = L428	521 = L502	586.i & ii = L558 a & b
392 = L365	457 = L429	522 = L493	587 = L559
393 = L366	458 = L430	523 = L500	588.i & ii = L560 a & b
394 = L367	459 = L431	524 = L494	589 = L561
395 = L368	460 = L432	525 = L495	590 = L587
396 = L369	461 = L433	526 = L501	591.i & ii = L562 a & b
397 = L370	462 = L415	527 = L496	592 = L563
398 = L371	463 = L434	528 = L497	593 = L564
399 = L372	464 = L435	529 = L502	594 = L588
400 = L373	465 = L436	530 = L498	595.i & ii = L565 a & b
401 = L374	466 = L437	531 = L499	596.i & ii = L566 a & b
402 = L375	467 = L438	532 = L507	597.i & ii = L567 a & b
403 = L376	468 = L424	533 = L503	598 = L568
404 = L377	469 = L439	534 = L504	599 = L569
405 = L378	470 = L440	535 = L505	600.i & ii = L570 a & b
406 = L379	471 = L442	536.i & ii = L506 a & b	601 = L589
407 = L380	472 = L443	537 = L508	602 = L593
408 = L381	473 = L444	538 = L509	603 = L572
409 = L382	474 = L449	539 = L510	604.i & ii = L573 a & b
410 = L445	475 = L450	540 = L511	605 = L574
411 = L404	476 = L451	541 = L512	606.i & ii = L575 a & b
412 = L383	477 = L452	542 = L513	607.i & ii = L580 a & b
413 = L384	478 = L453	543 = L514	608 = L576
414 = L405	479 = L454	544 = L515	609 = L577
415 = L405	480 = L455	545 = L548	610 = L578
416 = L405	481 = L456	546 = L516	611.i & ii = L579 a & b
417 = L385	482 = L471	547 = L517	612 = L581
418 = L386	483 = L472	548 = L518	613 = L591
419 = L406	484 = L457	549 = L519	614 = L582
420 = L387	485 = L458	550 = L549	615 = L583
421 = L388	486 = L459	551 = L521	616 = L584
422 = L389	487 = L460	552 = L522	617.i & ii = L571 a & b
423 = L396	488 = L461	553.i & ii = L523 a & b	618 = L592
424 = L390	489 = L466	554 = L524	619 = L585
425 = L391	490 = L462	555 = L525	620.i & ii = L586 a & b
426 = L392	491 = L463	556 = L526	621 = L590
427 = L393	492 = L464	557 = L527	622 = L594
428 = L408	493 = L467	558 = L520	623 = L595
429 = L394	494 = L468	559 = L528	624 = L596
430 = L409	495 = L465	560 = L529	625 = L598
431 = L395	496 = L469	561 = L530	626.i & ii = L599 a & b
432 = L410	497 = L470	562 = L531	627 = L600
433 = L397	498 = P1	563 = L532	628 = L601
434 = L398	499 = L473	564 = L533	629 = L602
435 = L399	500 = L478	565.i & ii = L534 a & b	630 = L603
436 = L547	501 = L474	566 = L535	631 = L604
437 = L414	502 = L475	567 = L541	632.i & ii & iii = L597 a & b & c
438 = L407	503 = L476	568 = L536	633 = L605
439 = L448	504 = L477	569 = L537	634 = L606
440 = L411	505 = L479	570 = L538	635.i & ii = L607 a & b
441 = L413	506 = L481	571 = L539	636 = L608

637 = L609	645.i & ii = L616 a & b	653.i & ii = L624 a & b	661 = L634
638 = L610	646 = L617	654 = L625	662 = L635
639 = L611	647 = L618	655 = L626	663 = L637
640 = L628	648 = L619	656 = L627	664 = L636
641 = L612	649 = L620	657.i & ii = L629 a & b	665 = L631
642 = L613	650 = L621	658 = L630	
643 = L614	651 = L622	659 = L632	
644 = L615	652 = L623	660 = L633	

PICTURE CREDITS

The photographs used in the essays in this book are in the Minnesota Historical Society Collections. Those listed below appear through the courtesy of Virginia E. Dehn. The names of photographers, when known, are given in parentheses.

Pages 3, 5, 6, 10, 12, 17 (John D. Schiff), 18, 20 (John D. Schiff), 21, 32 (Keystone View Co., New York and Berlin), 36 (Gene Pyle), 38 top, 39 (John D. Schiff).

DONOR CREDITS

Except as noted at right, the prints illustrated in this catalogue raisonné are from the collections of the Minnesota Historical Society. All are gifts of Virginia Engleman Dehn with the exceptions of prints purchased by the Society and the following additional gifts:
Little Sinner (Cat. No. 80), gift of Cameron Booth
Selected Tales of Guy De Maupassant portfolio (Cat. No. 390–409), gift of Le Sueur County Historical Society Museum, Elysian, Minnesota.

PERMISSIONS

The following museums or institutions gave permission for works in their collections to be reproduced in this catalogue raisonné.
PHILADELPHIA MUSEUM OF ART
Lac Aiguebelette, Savoie (Cat. No. 37), *Greetings from Margaret De Silver* (Cat. No. 162), *Waves* (Cat. No. 277) – Purchased: Lola Downin Peck Fund
Great God Pan (Cat. No. 313) – Purchased: Lola Downin Peck Fund from the Carl and Laura Zigrosser Collection (Joan Broderick, photographer)

THE BROOKLYN MUSEUM
Noon Hour (Cat. No. 141a) – 31.600, Gift of Mrs. Albert De Silver

UNIVERSITY ART MUSEUM, University of Minnesota, Minneapolis
Afternoon in Central Park (Cat. No. 303) – Purchase, 39.13

NEW YORK ARTISTS EQUITY ASSOCIATION, INC.
American Artists Group Advertisement (Cat. No. 475)

COLOPHON

This book was designed by Alan Ominsky with assistance from Nancy Leeper. It was composed in Palatino and Serif Gothic on a Compugraphic digital typesetter by Stanton Publication Services. Bolger Publications printed the book on two- and four-color Heidelberg presses using color separations supplied by Colorbrite, Inc. All of these firms are in Minneapolis. Bookmasters of St. Paul bound the book.